Breakthrough!

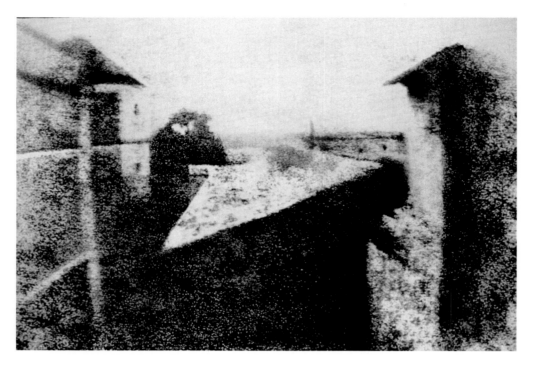

View from the Window at Le Gras, Joseph Nicéphore Niépce, the earliest known surviving photograph, Camera Obscura, 8 hours, 1826–1827.

Robert Gendler • R. Jay GaBany

Breakthrough!

100 Astronomical Images That Changed the World

 Springer

Robert Gendler
Rob Gendler Astropics
Avon, CT
USA

R. Jay GaBany
San Jose, CA
USA

ISBN 978-3-319-20972-2 ISBN 978-3-319-20973-9 (eBook)
DOI 10.1007/978-3-319-20973-9

Library of Congress Control Number: 2015950647

Springer Cham Heidelberg New York Dordrecht London
© Springer International Publishing Switzerland 2015

Cover image of M-57, the Ring Nebula, courtesy of Robert Gendler

Printed on acid-free paper

Springer International Publishing AG Switzerland is part of Springer Science+Business Media (www.springer.com)

We dedicate this book to our wives, Joanne and Anne, for their patience and loving support while we pursued our passions.

Preface

Until the mid-nineteenth century, observational astronomy was the primary means of advancing our knowledge of the universe. Paper and a writing instrument were all that recorded the wonders revealed by looking through a telescope eyepiece. Although the first telescopes were in use by 1609, astrophotography had to wait until the invention of the camera in 1839.

The coupling of a camera to a telescope soon followed, and in 1840, with the awkward snap of a primitive shutter, the first image of the Moon heralded the birth of astrophotography. This event was shortly superseded by photographs of the Sun, planets, stars, and comets. But all of these were relatively easy subjects because of their brightness, which only required a relatively short exposure.

Photographs that peered deep into the heavens, revealing stars far fainter than those observed with the naked eye or through an eyepiece, had to wait for a number of frustrating technical issues to be solved. These issues included the advent of more sensitive photographic media, more efficient telescope optics, and the precision clock drives necessary to carry those instruments for extended exposures.

Hundreds of thousands of pictures have been produced since the first telescopic images were exposed. Occasionally, a single image or a group of images will stand out as a substantial milestone in our understanding of cosmic phenomena. These pictures are rare and often as inspirational as they are groundbreaking. They may provide the first glimpse of a new object or structure previously unsuspected, provide fresh insight into a natural process that was only partially understood, or capture a cosmic event that alters our perspective about humanity's place in the cosmos. They may also represent a technical breakthrough that opens a multitude of new opportunities for understanding fundamental concepts previously out of reach.

Fast-forwarding to the twenty-first century, we can now look back and confidently say that for over a century and a half astrophotography has revealed most of what we know about the universe.

The nature, origin, and human stories behind these pioneering images are varied and fascinating. Some are produced by ground-based observatories, others by orbiting telescopes, and still others by manned and unmanned space missions near our planet or deep into the Solar System. Some are recorded by professional astronomers operating large telescopes from mountaintop observatories, while others are the work of gifted and resourceful amateur astronomers using modest equipment.

Many are stunningly beautiful, although some may appear visually simple, abstract, or mundane at first glance. In all cases, however, each image was in fact a revelation because of its enormous impact on our perception of the universe and our place within it. The history of modern astronomy is chronicled by astrophotographic images containing this measure of significance.

This book pays homage to these groundbreaking milestones of imaging by presenting 100 of the most extraordinary examples with the unique human and scientific stories that accompany them. Many images included in this book were chosen for their historical scientific importance, but some were also selected because of their ability to convey the majesty and wonder of the cosmos and by virtue of that quality have been elevated to an iconic status embedded within the collective consciousness of the public. Of course, the selection process

and the decision to elevate certain pictures above others was a subjective process that is open to contrary opinions.

Therefore, the authors sought suggestions from professional astronomers and astrophysicists plus trusted astronomical authors and leading publishers of astronomical print and web journals. We wish to extend our thanks to this esteemed group for their valued input.

However, the final choice of images was ultimately at the discretion of the authors. As such, we understand and accept the subjective nature of the selection process and we hope our list will stimulate not only enjoyable and educational discussions but also constructive disagreement.

This book is divided into chapters that include the major eras of astrophotography in a loose chronological sequence. Each chapter deals with either a specific era or category of astrophotography. These are segmented into subsections, each devoted to a single milestone of astrophotography accompanied by a description about the nature, relevance, and human story behind it. The pictures are diverse, and we think you will find many stunningly beautiful in addition to being significant milestones in humankind's understanding of nature.

It is our sincere hope and goal to provide the reader with a rich photographic anthology of modern astronomical achievement and history.

Avon, CT, USA Robert Gendler
San Jose, CA, USA R. Jay GaBany

Contents

About the Authors

Robert Gendler is a physician who began doing CCD astrophotography in the early 1990s. He spent his first decade imaging from his home using a portable setup. With advances in Internet accessibility and worsening light pollution at home, Gendler began imaging remotely in 2005 from observatories in the southwestern United States and later in Australia. Gendler now spends much of his time mining professional astronomical archives and assembling unique composite images from a wide variety of data sources, including the Hubble Space Telescope, Japan's 8.2 m Subaru Telescope, and various ground-based professional and amateur systems.

Gendler has published four books on astrophotography including *A Year in the Life of the Universe* (Voyageur Press, 2006), *Capturing the Stars: Astrophotography by the Masters* (Voyageur Press, 2009), *Treasures of the Southern Sky* (Springer, 2011) and most recently *Lessons from the Masters: Current Concepts in Astronomical Image Processing* (Springer, 2013).

In 2008, he was featured in the PBS documentary *Seeing in the Dark* by Timothy Ferris, who referred to Gendler as "one of the great astrophotographers in all of history." Gendler's images have been featured in two national stamp series (United Kingdom 2007, Germany 2011). In 2007, he was the recipient of the "Hubble Award" at Advanced Imaging Conference. His images have been featured by the NASA site "Astronomy Picture of the Day" over 100 times. This work has earned him international recognition and has led to professional collaborations with NASA's Hubble Heritage team on two Hubble Space Telescope projects (M106 in February 2013, and M31 in February 2015). Visit Gendler's web site at www.robgendlerastropics.com.

R. Jay GaBany, by profession, is an eCommerce product manager working in California and the recipient of five patents for innovations in his field. Over the last decade, he has earned a reputation as an elite astrophotographer. His work has been highly recognized internationally. He has also distinguished himself by his collaborations with professional astronomers such as his work with Dr. David Martinez-Delgado on tidal streams produced by galaxy mergers.

GaBany has coauthored several significant scientific papers on the subject. For his contributions at the professional level, he was given the Chambliss Award by the American Astronomical Society.

Among his many other accomplishments, GaBany's image of NGC 3521 was selected as the backdrop for the official crew portrait of Expedition 30 to the International Space Station. Incredibly, in 2012, he was selected by *Time* magazine as one of "The 25 Most Influential People in Space."

Pertinent to this book, GaBany has written numerous articles, blogs, and reviews for a variety of popular astronomy magazines such as *Sky & Telescope, Universe Today,* and *Astronomy Now.* Visit GaBany's website at www.cosmotography.com.

The Birth and Evolution of Astrophotography

Since the dawn of antiquity, humanity has relied on our understanding of the universe. In many ways, astronomy was the first science, and its roots can be found entangled throughout most cultures across the globe. This is because the changing nature of the sky has guided humanity through the cycle of the seasons.

For the first Neolithic farmers, it was important to know when to plant, when to harvest, and when to move their herds. Understanding the motions of the Sun during the day and the stars at night could guide the traveler on land and at sea where landmarks were absent.

Until the mid-nineteenth century, our notions about the cosmos were limited to only what our eyes could detect. For example, the first known star map, depicting the brighter stars in the constellation we now know as Orion, was carved on the ivory tusk of a mammoth about 32,000 years ago. As recently as 10,000 years ago, the Pleiades star cluster, a tight group of stars in the northern constellation of Taurus, was painted on a cave wall in France. By the year 430 B.C., the Chinese produced a star chart of the entire sky on a lacquer box.

Before his death in 120 B.C., Hipparchus of Nicaea, the Greek mathematician, geographer, and arguably the greatest ancient astronomical observer, compiled the first comprehensive star catalog of the western world that placed stars into six groups based on their apparent brightness and referred to these categories as magnitudes. He was the first to create accurate models explaining the motions of the Sun and Moon, and he produced a reliable method for predicting lunar and solar eclipses. His work was adapted three centuries later by the Greco-Roman astronomer Ptolemy, who placed Earth at the center of the universe and hung the Sun, Moon, stars, and planets on concentric crystal spheres that circled around it.

Our understanding of the universe did not much change until Copernicus who, shortly before his death in 1543, published a book representing one of the most significant accomplishments in the history of science that located the Sun at the center of the universe and Earth as one of its orbiting planets. In the early seventeenth century, Galileo Galilei, the Italian astronomer, physicist, mathematician, and philosopher, turned his small refracting telescope to the sky and ushered in the era of modern science with his observations of the Moon's craters, solar sunspots, the large moons of Jupiter, the phases of Venus, and his discovery of the vast star fields filling the Milky Way.

However, for the next 200 years generations of astronomical observers continued relying on manual notations to log the mountains of information and telescopic drawings they collected in meticulously maintained journals. Not only was this a laborious task, it was also incomplete because no individual could hope or aspire to catalog the characteristics of every star seen through a telescope.

Then came photography.

The Astrophotography Pioneers

Almost from its inception in the mid-nineteenth century, photography offered the tantalizing prospect that it could serve as a tool to document or even discover phenomena of the natural world hitherto unseen. As photographic techniques improved over time, photography offered a method of recording more information with far greater accuracy than would ever be captured by manually transcribing what the eye observed. Even more significantly, because photographic exposures worked by accumulating light, photography had the potential of capturing astronomical features too faint to be seen by the human eye.

© Springer International Publishing Switzerland 2015
R. Gendler, R.J. GaBany, *Breakthrough!: 100 Astronomical Images That Changed the World*,
DOI 10.1007/978-3-319-20973-9_1

Astrophotography by definition is the act of capturing radiation released by or reflected from a celestial object with a light-sensitive medium that results in an accurate facsimile or graphic representation of the subject. The light-sensitive material can be a chemical-based emulsion, a vidicon tube, an electronic chip, or any number of other sensors including radio receivers. The history of astrophotography is intertwined with advancements in telescope design, photography and, more recently, electronics and rocketry. Despite humble beginnings, improvements in each of these technologies gradually established astrophotography as the dominant means of improving our view of the heavens and gathering new information about the cosmos. Today astrophotography remains our greatest hope to better understand humankind's place in the universe.

The road leading to the production of astrophotographs began when the French inventor, Nicéphore Niépce, applied silver chloride to paper and succeeded in producing the first photographic negative images, where bright areas appear dark and vice versa, using a pinhole camera based on the ancient camera obscura. Unfortunately, these first pictures could not be preserved and slowly darkened over time. However, by the mid-1820s Niépce produced the oldest surviving crude photograph requiring an exposure that lasted several days to complete.

Niépce began working with Louis Daguerre, a French physicist and occasional scenery painter for the opera, to refine his process, and their collaboration produced higher quality pictures with exposure times reduced to hours. Following Niépce's sudden death in 1838, Daguerre began experimenting with producing photographs directly onto plates coated with light-sensitive silver iodide.

The official birth of photography occurred on January 7, 1839, when the French Academy of Sciences announced Daguerre's photographic process. Although the news spread quickly, the processes' details were withheld until the French government bought the rights in return for providing a pension to Daguerre and the son of his late partner, Niépce. Thus, complete instructions were made public on August 19, 1839 as a gift to the world.

Within a year of the processes' release, Daguerre attempted to produce the first image of the Moon through a telescope. Unfortunately, his attempts resulted in a fuzzy picture with less detail than is visible with the unaided eye. During the same year, John William Draper, an English-born American scientist, was more successful when he captured the first clear image of the Moon with his 5-inch (13 cm) reflecting telescope using the daguerreotype process. His 20-minute exposure produced a picture with sufficient clarity to display the cratered lunar surface. This picture, as humble and simple as it was, signaled the birth of astrophotography.

Although the daguerreotype method caught on enthusiastically and spread rapidly around the world, its use for photographing celestial objects proved difficult, and progress was painfully slow. For example, it wasn't until 1851 that bright celestial objects such as the Sun, Moon, Jupiter, the bright star 'Vega,' and a solar eclipse were successfully exposed using Daguerre's method.

In the same year, Frederick Scott Archer, an English sculptor, dramatically shortened exposure times by inventing the wet collodion process. The wet process was less expensive than the daguerreotype because the image was produced on glass spread with a solution containing potassium iodide. When the glass was dipped into a bath of silver nitrate, the silver and potassium compounds reacted to form silver iodide, the same light-sensitive silver salt used by Daguerre. The plate was then exposed while moist. Within a decade Archer's new process replaced the daguerreotype.

With this innovation came more firsts in astrophotography. For example, in 1854 Joseph Bancroft Reade, an English clergyman and amateur scientist, produced the first images of the Sun's photosphere, the outer shell that radiates light. Then, in 1858 the first image of a comet was taken by William Usherwood, an English miniature artist and commercial photographer. During the same year stellar photometry, the science of measuring the intensity of a star's electromagnetic radiation, was born when George Phillips Bond, an American astronomer, demonstrated that the brightness of stars could be accurately measured with photographs. Finally, Warren de la Rue, a British astronomer and chemist, exposed almost 2,800 photographs of the Sun between 1862 and 1872, including the total solar eclipse of July 18, 1860.

The wet process was very inconvenient because it required the photographic material to be prepared, exposed, and developed within the span of between 10 and 15 minutes. Similar to Daguerre's process, it also necessitated a portable darkroom for use in the field. The extreme inconvenience of shooting wet collodion stimulated the need to develop a dry process that could be coated in advance for later exposure and development at the photographer's convenience. In 1864 W. B. Bolton and B. J. Sayce published an idea that would revolutionize photography by proposing the use of an emulsion containing light-sensitive silver salts that could be spread across the surface of a glass plate.

Their idea soon bore fruit, and by the early 1870s the gelatin dry plate supplanted the wet process. This innovation used glass plates with a photographic emulsion of silver halides suspended in hardened gelatin. With this new method the photographer no longer needed chemicals on site but could expose the plates in the field then develop them later in a dark room. The dry gelatin emulsion was not only more convenient but could be made considerably more sensitive, greatly reducing exposure times. This improvement emboldened early astrophotographic pioneers to attempt more difficult and challenging targets.

In 1872 photographic stellar spectroscopy, the science of identifying the chemical components of stars by analyzing dark lines appearing in their spectra using photographs, originated when Henry Draper, an American physician and amateur astronomer, recorded the spectrum of the star Vega using the dry method, a 28-inch (72 cm) telescope, and a quartz prism.

Until this time, no photograph produced with a telescope had captured anything that had not already been observed visually through an eyepiece. So it was a revelation when, on January 30, 1883, Andrew Ainslie Common, an English amateur astronomer, trained his 36-inch (91 cm) telescope on the Orion Nebula for a 37-minute exposure and revealed stars within the cloud of gas and dust that had not been visually seen through the world's largest telescopes. Within a month, Henry Draper produced an even longer 60-minute exposure of the nebula, thus confirming the value of astrophotography to reveal previously unsuspected objects that had essentially been invisible. The potential for this new and powerful tool to expand our knowledge of the universe was being realized.

On November 16, 1885, two French astronomers and brothers, Paul and Prosper Henry, ended a long running debate within the scientific community about whether the Pleiades, a small bright grouping of stars visible during winter, was enveloped by a nebula when they photographed thin wispy clouds surrounding one of the bright stars in the star cluster using a 13-inch (33 cm) refractor. Around the same time, the Henrys realized photographs might make it easier to identify asteroids. Because they move quickly against the background of more distant stars, asteroids would appear as easily identifiable short streaks. They used this technique to eventually discover 14 of these small worlds.

The achievements by Common, Draper, and the Henrys were pivotal because they helped establish astrophotography as a legitimate research tool. Until the late 1880s, astrophotographic innovation was largely accomplished by non-professional astronomers using their own telescopes and equipment. This began to change as the accomplishments of these pioneering astrophotographers captured the attention of professional astronomers who quickly embraced and began to drive the future of the fledgling field.

The next 30 years, from about 1890 to 1920, saw an emerging generation of professional and non-professional practitioners aligned with and supported by institutional observatories. These new alliances gave these astronomers freedom to concentrate their efforts on specific projects and consequently push the boundaries of what had previously been accomplished.

For example, in 1887, the success of the Henry brothers inspired Edward Barnard, a self-taught astronomer working at California's Lick Observatory, to begin one of the first comprehensive photographic maps of the sky. Over a period of 40 years, Barnard produced hundreds of images, some requiring up to 7 hours exposure time. Fifty of these pictures were published in 1927, 5 years following his death, as *The Atlas of Selected Regions of the Milky Way*.

The Telescopic Leap

The next great leap in astrophotography was made possible through the expansion of telescopic light-gathering power and their evolution to acting primarily as large cameras. Astronomical telescopes serve two primary functions: to collect faint starlight and to resolve closely placed objects. Telescopes with larger diameters, or apertures, collect more light and provide greater resolution than smaller instruments of the same optical quality. From Galileo's first telescope until the close of the nineteenth century, telescopes were designed to be used visually by observing through an eyepiece. The increasing role of photography inspired mechanical adaptations that enabled astronomers to remove the eyepiece and insert a photographic plate holder.

Until early in the twentieth century, refracting telescopes were the scientific instrument of choice. At that time, the world's largest astronomical instrument was the 40-inch (1 m) refractor telescope at the Yerkes Observatory in northern Wisconsin. It was comprised of two 40-inch diameter lenses with a focal length extending 62 feet.

The 40-inch would remain the largest refractor ever built because the enormous weight of its lenses, which had to be supported at their edges, caused the optics to sag and lose focus. For example, a 49-inch (1.25 m) lens was displayed at the Great 1900 Paris Telescope Exhibition, but it was scrapped because its mount proved too impractical for use as a serious research tool. Thus, the Yerkes telescope remains the largest refracting telescope in the world to this day.

With the increasing role of professional observatories came the push to probe deeper into the known universe. The photographic exploration of fainter and more distant objects would necessitate telescope designs that could collect light more efficiently. The long focal length refractors of the late nineteenth century proved inadequate to the task, so astronomers turned their attention to reflecting telescopes. These instruments operated with a primary, slightly concave, mirror that collected and reflected light onto a smaller secondary, slightly convex, mirror that was usually placed directly in front of the primary. The secondary mirror bounced the light from the primary and focused it into an eyepiece or onto a photographic plate.

Reflecting telescopes did not have the size limitations of refractors because the primary mirror could be supported from behind. In addition, reflectors were lighter, more compact instruments than the larger, more cumbersome refractors and were therefore more suitable for the longer exposure times needed to achieve deep space photography. So, the beginning of the twentieth century saw the introduction of much larger and more powerful telescopes that reflected light instead of refracting it.

As photography was assuming greater importance it was replacing visual observation as the principal method of investigating the heavens. This transition accelerated during the closing decade of the nineteenth century. Simultaneously, as designs for larger instruments were evolving in the early twentieth century, their dual role as light collector and camera assumed greater significance, and the eyepiece became a secondary consideration that eventually was removed altogether.

Located on a 5,700-foot (1,737 m) peak in the San Gabriel Mountains northeast of Los Angeles overlooking Pasadena, the Mount Wilson Observatory became the home of two historically significant instruments: the 60-inch (1.5 m) Hale telescope, built in 1908, and the 100-inch (2.5 m) Hooker telescope, completed in 1917. The 60-inch Hale was the largest telescope in the world until it was superseded by the 100-inch Hooker instrument, which remained the world's most powerful telescope for the next 31 years.

Edwin Hubble's 1919 arrival at the Mount Wilson Observatory coincided with the completion of the Hooker telescope. Using the new instrument from 1922 to 1923 he exposed photographic plates of several 'spiral nebulae.' Astronomers had discovered dozens of nebulae with spiral shapes. But, because scientists believed the Milky Way represented the limits of the universe, the spiral nebulae were thought to be located within our home galaxy.

One of the spirals photographed by Hubble was the great spiral nebula in Andromeda. Upon analysis of his images, Hubble identified several variable stars known as Cepheids. Variable stars are those that go through a periodic cycle of brightening and dimming.

Hubble measured the brightness of Cepheid variable stars in the Andromeda Nebula from his photographs, and based on the previous groundbreaking work of Harriet Leavitt, he knew the amount of time required to complete their cycle. He was finally ready to determine the distance of the Andromeda Nebula from Earth.

His calculations shattered the existing model of the universe by placing the Andromeda Nebula well beyond the known limits of the Milky Way. Hubble's discovery of Cepheid variables in the Great Spiral Nebula of Andromeda conclusively proved that spiral nebulae were indeed other galaxies located at vast distances from our own, and the Milky Way was just one of countless galaxies filling the universe.

Just 400 years earlier, Galileo proved that Earth was not the center of the universe and humankind was not the center of all things. In 1925, using the new science of astrophotography, Edwin Hubble no less profoundly changed our understanding of the universe and our place within it by demonstrating the existence of other galaxies. Thus, he enlarged our understanding of the size and scale of the cosmos. This would have been sufficient to cement Hubble as a giant in the annals of science, but he had one more significant contribution yet to make using astrophotography.

In 1927 Georges Lemaître, a Belgium Catholic priest, astronomer, and physics professor, theorized Einstein's work predicted the universe was growing larger. But Einstein did not accept Lemaître's idea, saying "Your calculations are correct, but your physics is atrocious." Therefore, Lemaître's theory did not receive much scientific attention.

Then, in 1929, Edwin Hubble, utilizing redshift analysis of other galaxies, announced photographic proof that the universe was expanding in every direction – each galaxy in the universe was rushing away from all the others. Although Lemaître made other important scientific contributions, including the theory now known as the *Big Bang*, it was Hubble and his interpretation of the photographic analysis that is still credited with the discovery of universal expansion of the cosmos. Thus, with these shining achievements, the contributions of astrophotography took on monumental proportions.

From 1940 to the mid-1970s advances in optical design and engineering enabled the construction of even larger and more powerful instruments that were specifically optimized for astrophotographic use. In the northern hemisphere, the 200-inch (5 m) Hale telescope was constructed at the Palomar Observatory, northeast of San Diego, California. In the southern hemisphere, the 153-inch (3.9 m) Anglo-Australian telescope was built at Siding Spring Observatory in Australia. These instruments enabled astronomers to probe more deeply into the depths of space than ever before, and their combined locations afforded a collective view of the entire sky.

However, they shared one limitation. Because of their enormous size, their view of the sky was limited to only a fraction of the full Moon. This made them perfect for examining the small structure of faint distant galaxies or closely spaced stars but incapable of investigating large swaths of the night sky without the need to take hundreds of pictures and assemble them into a mosaic.

The large reflecting telescopes that had come into operation after the beginning of the 1900s were capable of producing much sharper images than the refractors favored by astronomer until the turn of the twentieth century. But their sharpness

was limited to objects placed near the center of the mirror. Objects that fell more than a fraction of an inch from the telescope's optical axis, a line perpendicular to the center of the instrument's mirrors, were blurred by the mirror's curvature. For example, the sharply focused area of the 200-inch Hale telescope is only about 60 arcseconds in diameter, or about the size of a bean.

A solution to this problem came in 1929 at the hands of Norwegian lens crafter Bernhard Schmidt when he proposed to build a combination reflecting telescope and camera that would be capable of producing sharp images of broad sky expanses. His concept had two parts. First it used a special lens that would be placed in front of the mirror to slightly bend the incoming light and correct the mirror's tendency to blur objects that lay too far from its optical axis. Next, Schmidt's telescope would use a holder that would bend the photographic plate slightly toward the mirror so it had a subtle convex curve. With these improvements, Schmidt proposed to capture images spanning up to 10 degrees, or 20 times the Moon's diameter, with the sharpness of the best reflecting telescopes.

In 1936, a Schmidt telescope was installed at Palomar Observatory. It featured an 18-inch (45 cm) correcting lens and a 26-inch (.6 m) mirror. It was used to prove that supernovae were the final cataclysm of massive stars.

With further innovations in design, a new generation of meter-class Schmidt cameras began to probe the skies above and below the equator. In 1948 the Oschin Schmidt telescope opened its eye at Palomar with a 48-inch (1.2 m) correcting lens and a 72-inch (1.8 m) mirror. Its lens was larger than the 40-inch maximum established by the refractor at Yerkes Observatory because, being only a correcting lens, it was considerably thinner and weighed considerably less.

In 1973, the UK Schmidt telescope was installed at Siding Spring Observatory in Australia. Similar in design to the Oschin Schmidt at Palomar, it also had a 48-inch (1.2 m) corrector and 72-inch (1.8 m) mirror. Combined, these two instruments enabled astronomers to probe huge areas of both the northern and southern sky using photographs filled edge to edge with pinpoint stars.

Beginning in 1949, the 48-inch Oschin Schmidt telescope at Mount Palomar was assigned to complete the first massive all-sky survey by accurately recording the positions of every star and galaxy in the northern sky down to the 22nd magnitude – a million times dimmer than the unaided human eye can see. Completed in 1958, the First Palomar Sky Survey (POSS I) filled 1,870 plates.

During the 1970s, the UK Schmidt telescope completed the Southern Sky Survey. However, due to progress in the construction of telescopes and sensitivity of film emulsions, the Southern Sky Survey was able to capture fainter objects than the original Palomar Sky Survey of the northern sky. So, in the early 1980s, Palomar's Oschin Schmidt was upgraded and set out to compile a second northern sky survey, called POSS II, which would match the sensitivity of the Australian catalog. POSS II is now available in digital format on the web as the Digitized Sky Survey.

Film Developments

By the late 1950s, astrophotography had reached a plateau. Even though photographic emulsions were capable of translating thousands of brightness levels into their corresponding tones, the relation between stellar brilliance and the gray tones in a photograph were not linear – one star twice as bright as another did not produce an image with twice its density. This major limitation of photographic emulsion is known as reciprocity failure. Despite many innovations in the photographic process reciprocity failure persisted as an impediment to progress in deep space astrophotography. In addition, emulsion sensitivity to light and the ability for photographs to capture fine details had only marginally improved since the beginning of the twentieth century.

For example, even the most sensitive photographic emulsion only captured about 1 % of the light it received. Even if a plate were exposed over a longer period of time, the faintest stars would be lost behind a layer of haze caused by nighttime emissions in the upper atmosphere called airglow. This was a particular challenge for spectroscopy, where significant activity had been taking place since the 1930s.

To create the spectrum of a star, the light had to be spread out into its constituent of colors. Doing this significantly reduces the intensity of the light falling onto a photographic plate, thus limiting the number of stars that could be studied. For example, the faintest stars suitable for spectroscopic photography with the 200-inch Hale telescope were 16 times brighter than the dimmest objects detected by its photographs.

Little progress in resolving these challenges was made until the 1970s when several new emulsions came onto the market. Some responded more strongly to red light wavelengths so they would capture faint stars and avoid the green wavelengths associated with airglow. Others offered higher resolution using smaller grains of silver salts, but these required longer exposures because the small silver grains had less light sensitivity than larger ones.

To overcome this challenge, astronomers developed techniques to hypersensitize these emulsions by boosting their responsiveness between 5 and sometimes as much as 2,000 times. This involved various approaches, such as baking plates while exposing them to a mixture of gases. This process was known as gas *hypersensitization* or *hypering* for short.

Even while emulsions were improving, David Malin of Australia's Anglo-Australian Observatory began experimenting with darkroom procedures to counteract airglow, producing high-fidelity color images and extracting as much information as possible from each plate. For example, photographic plates produced a poor print when transferred to photographic paper. A photographic plate can exhibit 100,000 shades of gray between pure white and total black whereas photographic papers usually only exhibit a range of 50 brightness levels.

So, based on the exposure time, a print of an astrophotograph on paper could be made to exhibit bright details, dim structures, some in the middle range, but not everything at the same time. Thus, the cores of bright nebulae would appear featureless if the faint outer reaches were also exhibited.

Malin solved this problem by adopting a lithographic technique called unsharp masking. This darkroom technique enabled the production of prints in which the brightest details are only about 30 times brighter than the faint ones. This was a tonal range photographic paper could accommodate. Using this procedure, Malin was able to reveal information from older plates that had been previously unseen. For example, he applied his expertise to photographs produced with the UK Schmidt telescope and discovered a galaxy, previously unsuspected, lying in the direction of the constellation Virgo. Estimated to be almost 1 billion light-years from Earth, astronomers determined it was one of the most massive and luminous galaxies ever detected.

Although color emulsion astrophotography made its entrance in the 1950s, when William C. Miller produced color images with the Mount Wilson and Palomar Observatory instruments, Malin is credited with the first true-color astronomical pictures by assembling three separate monochromatic photographs exposed through red, green, and blue filters. This tricolor process was originally introduced in 1861 by James Clerk Maxwell, but more than a century passed before it was applied astrophotographically by Malin.

Photoelectronics

Early work on the use of an alternative to emulsion-based astrophotography began in the 1940s and 1950s with the introduction of photomultiplier tubes originally developed during the 1930s to detect radiation and measure very faint light. When light strikes certain metallic elements and compounds, it creates an electric current; this is called the photoelectric effect. Photomultiplier tubes intensify this current up to 100 million times, enabling the detection of individual photons. Thus, they are light amplifiers.

Photomultipliers offered several advantages over photographic emulsions. First, they could accurately measure the value of tones in an image over a wide range. Next, by amplifying the light it received, photomultipliers could detect faint objects in space, such as new stars, and enable the spectroscopic analysis of stars that were too dim to be captured photographically. Finally, photomultipliers could detect objects up to 100,000 times fainter than the brightest ones captured in a picture. Emulsion photographs could only accommodate a brightness range of about 10,000 to 1.

However, photomultipliers were based on vacuum tube technology and did not have a panoramic field of view, like a camera. This restricted their use to a very small piece of the sky. Therefore, they supplemented rather than replaced astronomical photographic plates.

Each image produced with either Schmidt telescope (the one at Palomar or the other in Australia) might contain up to one million stars. Therefore, the amount of information quickly became overwhelming when manually searching through a sky survey to gather examples of a particular type of star. The solution to this problem required the plates to be digitized.

In the late 1960s, the digitization of astronomical images was performed with photomultipliers. Digitization required each plate to be divided into a fine grid containing thousands of squares called picture elements, or pixels. A beam of light was then passed through each pixel and the intensity of the beam was measured. Each grid was assigned a number, consisting of eight 1s and 0s, called bits. The brightness of each pixel was then assigned a value of between 0 and 255.

Once the images were turned into numbers they could be manipulated by computer software. During the 1970s algorithms were developed that could compare brightness between objects and distinguish stars, galaxies, comets, and nebulae from one another. During the mid-1980s, image processing software was developed that could extract information about the object's size and shape, thus revitalizing astrophotography as a useful tool in a manner few would have dreamed possible less than 25 years earlier.

At the same time photomultiplier tubes were being developed, work on electronic television cameras and image intensifiers for use in very low light situations was underway. The goal was to combine the accuracy, sensitivity, and unlimited exposure time of a photomultiplier with the television camera's field of view. Much of this development was motivated by the military for low light applications, but during the 1960s and 1970s image intensified devices were applied to astronomy. The most successful image intensifiers digitized each frame from the television camera and sent it to a computer where its photons were counted.

For example, in 1969 it was suggested that image intensifiers be used to produce short pictures of bright objects rather than taking long exposures in search of faint ones. The proposal was made by French physicist Antoine Labeyrie as a solution for poor seeing conditions. Seeing refers to the blurring and twinkling of astronomical objects caused by thermal variations in the atmosphere. Seeing can reduce the practical resolution of an astronomical instrument by a factor of 100 and lead astronomers to draw the wrong conclusions. For example, poor seeing contributed to the belief in canals on Mars.

Labeyrie compared the effect of poor seeing to the common everyday experience of noticing a shiny penny at the bottom of a sun-lit fountain. The penny will seem to flicker and appear as multiple objects when viewed from above the water's wave disturbed surface. This would make it impossible to identify which penny was real. However, a short exposure photograph could freeze the flickering. Similarly, Labeyrie proposed that a very short exposure of a star could capture its twinkling as bits, or speckles, of light, with each speckle representing a distorted image of the star. Therefore, he concluded, it should be possible to use a computer to combine each speckle and produce a single image without the distortions introduced by atmospheric turbulence.

Labeyrie thought it would require an exposure that was far quicker than the best photographic emulsions could muster. So, he suggested using an image intensifier.

In 1970, Labeyrie's theory was validated when the 200-inch Hale telescope captured the first speckle images. Soon after, computer programs that combined the information were developed. Speckle photography enabled astronomers to accurately measure the diameters of many large stars for the first time. From this information, their mass could be obtained with great precision. Soon afterward, other astronomers produced images of stars, the Sun, asteroids, and the outer planets and their satellites with unprecedented clarity.

Pixels in Space

A monumental advance occurred in 1969 when Willard Boyle and George Smith, two researchers working at Bell Laboratories, started investigating a new way to add more data onto computer memory chips. Their solution was the charged coupled device, or CCD. Like other chips in a computer, the CCD was made from silicon. However, instead of giving the chip a separate microscopic circuit for each of its memory cells, their system would contain electrical charges in 'potential wells.' Each potential well was a holding area for electrons. By removing the barrier between wells, each charge could be moved off the chip sequentially and into the computer's processing area.

Among the potential applications for the CCD was its use as a light detector. Since silicon exhibits a photoelectrical effect, photons of light falling on the chip could be transformed into electrons and placed into a potential well. Like photomultipliers, CCDs were also capable of recording over 100,000 variances in brightness between the faintest and most brilliant parts of an object, but they were ten times more sensitive to light. This would make it possible to capture both the dazzling cores of galaxies and the extremely faint outer arms that surround it without overexposing the bright central region.

Compared to film, CCDs are about 70 times more efficient at collecting light than the best photographic emulsions. This would enable a reduction in exposure times from hours to minutes. Just as importantly, the brightness information gathered by a CCD could be analyzed by image processing techniques.

Fundamentally, a CCD measures light intensity that falls onto each distinct picture element, or pixel, in an approach similar to that used in digitization with photomultipliers. The size of each pixel determines its sensitivity – larger pixels collect more light than smaller ones. Each picture element represents a small part of the celestial object. The first CCD cameras had thousands of pixels. Today, even the smallest handheld cameras contain millions of picture elements. The pixels are located on a wafer-thin chip that has been treated so different areas of the surface have different electrical properties.

When a pixel is struck by a photon of light it generates an electrical charge that is proportional to the brightness of the light that hit it. This is known as a "linear response" and represents a fundamental advantage of the CCD detector over film emulsion. Finally the problem of reciprocity failure was solved. The linear response of the CCD would offer tremendous advantages in many aspects of astrophotography.

During an exposure photons are collected and converted to electric charges. As the charges accumulate, they form a latent image that is electronically processed by a technique called charge coupling, which links the electrical charge to its corresponding pixel. Because the light from celestial objects is faint, the charges are very weak and must be amplified before they can be converted to numbers and stored in the computer's memory.

In 1971, Bell Labs unveiled the first monochromatic CCD camera. One year later they released a full-color version. This revolutionary invention later earned Boyle and Smith the 2009 Nobel Prize in Physics.

At the same time, scientists at NASA's Jet Propulsion Lab in Pasadena, California, dreamed of using CCD cameras on planetary spacecraft based on their belief that CCDs represented the most important astronomical advancement since the introduction of emulsion photography. For example, each of the CCDs' pixels could record wavelengths of light from infrared to X-rays and detect radiation from the brightest celestial objects to those 100,000 times fainter. The great sensitivity of the CCD would enable astronomers to probe ten times deeper into space.

In 1975, a second-generation CCD was used to produce an image of Uranus with the 61-inch (1.5 m) reflecting telescope on Mt. Lemmon, near Tucson, Arizona. The image that resulted had the resolution equivalent to an instrument twice the diameter of the 200-inch Hale telescope using film emulsion photography plates. The picture was used to accurately measure the diameter of Uranus for the first time, and it also displayed hints of structure in the distant planet's atmosphere. Just 11 years later, the *Voyager 1* spacecraft confirmed these structures as high-altitude methane clouds. In essence, the CCD increased the light-collecting power of the world's largest telescopes several fold.

It wasn't long before the CCD became an essential tool for astronomy, and few professional observatories were without one. For example, Einstein's general theory of relativity predicted a phenomenon called lensing, by which light from a remote galaxy could be split into multiple magnified versions of itself by the enormous gravitational field of a closer galaxy if the two were aligned along our line of sight. In 1976, the Hale telescope proved Einstein was correct when it revealed the first gravitational lens using one of the then most sensitive CCD cameras containing an 800×800 pixel array. The CCD also revolutionized spectroscopy by enabling astronomers to accurately track faint stellar objects while their spectrum was being captured.

The CCD's only challenge was its small size. Because CCDs were not much larger than a thumbnail, early CCDs could only produce images of a tiny portion of the sky. This made even small-scale surveys of the heavens a tedious undertaking. So, in 1982, Caltech's James Gunn assembled four slightly flawed CCD chips that had been originally intended for use on the Hubble Space Telescope wide-field camera. He attached the device to the 200-inch Hale telescope using a four-sided pyramid-shaped quartz mirror that diverted the telescope's light beam onto each of the CCD detectors, producing simultaneous images of four adjacent pieces of the sky. During the first test, this mosaic CCD camera began seeing celestial bodies deeper in space than had ever been detected. Some of the galaxies in the first photographs were nearly 12 billion light-years from Earth. Over the next three decades continued innovations in electronic detector technology produced subsequent generations of CCDs each more sensitive, less limited by noise, and larger in size than its predecessor.

In 2012, the world's largest and most sensitive CCD camera was assembled to study dark energy, the hypothetical form of energy that fills the universe and accelerates its expansion. The dark energy camera featured an array of 74 CCDs with a combined 570 million pixels that produced images of the sky covering six times the diameter of the full Moon in a single exposure.

Super-Sized Telescopes

With all these amazing advancements in electronic detector technology, limitations in telescope and mirror design took over as the major limiting factor in the deeper photographic exploration of space. For example, the 200-inch Hale telescope began collecting observations in 1949 and for over 30 years it remained the world's most powerful astronomical instrument, capable of detecting the light of a single candle 15,000 miles in the distance. However, based on the engineering challenges its designers had to overcome, the construction of even larger mirrors seemed to have reached a point of diminishing returns.

A mirror two times the diameter of Hale's could collect four times the amount of light, but it would have to hold its precise shape as it swung to view points across the sky. The traditional approach to insure the surface of a telescope's mirror reflected all the light it collected to a common focal point was to make the mirror thick. Even though the face of the Hale's primary mirror is supported by an underlying ribbed structure that cut its weight by half without reducing its rigidity, it still weighs 14.5 tons and is 2 feet deep at its outer edge.

A mirror twice as large as the Hale's would be twice as heavy and make it more prone to warp and sag as it was moved to point at different objects above the horizon. The thicker mirror would also be more difficult to cool each evening and make

it vulnerable to poor seeing caused by temperature differentials between the mirror and the surrounding night air. Finally, the cost of producing a larger monolithic mirror would be prohibitively expensive, due to the price tags of the mirror and the massive structure needed to support it.

So, during the 1980s, radical new solutions that departed from this traditional design were submitted, and several progressed into their construction phase. Most of these new-generation telescopes incorporated systems that compensated for distortions caused by the mirror's great weight. Some abandoned the monolithic primary mirror and replaced it with segments cast and shaped individually, and then fitted together to form a mosaic.

For example, the Very Large Telescope is actually a collection of four 27-foot (8.2 m) telescopes housed in separate buildings on top of Cerro Paranal, a high mountain in the extremely dry Atacama Desert of northern Chile. Significantly, each telescope has a flexible primary mirror only 7 inches thick. Supported from behind by dozens of computer-controlled pistons, called actuators, the shape of the mirror on each telescope can be changed by its surface being pushed and pulled 300 times per second to reduce the effects of the mirror's weight. When operating in concert, the four telescopes have the light-gathering power of a 54-foot (16 m) mirror.

During the 1990s, Hawaii's Mauna Kea Observatory saw the rise of twin 33-foot (10 m) Keck telescopes. The primary on each telescope is comprised of 36 individual elements that are designed to function as a single mirror; each segment is maintained to within one-millionth of an inch of perfect alignment by an active control system that adjusts their position twice each second.

The next generation of telescopes featuring even greater light-gathering capacities is now being funded. For example, the $1.4-billion Thirty Meter telescope's 98-foot (30 m) aperture will have more than nine times the light-collecting area of either Keck telescope and should provide resolution ten times sharper than the Hubble Space Telescope. Like the Keck's, the Thirty Meter's mirror will be segmented into almost 500 individual elements. Construction on this mammoth instrument has already started.

However, no ground-based optical telescope contender can currently match the design proposal for the European Extremely Large Telescope. Its 129-foot (39.3 m) mirror would put it easily beyond the Thirty Meter Telescope, with a primary spanning almost half a football field. Five adjacent mirrors, each consisting of almost 800 individual hexagonal segments, will form its main mirror and give earthbound astronomers the sharpest view ever of the cosmos in the visual light spectrum. This $1.3-billion instrument is anticipated to capture its first image early in the 2020s.

Even the sharpest ground-based picture of the heavens is much blurrier than it would be if the light didn't pass through Earth's atmosphere. As the size of telescope mirrors expand, the impact of atmospheric turbulence grows exponentially. So, beginning with the new generation of telescopes built since the 1980s, large telescopes employ a technique called adaptive optics. Although speckle imaging is capable of removing the effects of poor seeing, its use is limited to bright celestial objects and very tiny pieces of the sky. Photographs produced with adaptive optics have no brightness requirement and are only restricted by the telescope's natural field of view.

Adaptive optics was first proposed in 1953 by Horace Babcock, an American astronomer, but it was not made practical until computer technology advanced during the 1990s. Originally used by the U. S. military for tracking enemy satellites, it remained classified until the closing years of the 1980s that followed the end of the Cold War.

Adaptive optics work by inserting a small highly flexible mirror in the telescope's light beam prior to it reaching the CCD detector. The angle of the mirror can be tipped or tilted hundreds of times each second based on analysis of turbulence in the atmosphere detected by a separate sensor, so the effects of poor seeing can be vastly reduced or virtually eliminated. Some adaptive optics solutions also alter the shape of the adaptive mirror to remove even smaller distortions caused by changing atmospheric conditions. Adaptive optics has revolutionized ground-based astronomical research by enabling telescopes to reach close to their theoretical resolution potential.

Astrophotography for the Masses

The years that followed the early 1990s revolutionized astrophotography for non-professionals. The advances in electronic imaging used by professionals began to trickle down into consumer products. Within the first few years of the new millennium, amateur astronomers could purchase, at a reasonable cost, computer-controlled CCD cameras expressly designed for use with modest telescopes. These small but sophisticated devices contained imaging chips rivaling the sensitivity of CCDs used at professional observatories. At the same time, motorized mounts for personal telescopes equipped with electronic maps of the sky made it possible for even novice amateur astronomers to place thousands of stars, planets, faint nebulae, and galaxies in the center of an eyepiece or CCD chip by clicking a few buttons on a computer keyboard.

The Internet also became ubiquitous at the turn of the century, ushering in the ability to not only communicate with computers located anywhere in the world, but access and control them remotely.

As these and other technological advances merged during the early years of the twenty-first century, amateur astrophotographers began opening personal observatories located under distant dark nighttime skies and operating them from the comfort of their home. Software made it possible for the entire observing session to be scripted so the observatory and everything within it functioned autonomously without the need for manual intervention. This enabled amateurs to expose deep space images throughout the entire night even while they slept. Multiple exposures of the same galaxy or nebula could then be electronically combined to create a final picture that was equal to the sum of the individual exposure times. Private astrophotographers were now able to capture extremely faint deep space structures that heretofore were either only visible in images produced by large professional telescopes or never seen before.

Farms of remote telescopes soon spread around the globe, offering remote imaging for those willing to rent time. Professional astronomers, teachers, and students, whose demand for access to research instruments outpaced availability, increasingly started relying on these rental facilities or using amateur remote observatories to conduct scientific investigations.

This democratization of astrophotography has spawned a worldwide community of enthusiasts who are connected through the Internet and bound by their shared fascination with the universe.

The Hubble Paradigm Shift

The early 1990s saw the inauguration of what is arguably history's most significant astronomical instrument – the Hubble Space Telescope.

The idea of placing a telescope above the atmosphere had been proposed since 1923. But funding was not appropriated until the 1970s, with a launch target of 1983. But the project met delays caused by unexpected manufacturing problems, congressional funding issues, and the *Challenger* space shuttle disaster.

The Hubble Space Telescope was finally launched into Earth orbit on April 24, 1990. However, the first images produced disappointing results that were later traced to a flaw in the telescope's 8 foot (2.4 m) primary mirror. The images were slightly out of focus, not enough to render the telescope useless, but far below expectations for an instrument that cost over $1 billion to create.

Fortunately, Hubble was designed to be repaired and upgraded by visiting astronauts over the course of its mission. So, in 1993 astronauts installed a set of lenses to correct the distortions. The results were immediate, and the images it returned were spectacular. Four subsequent space shuttle visits have replaced, repaired, and upgraded many of its instruments.

Originally envisioned as a 20-year mission, Hubble is still producing cutting-edge scientific results that can be obtained nowhere else. Although the universe is magnificently transparent, pristine light traveling billions of years from distant galaxies must pass through Earth's turbulent atmosphere during the final nanoseconds of its journey to a telescope, or our eyes, on the ground. As a result, our view of the star becomes distorted by the same phenomenon that causes stars to twinkle. To minimize this problem, major observatories are located on tall remote mountaintops, above the thickest layers of Earth's atmosphere. But, even this solution often fails to produce crisp clear images of the heavens.

By operating in Earth orbit, Hubble captures light from deep space before it enters the atmosphere. Thus, its images possess an unrivalled level of clarity five times sharper than the largest ground telescope.

Hubble's scientific contributions have been enormous. For example, its keen vision has determined the age of the universe and confirmed its ongoing expansion, revealed the presence of super-massive black holes at the center of most galaxies, and helped astronomers understand how planets form. Its last servicing mission in 2009 is hoped to have extended the telescope's mission until at least 2018, when the more powerful James Webb Space Telescope is launched into high Earth orbit.

Seeing the Invisible

This discussion has focused on the history of astrophotography using visible, or white, light. However, since the 1930s, significant advances have been made that enable us to study the universe in light wavelengths our eyes cannot see. For example, although infrared and ultraviolet light have been known since the early nineteenth century, X-rays were not discovered until 1895, and radio waves originating from space weren't detected until the early 1930s.

Throughout the 1800s, astronomers confined their observations to optical light – the narrow band of visible wavelengths from blue to red that can be seen in a rainbow. The invisible wavelengths of electromagnetic radiation include, from shortest

to longest, gamma rays, X-rays, ultraviolet light, infrared light, and radio waves, with visible light falling between ultraviolet and infrared.

The first indication light contained more than the rainbow of color was discovered by the British music composer, astronomer, and discoverer of the planet Neptune, William Herschel, in 1800. While analyzing sunlight with a prism, he was surprised when a thermometer left in the apparently dark area just below the red end of the spectrum registered a rise in temperature. That area became known as infrared because it was located just beyond visible red light.

Infrared was still a scientific curiosity in 1881 when Samuel Langley, an American scientist, measured the Sun's energy through the visible spectrum and beyond using an instrument he developed called a bolometer. Langley found that the bolometer registered heat far past the region Hershel uncovered.

Hershel's and Langley's discoveries confirmed that infrared radiation was an important component of solar energy. Astronomers assumed other stars, similar to our Sun, must also be sources of infrared light. But the instruments with sufficient sensitivity to measure infrared radiation from distant stars did not become available for another 50 years. By that time, radio waves had caught the attention of the scientific community.

Imaging with Radio Waves

Radio astronomy was the first non-optical science. It began by accident when Karl Jansky, an American communications engineer working for Bell Labs, was asked to identify the sources of static interfering with ship-to-shore radio communications. Jansky detected a source that clearly originated from the sky because it moved with the stars as they rose and set during the night. He identified its location as being toward the constellation of Sagittarius. This is also in the direction of the center of our galaxy. However, his discovery did not cause an immediate stir among the astronomical community.

For many years the only radio astronomy researcher was an American electrical engineer named Grote Reber, who constructed a 30-foot (9.4 m) parabolic dish antenna in his suburban Chicago backyard. Although his antenna was primitive compared to today's instruments, its design has served as the model for every radio telescope that followed. Radio waves striking the metal strips that comprised the parabolic dish were reflected to a radio receiver at the antenna's focal point. Starting in 1927, Reber recorded radio signals from the sky, culminating in a map he published in 1947. Unfortunately, he could only speculate about the sources of the signals.

Within months following the end of World War II, many of the scientists and technicians who had worked during the war to develop radar technology turned their attention and their surplus equipment to the peaceful study of the heavens. During 1951, researchers around the globe used radio waves to detect hydrogen emissions within the Milky Way. In 1958 the first complete galactic hydrogen radio map confirmed the Milky Way had a spiral shape punctuated by vast clouds of hydrogen, like other galaxies.

Still, in the early 1960s, it became clear that the new tools of radio astronomy would require a great deal of improvement before they would match the resolution of optical telescopes. Fundamentally, the length of radio wavelengths was too long to focus without huge antennas. For example, a 300-foot (91.4 m) radio telescope provides a view of the sky that is less clear than that seen by the unaided eye.

Radio astronomers attempted to overcome this challenge by building larger instruments. For example, in 1963, Cornell University astronomers built the world's largest radio telescope in an enormous natural limestone valley near Arecibo, Puerto Rico. Its immobile 1,000-foot (305 m) diameter bowl is over 400 feet (122 m) deep and scans the sky only as Earth rotates. When it was placed into service, the surface consisted of half-inch galvanized wire mesh laid directly on the support cables. In 1974 the wire mesh was upgraded with thousands of individually adjustable aluminum panels. Even with its enormous size, Arecibo's resolution when detecting hydrogen, for example, is only almost as good as the unaided eye in visible light.

Arecibo proved bigger was not necessarily better with radio astronomy. So, astronomers turned their attention to another technique, called interferometry, as a method of improving their ability to resolve details of radio sources emanating from the cosmos. When two or more electromagnetic waves are added together, they produce an interference pattern, similar to the speckles used by optical speckle imaging. By combining the signals from two or more separate radio antennas, astronomers proposed to create a synthetic aperture telescope whose size would be comparable to a single radio telescope equal to the distance separating the antennas.

The first successful use of this technique was accomplished by a team lead by Martin Ryle, who later received a Nobel Prize for his work, using two antennas in 1958. It was an unwieldy device with two 60-foot (18 m) dishes mounted on a mile-long railroad track. Moving the antennas along the track was a slow process, so it took almost 2 months to complete a map of a single source. However, the Cambridge One Mile telescope, as it became known, provided almost 30 times the

resolution of any existing radio telescope at that time and convinced other scientists that interferometry was a workable solution.

In the early 1960s, plans were drawn up for an array of radio telescopes with the angular resolution of the largest optical telescopes. Known as the Very Large Array, or VLA, it envisioned positioning multiple telescopes spread across 20 miles (32 km). The first two radio telescopes began operation in 1976. By 1980, the entire array of 27 antennas was completed.

The VLA was an immediate success. Its resolution exceeded its designer's expectations by having ten times the resolving power of the world's largest optical telescopes.

Seeing Infrared

Infrared astronomy made very little progress until the second half of the twentieth century. The research was limited by the insensitivity of instruments. Then, in the early 1960s, Frank Low, a physicist working for Texas Instruments, began research into superconductors – materials chilled to extremely low temperatures so they can conduct electricity without a loss of energy – and realized it would be useful to improve the sensitivity of the bolometer.

Since Texas Instruments was a leader in the research of semiconductors, materials whose conductivity could be altered, Low constructed an improved bolometer using germanium, a substance that is capable of changing its ability to conduct electricity when it absorbs energy. When used in a bolometer, the change in conductivity was proportional to the amount of energy entering the device. It worked far more effectively than Low expected and was 20 times more sensitive than any existing infrared detector. When astronomers learned of the new device, they encouraged Low to adapt it for astronomical use.

In 1963, the new bolometer studied Mars in the infrared while being carried into the stratosphere tethered to a balloon. These observations proved there was no infrared radiation emanating from organic molecules on the Red Planet.

By the 1970s, infrared detectors were being pointed everywhere in the sky. However, most of the infrared observations were made by ground-based telescopes and were confined to the near-infrared portion of the spectrum. Longer wavelength infrared radiation was more difficult to obtain because it was absorbed by Earth's atmosphere. Therefore, only short observations had been possible using airplanes, balloons, and short duration rocket launches that reached the edge of the atmosphere.

In the mid-1970s, several prominent infrared astronomers joined together and petitioned NASA to launch an infrared telescope into Earth orbit, making longer wavelength observations more practical. On January 25, 1983, the first infrared space telescope was launched from Vandenberg Air force Base in California and placed into a 560-mile polar orbit. For the next 10 months IRAS produced remarkable results observing approximately 250,000 infrared sources.

The space shuttle program was originally envisioned to support weekly flights of up to 30 day's duration. So, in 1983 NASA proposed a 40-inch (1 m) infrared telescope that would be launched on the space shuttle as a payload. It would remain attached to the shuttle throughout its mission, return to Earth for refurbishment then re-flown again. However, in 1985 NASA concluded the shuttle environment was not suited for infrared observations due to contamination from the orbiters. So, the infrared space telescope was re-envisioned to be a free-flying orbiting instrument.

Launched in 2003 from the space shuttle and named for Lyman Spitzer, the Spitzer Space Telescope, or SST, was equipped with a 33-inch (0.8 m) telescope. It was intended to operate until its onboard tank of liquid helium became exhausted – a period estimated to be about 5 years. However, the liquid helium lasted until 2009, though its 256×256 pixel CCD camera continued to function in two short infrared wavelengths. So, the telescope has continued to perform science.

Beyond the Blue

If satellites are important to infrared astronomers, they are essential for ultraviolet observations because the ozone layer, 10–30 miles high in the atmosphere, blocks out most ultraviolet radiation received from space. Without this shield, life on Earth would be impossible to sustain.

Ultraviolet radiation exists beyond violet visible light. The atmospheres of most stars – regions of interstellar gas, elements such as hydrogen, oxygen, helium, carbon, nitrogen and silicon – all emit ultraviolet radiation. Thus, the study of ultraviolet radiation can provide important information about the temperature and composition of celestial objects that can be obtained in no other manner.

Launched in 1972, the Copernicus satellite conducted observations in the ultraviolet for 9 years and augmented astronomers understanding about the distribution of interstellar gas throughout the Milky Way.

In 1978, the International Ultraviolet Explorer satellite was launched into a 22,500-mile-high geosynchronous orbit that positioned it above the Atlantic Ocean. By the end of its 18-year life, over 104,000 observations were completed, and it was considered at the time the most successful astronomical satellite ever placed into service.

In 2003, the Galaxy Evolution Explorer, also known as GALEX, was carried aloft aboard a Pegasus air-launch rocket capable of sending small payloads into Earth orbit after being released from the belly of an aircraft flying at an altitude of 40,000 feet. It was intended to be a 2-year mission, but it collected useful observations for 10 years.

GALEX was small and could fit on a tabletop. It packed a 19 inch (50 cm) telescope that could image a section of the sky three times the diameter of the full Moon in ultraviolet light.

During its mission, GALEX surveyed hundreds of millions of galaxies in ultraviolet light across 10 billion years of time with the goal of determining the distance of each galaxy from Earth and the rate of star formation in each galaxy. GALEX discovered galaxies were forming more new stars 8 billion years ago than they are creating today, and around many galaxies it found bands of new stars that were previously undetected.

Going There

Like ultraviolet and some infrared radiation, the study of gamma rays and X-rays required instruments outside Earth's atmosphere. This became possible when the United States and Russia, then known as the Soviet Union, announced plans to hurl an artificial satellite into orbit around Earth by 1958. The Soviet Union accomplished this first with the successful launch of Sputnik in 1957. This event resulted in an unprecedented commitment by the United States to pour massive amounts of funding into science and the development of new technology.

Although the Soviet-American space race that resulted was initiated by political concerns, it ushered in a new chapter of Solar System astronomy that relied on cameras, rockets, and life support systems instead of telescopes on the ground. For over 60 years, this has provided humanity breathtaking close-ups of the Sun, Moon, neighboring planets, asteroids, and comets. We've seen pictures from landers on the surfaces of Venus, Mars, and Titan, one of the moons orbiting Saturn. Our spacecraft have left the bounds of the Sun's gravitational embrace on a never-ending journey into deep interstellar space. We have borne witness to astronauts walking, driving, hop-skipping and jumping across the surface of the Moon live on television from the comfort of our living room easy chairs.

At a time when all but the brightest stars and planets are hidden behind an ever thickening blanket of artificial nighttime light, astrophotography has enabled Earth's citizens to maintain contact with the sky. Ancient beliefs and myths have been displaced by a virtual nonstop stream of scientific revelations by astrophotographs produced from spacecraft.

Humanity has always felt a strong need to understand the universe. The sky's effects on Earth convinced ancient cultures there was a connection between celestial and human events. The Sun's movement throughout the day and the seasonal patterns were carefully noted to shine a light on an otherwise chaotic world. Then, almost two centuries ago, the tools that would ultimately replace manual notations with photographic evidence were invented. As a result, astrophotography now provides the brightest illumination for our continuing quest to understand the universe and our place within it.

Photography was born in 1826 when the French inventor Nicéphore Niépce used the camera obscura and an exposure of at least 8 hours to create his historic "View from the Window at Le Gras." Niépce's associate Louis Daguerre later refined the photographic process and introduced the daguerreotype, a photographic medium made of highly polished silver on a copper plate. It became the first publicly announced photographic process, requiring only minutes of exposure to produce a clear and finely detailed image. The invention, announced to the world in 1839, produced an explosion of enthusiasm that quickly spread around the world. It took little more than a year before John William Draper made the first photograph of the Moon, which heralded the birth of astrophotography.

The First Daguerreotype of the Moon and the Birth of Astrophotography

With the advent of photography by Daguerre in 1839, the fledgling craft would spread rapidly throughout Europe and across the Atlantic. The entire visible world quickly became suitable subjects for the camera and photographic plate. Although people were naturally the first subjects of photography, it wasn't long before daguerreotypes were being made of the natural world. The field of astronomy, long dependent on visual observation, would be one of the first branches of science to reach out to this new technology to experience what it had to offer.

In 1837, John William Draper (1811–1882), an American physician and scientist entered the emerging field of photography. It would be 2 years before the daguerreotype process would be announced to the world by the French government. Upon learning about Daguerre's process in late 1839, Draper immersed himself in finding ways to advance it. He refined Daguerre's original technique by developing a faster lens system that allowed for shorter exposure times. His improvements led him to make some of the first successful photographic portraits. His daguerreotype portrait of his sister, Dorothy Catherine Draper, became known as one of the earliest photographic portraits ever made.

During the winter of 1839/1840 Draper turned his attention to the sky and made several attempts at photographing the Moon using his refined daguerreotype process. The first attempts were unsuccessful, but Draper persisted, and on March 23, 1840, he announced his first successful photograph of the Moon. The 20-minute exposure, made using a small daguerreotype camera, was crude but clearly in focus and revealed large-scale features of the lunar surface. This monumental image was the first of its kind and heralded the new era of astrophotography. It also cemented John William Drapers place in astronomical history.

The first photographic portrait of the Moon was gifted a few weeks later to Sir John Herschel. Unfortunately the original daguerreotype was destroyed in a fire in 1865. A purported replica of the original image exists today. John William Draper went on to make further advancements in photography and medicine and founded the New York University School of Medicine. During his long esteemed career in science he wrote textbooks on a variety of subjects, including philosophy, physiology, and chemistry. His greatest passion, however, was photochemistry, a field in which he made highly significant contributions. He passed away in 1882, but his legacy would be continued by his son Henry Draper, a great innovator in his own right who made his own seminal contributions to astrophotography.

© Springer International Publishing Switzerland 2015
R. Gendler, R.J. GaBany, *Breakthrough!: 100 Astronomical Images That Changed the World*,
DOI 10.1007/978-3-319-20973-9_2

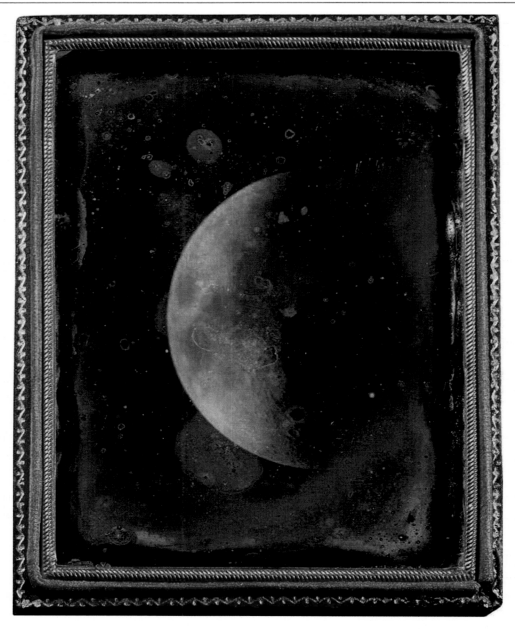

Fig. 2.1 Drapers original historic daguerreotype, the first astrophotograph, was sadly destroyed in a fire in 1865. The image seen here, a very early daguerreotype of the Moon by John Adams Whipple made on February 26, 1852, is likely very similar to the very first daguerreotype made by Draper. Although some early daguerreotypes (such as this one) appeared to have color, this was not a true-color photographic process but in fact involved a technique known as "hand coloring" using colored powders, pigments, and even electroplating, which came into vogue soon after the first daguerreotypes were produced (Courtesy of the Harvard College)

Capturing Sunlight

With the first image of the Moon made in 1840 by John Draper, the next milestone of astrophotography, photographing the Sun, would naturally be next. The Sun, however, was a much different and photographically challenging subject. Because of the Sun's intense brightness, exposures limited to only a few seconds would be necessary in order to record any surface detail. Up until this time the original daguerreotype process required at least several minutes of exposure time, much too long for solar photography. New modifications to the photographic process would be required to reach the next great milestone of astrophotography, that of imaging the photosphere of the Sun.

Around the time Daguerre's process was becoming increasingly popular, two highly accomplished nineteenth century French physicists, Louis Fizeau and Leon Foucault, were collaborating to unravel some of the mysteries surrounding the physics of light. As part of their investigations they were also determined to capture the first photographic image of the Sun.

In 1840 Fizeau attended several talks on the daguerreotype process given by Louis Daguerre himself and set out to make improvements to Daguerre's original method by making it more sensitive and therefore more suitable for photographing a very bright subject such as the Sun. His first innovation was known as "gilding," in which the plate was heated in a solution of gold chloride and sodium thiosulfite to produce a much sharper and luminous image. The second advance was the substitution of bromine-based chemicals for iodine to dramatically improve sensitivity. Together these advances were able to shorten exposure times from several minutes to less than 20 seconds.

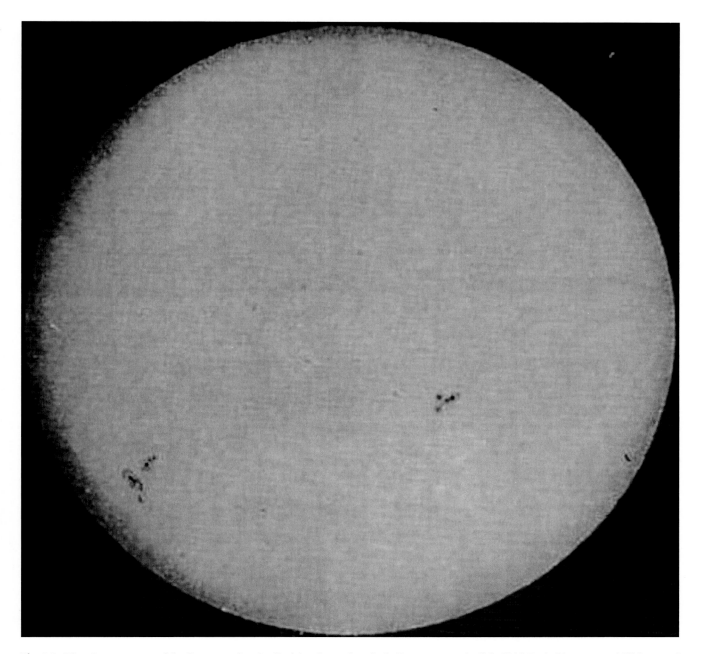

Fig. 2.2 First daguerreotype of the Sun, capturing detail of the photosphere including sunspots, April 2, 1845, Paris Observatory, 1/60th second exposure

Working together at the Paris Observatory from 1843 to 1845, Fizeau and Foucault began by producing small daguerreotypes of the Sun. However, they recorded only minimal detail of the photosphere. Still, this early work did lead to an important observation. They noted that the brightness of the Sun dropped off noticeably from the center to the periphery. Their curiosity aroused, they wondered if this was an artifact or a real phenomenon. The answer would require a larger and more detailed image. Modifying the daguerreotype process further they began to produce larger images of the Sun while making use of a more massive refractor having a focal length of almost 10 m. Finally they produced a sizeable image 90 mm across that confirmed the phenomenon of "solar limb darkening." Although not clearly understood at the time it was explained years later as a result of decreasing density and temperature as the distance from the center of the Sun increases.

Of these important images made by Fizeau and Foucault only one survived. It was produced on April 2, 1845 and became known as the first detailed daguerreotype of the Sun's disc. The image clearly reveals in sharp detail two large well defined sunspots on the Sun's surface. Thus another great milestone of astrophotography was achieved.

Fizeau and Foucault went on to receive many honors for their contributions to solar science. Aside from producing the first detailed daguerreotype of the Sun they made major scientific contributions such as the refinement of the speed of light and other important discoveries on the physical nature of light.

Reaching for the Stars

After the first daguerreotype of the Moon in 1840, it was expected that images of the Sun and other stars would follow in fairly rapid succession. Although the Sun was photographed by Fizeau and Foucault in 1845 using Daguerre's method, other stars would pose a more serious challenge for the early daguerreotypists because they were far fainter subjects. Sharp stellar images would require considerably longer exposures and a substantially more sensitive photographic medium. During the next few years an unlikely pair of innovators would push the available technology to capture the first successful images of distant stars.

American astronomer William Cranch Bond (1789–1859) was the first director of the Harvard College Observatory. Bond had been an amateur astronomer since age 17, when he witnessed his first solar eclipse. After his start at the Harvard Observatory in 1839 as an "unpaid" observer he would devote his entire career to developing and expanding the facility. He was instrumental in acquiring the observatory's first premier research instrument, a German-made equatorial-mounted 15 inch refractor, one of the largest in the world at that time. Using this instrument William Cranch Bond and his son, George Phillips Bond, who joined the observatory in 1841, would achieve a number of astrophotography milestones from 1847 to 1857.

To successfully pursue photography with the 15-inch refractor the observatory hired the services of a local photographer named John Adams Whipple (1822–1892). Whipple made a name for himself in the Boston area as a highly competent daguerreotypist and portrait photographer. His additional interest in science attracted the attention of the Bonds, who, realizing Whipple's skills, asked him to join the observatory. Beginning in 1847 Whipple would make a series of pioneering daguerreotypes of the Sun, Moon, and for the very first time, a distant star.

On July 17, 1850, William Bond and John Whipple made photographic history by recording the very first daguerreotype of the 1st magnitude star Vega (alpha Lyrae). The exposure time was a staggering 100 seconds, as the daguerreotype process was extremely insensitive. In the observatory record William Bond wrote "with the assistance of Mr. Whipple, daguerreotypist, we have obtained several impressions of the star Vega (alpha Lyrae). We have reason to believe this to be the first successful experiment of the kind, ever made, either in this country or abroad." The great possibilities of stellar photography were not lost on the Bonds, although the image of Vega would be the last stellar image made using Daguerre's outdated process.

Soon Bond and Whipple moved on to the new and improved wet collodion photographic process (developed by Frederick Archer), which was vastly more sensitive. In addition, they improved the guiding mechanism of the 15-inch refractor's mount. They returned to stellar photography on April 27, 1857 and proceeded to take an extraordinary image of the double star Mizar with its companion Alcor, which are respectively 4th and 5th magnitude stars, far fainter and more challenging than their first image of Vega.

The first images of stars, although appearing as modest photographic achievements, raised the possibility of someday achieving true deep space astrophotography. It wouldn't be long before this next chapter in astrophotography would begin.

Moving Targets: The First Comet Photographs

The story of the first successful comet image is a combination of serendipity and misfortune. The mid nineteenth century was a time of rapid advancements in astrophotography. It was an era defined by a series of firsts where incredible milestones seemed to occur every few years. By 1881 images of the Moon, Sun, stars, and even a nebula had been accomplished.

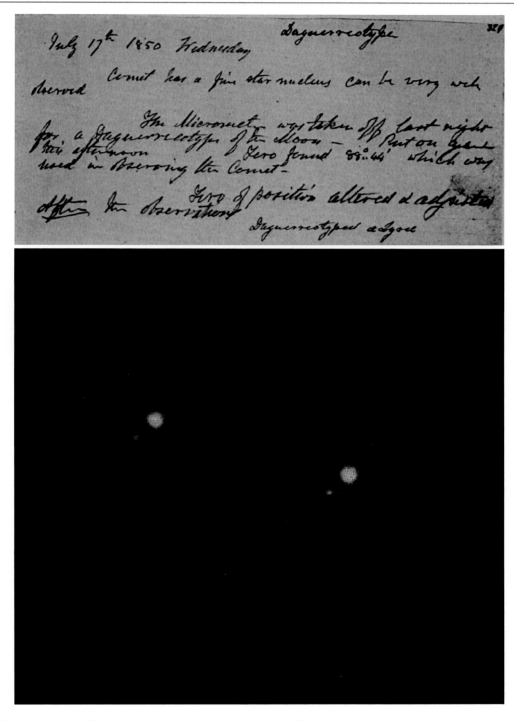

Fig. 2.3 (*Top*) The catalog of the 15-inch refractor is the only surviving record of the very first stellar photograph, a daguerreotype of alpha Lyrae (Vega) on July 17, 1850. The bottom line "Daguerreotyped alpha Lyrae" tells the story. (*Bottom*) Almost 7 years later, on April 27, 1857, using the new "wet collodion" process, Bond and Whipple produced a much higher quality image of the double stars Mizar and Alcor

Comets had been observed and studied for hundreds of years before the era of astrophotography. A great deal of knowledge came by way of observation from the likes of Tycho Brahe, Isaac Newton, and Edmund Halley, among many others. Photography of a comet would be a very special challenge as it would require longer exposures and more sensitive media to capture detail of the nucleus and the faint tail. Although comets were observed visually for some time little was known about their composition and photography offered a deeper glimpse into their diverse structure and make-up.

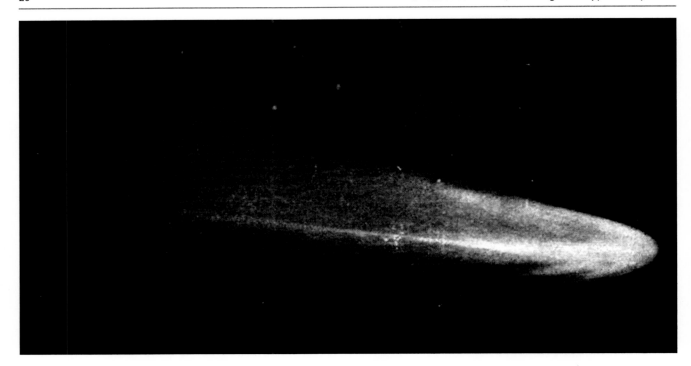

Fig. 2.4 First surviving photograph of a comet (Tebbutt 1881), June 30, 1881, using the new "dry plate" method, Jules Janssen, 50 cm refractor, 30-minute exposure

Despite efforts by many of the great observatories and astronomers, both professional and amateur, the credit for the earliest image of a comet must go to England's William Usherwood (1821–1915). Neither an astronomer nor astrophotographer, Usherwood was a small time businessman who made a living in photography as a portrait painter. His famous feat occurred on September 27th, 1858.

The Great Comet of 1858, known as "Donati's Comet" after the Italian astronomer who discovered it, was a special opportunity for many ambitious astrophotographers of that time. Renowned astronomers such as George Phillips Bond of Harvard College and Warren De la Rue, the British chemist and astronomer, failed in their attempts to image Donati's Comet. Usherwood, on the other hand, produced a good negative that documented details of the very faint tail using a short focus portrait lens and a 7-second exposure. Usherwood's historic image was likely a product of serendipity, because the comet was fairly low in the sky and his camera was situated 700 feet above sea level. These facts plus the short focal length (faster) lens gave him an advantage neither Bond nor De la Rue had with their slower long focal length systems.

Unfortunately, neither the original collodion plate nor any paper copies of Usherwood's image have survived. Although credited with taking the earliest comet image, the first image for which there is an existing record must be attributed to Pierre Jules Cesar Janssen, a seasoned French astronomer and photographer.

The next great opportunity to photograph a comet was Tebbutt 1881 III. It drew the attention of well-known amateur astrophotographers such as American Henry Draper and British A. A. Common, both of whom failed to make a successful image of the nucleus and tail. Janssen made his historic image of the comet on July 1, 1881, using a dry plate technique and a "fast" 20 inch telescope. Only a single paper copy survives of the image clearly showing the nucleus and extended tail. The original is lost.

Coronal Light: The First Daguerreotype of a Solar Eclipse

Although the ancients were vaguely aware of a "winged" Sun, it wasn't until the nineteenth century that the true nature of the Sun's corona began to be known. During the eighteenth and early nineteenth century the corona was observed visually during total solar eclipses but it was mistakenly attributed to the atmosphere of the Moon. It wasn't until after the advent of solar photography that the corona was correctly identified as a component of the Sun's atmosphere.

The great story of solar photography began with the first image of the Sun's photosphere on April 2, 1845, by Fizeau and Foucault. The first unsuccessful attempts at photographing a solar eclipse were attempted as early as 1842. As a result

of continued improvement in the daguerreotype process the first successful image of a solar eclipse taken during totality occurred on July 28, 1851. It was made at the Konigsberg Observatory, in Russia, by a local daguerreotypist named Johann Julius Friedrich Berkowski. Hired by the director of the observatory, Dr. August Ludwig Busch, Berkowski used a small 2.4 inch (60 mm) aperture refractor telescope with a 32 inch (.8 m) focal length to expose the daguerreotype for 24 seconds during totality.

When the plate was developed, the shimmering corona and several large prominences located along the limb of the Sun were apparent. This was an extraordinary achievement. However, further advancements in eclipse photography had to wait for the total solar eclipses of 1860 and 1869.

On July 18, 1860, Warren De la Rue used the new "wet" collodion process and an instrument specifically designed for solar photography known as the "Kew photoheliograph" to produce images of the corona far surpassing the original image by Berkowski. On August 7, 1869, after several new innovations, the most revealing coronal image yet was obtained by John Adams Whipple.

Prior to the invention of the coronagraph in 1930 by French astronomer Bernard Lyot, eclipse photography was the only means to study the solar corona. The coronagraph led to a rapid expansion in our knowledge about the nature of the corona. We now know that the solar corona represents a rarefied multi-million degree plasma extending millions of kilometers into space. The corona has several unique properties, including distinct spectral lines from highly ionized iron, and emits abundantly at X-ray wavelengths.

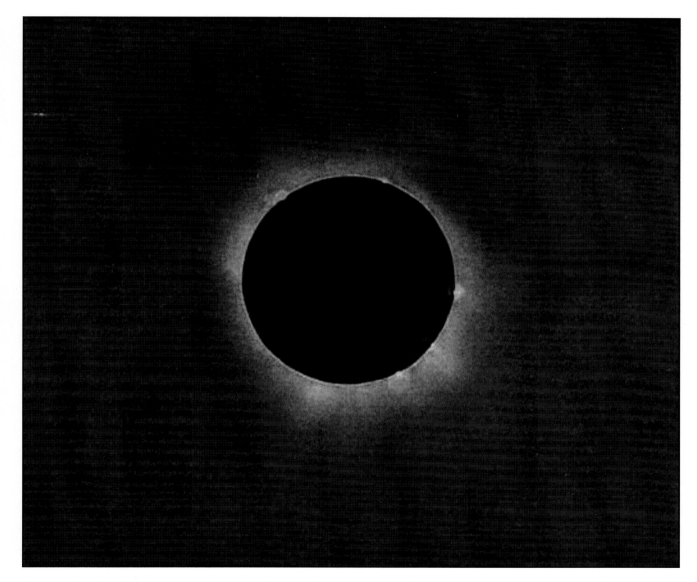

Fig. 2.5 (*Top*) First daguerreotype of a total solar eclipse, showing corona and prominences, Johann Julius Friedrich Berkowski, July 28, 1851, 60 mm refractor, 24-second exposure

Beyond the Sun and Moon: The First Detailed Images of Saturn and Jupiter

Detailed telescopic observation of the larger planets predated photography by several centuries. Galileo Galilei first observed the rings of Saturn and the moons of Jupiter in 1610. Over the next few centuries detailed observation and sketches of Saturn and Jupiter were made with increasing clarity by Huygens, Cassini, Herschel, and others. Details about the ring structure of Saturn and the spots and bands of Jupiter were already known prior to the first attempts to photograph the planets in the late 19th century. Although observational studies of the planets were fairly advanced by the 1880s, photographic technology was gaining and poised to begin making its impact on planetary science.

By the 1880s the wet collodion process had advanced astrophotography significantly. The first images of the Moon, Sun, stars, comets, eclipses and even a nebula had been accomplished. Planetary photography would mark its official birth at the renowned Paris Observatory when the Henry brothers, Pierre Paul and Mathieu Prosper, produced the first images of Jupiter and Saturn.

The brothers, born roughly a year apart, were self-taught opticians. They were hired in their early teens by the director of the Paris Observatory, Urgain Le Verrier, who had noticed their mastery of optics. They were initially assigned to perform small jobs, but in 1871, in recognition of their skills and work ethic, they were given the daunting task of visually mapping the stars down to the 13th magnitude within a 5-degree wide band centered on the ecliptic. They worked tirelessly on this project from 1871 to 1884, recording their observations night after night. In 1884, with only one quarter of the survey completed, it became evident it would be impossible to visually map the high stellar densities near the Milky Way's center. So, they turned to the idea of doing a photographic survey.

Tapping into their optical skills, they were asked to build an astrograph; a telescope designed to photograph large swaths of the sky and therefore well suited for a wide field survey. Together, the brothers built several superb astrograph refractors that would later be recognized as some of the premier photographic instruments of their time. Their first telescope, built in 1884, was a 6.5-inch (16.5 cm) astrograph refractor that could record 6 square degrees of sky – an area large enough to hold 144 full Moons – down to around 12th magnitude.

Their next instrument – a much larger telescope – was completed in 1885. It was, by all accounts, considered a masterpiece of optical perfection. This magnificent 13.4 inch (33 cm), F/10 astrograph refractor was the world's largest at that time. A 7.6-inch (19 cm) guiding refractor was piggybacked on this instrument. The mount was designed and built by the great Parisian engineer Paul Gautier. The refractor quickly achieved several deep sky photography milestones, including the recording of an astonishing 1,421 stars in the Pleiades cluster and the first photograph of the Maia nebulosity around the star 20 Tauri.

This same instrument was also used to make history when the brothers captured the first detailed images of Saturn and Jupiter in 1885 and 1886. The Henry brother photographs of Saturn were remarkable for resolving not only the A and B ring but also Cassini's gap, in addition to surface features of the Ringed Planet. Their images of Jupiter in 1886 clearly showed the belts and zones of the gas giant for the first time. The Henry brothers stayed active in astronomy until their deaths and were known for creating some of the most remarkable astrographs of that era.

It should be noted that John Adams Whipple, the American daguerreotypist who worked with William Cranch Bond at the Harvard College Observatory, is often credited with producing the first successful daguerreotypes of the two gas giant planets in 1851. Unfortunately, his photographs have not survived.

Measuring the Sky: The Birth of Photographic Astrometry

The history of astrometry (the branch of astronomy that measures the positions and movements of stars and other celestial bodies) is a rich and long one. Astrometry has touched on all aspects of research astronomy from antiquity to modern times. Its use began as far back as 190 B. C. with Hipparchus and the first models explaining the motions of the Sun and Moon. Astrometry has contributed substantially to the fields of stellar dynamics, galactic astronomy, and even cosmology. Today it is an integral part of the emerging field of extra-solar planet detection and the tracking of near Earth objects.

With the advent of astrophotography in 1840 and the first stellar images in 1851, it wasn't long before photography proved superior to observational methods in charting the sky. The birth of photographic astrometry is attributed to two American innovators, astronomers Benjamin Gould (1824–1896) and Lewis Rutherfurd (1816–1892).

The two combined their experience and areas of expertise in the mid-1860s to pursue their goal of charting the night sky. Using the newly developed wet collodion photographic process, Rutherfurd established himself as a leading astrophotographer of his time. In the mid-1860s Rutherfurd transitioned from making high-quality images of the Moon to imaging star clusters such as M44 and M45, also known as the Praesepe and the Pleiades. Working on several plates of these clusters made between 1864 and 1866 Gould and Rutherfurd, using a specially made micrometer, accurately measured stellar positions in the sky. Their work heralded the birth of photographic astrometry.

Fig. 2.6 The first detailed images of Saturn and Jupiter, Henry brothers, 33 cm refractor, Paris Observatory, 1886

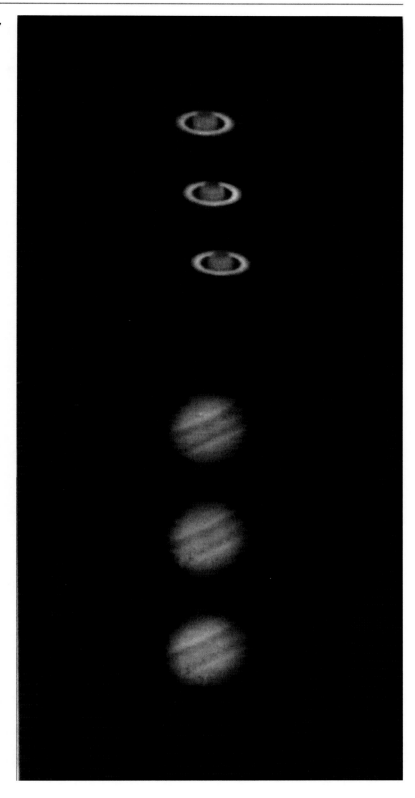

From 1872 to 1882 Gould continued to advance the methods he and Rutherfurd developed together. Gould traveled to Argentina and proceeded to conduct a photographic survey of the southern sky. He and his assistants took hundreds of photographs while recording and charting the brightest stars down to about magnitude 10.5. This work laid the foundation for the publication of *Uranometria Argentina*, for which Gould was awarded the Gold Medal of the Royal Astronomical Society.

Fig. 2.7 One of Rutherfurd's original wet collodion plates of the Pleiades exposed in 1864 with stellar positions charted

In addition to his work with Gould, Rutherfurd went on to make significant contributions to the emerging field of stellar spectroscopy, which laid the groundwork for that field as well.

Dividing Light: The Birth of Photographic Spectroscopy

It is difficult to overstate the impact of spectroscopy on the growth of modern observational astrophysics. Without doubt, the early innovators in visual and photographic spectroscopy laid the foundation for modern solar physics and accelerated the understanding of the Sun, stars and deep sky.

Early progress in spectroscopy occurred in fits and starts. The groundwork was set by Newton in 1672 with the publication of his work on the color spectrum of light. Much later the discoveries of infrared light in 1800, by the famous British astronomer William Herschel, and ultraviolet light in 1801, by the German physicist and chemist J. W. Ritter, set the stage for several important observational milestones. For example, in 1802, using a glass prism, William Hyde Wollaston, the English physicist, discovered that the spectrum of sunlight is interrupted by a series of dark lines. Many consider this discovery the birth of solar spectroscopy.

Wollaston's work lay dormant until 1814, when German optician Joseph Von Fraunhofer independently rediscovered the solar spectrum's dark lines using a quartz prism. Fraunhofer would never truly understand the meaning of the dark lines and he used the information only to determine the index of refraction for the high-end optical glasses he designed. His name, however, would be immortalized for rediscovering the phenomenon of what later became known as "Fraunhofer lines."

Genuine understanding of Fraunhofer lines came in 1861 with the work of two Germans, physicist Gustav Kirchhoff and chemist Robert Bunsen, who together conducted experiments proving the dark lines of the solar spectrum were in fact signatures of specific elements. Their work carried enormous significance because it provided insight into how light absorption creates the dark lines and it revealed the presence of known elements existing in a non-terrestrial body, namely the atmosphere of the Sun. Following in quick succession was the discovery of a number of Fraunhofer lines representing a variety of known terrestrial elements. Out of their work came discoveries of several new elements never before known.

Until this time spectroscopy was the domain of observational astronomy. This would change when American amateur astronomer Henry Draper made the first photograph of a stellar spectrum on May 29, 1872. His photographic recording of the spectrum of the bright star Vega was indeed seminal, and proved beyond doubt the power of spectroscopy in probing the physical properties of stars. The sensitivity advantage of the photographic process over observational methods was obvious and propelled photographic spectroscopy into a new era that opened a vast window into investigating the chemical composition of the universe.

Around the time Draper was making his own inroads several other extraordinary innovators were rapidly advancing the emerging science of spectroscopy. Sir William Huggins, an English amateur astronomer, using visual observation and later photographic methods, broadened the science of spectroscopy by exploring the spectra of non-stellar objects such as nebulae and comets. Huggins was the first to show spectral differences between nebulae and galaxies, and he was the first to study the spectrum of a planetary nebula.

By the end of the nineteenth century the role of spectroscopy in advancing stellar astronomy rapidly matured when several concerted efforts commenced to map and classify the known stars according to their spectrum. Although Henry

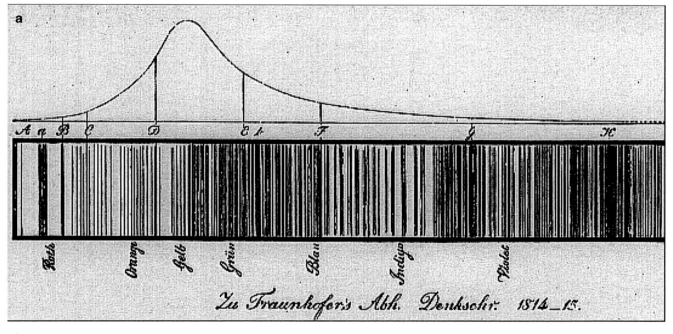

Fig. 2.8 (*Top*) Reproduction of Fraunhofer's original 1817 drawing of the solar spectrum. (*Bottom*) Photographic spectral plate of Alpha Lyrae (Vega) made by Sir William Huggins in 1876, identical to Draper's historic and seminal spectral plate of the same star made in 1872

Draper died in 1882 his work was continued by his widow Anna Palmer Draper. Supported by the Henry Draper Memorial fund, a massive photographic stellar spectra survey commenced at the Harvard College Observatory beginning in 1886. In 1890 the first survey results were published as the "Henry Draper Catalogue of Stellar Spectra" with its famous star classification system (O, B, A, F, G, K, M). It listed the spectra of 10,351 stars. The second and final publication was the timeless and monumental "Henry Draper Catalogue", begun in 1911 and published in nine volumes from 1918 to 1924. It cataloged the spectra and positions of an amazing 225,300 stars!

Our Backyard Star: Exploring the Surface of the Sun

The Sun was photographed as early as 1845 using the daguerreotype process. Some details of the solar atmosphere such as sunspots, prominences, and the corona were apparent in the early daguerreotypes of the Sun and solar eclipses. Finer details of the Sun's atmosphere (the photosphere, chromosphere, and corona) would require further technical advances to overcome the immense brightness of the Sun. The advent of the spectroheliograph would circumvent this problem.

A spectroheliograph is an instrument that captures a photographic image of the Sun at a single wavelength of light. The wavelength is usually chosen to coincide with a spectral wavelength of one of the known chemical elements present in the Sun. The spectroheliograph works by passing sunlight through a prism or diffraction grating and then through a narrow slit that isolates a single wavelength. The monochromatic light is then focused onto a photographic plate to form an image.

The first spectroheliograph was invented by the famous American astronomer, George Ellery Hale (1868–1948) in 1889. Hale was a distinguished leader in astrophysics from the late nineteenth century to the 1930s. He witnessed the birth of deep space astrophotography and brought Harlow Shapley and Edwin Hubble to Mount Wilson, where they made history. Hale had a storied career and founded several preeminent institutions including the Yerkes Observatory, Mount Wilson Observatory, Palomar Observatory, and the Hale Solar Laboratory at Mount Wilson.

As a scientist, Hale was one of the great solar physicists of his time. His interest in the Sun began early. As a child he photographed the Sun's spectrum using a prism spectroscope purchased by his father. Throughout Hale's early life he received unlimited support and encouragement from his wealthy father, who provided the necessary equipment for any scientific endeavor his son showed interest in. About his early interests Hale would say, "Solar spectroscopic work appealed to me above all things, and I read everything I could find on the subject."

In 1886 Hale entered MIT. He majored in physics and continued to pursue his interest in spectroscopy. The story goes that in 1889 Hale was riding on a Chicago trolley car when an idea came to him for an instrument that would solve the problem of photographing solar prominences in full daylight to produce a photographic image of these and other solar phenomena.

Although prominences had been observed visually by French astronomer Jules Janssen and Norman Lockyer, the English astronomer, in 1868, no one had yet photographed prominences on the Sun's surface outside of an eclipse. By the fall of 1889 Hale completed construction of his first spectroheliograph and reported its results in his senior thesis titled "Photography of the Solar Prominences." Subsequently, larger and more sophisticated spectroheliographs were developed that revolutionized solar research and dramatically enhanced our knowledge of the Sun.

Hale would go on to design and build a series of solar telescopes and solar observatories during his career that allowed him to make substantial contributions to solar science. His contributions to solar research were so substantial he is considered by many to be the father of modern solar observational astronomy.

Variable Stars and the Prelude to Modern Cosmology

The first observation of a star that changed its light output over time was made in 1638. Stars of this nature became known as "variable" stars. Stars may vary their light output for several reasons. Binary stars may accrete matter or block light from their companion. Stars may pulsate or exhibit outbursts or flares.

The science of variable stars has not only contributed to our knowledge about stars but has become the cornerstone of several diverse areas in astronomy, from cosmology to exoplanet discovery. Variable star research is also a field where amateurs, and particularly women, have historically made enormous contributions. One of the great contributors was American Henrietta Swan Leavitt (1868–1921).

Leavitt graduated Radcliffe College in 1892. Her only exposure to astronomy was a course she took in her senior year. This brief introduction inspired her love for scientific research in which she would later make a monumental discovery.

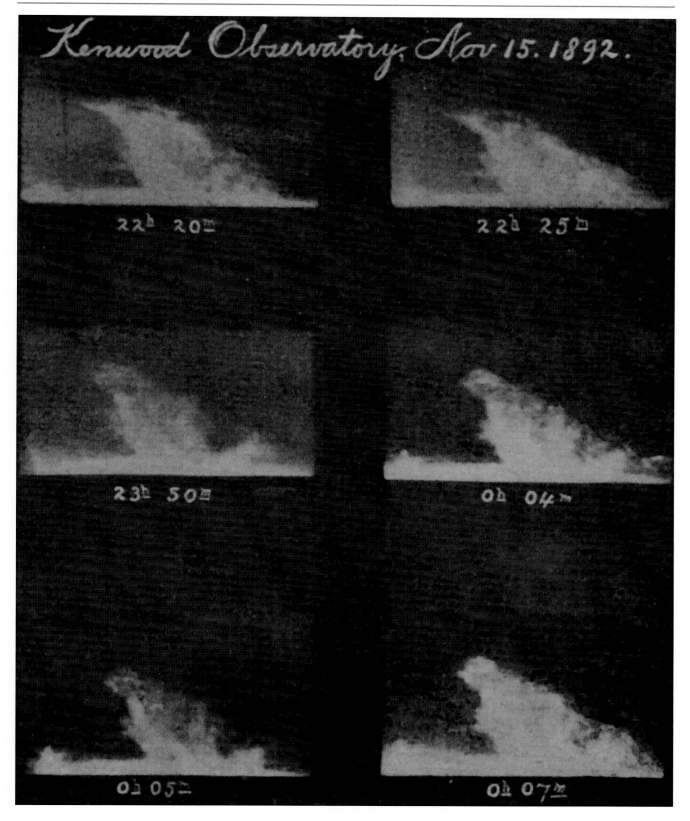

Fig. 2.9 One of the earliest images of solar prominences made by Hale using his spectroheliograph, November 15, 1892

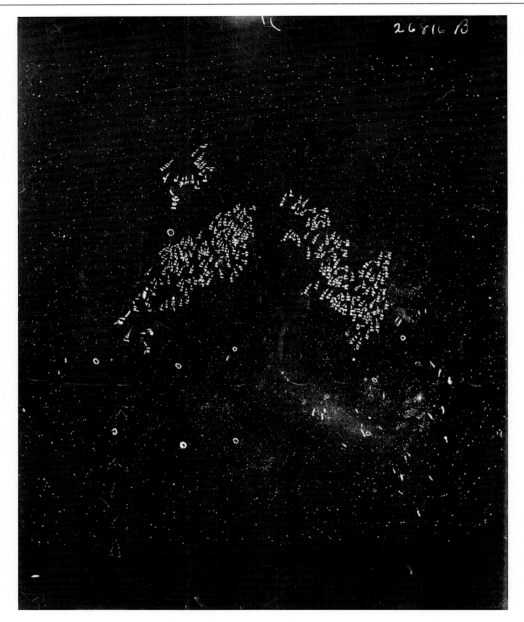

Fig. 2.10 Plate b26816 of Large Magellanic Cloud taken on December 18, 1900, from Arequipa, Peru, with the 8-inch Bache Doublet. The exposure was 60 minutes, centered on 5h09m47s R.A. and –67d22m51s Declination. The plate shows Leavitt's original annotations

In the 1890s Charles Pickering, the director of the Harvard Observatory, was conducting an ambitious study to measure and catalog the brightness of stars. The work entailed the meticulous and mundane examination of large photographic plates to record stellar magnitudes and spectral information. As no computers existed at the time, the work had to be done manually.

As the incoming data began to exceed his male assistant's ability to assimilate it, Pickering began to hire women (at a considerably lower wage) to perform the arduous, but important, tasks. These women, referred to as "human computers," proved highly competent and efficient, and several would go on in their own right to make enormous contributions to science even though women had minimal roles in academia during the late nineteenth century.

The first woman Pickering hired was his house maid, Williamina Fleming. Impressed by her devotion and stamina, Pickering went on to hire many other women including Annie Jump Cannon, Henrietta Swan Leavitt, and Antonia Maury, all of whom would make critical discoveries in astrophysics. Cannon, Maury, and Fleming worked together and produced the Harvard Spectral Classification, later to become the Morgan Keenen system of star classification.

Over time Pickering's female staff came to be known affectionately (although patronizingly) as "Pickering's harem."

Working for only 30 cents/hour, Henrietta Leavitt joined the observatory's staff in 1893. Her assigned work involved the study of variable stars. With time her research and science skills evolved, and in 1908 she published her years of painstaking work on variable stars in a landmark paper titled "1777 Variables in the Magellanic Clouds." Her paper confirmed the relationship between the brightness of certain faint variable stars, known as Cepheid variables, with their periodicity and noted the brighter variable stars have proportionally longer periods. The data for her paper came from photographic plates of the Magellanic Clouds taken with the 24-inch Bruce refractor at the Harvard Observatory's southern station in Arequipa, Peru.

Leavitt's epic contribution would form the foundation for a future leap in our understanding about the nature of the universe because it provided a method for astronomers to measure the vast distance to other stellar systems. However, her "period-luminosity law" would require a distance calibration before it could be used as a reliable yardstick.

In 1913, Ejnar Hertzsprung, the Danish astronomer, used parallax to calculate the distance of the North Star, Polaris. Parallax is the displacement of close object compared to a more distant object when the observer's position is changed. This method can be used to determine the distance of relatively near-by stars. Since Polaris is a Cepheid variable, this permitted a period-luminosity-distance relationship to be developed. Thus, the distance to other Cepheid variables, even those located far away in other galaxies, could be determined within a small range of error.

Henrietta Leavitt would not live to see her work achieve its deserved recognition. Two years after her death Edwin Hubble, using Leavitt's law, calculated the distance to the nearby galaxy M31 and forever changed the paradigm of cosmology. Leavitt published 25 technical papers while at the Harvard College Observatory. She also discovered approximately 2,400 variable stars. Astonishingly, this represents roughly 10 % of all variable stars known today! Still, her shining contribution to science was her exposition of the period-luminosity law.

The Hertzsprung-Russell Diagram and the Life of Stars

The late nineteenth and early twentieth century was a time of rapid progress in the charting and classification of stars. There was a concerted effort among several of the world's major observatories to chart the stars positions in the sky as well as catalog their magnitudes, spectral type, and temperatures. The culmination of this mass effort was the discovery of a relationship that provided fundamental insights into stellar evolution. This profound insight, made over 100 years ago, remains today the cornerstone for understanding the nature of stars.

In 1910, the Danish chemist and astronomer Ejnar Hertzsprung (1873–1967) noticed an interesting pattern in the Draper catalog of stars compiled in the late nineteenth century by the Harvard Observatory. He recognized that some stars were less bright than other stars of the same spectral type. He computed their absolute magnitudes by first determining their distance using the method called secular parallax, which measures the average distance to stars. He then plotted their absolute magnitude versus their spectral type and discovered a consistent relationship. The brighter stars tended to be at the blue end of the spectrum while the dimmer stars at the red.

In 1913 the American astronomer Henry Norris Russell (1877–1957) independently published a diagram illustrating the same relationship of absolute luminosity to spectral type. He noticed that almost 90 % of the stars fell along a diagonal ribbon that stretched from the top left to the bottom right of his diagram. Beginning in 1919 this insightful diagram, independently formulated by both Hertzsprung and Russell, would be known as the Hertzsprung-Russell diagram, or HRD.

The implications of the HRD form the foundation for understanding stellar evolution. The diagonal ribbon where Russell found roughly 90 % of all stars is now known as the "main sequence." The main sequence, where stars spend around 90 % of their lives, stretches from upper left (hot luminous stars) to lower right (cool faint stars). Stars exist on the main sequence during the time they consume hydrogen fuel in their nuclear furnaces (See Fig. 2.11).

Red giant and red supergiant stars occupy the region above the main sequence, meaning they have low surface temperatures and high luminosities. Stars enter this stage once they begin to exhaust their hydrogen fuel. White dwarf stars are found in the lower left and represent the end stage for low and intermediate mass stars. These stars are very hot but have low luminosities due to their small size. Blue supergiants (high temperature and high luminosity) and red dwarfs (low temperature and low luminosity) are located in the upper left and lower right of the HRD, respectively.

The original HRD displayed the absolute visual magnitude on the vertical axis versus the spectral type of stars on the horizontal axis. Modern HRDs replace spectral type by a color index. In a further refinement, the HRD plots the luminosity of the star against the "effective surface temperature," which is a corrected value determined by theoretical calculations of stellar temperatures. This is referred to as the "theoretical Hertzsprung-Russell diagram."

Fig. 2.11 (*Top*) Russell's original diagram published in 1913 made use of photographically acquired spectral data to illustrate the relationship of luminosity (Y-axis) to spectral class (X-axis). It was known as the Russell diagram for several years until it was found that the Danish astronomer Ejnar Hertzsprung had published the same findings independently in 1911. It then became known as the Hertzsprung-Russell diagram. (*Bottom*) Modern graphic of the "theoretical" HRD with calculated surface temperatures as the X-axis plotted against luminosity as the Y-axis

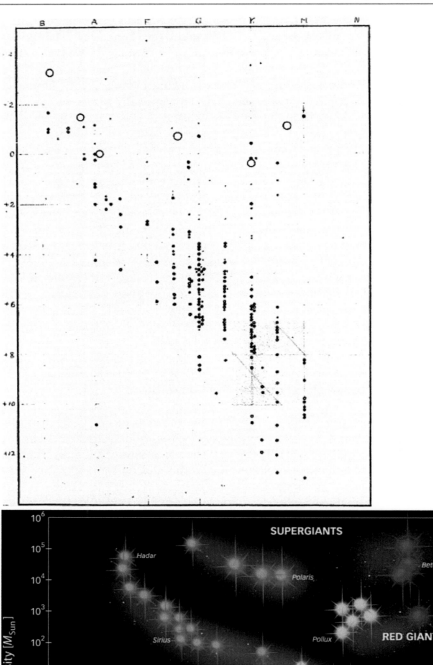

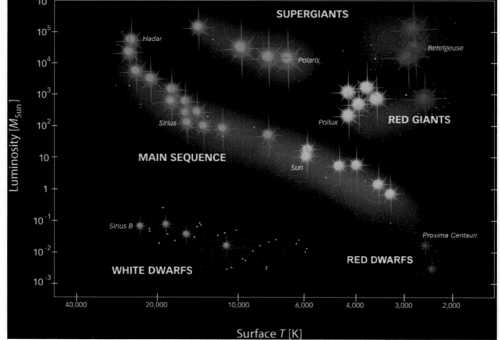

The Photographic Exploration of Deep Space and the Realm of the Nebulae

3

The late nineteenth century saw two transitions in astrophotography. The first was the refractor's relinquishment as the instrument of choice and its replacement by the reflecting telescope. The silver mirrored reflector boasted a tremendous aperture advantage and, being a more compact and efficient light collector, it was ideally suited for the next phase of astrophotography – exploring the faint nebulae of the deep sky. The second transition was the advent of the "dry" gelatin photographic plate which was not only supremely more sensitive, it also allowed a series of plates to be exposed in the field and later developed in the darkroom. Dry gelatin plates essentially separated the process of "taking" photographs from "developing" photographs. These two innovations propelled astrophotography into the twentieth century, the era of deep sky exploration.

Beyond the Visual: The Deep Space Era Begins

Advances in the early years of astrophotography were predominantly made by non-professional astronomers. The first images of the Sun, Moon, stars, and comets were all achievements by amateur astronomers using their own equipment. This model of advancement continued well into the late nineteenth century. During this period objects in the sky that weren't planets or stars were called "nebulae." They were observed to be very faint and extended, but their nature was not understood for almost another 50 years. Until 1880, successful imaging of nebulae remained elusive for two reasons. First, the daguerreotype and the wet colloidal process that followed were too cumbersome and delicate for the long exposures faint objects required. The second challenge involved the integration times needed by long exposures. For example, long exposures require mechanical precision that did not yet exist. This included sidereal clock drives, to move the telescope so it accurately tracked objects as they moved across the sky during the night, and telescope guiding mechanisms, to keep the instrument precisely pointed at the object during the exposure.

Successful deep sky astrophotography commenced in 1880 with the work of Andrew Ainslie Common (1841–1903), an English amateur astronomer. It's hard to escape the irony that such a grand achievement would be made by a man with the name "Common." Common was a sanitary engineer by profession but embraced astronomy as a passion beginning at age 10 when his mother encouraged him to use a telescope borrowed from a local physician. As an adult he began experimenting with dry gelatin plate astrophotography using a small refractor. He built a series of smaller Newtonian reflectors, and in 1879 he began using the instrument that would deliver a fantastic new milestone in the emerging field of astrophotography.

Common is also credited with refining the clock drives and guiding mechanics that were necessary for successful deep sky imaging. Soon after the clock drive's construction Common used his homemade 36-inch (.9 m) Newtonian telescope to make seminal observations of the satellites of Mars and Saturn and to photograph comet C/1881 K1. However, the work that defined his legacy remains several photographs of M42, also known as the Orion Nebula, produced from 1880 to 1884.

But, Common was not the first to photograph the Orion Nebula.

Henry Draper was an American physician and the son of John Draper, who produced the first photograph of the Moon. Draper used a small refractor to produce a 50-minute exposure of M42 that revealed considerable nebulosity but failed to record faint structures not visible through an eyepiece.

© Springer International Publishing Switzerland 2015
R. Gendler, R.J. GaBany, *Breakthrough!: 100 Astronomical Images That Changed the World*,
DOI 10.1007/978-3-319-20973-9_3

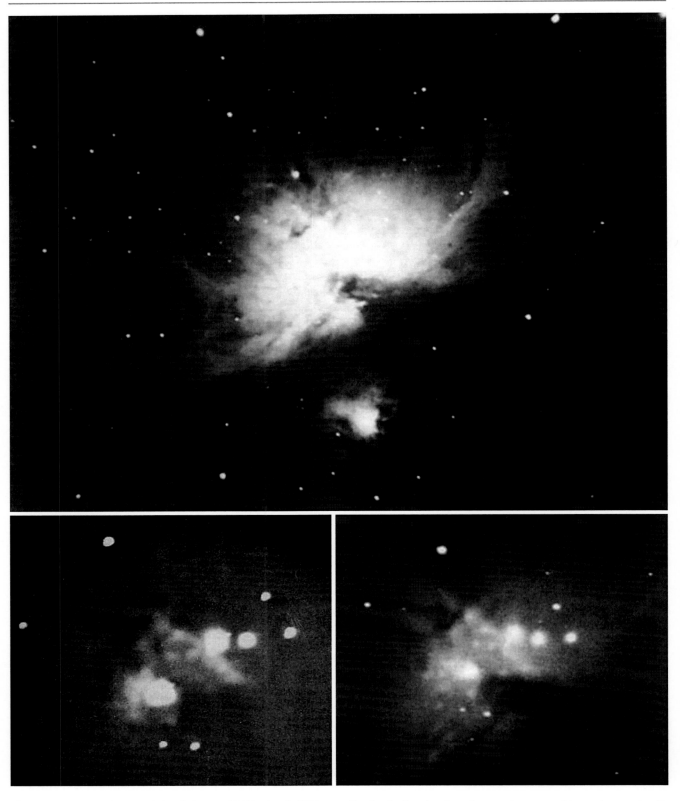

Fig. 3.1 (*Top*) A. A. Common's iconic image of M42 taken in 1883, revealing for the first time in a photograph stars too faint to observe visually through the telescope. (*Bottom left*) Henry Draper's landmark image, the very first of a "nebula." (*Bottom right*) Draper's second image of M42 taken in 1882. Both images failed to reveal stars fainter than what could be seen through the telescope

Using his new 32-inch instrument and the more efficient "dry plate" technique, Common made two long exposure photographs of M42 that proved promising but were still limited by blurring due to guiding issues. His first attempt, on January 20, 1880, was mostly unsuccessful but exposed several mechanical and photographic issues that needed to be solved. He further refined the sidereal clock drive of his mount and took advantage of recent advances that increased the sensitivity of his photographic plates. On March 17, 1882, he made a second long exposure that was the most promising image of M42 yet produced.

The culmination of his work occurred on January 30, 1883, when he completed a 37-minute exposure of M42 that revealed, for the first time, stars within the nebula that had never been seen through any existing telescope. Common's milestone image of M42 accomplished two things. First, it heralded the beginning of deep space astrophotography and second, it established astrophotography as an indispensable research tool.

The image naturally attracted the attention of professional astronomers and organizations. For his immense contributions to astronomy and astrophotography Andrew Ainslie Common was awarded the Gold Medal of the Royal Astronomical Society in 1884. Common had this to say about his monumental achievement: "Although some details are lost in the enlargement, sufficient remains to show that we are approaching the time where a photograph will give us the means to recording in its own inimitable way the shape of a nebula and the relative brightness of different parts, in a better manner than the most careful hand drawing."

Looking South: The Magellanic Clouds and Southern Sky Photography

Much of the early observational and photographic exploration of the sky occurred from northern latitudes. Charting of the southern sky was mainly accomplished by well-known observers from northern observatories such as Sir John Herschel, who only traveled south of the equator to complete work focused on the northern sky. Photography of the southern sky followed a similar path. By the mid and late nineteenth century dozens of great observatories established throughout Europe and the United States were actively charting the northern skies and achieving important milestones in both astronomy and astrophotography. For a number of reasons, not the least of which was geographic isolation, there remained a limited number of serious research institutions south of the equator. This made southern sky astrophotography a challenge. Despite these difficulties southern astrophotography was advanced by highly competent people such Scottish astronomer David Gill, who spent much of career in South Africa; Benjamin Gould, the American astronomer who made several important contributions during his years in Argentina and Henry Russell.

Henry Chamberlain Russell (1836–1907) was an Australian astronomer and meteorologist who was a pivotal figure in southern astronomy. In 1862 he became the director of the Sydney Observatory.

Around 1870 Russell began to prepare the observatory for systematic work on star positions, including observations of double stars and star clusters. He also established a large number of meteorological stations in Australia. With his contributions to southern hemisphere climate science he became a renowned global meteorologist.

Russell first became known for astrophotography when he presented his photographs of the transit of Venus, taken in 1874, to the Royal Astronomical Society in London. His photographs of the transit were well received and made a significant contribution to the final analysis of data for the transit. While in Europe he met leading astronomers and technicians from around the world and began to make plans to further equip the Sydney Observatory for systematic surveys and ultimately astrophotography.

In 1887 Russell attended the International Astrophotographic Congress in Paris where, as part of an ambitious international project known as the *Carte du Ciel* (Map of the Sky) ,the Sydney Observatory was assigned the task of photographically charting the night southern sky from −52° to −64°. As part of a twenty-nation consortium, the Sydney Observatory began their part in 1892; the work would continue well into the mid-twentieth century. The *Carte du Ceil* proved overly ambitious and was never completed, as it overstretched the technology and resources of its time. It did, however, propel astrophotography into the era of systematic sky surveys.

In 1890, while waiting to secure a true astrograph for the observatory, Russell began his survey using a 6-inch (15.2 cm) portrait lens made by J. H. Dallmeyer, a prominent Anglo-German optician. Russell was a very resourceful individual who personally conceived and constructed many of his own instruments including telescope mounts. Using Dallmeyer's portrait lens Russell took a number of scientific photographs of the stars which he believed were "the first of their kind of the Southern Skies."

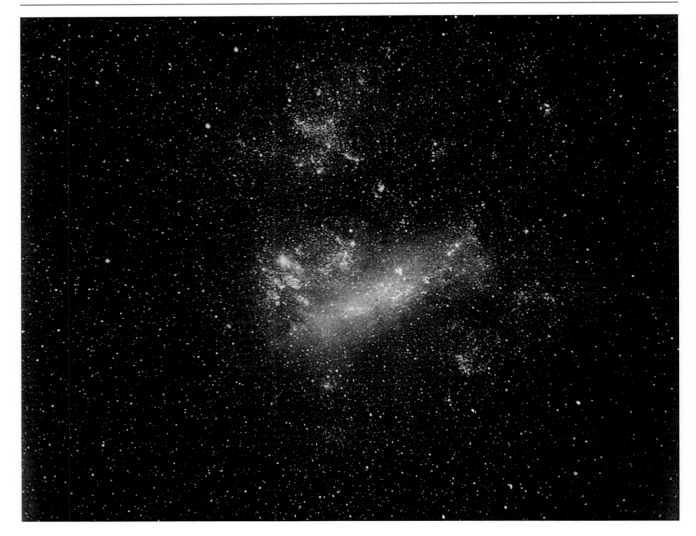

Fig. 3.2 Russell's 1890 photograph of the Large Magellanic Clouds was later recognized as the first to reveal fully resolved stars in another galaxy. The spiral form of our Milky Way's satellite galaxy was also noticed for the first time, by Russell. Russell's original image has been remastered by David Malin

Russell's most significant photographs were his 1890 images of the Magellanic Clouds, the Milky Way's small satellite galaxies that can only be seen from the southern hemisphere. The image of the Large Magellanic Cloud produced by Russell and his camera operator James Short was the first to resolve individual stars in another galaxy. This was not appreciated at the time because the true nature of galaxies as being separate stellar islands outside the Milky Way wasn't discovered until the 1920s. Russell did take notice and comment on the spiral nature of the Large Magellanic Cloud, which was an important observation. The nature of the Magellanic Clouds remains a subject of continued interest and debate in galactic evolution over 120 years later.

The Reflecting Telescope and the Pursuit of Spiral Nebulae

With the advent of the "dry gelatin plate" in the late nineteenth century photographic exploration of the deep sky commenced at an increasing pace. The nature of nebulae and in particular, the spiral nebulae, as they were known at that time, remained a mystery although a variety of ideas were proposed to explain their structure.

The largest spiral nebula in the sky, designated M31 but also known as the Andromeda "Nebula," would be the first photographic subject of its kind. In 1864 William Huggins observed the spectrum of M31 and noted it displayed a continuum of

frequencies similar to the spectra of individual stars, suggesting it might be of a stellar nature. It was believed by some that perhaps the central bright core represented a sun, while the other smaller brighter elements, now known as M31's satellite galaxies, represented planets that revolved around a central sun similar to our Solar System. The true nature of these objects would elude astronomers for several decades. However, astrophotography would venture forward and capture them nevertheless.

The photographic exploration of the faint nebulae would be accelerated by the transition from cumbersome long focal length refractors to the larger aperture reflectors, which were not only more compact but dramatically more efficient at collecting light. This became evident with the seminal photograph of M42 by A. A. Common.

In 1887 Isaac Roberts, a Welch engineer and amateur astronomer, recorded the first of several successful deep images of M31 from his home observatory using a specially constructed 20-inch reflector. Roberts, a strong advocate of the reflector design for astrophotography, advanced deep sky imaging by mounting photographic plates directly at the prime focus of his reflector thus eliminating the need for a secondary mirror. This dramatically reduced light loss and improved the contrast of his pictures. Roberts was also the first to attach a small refractor telescope to his main instrument and use it as a guiding telescope when taking long exposures.

Roberts recorded an astounding 2,485 images of deep sky objects from 1883 to 1904. But, the culmination of his efforts was a 4-hour exposure of M31 made on December 29, 1888. Although he later made several additional long exposures of M31, this seminal image revealed in clear relief M31's spiral structure for the very first time. It also held the distinction of being the first photograph of another galaxy.

The importance of Isaac Roberts' work cannot be overstated. Along with A. A. Common, Roberts is considered a pioneer of long integration imaging, so critical to the long exposures needed to record faint deep sky objects.

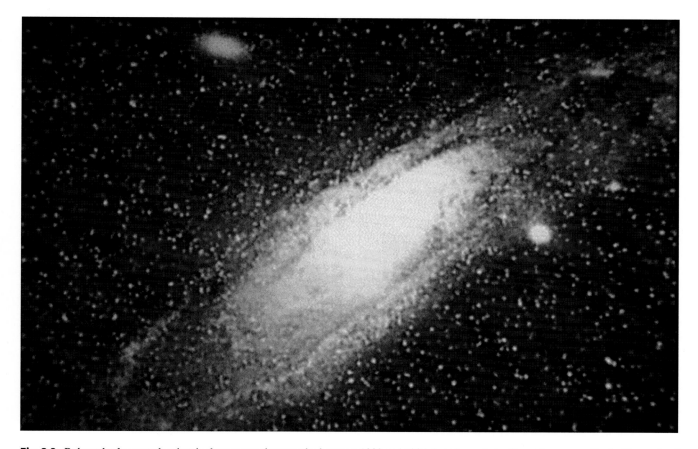

Fig. 3.3 Roberts broke many barriers in deep space photography between 1883 and 1904, but his most significant image was the first he made of M31, a 4-hour exposure on December 29, 1888. It revealed for the first time spiral structure in a nebula. Only later was it recognized as the very first photographic image of another galaxy

In 1890 he was elected a Fellow of the Royal Society and despite being considered an amateur, he was awarded an honorary degree of D.Sc. by Trinity College, Dublin, on the occasion of its tercentenary in 1892. In 1895 the Royal Astronomical Society awarded the gold medal to Roberts for his photographs of star clusters and nebulae.

Roberts published his life's work in *A Selection of Photographs of Stars, Star-clusters and Nebulae* that was released in two separate volumes in 1893 and 1899.

The Further Refinement of Deep Space Photography

William Edward Wilson (1851–1908) was an Irish amateur astronomer and a remarkable figure in the early years of deep space astrophotography. For example, he had no formal education beyond home schooling yet made significant contributions to solar science and astrophotography.

Wilson was born into an affluent family. Despite this advantage he suffered from ill health and had to be privately educated at home. As his primary teacher, his father instilled the value of learning, hard work and an appreciation of science from an early age. His initiation into astronomy began at the age of 19, when he participated in an expedition to witness the total solar eclipse of December 1870 in Algeria. Among the expedition members were notable astronomical icons such as William Huggins, the spectroscopic pioneer, and French astronomer Jules Janssen, who undoubtedly influenced Wilson's later scientific contributions about the Sun and stars.

Within a year of his return from Algeria, Wilson opened an observatory on the family estate in northern Ireland. Although lacking a formal degree in astronomy, he commenced serious research and observations as an unpaid amateur. In 1871, Wilson had his first scientific instrument installed – a 12-inch (30 cm) reflector telescope figured and built by Sir Howard Grubb, the renowned Irish optical designer.

Over time, the observatory was gradually expanded and equipped for astrophotography. For example, in 1881 the 12-inch telescope was replaced with a 24-inch (.6 m) reflector. Wilson used the larger instrument to conduct solar research and produce unprecedented deep sky photographs. Wilson also investigated several areas of astrophysics that included estimating the surface temperature of the Sun, measuring thermal emission from sunspots and the photoelectric measurement of starlight.

However, Wilson's most passionate endeavor was astrophotography. Although he began celestial photography like others before him, by taking images of the Moon, he soon ventured into a new and more challenging direction by experimenting with deep space photography. In 1893 Wilson began capturing images of faint objects using the recently introduced "dry plate" technology. Wilson did his best work between 1893 and 1899, producing some of that period's most iconic images including pictures of globular cluster M13, the near-by spiral galaxy M33, the dumbbell nebula M27, the Great Orion nebula M42, the whirlpool galaxy M51 and the ring nebula M57.

In 1898 he took the first movie of a sunspot using a cinematograph, an early motion picture camera that also served as a projector and printer. But, after 1899 Wilson was relatively unproductive in astrophotography due to poor weather in Ireland. He died in 1908.

Despite his amateur status he was honored in 1896 when he was elected into the "Royal Society." In 1901 he was awarded an honorary Doctorate of Science by the University of Dublin.

Probing Deeper into the Unknown: Nebulae Everywhere

Advancement in astrophotography has, from its very conception, been inextricably tied to telescope innovation. The quest for new optical designs was frenetically pursued primarily to satisfy photographic requirements. This was particularly true around the end of the nineteenth century as the domination of large refractors gave way to the larger aperture and greater efficiency of silver mirrored reflecting telescopes. The introduction of larger reflectors at the turn of the century permitted the exploration of deep space and the study of the mysterious "nebulae," as all deep space objects other than stars and planets were known at that time.

American astronomer James Keeler was one of the earliest advocates for large reflecting telescopes and one of the great early pioneers of deep space astrophotography.

Keeler worked as an assistant at Mt. Hamilton's Lick Observatory beginning in 1888 where he made the first observation of Enke's gap in the planet's A ring. He left Lick in 1891 after being appointed director of Pittsburgh University's Alleghany Observatory. Then, in 1898, Keeler returned to Lick as its director.

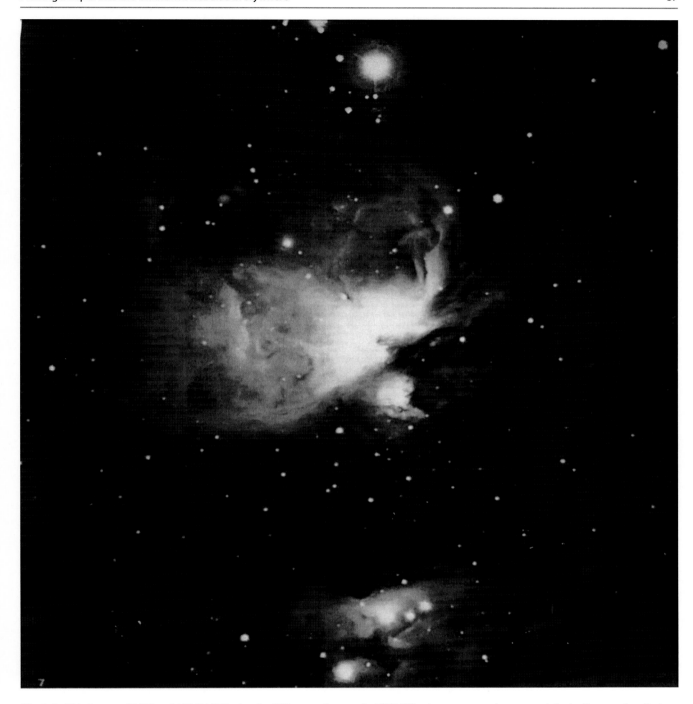

Fig. 3.4 This image of M42 and NGC 1977 taken by Wilson on January 3, 1897 (40-minute exposure), surpassed A. A. Common's milestone image of M42 taken more than a decade earlier

During Keeler's tenure as the director of Lick Observatory, he devoted much time to using its famous 36-inch Crossley reflector, originally built by the English amateur astronomer Andrew Common. The Crossley reflector was the first large silver-coated mirrored telescope to be owned by a professional American observatory. Its arrival at Mount Hamilton in 1895 signaled the beginning of a new era, one in which the large reflector would become the dominant research instrument in the world.

In his position as director, Keeler made modifications to the Crossley instrument that prepared it for deep space photography. He then produced a series of astounding deep sky photographs that featured unprecedented detail and depth for his era. One of Keeler's first images produced with the modified Crossley instrument was of the Great Orion Nebula M42, which exceeded the quality of the notable image taken by the telescope's maker, A. A. Common, in 1882.

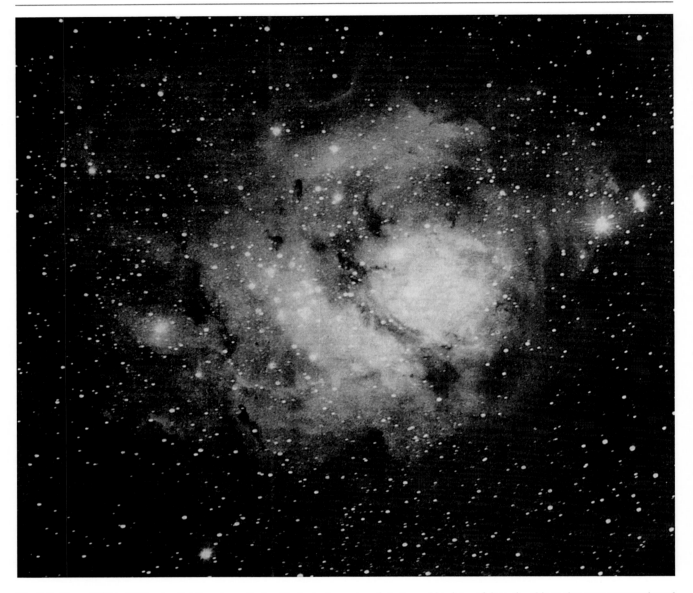

Fig. 3.5 From 1898 to 1900 using the Crossley reflector, Keeler took a series of photographic plates of deep sky objects that were unprecedented in depth and detail for that era. One of his deepest and most dramatic images was that of M8 (The Lagoon Nebula) made on July 7, 1899, with a 4-hour exposure

In just 2 years Keeler produced a large number of extraordinary astrophotographs with the Crossley before he unexpectedly died in 1900. In 1908 his Crossley images were published posthumously in *Photographs of Nebulae and Clusters made with the Crossley Reflector, Publications of the Lick Observatory, Volume VIII.*

One of Keeler's interests was the surprising prevalence of "spiral nebulae" among the many deep sky objects he photographed. Understanding of their true nature was less than a few decades away.

A Passion for Capturing the Sky

Edward Emerson Barnard is unquestionably a singular figure in the history of astrophotographic surveys of the deep sky. His contributions were many, but his masterwork remains his legendary publication *A Photographic Atlas of Selected Regions of the Milky Way*. This represented the defining anthology of his life's work dedicated to exploring and charting the Milky Way, particularly its dark nebulae and dense star clouds. The work was published 5 years after his death and remains to this day a fitting tribute to one of history's finest and most prolific astrophotographers.

Born in Nashville, Tennessee, on December 16, 1857, Edward Emerson Barnard endured an impoverished childhood during the Civil War years. As an adult he would say about his childhood, "so sad and bitter that even now I cannot look back to it without a shudder." Despite the abject poverty he endured, Barnard followed his passion for astronomical observing, later embracing astrophotography and ultimately becoming an observer and photographer at the famous Lick Observatory on Mt. Hamilton in California. His prodigious contributions and reputation ultimately led him to the directorship of Yerkes Observatory in Chicago.

Critical to Barnard's success was a prodigious capacity for work and an equally enormous determination to succeed at whatever observing or photographic project was placed before him. His career began at the age of 9 as an errand boy for a local photographer. He later began to observe the night sky through a series of modest telescopes during his teenage years. When he turned 20, Barnard used his savings to purchase a high quality 5-inch (13 cm) refractor telescope and equatorial mount with which he commenced serious observations of planets, nebulae, and comets. Before long his keen observing skills and growing list of comet discoveries earned him an international reputation as a prolific astronomical observer and highly successful comet hunter.

Fig. 3.6 Of Barnard's 500 photographic plates of the Milky Way he regarded a select few as truly seminal and revealing above all others. Of those few, his image of "Nebulosity in Taurus" retained a special distinction in his mind. In his own words Barnard spoke about Plate # 380 made at the Mount Wilson Observatory on January 9, 1907: "a 5 hour 30 minute exposure using the Bruce Astrograph....Very few regions of the Milky Way are so remarkable as this one. Indeed the photograph is one of the most important of the collection, and bears the strongest proof of the existence of obscuring dark matter in space"

In 1888 Barnard's emerging reputation won him an observing position at the Lick Observatory, where the massive 36-inch (.9 m) refractor, the world's largest telescope at that time, was nearing completion. He spent 8 years at Lick and continued his comet work eventually amassing 16 comet discoveries during his lifetime. More importantly, he began to turn his attention to photographing the wonders of the Milky Way. Intrigued by its light-obscuring dark nebulae and dense star clouds, Barnard began to hone his photographic skills on these fields using a refigured 6-inch (15 cm) portrait lens fitted on an equatorial mount. This instrument was later named the Crocker telescope.

His photographic sessions were grueling by anyone's standards and a testament to Barnard's determination and endurance. For example, it was not unusual for him to conduct 4- to 5-hour manually guided exposures sometimes in sub-zero conditions.

In 1895 Barnard accepted the position of Chief Observer at Chicago's Yerkes Observatory, home of the giant 40-inch refractor, by then the world's largest telescope. However, in 1905, frustrated by the poor seeing and cloudy conditions of Chicago, Barnard transported his prized photographic instrument, a 10-inch (25 cm) photographic telescope and equatorial mount built while he was at Yerkes, to the dark skies of the Mount Wilson Observatory overlooking Pasadena California. During his 8 months there, he completed his survey of the Milky Way.

Dark Clouds, Star Fields, and the Exploration of the Milky Way

Edward Emerson Barnard's prolific and famous photographic forays into the wonders of the Milky Way spanned nearly three decades from 1892 to 1919, involved the construction and use of several unique instruments, and ultimately followed him through professional appointments at three prestigious observatories.

His survey work began in 1892 with the Lick Observatory's purchase of a 6-inch (15 cm) refigured portrait lens used as an astrograph and renamed the Crocker telescope. Astrographs are telescopes designed for the sole purpose of producing, usually wide field, astrophotographs. During his final 3 years at Lick, from 1892 to 1895, he used this instrument to expose 89 photographic plates, primarily of Milky Way star fields.

After moving to Chicago's Yerkes Observatory in 1895, Barnard had a 10-inch (25 cm) astrograph constructed. The astrograph's optical components included a 10-inch (25 cm) doublet, a 6.25-inch lens (16 cm) and a 5-inch (13 cm) guiding refractor. These were assembled into a single unit that comprised one of the greatest photographic survey instruments of that time. The astrograph was completed in 1904. In 1905, a year after this, Barnard transported his prized photographic instrument to the 6,000 foot summit and dark skies at the Mount Wilson Observatory in California primarily out of frustration with the poor seeing and cloudy conditions of Chicago.

At Mount Wilson Barnard completed his photographic survey of the Milky Way, a feat totaling 500 photographic plates, and produced some of his most stunning, groundbreaking images that provided early insights into the structure of the our home galaxy, the Milky Way. Barnard's 4 hour and 30 minute exposure of the Rho Ophiuchi nebulosity made with his 10-inch astrograph ranks as one of the most beautiful and insightful photographic deep sky portraits of his time. This picture convinced both Barnard and the worldwide astronomical scientific community that the reduced number of stars visible in this area of the sky was not due to the absence of stars but because intervening dark clouds of gas and dust absorbed and blocked the light of stars located behind the clouds.

Barnard had this to say about this timeless portrait: "The region of Rho Ophiuchi is one of the most extraordinary in the sky. It is clear, from an inspection of the picture that the actual background of the sky here consists of a uniform distribution of faint stars….if part of the picture is covered so as to hide the large nebula and dark lanes….the conclusion is therefore irresistible that there is no real vacancy (where dark nebulae intersect)….but that the nebula is between us and the background of stars and blots out the more distant ones."

Soon after his death in 1923, Barnard's landmark work, *A Photographic Atlas of Selected Regions of the Milky Way*, was published. This catalog, with its *B* designations, is still in popular use today by amateurs and professional astronomers.

In addition to Barnard's survey, his contributions included several discoveries such as Jupiter's fifth moon *Amalthea,* the first new moon of Jupiter since Galileo's discovery of the 4 Galilean satellites in 1610 and the last planetary moon discovered visually; approximately 30 comets; the fastest moving star in the sky, subsequently named Barnard's star; Barnard's Galaxy (NGC 6822) and Barnard's Loop in Orion.

The Large Light Buckets: Deep Space Photography Passes to the Professionals

By the early twentieth century it became clear further progress in astrophotography would demand advancements in telescope technology and aperture that exceeded the resources of private citizens. Thus, the funding for the sophisticated designs and engineering of twentieth century telescopes passed into the hands of professional astronomers working at large observatories. Subsequently, the large reflectors of the twentieth century opened a window to extragalactic astronomy,

Fig. 3.7 Plate # 13, Region of the Great Nebula of Rho Ophiuchi, taken April 5, 1905, Bruce Astrograph, 4 hour 30 minute exposure. From *A Photographic Atlas of Selected Regions of the Milky Way*

accelerated the exploration of deep space and ultimately established a new paradigm of understanding that led to the modern era of cosmology. The most significant figure in this transition to large professional instruments was American optician and astronomer George Willis Ritchey (1864–1945).

Ritchey played a pivotal role in the development of several of the world's largest research telescopes in the early twentieth century. Ritchey was most celebrated for his work in designing the 60-inch (1.5 m) and 100-inch (2.5 m) reflecting telescopes at the Mount Wilson Observatory. Aside from Ritchey's accomplishments as an inventor, designer and engineer of world class telescopes, he was also a renowned astrophotographer. Ritchey took some of the most cutting-edge deep sky images of his time using the remarkable telescopes he created.

Ritchey's talents were initially discovered by George Emery Hale, the founder of the Mount Wilson Observatory. Hale recruited Ritchey to the Yerkes Observatory to work on optics for the 60-inch (1.5 m) reflector Hales planned to install at the Mt. Wilson Observatory. After the 60-inch telescope was completed in 1908, Ritchey used the telescope to produce photo-

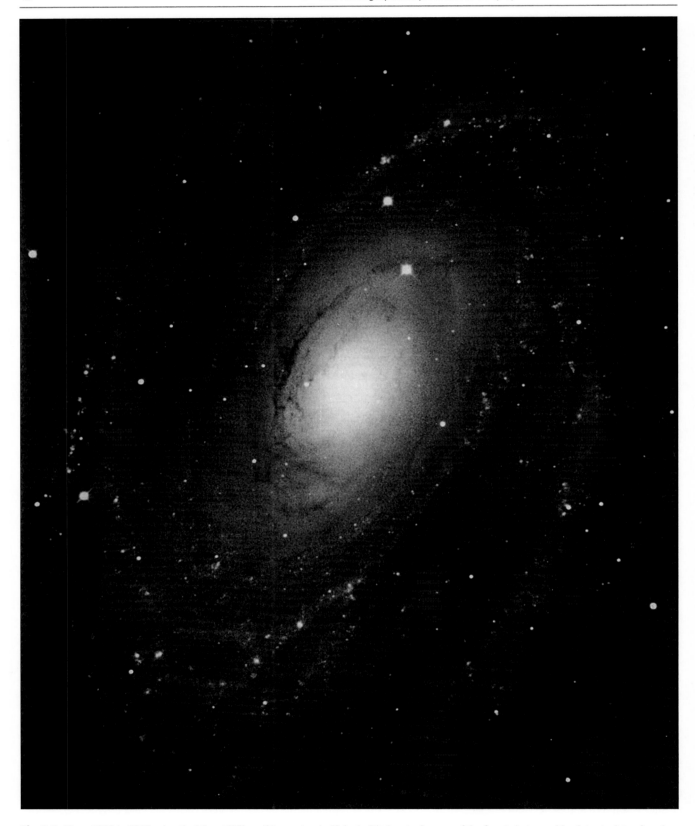

Fig. 3.8 From 1908 to 1917 using the Mount Wilson Observatory's 60-inch, Ritchey took some of the finest photographic plates to date of a selection of deep sky objects, surpassing all those made previously. Ritchey regarded this image of M81 taken in 1917 with the 60-inch as among his very best

graphic plates of deep sky objects surpassing any made prior to that time. These included many of the spiral nebulae that were later identified as external galaxies.

Following his work on the 60-inch instrument, Ritchey spent six additional years figuring the mirror for the legendary 100-inch (2.5 m) reflector at Mt. Wilson that saw first light in 1919.

Ritchey wanted the 100-inch to follow a design he co-invented with French astronomer Henri Chrétien called the Ritchey-Chrétien telescope, also known as an RC. The RC is a specialized Cassegrain telescope with hyperbolic primary and secondary mirrors designed to eliminate optical errors present in traditional reflecting telescope using parabolic shaped mirrors. These optical mistakes cause stars to appear elongated at the edges of the instrument's field of view. The Ritchey-Chrétien telescope produced photographs with circular stars across the entire image.

Ritchey proposed this novel design to George Hale for the 100-inch telescope on Mt. Wilson. But Hale declined because he did not want the 100-inch to be the first major RC telescope and he had concerns about its development costs while maintaining a flow of funds from one of the projects principal financial backers, John D. Hooker, for whom the instrument was named.

Ultimately, Hale removed Ritchey from responsibility for designing the 100-inch mirror and promoted the optician's assistant to oversee the project. Eventually, Ritchey was fired in late 1919 due to some careless criticism he privately expressed that got back to Hale about the quality of the 100-inch telescope. This critique was rooted in competitive jealousy of his former assistant and Ritchey's clash of egos with Hale. It is unfortunate to also mention that the animosity between Hale and Ritchey eventually clouded Hale's judgment when he decided the 200-inch Mt. Palomar telescope would not use the Ritchey-Chrétien design. Thus, the 200-inch was the last large traditional telescope.

When it was completed, the 100-inch Hooker telescope was considered an optical masterpiece. It was the largest telescope in the world and would retain that distinction for the next three decades. Images produced with the new Mt. Wilson behemoth, resolved Cepheid variable stars in the Andromeda galaxy M31, then referenced as a nebula and thought to be located within the Milky Way. Because Cepheid variables can be used to calculate great distances, these pictures provided Edwin Hubble with evidence the Andromeda nebula was actually a separate star system outside and millions of light-years distant from our own galaxy. Furthermore, this led astronomers to realize the Milky Way was only one of countless galaxies scattered throughout a universe more vast than anyone had previously suspected.

After being dismissed from Mt. Wilson, Ritchey continued to promote the Ritchey-Chrétien optical design. A .5 m demonstration telescope installed in France just over a decade later eventually caught the attention of US Naval Observatory which was in need of a new instrument. The 40-inch telescope that resulted became the first RC telescope placed into service and the last instrument Ritchey would produce before his death. Although completed in the late 1930s, its superb optical capabilities was not realized until the mid-1950s after the instrument was relocated from light polluted Washington DC to the dark skies near Flagstaff, Arizona. Since then, virtually all major research telescopes have used the Ritchey-Chrétien design including the Hubble Space Telescope.

Many of his ideas that seemed outrageous to his contemporaries are now accepted as necessary to obtain the greatest performance from large telescopes by the scientific community. Ritchey's inspiring vision and optimism were strongly expressed in his 1928 address to the Royal Astronomical Society: "[T]hese telescopes will reveal such mysteries and such riches of the universe as it has not entered the heart of man to conceive."

Measuring the Universe: Cepheids, Edwin Hubble, and the Standard Candle

The American astronomer, Edwin Hubble (1889–1953), is a transcendent figure in the history of astrophysics. His scientific contributions were epic achievements and through them our understanding about the universe was transformed. His new paradigm is a foundation of modern cosmology.

Prior to the 1920s our home galaxy, the Milky Way, was believed to represent the entire visible universe. Using the newly commissioned 100-inch (2.5 m) Hooker Telescope at Mount Wilson, Hubble identified Cepheid variable stars in the great Andromeda spiral nebula M31 between 1923 and 1924. The great Andromeda spiral, like other spiral nebulae, were thought to be located within the Milky Way but the period and brightness of Cepheid stars could be used to measure their distance from Earth. In 1924, Hubble's announced his discovery of these useful variable stars within M31 and used their immense distance to prove the Andromeda spiral nebula was a separate island universe, or galaxy, similar to but separate from the Milky Way.

In 1929, Hubble's made another equally monumental contribution to science when he recognized the redshift of light waves from other distant galaxies could only be explained if the universe was expanding in all directions causing the galaxies to rush away from each other. This became known as *Hubble's Law*. Hubble's discovery also provided supporting evidence for the *Big Bang* theory about the origin of the cosmos. Proposed in 1927 by Georges Lemaître, a Belgium Catholic priest,

astronomer, and physics professor, it had been rejected and forgotten by the scientific community but was revived in 1931 following Hubble's announcement.

The background for Hubble's initial work began with American astronomer Henrietta Swan Leavitt who, while working at the Harvard Observatory, discovered the period-luminosity relationship of Cepheid variable stars. This was later applied by Danish astronomer Ejnar Hertzsprung to calculate the distance of several Milky Way Cepheids.

Hubble's 1917 thesis dissertation *Photographic Investigations of Faint Nebulae* was a prelude to what would later become revolutionary contributions to science on par with those made by Copernicus and Galileo. He completed his Ph.D. at the Yerkes Observatory in Chicago, spent 2 years in Europe during the First World War then joined George Hale's staff at Mount Wilson Observatory in 1919. Hubble's arrival at Mount Wilson coincided with the completion of Hale's world renowned research instrument, the 100-inch (2.5 m) Hooker telescope, the largest astronomical instrument in the world at that time. The Hooker's immense aperture provided unprecedented extragalactic views that paved the way for a new understanding of the cosmos.

At that time the most pressing question in astronomy was the nature of spiral nebulae – were they small and located within the Milky Way or were they large, more distant island universes located outside our galaxy. The controversy culminated in a famous debate between American astronomers Harlow Shapley and Heber Curtis on April 26, 1920. Shapley, an accomplished researcher who was on the staff at Mount Wilson, believed the Milky Way was the entire universe. He supported his hypothesis using Henrietta Leavitt's Cepheid work to measure distances to known globular clusters. After several adjustments he concluded the Milky Way, and therefore the universe, was approximately 300,000 light-years in diameter, ten times larger than any previous estimate. On the other hand, Curtis proposed the Milky Way was smaller and located within a far vaster universe filled with other island universes. Unfortunately, neither proponent had sufficient information to support their argument. So the face-off was a draw.

As early as 1917 Hubble's dissertation unambiguously stated a visionary premise:

[T]he great spirals, with their enormous radial velocities, and insensible proper motions, apparently lay outside our star system (Milky Way).

The debate raged throughout the early 1920s. Then evidence finally arrived on photographic plates produced with the 100-inch (2.5 m) Hooker telescope.

In 1923 photography on the 100-inch was progressing rapidly. The photographer in charge, Milton Lasell Humason (1891–1972), began his career at Mount Wilson as a janitor. Despite lacking a formal education, he possessed a natural enthusiasm and inquisitiveness for the work conducted at the observatory. He impressed enough people with his resourcefulness and skills that he soon graduated to the title of assistant at the observatory. With encouragement and training from astronomer Victor Benioff, Humason was soon in charge of operating the major telescopes and using them to expose photographic plates. He and Hubble soon became a formidable research team.

With Humason's skill using the 100-inch, it was possible to identify Cepheid variables on the photographic plates. The first extra-galactic Cepheids were discovered by Hubble on plates of NGC 6822, an irregular galaxy located in the constellation of Sagittarius, made in July 1923. A few months later, a series of plates were then exposed of the Andromeda nebula M31, the largest spiral nebula in the sky.

On Plate Number 335 produced on the night of October 5, 1923, Hubble positively identified the first extra-galactic Cepheid variable in M31. He continued exposing plates of M31 over the next 5 months, constructing a light curve for what he called variable number 1. The light curve showed a period of 31.5 days and a magnitude variation of 1.2. From these values, and using Shapley's own calibration data, Hubble calculated M31 was a million light-years distant. Over the years, improvements made to the calibration data have resulted in the currently accepted distance of 2.5 million light-years.

On January 1, 1925, Hubble's results were announced to the world at a meeting of the American Astronomical Society. The monumental news was reported by the *New York Times*:

Finds spiral nebulae are stellar systems. Doctor Hubble confirms view that they are 'island universes' similar to our own.

After 1925, the worldwide astronomical community accepted all spiral nebulae represented independent island universes lying at vast distances outside the Milky Way.

The Expanding Universe: A New Paradigm of Cosmology

Although Hubble's 1925 announcement, that the Milky Way was only one of countless galaxies, redefined mankind's perception of the universe, he had one more scientific contribution, another great cosmological revelation, to make in his future.

During the second and third decades of the twentieth century, some scientists postulated the universe might be growing larger. For example, prior to 1917, Vesto Slipher, an American astronomer working at Lowell Observatory in Flagstaff, Arizona, measured the Doppler shift of spiral nebulae and confirmed several were moving away at very high speeds.

Fig. 3.9 (*Top*) Plate # 335 taken with the 100-inch telescope on the night of October 5, 1923. Originally marked "N" for Nova, later crossed out and replaced with "Var!" by Hubble upon realizing the discovery of a Cepheid in M31. (*Bottom*) Original light curve drawn by Hubble for "Variable No. 1 in Messier 31"

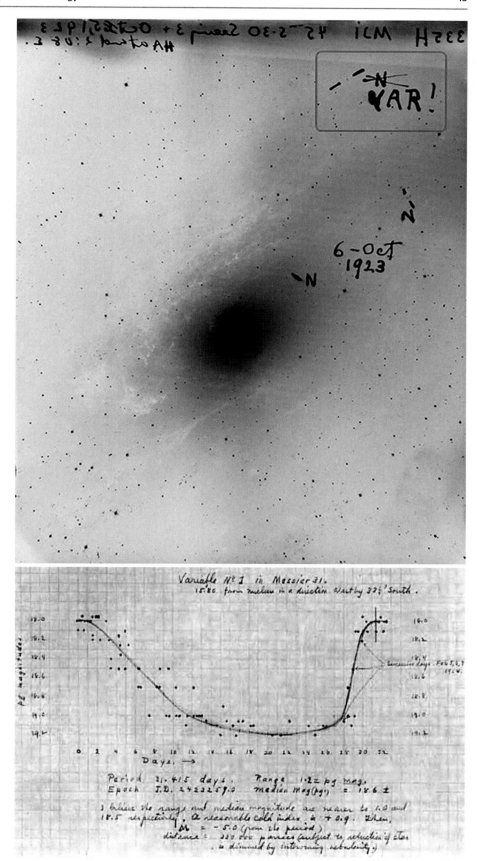

In 1917 Einstein published a paper that applied his theory of general relativity to the cosmos. Much to his consternations, he discovered his formulas indicated the universe should have already contracted. Because he knew of no observational evidence to suggest the universe was changing its size, Einstein added a *cosmological constant* to correct what he thought was an error. Thus, he forced his equations to match what he knew. Einstein would later regard the application of this unnecessary correction as the greatest mistake of his career.

In 1918, German astronomer Carl Wirtz observed a systematic red shift when observing spiral nebulae. In a 1922 paper he argued the red shift of distant spiral nebulae was more pronounced than closer ones. Wirtz concluded they were receding from Earth and the speed of their recession increased with their distance.

In 1927, the Belgium Jesuit astronomer and mathematician Georges Lemaître discovered solutions to Einstein's field equations of general relativity that described not a collapsed universe but a cosmos in expansion. Unbeknownst to Lemaître, Alexander Friedmann, a Russian physicist and mathematician, independently reached the same conclusion in 1922.

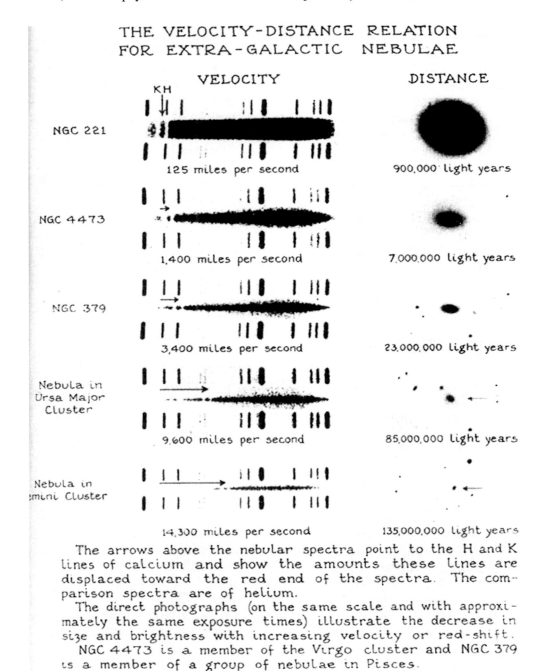

THE VELOCITY-DISTANCE RELATION
FOR EXTRA-GALACTIC NEBULAE

VELOCITY DISTANCE

NGC 221 125 miles per second 900,000 light years

NGC 4473 1,400 miles per second 7,000,000 light years

NGC 379 3,400 miles per second 23,000,000 light years

Nebula in
Ursa Major 9,600 miles per second 85,000,000 light years
Cluster

Nebula in
Gemini Cluster 14,300 miles per second 135,000,000 light years

The arrows above the nebular spectra point to the H and K lines of calcium and show the amounts these lines are displaced toward the red end of the spectra. The comparison spectra are of helium.

The direct photographs (on the same scale and with approximately the same exposure times) illustrate the decrease in size and brightness with increasing velocity or red-shift.

NGC 4473 is a member of the Virgo cluster and NGC 379 is a member of a group of nebulae in Pisces.

Fig. 3.10 Hubble's original redshift data using the 100-inch telescope and the original plotted velocity-distance graph. (*opposite page*) From *Realm of the Nebulae*, Edwin Hubble, 1936

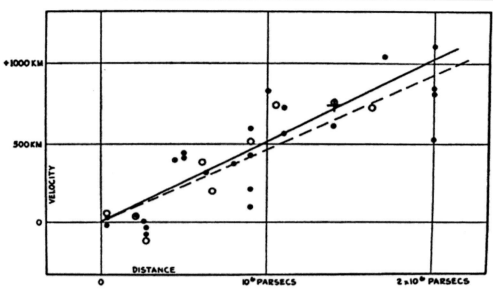

Fig. 3.10 (contiuned)

If the universe was growing larger, there must have been a time in the distant past when all matter in the cosmos was extremely compact, according to Lemaître . He referred to this compressed state as the *Primeval Atom* and proposed it exploded at the instant of creation in a paper published later that year. Lemaître's novel idea was derisively called the *Big Bang* by mid-twentieth century proponents of a steady state universe. Unfortunately, Albert Einstein refused to endorse Lemaître's theory when it was published and the scientific community ignored it. Therefore, Lemaître's proposal languished for several years without significant consideration until the early 1930s.

Observational evidence was needed to support these bold proposals.

Shortly after his arrival on Mt. Wilson in 1919, Hubble and his assistant, Milton Humason, began the arduous task of recording the velocities and spectra of all known spiral nebulae once again using plates recorded by the 100-inch (2.5 m) Hooker telescope.

By observing redshifts in the light wavelengths emitted spiral nebulae, Hubble realized they were moving away from each other at a rate constant with the distance between them. Hubble based his conclusions on both his observations and the work performed earlier by Vesto Slipher. This came to be known as Hubble's law. As a result, the speed of a galaxy's recession increases with its distance. This led Hubble to the unequivocal conclusion that the universe was growing larger.

Hubble formally published his findings in a 1929 landmark paper titled *A Relation between Distance and Radial Velocity among Extra-Galactic Nebulae.*

Hubble's calculations, based on the information of the late 1920s, gave a constant to the expansion of 50 km/second/Mpc (kilometers per second per mega parsec). This is known as the Hubble Constant. This value would be refined again and again during the next 80 years as information with greater precision became available. The currently accepted value is 67.8 km/second/Mpc as of March 21, 2013. Based on the Hubble constant, the age of the universe is now believed to be 13.798 billion years.

Hubble's scientific contributions were extraordinary. He discovered the true nature of spiral nebulae and proved the universe is expanding. His work in the 1920s resulted in a model of the universe 100 times larger than previously thought. It also represented the most profound change in mankind's view of the universe since the revelations of Copernicus 400 years earlier. Finally, it laid the foundation for the future of modern cosmology.

The Invention of the Schmidt Camera and the Birth of Deep Sky Surveys

Early photographic sky surveys were conducted with small refractors or portrait lenses configured into makeshift astrographs. These instruments sufficed at the time but all suffered from a variety of limitations. For example, slow f-ratios required very long exposure times and flawed optical designs resulted in distortion at the edge of the photographic plates. Deeper and more detailed sky surveys would require a radical departure from conventional telescope designs.

Bernhard Schmidt (1879–1935) was a German optician who was, without doubt, one of the great telescope innovators of the twentieth century. He designed many instruments, but his greatest achievement was the invention of the Schmidt camera – arguably one of the most revolutionary photographic telescopes ever designed.

Schmidt led a modest life and he was extremely gifted. His interest in optics, astronomy, and cameras began early. By the time he was a teenager he had already built several cameras. At age 15, he lost his right hand in an accident which likely contributed to his introspective, self-conscious and somewhat shy adult personality. Consequently he immersed himself in work throughout his entire life.

In 1900 Schmidt began experimenting with designing telescope optics and by 1903 he was designing high-quality telescope optics for scientific research and correcting the optics of existing research instruments. He began producing astrophotographs around this time. This was to become Schmidt's life's work. In 1904 he opened an optical workshop in Mittweida, Germany where he gained a widespread reputation for producing high precision mirrors over the next 10 years.

Schmidt suffered a significant setback with the arrival of WWI, spending time in an internment camp and having all his equipment confiscated. Life turned around for Schmidt in 1927 when he began working at the Hamburg Observatory under its director, Richard Schorr. It was during his time at Hamburg that Schmidt made the most important contribution of his lifetime; an invention that would revolutionize astrophotography.

Until the late 1920s, most telescope designs suffered from limited photographic field of views. The long focal length photographic refractors of the late nineteenth century could capture only one or two degrees of the sky- an area equivalent to a few full moons. Sky surveys using these telescopes required enormous time commitments that usually spanned several years Fast reflector telescopes, those with an f-ratio of 3 or less, could capture larger swaths of the sky but their focus was not consistent across the field of view resulting in a distortion called coma; stars in the middle of the field were sharp but they became increasing distorted based on their distance from the center. So, there was a strong scientific demand for an instrument that would make photographic sky surveys more efficient by producing wide field, sharp to the edge images without the need for extremely long exposures.

Schmidt began contemplating optical designs to answer these requirements in the late 1920s. By 1930 he hit upon the ultimate design. His telescope used a unique mirror design that corrected for astigmatism and coma by substituting the usual parabolic curvature of the primary mirror for a spherical one. He then eliminated the primary's spherical aberration by positioning a corrector plate at the front of the telescope. Essentially, the corrector was a curved lens with a convex center and concave edge. Schmidt's design produced a sharp, extremely wide image. This became the first catadioptric telescope; one that includes both mirrors and lenses.

The first Schmidt camera, or *Schmidtspiegel*, had an aperture of 17.3 inches, a focal length of 24.6 inches and an incredible focal ratio of f1.75. It captured an astonishing 16 degrees of the sky – enough to hold over 1,000 full moons. Schmidt's new invention caused a sensation around the world and soon revolutionized the field of sky survey photography.

Unfortunately, Bernhard Schmidt passed away in 1935, before his new optical design was spread among the world's great observatories. Less than a year after his death, the second Schmidt camera with an 18-inch aperture was completed and in use at the Mount Palomar Observatory. From 1945 to 1980 a total of eight Schmidt cameras, with apertures greater than 1 m, were in use around the world and employed in a variety of sky surveys. The largest Schmidt camera to date is the 2-m Schmidt telescope first installed at the Karl Schwarzschild Observatory and later moved to the Calar Alto Observatory in 1976.

Fig. 3.11 First light image taken in 1932 by Bernhard Schmidt using his prototype 17.3-inch f1.75 Schmidt camera. The photographic field of the first Schmidt camera was a remarkable 16 degrees with no distortion out to the edge. NGC 7000 was the first image captured by Schmidt with his revolutionary design, on September 25, 1932

The Universe in Color and the Transition to Electronic Imaging

4

The human eye and brain evolved the ability to distinguish small differences in the wavelengths of light reflected or emitted from objects. The human eye responds to light from around 400 to 700 nm, with peak sensitivity at 555 nm and can distinguish ten million distinct colors. The process of color vision begins with photoreceptor cells in the retina, known as cones, and concludes in the visual cortex of the brain with the perception of color. Among several accepted theories of color perception, the trichromatic theory explains color vision based on the retina's three types of cones, each preferentially sensitive to blue, green, or red light.

All celestial bodies possess some color. However the detection of color requires a physiologic threshold of light intensity that most astronomical objects fail to achieve. Therefore the celestial world seen through the telescope is mostly devoid of color even through the largest instruments. With the advent of astrophotography came the ability to amplify light from faint celestial sources and the potential to derive meaningful color information about them. Innovations in the photographic process would eventually succeed in recording the most subtle hues of astronomical structures that served to distinguish their chemical and physical properties as well as call attention to their remarkable natural beauty.

The original theory of three-color additive photography proposed by James Clerk Maxwell in 1861 provided the foundation for color emulsion photography and later tricolor electronic imaging. It would be almost a century after Maxwell's discovery for William C. Miller, a photographic engineer, to begin applying color photography to astronomical imaging using instruments at the Mount Palomar Observatory.

Miller's groundwork laid the foundation for another photographic innovator, David Malin. Malin, a photographic scientist and astronomer for the Anglo-Australian Observatory, expanded on Maxwell's technique of color separation photography to lift color astronomical imaging into the modern era. The seminal work of Miller and Malin set the stage for all future generations of astrophotographers to embrace astronomical color information for its immense scientific and aesthetic value.

The advent of the charge couple device, commonly called the CCD, fundamentally changed astrophotography. During the 1970s and 1980s commercial CCDs gradually replaced film as the preferred photographic medium used by professional astronomers. By the late 1980s CCDs became standard equipment at all professional observatories.

The 1990s saw the proliferation of commercially available low cost CCD cameras as well as budget conscious, high precision telescope equipment. The amateur astrophotography community welcomed in this new age and eagerly embraced the opportunity to photograph the night sky in ways never before imagined.

Advances in equipment were paralleled by the rapid evolution of powerful digital image processing techniques. What amateurs lacked in aperture and location they compensated with time, exposure length, and processing prowess. While professional astronomers had to compete for limited available time on a relatively small number of large instruments, the amateur had the freedom to devote enormous amounts of time to any project or task they deemed worthy.

Astrophotography has flourished in the hands of amateurs who have contributed in substantial ways both technically and creatively with the same passion and ingenuity the very first amateur innovators exhibited a century and half before.

© Springer International Publishing Switzerland 2015
R. Gendler, R.J. GaBany, *Breakthrough!: 100 Astronomical Images That Changed the World*,
DOI 10.1007/978-3-319-20973-9_4

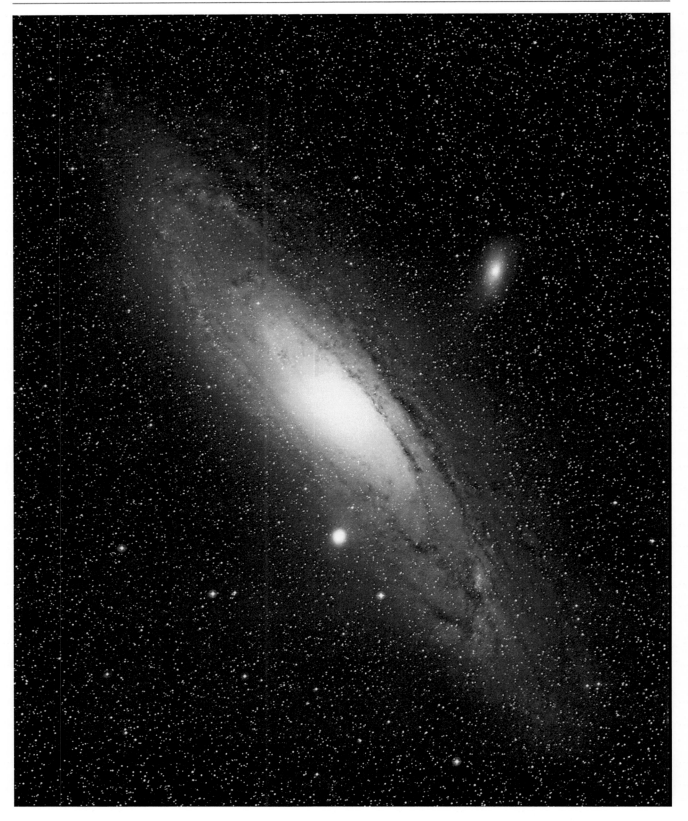

Fig. 4.1 This 120-minute exposure of M31 was made on August 11, 1958, using the Palomar 48-inch Schmidt telescope (now the Oschin Schmidt) by Mount Wilson and Palomar observatories' William C. Miller. Miller used the then revolutionary super ansco reversal film, which had a nominal speed of 100ASA. The image was digitally remastered by David Malin from the original plates made by Miller

The Birth of Color Astrophotography: The Colors of Andromeda

Throughout the 1920s deep space photography was becoming increasingly refined. Paramount to this progress were the two largest world-class research instruments of that time, the 60-inch (1.5 m) and 100-inch (2.5 m) Mount Wilson reflectors. By the late 1920s, however, these instruments had achieved their potential, and it was now time for a new generation of research telescopes to pioneer the next advancement wave in astronomy.

In 1928 George Ellery Hale received a $6 million "Rockefeller" grant to begin work on his next-generation research observatory and its premier instrument, a 200-inch (5 m) reflector. Unlike Mount Wilson Observatory, operated by the Carnegie Institution, the new observatory and its 200-inch reflector would be administered by the recently founded California Institute of Technology, also known as Caltech.

Hale passed away in 1938 and WW II further delayed the construction of the new observatory located on Palomar Mountain near Pasadena, California. So, Palomar Observatory and its premier 200-inch instrument weren't ready for first light until 1948. During the interim, funding was also found for another research instrument, the 48-inch (1.2 m) Samuel Oschin Schmidt telescope. Both the Oschin Schmidt and the 200-inch would represent the world's foremost research instruments for the next several decades.

During the 1950s numerous major research assignments were accepted by the Palomar Observatory. One project was the first trial of using color emulsion in astrophotography. This became the primary task of William C. Miller, a photographic engineer employed by the Mount Wilson and Palomar observatories from 1948 to 1975.

By the 1950s several companies were working on color emulsion films. As early as 1935 Kodak introduced KODACHROME, the first commercially successful color transparency film. In 1942 KODACOLOR was introduced. It was the world's first full-color negative film.

In the late 1950s Miller began to test color films on both the 48-inch Schmidt and the 200-inch telescopes. Miller chose to use Anscochrome, a color film made by Ansco, an American affiliate of the German company Agfa. Anscochrome was selected because it was relatively easy to process on site as opposed to Kodachrome, which required factory processing and several weeks of turn-around time.

After 2 years of extensive testing and modification Anscochrome was ready for long exposure imaging. Miller's tests made it possible to achieve a reliable color balance. On August 11, 1958, Miller exposed an image of the great Andromeda galaxy M31 using the 48-inch Schmidt camera at Palomar. This epic image represented several firsts. It was the first color corrected astronomical image recorded on color film and the first spiral galaxy photographed in full natural color. This was an extraordinary achievement and opened the door to increasingly sophisticated color astronomical photography in the coming decades and paved the way for the modern era of tricolor CCD imaging.

The Hues of Heaven

The first successful test images using color film on the Palomar instruments in 1958 produced not only the first color image of a galaxy, the Andromeda Galaxy M31 but also the first color photographs of nebulae.

The images, produced with Miller's Anscochrome color film, were published in a *Life* magazine article appearing in the April 1959 issue entitled "The Hues of Heaven." The article officially announced Miller's work as the very first color images of celestial objects. The images Miller produced using the 200-inch Hale telescope, as it was now named, and the 48-inch Samuel Oschin Schmidt telescope were enormous milestones in astrophotography. Prior to taking his set of color images, Miller spent 2 years optimizing the color film for long exposure photography and making sure the film would generate a color corrected image.

William C. Miller was a true pioneer in the field of astrophotography. Those practicing the craft today may not recognize the extent to which we are indebted to Miller for his early work in producing color corrected astronomical photographs. Miller was employed by the Mount Wilson and Palomar observatories from 1948 to 1975 as a photographic engineer. He originated or perfected many of the photographic techniques used by the large professional observatories of that time.

Like many astrophotographers before and after him, Miller had no formal training producing astronomical pictures. He had a diverse background in optics, physics, engineering, and astronomy and used these to develop and enhance astrophotographic techniques practiced at that time.

Miller did most of work using the 200-inch Hale and 48-inch Schmidt telescopes at the Mount Wilson and Palomar observatories. Specific contributions made by William C. Miller include the development of hyper-sensitizing, a process that baked an immersion of photographic emulsions in forming gas to make them more sensitive to low levels of light.

Miller's color image of the Ring Nebula M57 through the 200-inch was the first of its kind. Previously the colors of M57 could only be estimated from exposures using monochrome plates of different spectral sensitivities. For the first time a single photograph displayed the natural hues of a nebula produced by a dying sun-like star.

M57 is one of the best examples of a planetary nebula that exhibits the gaseous remains of a sun-like star entering its final stages of evolution. The intense radiation from the stellar remnant ionizes the star's previously ejected gases. The inner shell glows green from ionized oxygen and nitrogen, while hydrogen in the outer shell glows red. Where the two shells meet, a yellowish hue is produced. The blue stellar object in the center is a 15th magnitude planet-sized *white dwarf*. This is all that remains of the star that created the surrounding ring. Glowing at a temperature of over 100,000 degrees, the heat is generated by its incredible density rather than nuclear fission.

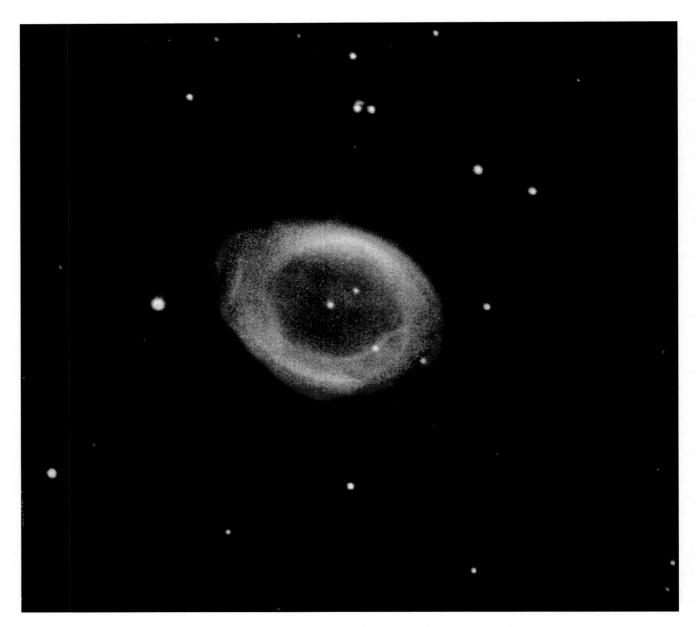

Fig. 4.2 The first color photograph of the Ring Nebula (M57) and one of the first of a nebula ever made using the 200-inch Hale telescope of the Mount Palomar Observatory, taken in 1958. The distinctive hues and their subtle transitions are apparent in this milestone image

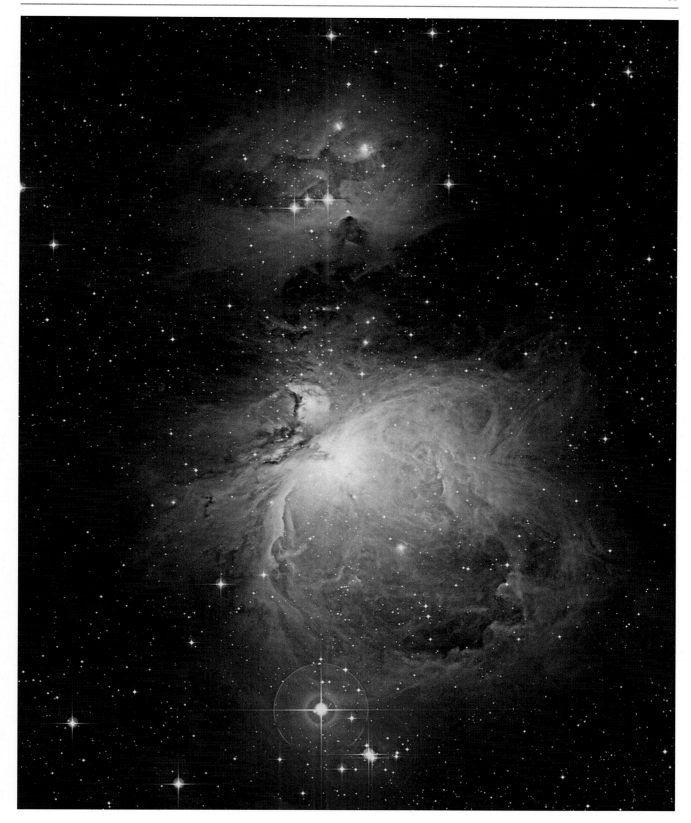

Fig. 4.3 This image of the Orion Nebula was made by David Malin using the UK Schmidt camera. The colors in the photograph are indicators of the chemical and physical processes occurring in the nebula. The most abundant element, hydrogen glows in a distinct red hue. Oxygen radiates green, and when its light is combined with hydrogen emission, it produces the subtle yellow hues in the nebula. Dust produces the bluish hues by reflecting the light of hot young stars imbedded in the cloud

David Malin and Three-Color Additive Photography

The first fledgling steps into color emulsion astrophotography by Bill Miller in the late 1950s were extraordinarily promising and provided a preview to a universe of spectacular hues that defines its chemical and physical processes and reveals its sublime beauty. In the late 1970s David Malin, a photographic scientist-astronomer with the Anglo-Australian Observatory, understood the scientific value of color astronomical photography and worked to advance the process using the technique of three-color additive photography.

The premise of the three color process was based on the work of James Clerk Maxwell in 1861. He demonstrated true-color images could be created by photographing a subject through red, blue, and yellow filters then recombining the filtered images into a single full color composite. It would take over a century before this method would be successfully applied to astrophotography.

Malin photographed the same field three times, each time using specific filters and emulsions to produce three separate monochrome negatives. Each negative would contain either the blue, green, or red information of the subject. The negatives were made into film positives and then projected using an enlarger, one after the other, through red, green, and blue filters onto a *receiving material* that finally recombined the color information in the original scene.

In addition to the process of combining color information, Malin made use of original techniques, such as multi-image addition and unsharp masking, to amplify subtle or faint astronomical information in his photographs. He also took great care to photographically color balance his images to insure that the colors were consistent and reliable representatives of reality.

After some initial experimentation, the results proved spectacular beyond his expectations. During his time at the Anglo-Australian Observatory, Malin produced a large collection of astoundingly beautiful and scientifically revealing color portraits using the 4-m (157-inch) Anglo-Australian telescope and the UK Schmidt telescope from 1975 to 2001. His color photographs remain timeless masterpieces and are still featured in books and astrophotography exhibits around the world.

David Malin's photographs have also contributed substantially to astronomical science. In Malin's own words:

> [I]n the visible part of the spectrum, a change in the proportions of light at different wavelengths is seen as a change in color, and color brings with it extra information that monochrome cannot.

One of Malin's iconic portraits, assembled with his three-color technique, reveals the magnificent colors of the Orion Nebula. This particular image, a triumph of his meticulous work, received tremendous recognition for decades.

Rediscovering the Horsehead

David Malin's color astrophotographs attracted worldwide attention for their astounding beauty and universal appeal. They were unlike any astronomical images of past eras because they revealed a universe of depth and filled with colors not apparent in the traditional grayscale photographs. Less well known but equally significant was the bounty of astronomical information found within Malin's pioneering photographic color plates.

Malin's three-color images of the field around the Horsehead Nebula produced with the UK Schmidt telescope and the Anglo-Australian Telescope (AAT) were the first highly detailed color images of this remarkable section of the sky. The Horsehead Nebula (also known as Barnard 33) is a dusty protrusion into a surrounding complex of emission and reflection nebulosity. The region also contains the reflection and emission flame-shaped cloud NGC 2024 and the reflection nebula NGC 2023. This field appeared in many grayscale photographs in past eras but never before like this, with its vast range of deep and vibrant hues seen for the first time in this most familiar object.

Close examination of Malin's plates revealed a host of objects and structures previously unknown in grayscale images, but now made visible by Malin's three-color process. Several small knots of glowing nebulosity known as Herbig-Haro objects were found at the base of the Horsehead and near the edge of NGC 2023. These small brightly glowing clouds are formed by the energetic outflows of low mass protostars hidden within thick clouds of dust. The outflows heat the surrounding ambient gas, which releases the newly acquired energy in the form of red light and make themselves visible as a series of delicate torches in the night. Herbig-Haro objects are found in areas of active star formation.

Using his technique of unsharp masking, Malin brought out another previously unseen phenomenon on the AAT plates. Within the reflection cloud NGC 2023 were filaments of red emission known as ERE (extended red emission).

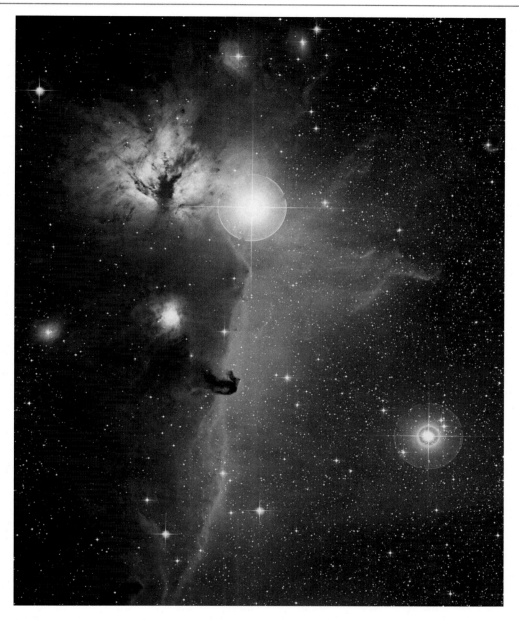

Fig. 4.4 The field of the Horsehead Nebula, including NGC 2024, NGC 2023, IC 434, by David Malin using the UK Schmidt telescope. The red filaments of the hydrogen emission cloud (IC 434) silhouette the conspicuous dark form of the Horsehead Nebula. Partially obscured by the light of the bright star Zeta Orionis, the flame-shaped cloud NGC 2024 is seen to its left. The blue emission nebula (NGC 2023) is below the Flame Nebula in this image. These magnificent objects all lie in the same field, making this one of the most photographed celestial scenes in astrophotography

Of Comets and Tails: The Spectacle of Hale-Bopp

Documenting new celestial events remains high on the list of activities and contributions by amateur astrophotographers. Of all new celestial events possibly the most dramatic is the appearance of a new comet in the sky. Because they have a bright and extended nature photographing comets has been an amateur endeavor well suited to the wider coverage of modest equipment such as camera lenses and short aperture telescopes.

Once thought to be "omens of doom," we now know comets represent icy Solar System bodies that release gas and dust into space. Most comets are thought to originate within either the Kuiper Belt of the inner Solar System or the Oort Cloud that lies outside the Sun's planetary family. Comets may orbit the Sun with a periodicity ranging from hundreds to even thousands of years. As they travel closer to the Sun the core or nucleus of the comet, primarily composed of water-ice along

with frozen ammonia, carbon dioxide, carbon monoxide, or methane, sublimates into gas and forms an atmosphere of rarefied material known as the *coma*. Solar radiation causes the coma to split into two extended tails; a dust tail of fine particles and a gaseous ion tail, both pointing away from the Sun.

Although many great comets have been observed and photographed in recent history, perhaps the most spectacular, resilient, and intriguing was the appearance of comet Hale-Bopp from 1995 to 1997. Discovered independently on July 23, 1995 by two American observers, Alan Hale and Thomas Bopp, the comet became the brightest and most observed comet of the twentieth century.

From the moment of its discovery Hale-Bopp showed great promise. However, if history has taught comet observers anything, it's that cautious optimism should rule because these interlopers have shown a tendency to be unpredictable and occasionally downright disappointing. That wasn't the case with Hale-Bopp which reached a spectacular perihelion during its closest approach to the Sun on April 1, 1997. As that date approached, the comet reached its visual pinnacle outshining any stellar object in the sky with the exception of the brightest star, Sirius. Its tail stretched over 45 degrees across the sky and the comet was easily seen in broad daylight. Hale-Bopp put on a magnificent performance for observers, photographers, and the general public whose attention and interest propelled the bright interloper to celebrity status.

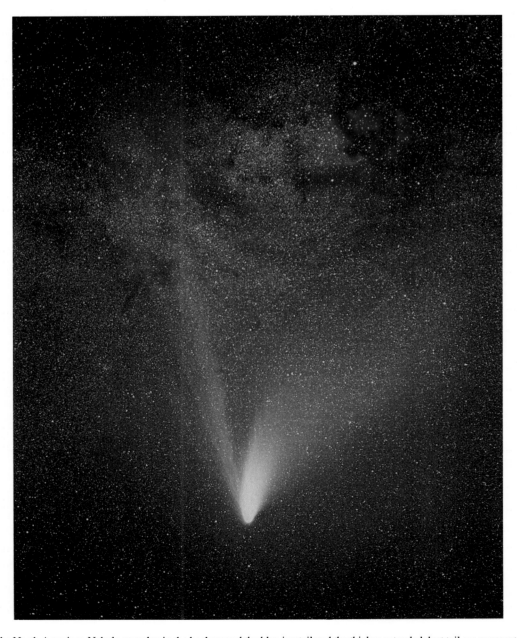

Fig. 4.5 With the North American Nebula complex in the background the blue ion tail and the thicker extended dust tail are apparent. Hale-Bopp put on a remarkable show while remaining visible to the naked eye for a record 18 months, twice as long as the previous record holder (the Comet of 1811)

Tony Hallas was determined to record the comet at its peak. Hallas was no stranger to the task, being one of the foremost film astrophotographers of his time. In those days Hallas produced most of his astrophotographs from the dark skies above Mount Pinos, north of Los Angeles. Using a Pentax 67 with a 105 mm f/2.8 lens and hyper-sensitized ASA 400 120 film, Hallas captured Hale-Bopp in a stunning composition as it passed alongside the popular North American Nebula NGC 7000. This timeless image is still a favorite whenever Hale-Bopp is mentioned.

Moving on from Film: The Arrival of Electronic Imaging

In 1969 the charged-couple device (CCD) was invented by Willard Boyle and George E. Smith of AT&T Bell Labs. It was initially conceived as a memory storage mechanism but Bell researchers realized its imaging potential and by 1971 were able to capture crude images with a simple linear CCD. This work caught the attention of several companies, including Fairchild

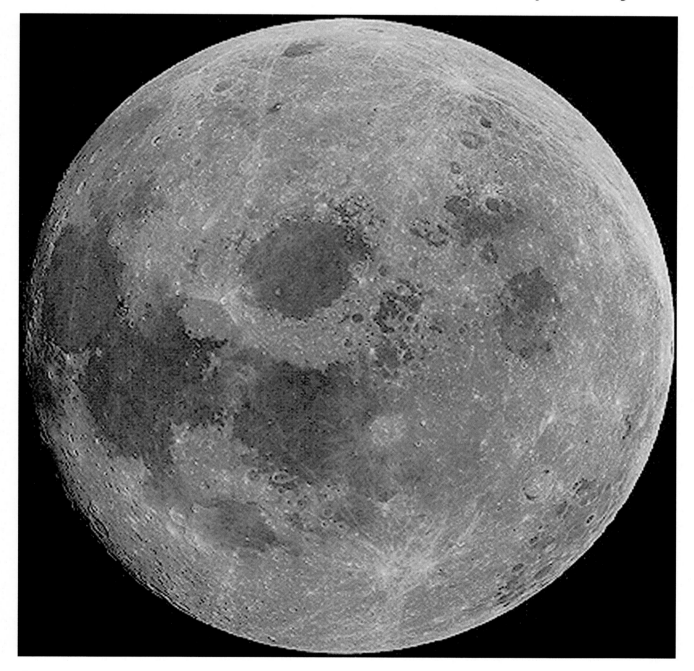

Fig. 4.6 This image of the Moon taken in 1974 was the very first CCD image of a celestial object. The 100 × 100 pixel CCD was made by the American company Fairchild Imaging. This milestone image bore remarkable similarity in its significance to John William Draper's first daguerreotype of the Moon accomplished 134 years before

Semiconductor, which picked up on the invention and began research and development programs to explore the vast potential of the CCD.

It quickly became apparent the CCD carried several inherent advantages over traditional photographic media including high sensitivity, high linearity, broad dynamic range and low noise plus the image signal could be amplified and modified using computer software.

In 1973, the American company named *Fairchild Imaging* developed its first commercial CCD. The primitive detector consisted of 100 × 100 pixels. It was used in 1974 to produce the first astronomical photo ever produced with a digital camera. This first astronomical CCD image was a picture of the full Moon captured through an 8-inch telescope. This imaging milestone bore a remarkable similarity to John William Draper's first daguerreotype of the Moon 134 years earlier. Similar to Draper's achievement, this one also heralded the birth of a new era. Electronic astronomical imaging had arrived and within two decades it would essentially replace the use of film emulsion for astrophotography.

The CCD quickly proved itself to be the ideal astronomical imaging device. Professional observatories saw its great potential as a medium to capture faint astronomical light sources. In 1979, the Kitt Peak National Observatory mounted a 320 × 512 pixel digital camera on their 1-m telescope and quickly demonstrated the superiority of CCDs over photographic plates.

By 1983 CCDs were becoming widespread among professional observatories around the world because these electronic sensors made it possible to record detailed images from celestial objects thousands of times fainter than anything recorded previously using even the most sensitive photographic plates. This was indeed a monumental transition in astronomical imaging. Today, digital detectors are an integral part of the standard equipment in all professional observatories.

The CCD Arrives: Extraordinary Imaging from Ordinary Places

At various times during the history of astrophotography amateurs have made extraordinary contributions. During the mid and late nineteenth centuries, when astrophotography was still a fledgling craft, it was amateurs who achieved the major milestones and overcame many of the technical obstacles. Then in the early twentieth century it was the professional observatories, with their powerful instruments, pristine locations, and unlimited resources, that pushed the envelope of progress.

With the introduction of the CCD the traditional barriers to effective imaging began to fall rapidly. By the 1990s the rapid proliferation of "off the shelf" low-budget CCD cameras falling into the hands of amateur astrophotographers began to level the playing field of performance between amateurs and professional observatories.

By the turn of the twenty-first century, advances in CCDs and amateur telescope design combined to add torque to amateur astrophotography. Advances in technology were paralleled by the rapid evolution of powerful digital image processing techniques. Amateurs could now effectively record some of the faintest objects from very ordinary dark sky locations. Their lack of large aperture instruments situated at world class mountain top imaging locations was compensated with enthusiasm, determination, patience and image processing ingenuity. While the professional had to fight for time on a limited number of available large professional instruments, the amateur had the freedom to devote enormous amounts of time to use their modest telescopes for any project or task they considered interesting.

As the new millennium dawned, a few amateurs began experimenting with very long exposures that spanned many hours. These prolonged imaging sessions coupled with newly mastered digital processing methods produced numerous novel and unexpected results.

For example, one of the first very deep images was a 50-hour multi-panel mosaic of the great Andromeda galaxy M31 produced by Robert Gendler beneath the light-polluted skies above Hartford, Connecticut that obscured any celestial object dimmer than magnitude 4.2. Although surpassed many times since, during the early 2000s it represented a new imaging level of achievement for an amateur using modest equipment from a poor observing location. The picture was a turning point in astrophotography and it inspired an emerging generation of amateur astrophotographers to probe deeper by taking longer exposures and to expect exhilarating results in return.

Although a modest achievement by current standards, it demonstrated that the extraordinary sensitivity of the CCD could, in effect, enable the light-gathering potential of a modest telescope to approach that of a much larger instrument. No longer was aperture an obstacle to quality imaging. From this point forward amateurs would continue to demonstrate the enormous potential of the CCD by pushing its performance envelope further and further.

As astrophotography entered the twenty-first century, amateurs and their mastery of digital image processing helped bridge the gap between astrophotography as an art form and a science. Astrophotography entered a new era where the production of true astrophotographic works of art became possible and in this context amateurs led the way. Advancements in digital processing techniques and imaging strategies would be the shining achievement of amateur astrophotography during this era of rapid advancement.

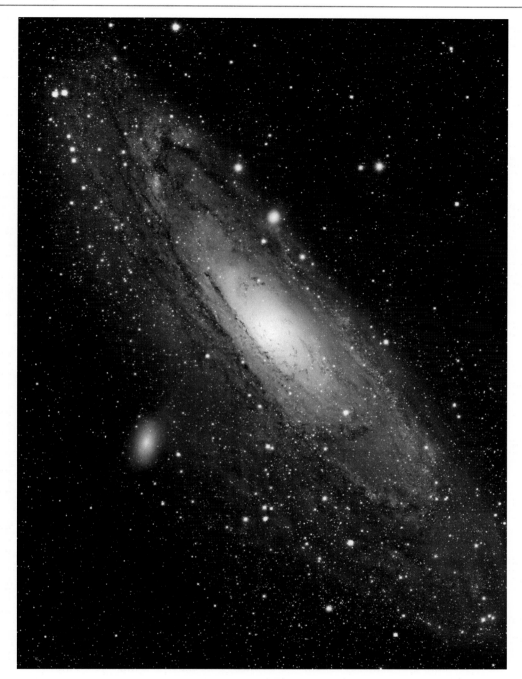

Fig. 4.7 This deep image of M31 was remarkable at the time for its depth and color despite being recorded under considerably light-polluted skies (magnitude 4.2). Fifty hours of exposure with a 12.5-inch telescope, an off the shelf CCD camera, and modern image processing tools made possible a result not previously attainable in the pre-CCD era

An Unexpected Discovery

Beginning in the 1990s digital astrophotography experienced a global surge as the amateur CCD market placed low cost, high quality CCD cameras into the hands of imagers eager to use them. As non-professionals, the ever growing ranks of amateur astro-imagers enjoyed the freedom to use their equipment for a range of purposes, from furthering science to simply recording the beauty of the night sky. A few used their new electronic cameras to make highly significant discoveries, too.

On the night of January 23, 2004, Julian (Jay) W. McNeil, an amateur astrophotographer from Paducah, Kentucky, was using his CCD camera and small 76 mm aperture refractor to explore the dense clouds in Orion near the large reflection

nebula known as M78. He took a series of unfiltered exposures and while examining the results a few days later discovered a compact bright nebula where none had existed in images going back four decades.

Jay quickly relayed his findings to the professional astronomy community and within 48 hours professional astronomers from the University of Hawaii and the Gemini Observatory on Mauna Kea, Hawaii acquired image data at different wavelengths to investigate the new nebula. Dr. Bo Reipurth from the University of Hawaii, one of the world's leading researchers in the area of early stellar evolution, was able to use the higher resolution images obtained with the larger telescopes to clarify the nature of McNeil's new nebula.

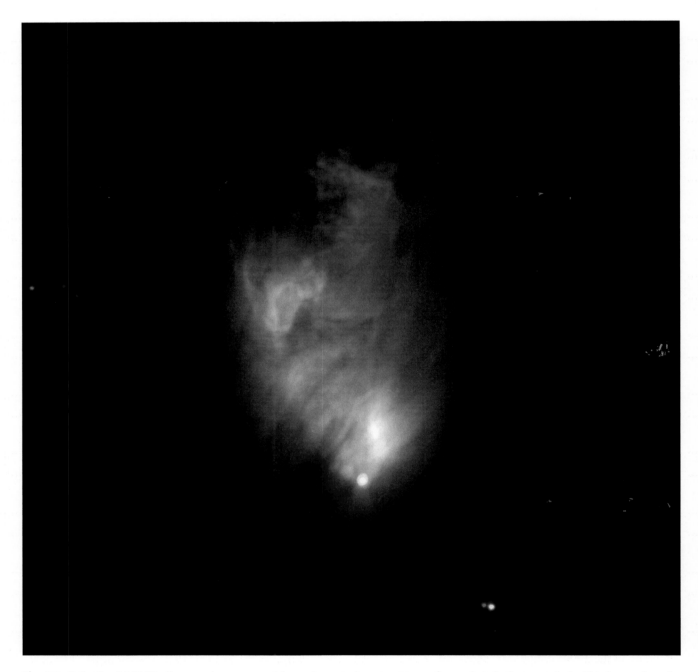

Fig. 4.8 Following McNeil's discovery image, several large observatories set out to confirm and study the new nebula. This image, from the Frederick C. Gillett Gemini Telescope in Hawaii, shows the nebula and its illuminating star V1647 Orionis as it appeared on Feb. 14, 2004 (Credit: Gemini Observatory)

The nebula represented a recent energetic outburst from a deeply imbedded protostar previously only visible in the infrared and radio part of the spectrum. Protostars are known to experience outflows of energy as they accrete matter and approach the main sequence. The new nebula was an outflow of energy partially converted to light, which was then reflected from surrounding dust cloud in the vicinity.

As more data became available the significance of McNeil's discovery became apparent. The new nebula was known as a cometary reflection nebula, of which only about a dozen are known. The nebula is illuminated by the young star V1647 Orionis, located 1,300 light-years away in Orion's dense star-forming nursery.

Recent investigations at X-ray wavelengths by NASA's Chandra X-ray Observatory and Japan's Suzaku satellite discovered the infant star rotates once per day, spinning 30 times faster than our Sun, and brightens 100 fold during its eruptions. After erupting in 2004 the star became quiescent by 2006. In 2008 it erupted again and has remained bright up to the date of this publication.

The young star and its nebula continue to provide astronomers with valuable information about star formation. Although a serendipitous finding by an amateur astrophotographer, McNeil's discovery advanced our knowledge of stellar evolution and remains a highly significant contribution in the modern age of astronomy.

The Photopic Sky Survey

Probably the greatest asset of the modern amateur astrophotographer is time. Despite being equipped with the latest electronic imaging technology and image processing software, the limiting factor for the most ambitious imaging project is the clock.

Nick Risinger, a 28-year old Seattle native and marketing executive, understood this more than most amateurs. Determined to create a dramatic 360 degree all-sky panorama in true color, Nick left his job and set out in March 2010 to spend a full year traveling around the western United States and South Africa pursuing his dream. He sought out the darkest locations to obtain the 37,440 images he later assembled into the first true-color all-sky image.

Risinger long had a fascination with elaborate sky surveys, particularly the ambitious professional investigations of the past such as the Palomar and Sloan projects that generated the immensely popular Digitized Sky Survey (DSS). He also understood the limitations of previous amateur full color all-sky surveys in terms of exposure, color, resolution, and coverage.

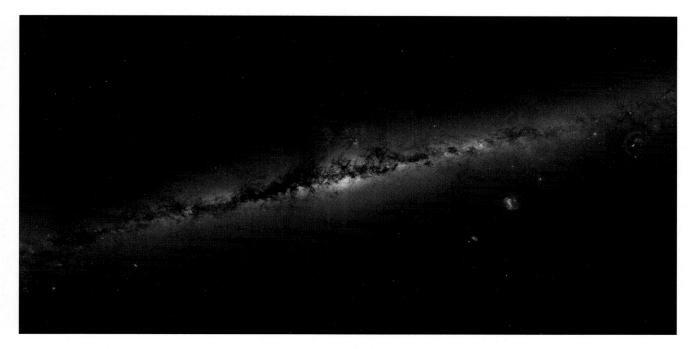

Fig. 4.9 Risinger's epic image is the culmination of a year spent capturing the sky from both northern and southern hemisphere locations, and then months of processing the 37,440 individual frames into a true color, spatially corrected, all sky view of our galaxy

Risinger conceived his project with the intention of providing three color band passes of the entire northern and southern skies for the first time. He decided this was the best way to capture the full range of hues exhibited by our galaxy. To accomplish his goal in a reasonable time period Risinger constructed an array of six telephoto lens and attached each one to a cooled CCD camera and filter assembly. Most of the northern sky was imaged from dark desert locations in Arizona, Texas, Oregon, Colorado, California and Nevada. He then imaged the southern sky during two trips to South Africa.

The execution of such a daunting and ambitious project required meticulous planning. Risinger had the help of his father during many of the sessions. Together they developed an efficient plan that broke the sky into 624 areas, each 12 degrees wide, then they produced about 60 exposures of each section. Different length exposures were obtained for each area using the six-camera array to control noise, capture extremes of dynamic range, compensate for satellite trails and other technical mishaps.

Once the arduous task of recording two hemisphere's worth of all sky data had been completed, the next step of assembling the behemoth image began. The latter half of the project commenced in January 2011 and carried its own special demands, including the need for 4 terabytes of computer storage. Special software was required to stack, register, and align the data as well as correct the inherent distortion introduced by the camera lenses. After 3 months of data crunching, Risinger completed his dream image about 1 year after the project started. The result was a magnificent true-color panorama of the entire sky captured in a 5,000-megapixel mosaic picture that included our home galaxy from end to end.

This exquisitely planned, perfectly executed and expertly processed image, called *The Photopic Sky Survey*, received abundant and well deserved recognition in the world wide press. Nick had this to say about the project:

> *The purpose of this project is to show the big puzzle….it's the forest-for-the-trees concept….this is more to appreciate the forest.*

Fossils from an Earlier Universe

Today's advanced amateurs enjoy a range of technical resources unparalleled in the long history of amateur astronomy. Together with modern Internet communication these resources provide a tremendous sense of freedom for amateur astronomers to use their equipment and time to pursue a diverse range of worthy imaging projects. A few of these projects have produced remarkable dividends, altering our understanding of important cosmic phenomenon.

R. Jay GaBany became a key contributor in a collaboration that combined the time and dedication of an amateur deep sky imager with the knowledge and resources of a professional astronomer team. Together they hoped to elucidate an important phenomenon of galaxy evolution. Jay was well known for his prodigious image processing skills and in particular his ability to extract faint large scale structures from his exposures. Jay's talents captured the attention of Heidelberg University astronomer David Martinez-Delgado, who understood the untapped potential of enlisting the skills of experienced deep sky amateur astrophotographers.

Working with the professional team assembled by Martinez-Delgado, Jay focused his telescope, CCD camera and image-processing expertise on the task of identifying faint and extended stellar tidal streams within the halo of distant galaxies. Martinez-Delgado hypothesized the detection of faint tidal star streams, thought to be present within the halos of most nearby galaxies, would represent fossil proof of remote accretion events that likely contributed to hierarchical galaxy evolution in the distant past.

The prototypical galaxy was NGC 5907. Jay went to work taking very long exposures of the galaxy from his private remote observatory. Jay's meticulous processing of the large cache of data he obtained confirmed the presence of complex arcing loops of tidal debris within the galaxy's halo. N-body simulations provided highly suggestive evidence that the tidal features observed in NGC 5907 could be explained by a single accretion event, likely the consumption of a dwarf galaxy by the host galaxy in the remote past.

Jay's collaborative work with Martinez-Delgado's team on NGC 5907 and a number of other similar galaxies provided excellent observational evidence supporting the idea the halos of spiral galaxies in the local universe still contain a significant number of galactic fossils from past eras of hierarchical formation. Jay's work earned him the recognition of the professional astronomical community when he received the Chambliss Amateur Achievement Award given by the American Astronomical Society in 2010. Jay was also coauthor on a number of peer-reviewed papers reporting the team's findings.

Fig. 4.10 Jay's extraordinarily deep color image required over 11 hours of imaging from June to August 2006. The faint arcing structures extending more than 150,000 light-years from the narrow, edge-on spiral represent signal barely above the background. The faint signal was successfully brought out in the image by Jay with skillfully applied state of the art image processing techniques. The structures are believed to represent the fossil remains of a tidal disruption of a dwarf galaxy by the host galaxy in the far distant past, possibly as long as several billion years ago

Einstein's Cross (A Cosmic Mirage)

Einstein's Cross is perhaps the most famous of all cosmic mirages. The cross-shaped configuration is tiny and spans only 1.6 arcseconds. For comparison, the Moon is 1,800 arcseconds in diameter making the width of Einstien's cross equal to observing a 2.2 km diameter lunar crater from Earth.

The cross displays four views of a single extremely distant celestial source known as a quasar.

The multiple images are one of the most famous examples of gravitational lensing by a foreground galaxy. The effect was predicted by Albert Einstein as a consequence of his theory of general relativity. His theory proposed if a concentration of matter, such as a massive galaxy or a group of galaxies, is positioned between a more distant object and an observer, the mass of the intervening object will create a gravitational lens capable of bending light from the more distant source as it travels to the observer.

Quasars, or quasi-stellar radio sources, are among the most luminous, powerful and energetic objects known in the universe. In most optical images, quasars appear as a single point of light indistinguishable from stars except for their peculiar spectra. Today astronomers believe that quasars represent the highly energetic cores of remote *active* galaxies that existed in the early universe. Quasars can radiate up to 1,000 times the light of a normal spiral galaxy such as the Milky Way.

The quasar's central engine mechanism is believed to be accretion of material into a supermassive black hole, similar to what powers its less energetic cousins existing in the present day universe such as the Seyfert and radio galaxies. Similar to their present-day cousins, quasars often exhibit powerful jets and lobes arising from their nucleus. Most quasars are found in the remote universe at very high redshifts between 0.056 and 7.085 and at distances on the order of billions of light-years, leading us to believe they were much more common during an earlier epoch of our universe. It is likely quasars represent an earlier stage in galactic evolution that no longer exists today.

The multiple images in the Einstein Cross are caused by the gravity of a massive galaxy located between Earth and the quasar. Because bending is not necessarily symmetric, it is not uncommon for observers to see multiple images or distorted images of the same more distant object. If the lens is in direct alignment with the object and observer, the mirage will form an Einstein ring. When alignment is not perfect two or more images can form. As the mass of the lensing object becomes greater the separation of the multiple images or the diameter of the ring increases. The mass of the lens can therefore be determined by the characteristics of the mirage.

The main light source in Einstein's Cross is the incredibly distant quasar Q2237+0305, located approximately 8 billion light-years away, whereas the foreground-lensing galaxy PGC 69457 is ten times closer. The lensing galaxy's gravitational field bends and magnifies the quasar's light and splits it into four separate symmetrical views. The less distant lensing galaxy, PGC 69457 is also known as Huchra's lens, after the American astronomer John Peter Huchra who discovered the phenomenon in 1985.

There are other examples of gravitational lensing, but what makes Einstein's Cross so special is the near-perfect alignment of the foreground galaxy and the much more distant quasar. This near perfect in-line situation causes the foreground galaxy to fracture the ancient light of the quasar into four perfectly symmetric ghostly views. In addition to splitting the light source of the quasar, the gravity of the foreground lensing galaxy also magnifies the light of the quasar considerably.

As observed with other quasars the light source of Einstein's Cross undergoes color and brightness variations within a time scale of only a day or so. Quasar luminosities are variable, with time scales that range from months to hours. We know quasars generate and emit their energy from very small regions. Enormous energy outbursts from such a small region requires a power source with great efficiency, one that can only be explained by matter falling inward toward a massive black hole.

Gravitational lensing is remarkably useful to cosmologists. For example, they provide one of the only tools to indirectly measure dark matter. Gravitational lensing is directly sensitive to the amount and distribution of dark matter. So, they have helped astronomers calculate the quantity of dark matter in the universe.

Fig. 4.11 This image of the Einstein Cross was taken by the 3.5 m WIYN telescope, on the night of October 4, 1999. The four symmetric blue light sources represent the same distant quasar Q2237+0305, whose light has been split by the much closer but more extended light source, the lensing galaxy PGC 69457

The Hubble Telescope and the Era of Satellite Observatories

5

Although not the first satellite observatory in space, the Hubble Space Telescope, also known as HST or Hubble, is by far the most versatile and the only one designed to be upgraded and serviced in space. Planned as early as the 1970s it was finally launched into orbit in April 1990. The project represented an ambitious vision of NASA with the objective of accomplishing a wide range of scientific goals. Not the least of its goals was to stimulate the public's awareness of astronomy by producing images of the universe having unprecedented aesthetic beauty in addition to extraordinary informational content.

Although it carried the hopes and dreams of astronomers its early years were not without problems. A serious optical flaw in the primary mirror placed the entire project in jeopardy. The very first servicing mission in January 1994 became a pivotal event to restore public confidence in Hubble by successfully correcting its flawed optics. The mission was a complete success. Four additional servicing missions enabled astronauts to equip HST with new and upgraded instruments. The last visit to the telescope took place in 2009.

The years have seen the Hubble Space Telescope not only fulfill its original mission but profoundly change the history of science. Since its launch in 1990, it has made over a million observations, photographed more than 38,000 celestial targets and contributed to 11,000 scientific papers making it one of the most productive scientific instruments ever built. The HST's accomplishments as an orbiting optical telescope have generated the most significant advances in astronomy since the revolutionary work of Galileo, Newton, and the telescope's own namesake, Edwin Hubble.

Many monumental images have been produced by the Hubble Space Telescope, yet a subset of pictures exists that are so provocative or so pioneering in their informational content they stand alone in their significance and deserve special recognition as timeless works of science and art.

The Plasma Jet of M87

M87 is the most dominant and massive galaxy in the Virgo cluster, a group of between 1,300 and 2,000 galaxies. This powerful elliptical galaxy of over 1 trillion stars is enormous by all galactic standards. Located over 52 million light-years from Earth, M87 is over one million light-years in diameter and surrounded by thousands of globular clusters visible in deep images as fuzzy dots. Impressively, M87 is responsible for much of the energy output of the entire Virgo cluster through its release of X-ray and radio wave emissions. The massive elliptical galaxy is probably best known as the famous giant radio galaxy with a unidirectional jet extending about 6,500 light-years from its nucleus. The jet is highly visible in both amateur and professional images and at multiple wavelengths, including radio, optical, and X-rays.

The first observation of M87's nuclear jet was made in 1918 from photographs exposed at the Lick Observatory. Described at the time as *a curious straight ray*, its importance wasn't known until much later when M87 was found to coincide with the radio source Virgo A. It then became evident that many galaxies with active galactic nuclei such as Seyferts, quasars and radio galaxies often exhibit jet phenomenon similar to M87 where giant plumes of plasma are ejected from the nucleus. However, the jet of M87 has special significance because no other jet yet observed has emissions even remotely as bright as M87. The jet powers enormous radio lobes several times the optical size of the galaxy. For a long time the central engine responsible for this peculiar energy emission remained a mystery.

© Springer International Publishing Switzerland 2015
R. Gendler, R.J. GaBany, *Breakthrough!: 100 Astronomical Images That Changed the World*,
DOI 10.1007/978-3-319-20973-9_5

The Hubble Space Telescope provided the highest resolution images to date of the jet at optical wavelengths in a series of images released in January 1992. These observations helped elucidate the dynamic nature of the jet phenomenon. The detailed images of the jet and central region of the galaxy, where stellar density is at least 300 times greater than expected, has provided some of the first direct evidence for one of the most massive black holes known. Due to extreme gravitational

Fig. 5.1 The immense plasma jet of M87 was imaged by the Hubble Space Telescope in February 1998, with the WFPC2 detector through visible light broadband filters. The image covers a span of about 7,500 light-years and captures the visible light emission of the jet. Although substantially larger at radio wavelengths the visible light emission is produced by synchrotron radiation, which gives it its bluish hues. M87's jet is likely fueled by a supermassive black hole at its center

forces centrally located stars are gradually pulled further towards the center of the galaxy and into tight orbits around the supermassive black hole located there. Under gravitational pressure the core of the galaxy continually collapses inward thus creating an extremely high density of stars near the center. Some of these stars will eventually be consumed by the black hole, fueling its growth and providing energy to power the enormous plasma jet at M87's core.

Evidence from Hubble and other sources point to a likely sequence of events occurring at M87's center. The famous plasma jet arises from a rotating disk of stars and material known as an accretion disk that gives up mass to feed one of the most supermassive black holes known in the universe. Approximately the diameter of our solar system, this supermassive black hole has a total mass greater than 3 billion suns. The accretion disk spans almost half a light-year in diameter and rotates at 1,000 km/second. As material falls into the supermassive black hole mass is converted to energy. The plasma jet is produced as heated gases are pulled away and propelled from the black hole in the form of a narrow well collimated beam. The light we see and the radio emissions we detect arise from high energy electrons that spiral around the jet's strong magnetic field. This produces a specific form of energy known as synchrotron radiation, a type of radiation generated by high-speed charged particles accelerated in a magnetic field.

Bright knots within the jet, some as large as 10 light-years across, are thought to represent regions where the electrons are accelerated to even higher energies. The dynamic nature of M87's plasma jet was revealed by the Chandra X-ray Observatory and Hubble in 2005. These observations captured an outburst of energy from a knot known as HST-1.

Proplyds of M42

HII regions within the spiral arms of galaxies serve as celestial recycling stations where the birth of new stars completes a great cycle by creating and converting matter. With a gaseous repository of 10,000 suns, and illuminated by a cluster of hot young stars, the clouds of the Great Orion Nebula M42 glow with fantastic colors and shapes making it the most photographed object in astronomical history and providing a bird's eye view into one of the greatest star-forming nurseries in our part of the galaxy.

In 1992 the Hubble Space Telescope began producing high resolution images of previously known compact sources within the Orion Nebula. These areas were located close to a tight grouping of new, bright stars that illuminate M42 known as the *Trapezium*. As early as 1979 ground-based telescopes had produced images of compact ionized sources within the clouds, but they were thought to represent a different type of object known as partially ionized globules, or PIGs, comprised of gas and dust similar to those found in other star-forming clouds.

Hubble observations beginning in 1992 further resolved and characterized the enigmatic compact objects and offered a novel explanation about their nature. Of the 50 compact objects initially observed by HST most were not globules. They are something much more noteworthy; a cocoon of primordial material surrounding an infant star known as a protoplanetary disk or proplyd. Up to that time only four known proplyds had been identified using ground based instruments.

Proplyds of gas and dust are now believed to form around most embryonic stars as they evolve towards the main sequence. The process of star birth begins when a portion of a molecular cloud reaches a critical mass and begins to collapse under its own gravity. As the collapsing cloud, known as a solar nebula, becomes increasingly dense its angular momentum causes the rotational velocity of the cloud to increase as the size of the nebula decreases. The increasing rotation causes the cloud to flatten into a disk, much like a pizza or Frisbee, over a period of up to 100,000 years and at its center, a new star starts to form. As the central star matures and its nuclear furnace awakens, the residual protoplanetary disk gives rise to a solar system of planetary bodies. Our own Sun and Solar System formed in this way some 4.8 billion years ago.

The M42 proplyds imaged by the HST fall into two categories based on appearance. Those near the hot ionizing Trapezium star named Theta 1 C have their outer shells excited by the star's powerful ultraviolet radiation and therefore shine brightly in visible light. Those unfortunate proplyds located even closer to Theta 1 C bear the full fury of its radiation, which causes evaporation of the disk thus forming a characteristic cometary configuration. The proplyds located further away from the Theta 1 C are not subject to the harsh radiation and are detected as a dark silhouette against the background of the bright nebula. Some proplyds have outflows of jets of matter and various sculpted features due to shockwaves formed from the stellar winds of nearby massive stars. The brighter proplyds typically possess a glowing cusp of excited material that faces the ionizing star. Depending on their orientation within the nebula, some proplyds appear edge-on, and others appear face-on.

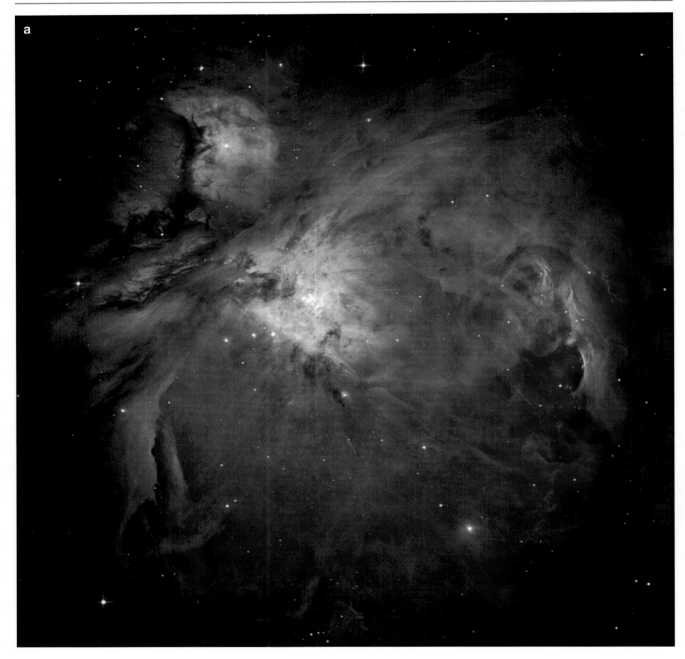

Fig. 5.2 (**a**) This grand mosaic of M42 was released by the Hubble Space Telescope Orion Treasury Project. 520 Hubble images, taken in five colors by the Advanced Camera for Surveys from October 2004 to April 2005 were assembled together along with elements of ground-based data to create the final glorious composition. (**b**) A selection of a variety of proplyds (protoplanetary disks) in higher resolution from the image representing the most detailed views ever of the progenitors of future solar systems

Fig. 5.2 (continued)

The Eta Carinae Homunculus

A bright photogenic patch of the southern Milky Way holds one of the most enigmatic and exotic stars known. Eta Carinae is the centerpiece and ionizing star of the great HII region, the Eta Carinae Nebula. The nebula spans about 260 light-years and is about 7 times the size of the great Orion Nebula 42.

Referring to Eta Carinae as massive might be an understatement because the great star weighs in at some 100 to 150 solar masses and shines with the light output of around five million Suns. As one of the most massive stars known, Eta Carinae pushes the theoretical limits of stellar energy output thus it has attracted much interest among astronomers investigating the physics of super-massive stars. This young supergiant star is only 2 to 3 million years old yet it pumps out as much energy in 6 seconds as our Sun does in an entire year. Its prodigious stellar wind releases the equivalent mass of Jupiter each year, exceeding our Sun's yearly mass loss 100 billion fold.

Eta Carinae is well known as an extremely variable star. Normally the star appears to shine just at the threshold of normal vision when viewed from a dark non-light polluted sky, about sixth-magnitude. But in 1843, it became much brighter and reached visual magnitude −1. This temporarily made it the second brightest star in the night sky; only Sirius was more brilliant. During the 1843 outburst, and presumably during earlier unrecorded outbursts, Eta Carinae expelled an enormous

amount of gas into its surrounding interstellar medium. This material can be observed in ground-based telescopes as a small oblong nebula slowly expanding away from the star.

The nebular shell of gas and dust partially released in the 1843 eruption is known as the *homunculus*, which is Latin for *little man*. The term was given to the expanding shell in 1950 by the Argentine astrophysicist Enrique Gaviola because its appearance suggests appendages that vaguely resemble a head and feet. The large bi-lobed homunculus has a mass of about 10–15 Suns, almost extends for a light-year and continues to expand into space at about 1.5 million miles per hour.

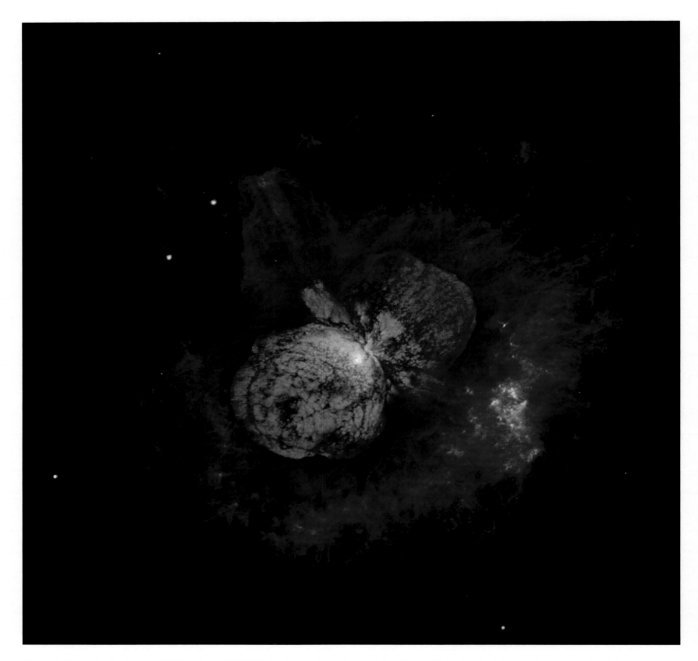

Fig. 5.3 Taken in September 1995 with the WFPC2, the image shows in great detail the bi-lobed material and thin equatorial disk that surrounds the powerful and unstable star Eta Carinae. Much of the material (known as the Homunculus) was thought to have been released during a giant outburst about 150 years ago (during the 1843 eruption). At over 100 times the mass of our Sun Eta Carinae is one of the most massive stars in the Milky Way

Astronomers believed Eta Carinae exploded during the 1843 event. However, ground-based infrared images exposed in 1969 not only revealed the star's continued presence but confirmed its prodigious light output. Remarkably, if it were not cloaked within an expanding shell of dusty stellar ejecta, it would outshine all objects in our sky except the Sun and Moon.

The stars explosive variability has been studied extensively. Incredibly, during 300 years of observations the stars brightness has fluctuated wildly from magnitude −0.7 to magnitude 7.6. Its variability has a periodicity of approximately 5.5 years. In a 2005 investigation, researchers described Eta as a binary star paired with another supergiant of some 30–60 solar masses. Every 5.5 years the two supergiant stars approach to within 2 or 3 astronomical units. This allows their powerful stellar winds to collide thus producing an enormous outflow of light and radiation.

From 1991 to 1996 the Hubble Space Telescope recorded the highest resolution images ever produced of the Eta Carinae homunculus. The images revealed several surprises that redefined some of the extreme phenomenon occurring in the mysterious star. For example, the Hubble observations discovered a well-collimated set of parallel jets exiting the northeast portion of the central homunculus complex. The jet's rippling structure suggested wave phenomenon in the flow of material away from the star. HST pictures have also indicated that the axis of the Eta Carinae system is aligned with its powerful jets. Finally, the Hubble pictures have helped expand our knowledge about stellar evolution and, in particular, the science of super-massive stars.

Because of its extraordinary mass, the star is expected to end as a great supernova sometime in the future. This could happen tomorrow or in a thousand years. In fact, because of its great distance from Earth and the speed of light, it may have already happened and the light from the event simply has not reached us. Regardless, when it detonates, the energy outburst will be sufficient to devastate stars and planets within a few thousand light-years' of the explosion.

The Horsehead Nebula in Infrared Light

Earthly dust may seem insignificant and trivial, but the cosmic type is an all-important constituent of matter in the universe and essential to making stars. The famous Horsehead Nebula is a dark cloud of dust and gas that obscures, absorbs and silhouettes the light emitted from nebula IC 434 that lies behind it. The source of illumination causing IC 434 to glow is the bright star Sigma Orionis, located about 1,150 light-years from Earth. Protruding from its parental cloud, the Horsehead is really a dynamic structure and a fascinating laboratory of complex physics. As it expands into the surrounding environment areas of the cloud sustain stresses that trigger the formation of low mass stars.

The Horsehead Nebula is arguably one of the most intriguing structures in modern astronomical history. Discovered on photographic plates exposed in 1888 by the Scottish astronomer Williamina Fleming at the Harvard College Observatory, it was photographed and cataloged in 1894 by the American astronomer Edward Barnard and designated B33 in his famous catalog of dark nebulae. Since that time the Horsehead has been a favorite target by every new imaging technology to come along during the last 120 years. Although one of the most spectacular objects in the sky, the Horsehead Nebula is a transient dynamic object that will likely erode in about 5 million years.

To celebrate its 23rd anniversary in April 2013, the Hubble Space Telescope produced an image of the Horsehead unlike any before. The image was assembled from near infrared exposures made with HST's WFC3 detector through near infrared filters. Although thick and opaque in optical images, the new near-infrared portrait produced a transparent, ethereal view that propagated a rebirth of interest in the iconic Horsehead by giving it an entirely new presence.

The spectral range of infrared light lies beyond the visible spectrum. Discovered by William Herschel in 1800, the infrared universe reveals structures and processes completely invisible to the naked eye or optical instruments. Objects embedded in dense regions of gas and dust or objects too cool and faint to be detected in visible light can be identified in the infrared. Much of what we know about the early universe and stellar evolution was achieved through infrared astronomy. Because infrared light is absorbed by water vapor in Earth's atmosphere most infrared telescopes are located either in space or in dry places at high elevations, above as much of the atmosphere as possible.

Dark nebulae such as the Horsehead are comprised of cold dense clouds and therefore great targets for infrared imaging. At infrared wavelengths the dust within the Horsehead becomes increasingly transparent. This enables the detection of embedded stars and distant background galaxies not apparent at optical wavelengths. Infrared light allows us to view the dark Horsehead as a thriving stellar nursery, where areas of active star birth are clearly evident.

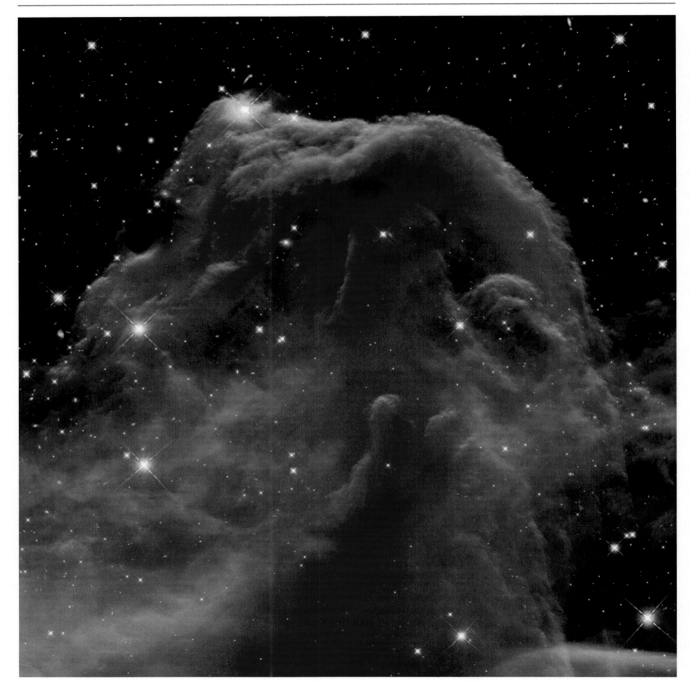

Fig. 5.4 Captured from October 22, 2012, to November 7, 2012, this image is a composite of two sets of filtered exposures acquired by the WFC3/IR instruments through two separate band passes in the infrared. False-colors were then assigned in the following manner: F110W (cyan/blue) and F160W (red/orange). The infrared signal gives the image a transparent quality, revealing dust and even distant background galaxies normally invisible due to the opaque clouds at visible wavelengths. The image covers a field of about 2.5 light-years across

M16: The Pillars of Creation

The legendary pillars of the Eagle Nebula M16 represent columns of cold molecular hydrogen, with two atoms of hydrogen in each molecule, and dust that remain stubbornly intact despite the evaporating power of ultraviolet radiation produced by massive neighboring stars. The process is analogous to Earth's sandstone buttes that stand erect despite the erosion of their

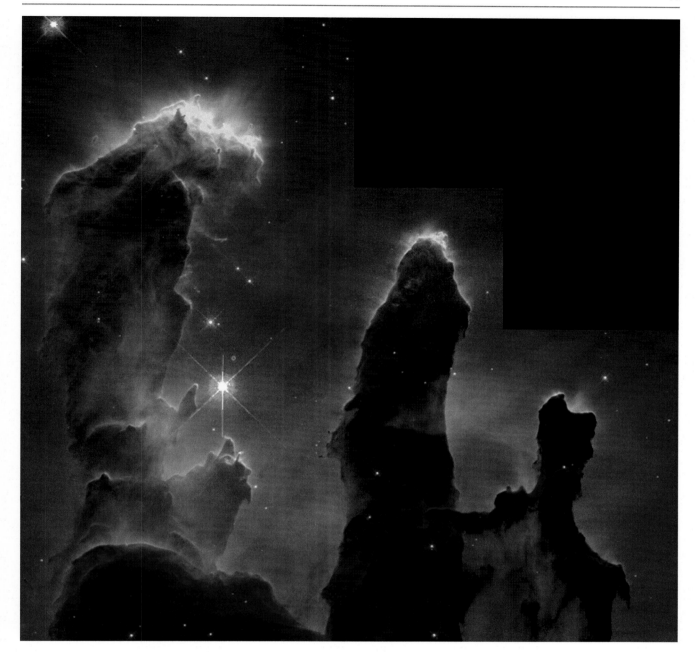

Fig. 5.5 This iconic image, which symbolized the new age of HST contributions, was exposed on April 1, 1995, making full use of the newly refurbished optics of the Hubble Space Telescope. The images were exposed through narrowband filters isolating the light of ionized oxygen, sulfur, and hydrogen. The false-color composite was created using a specific palette of color assignments that highlighted dramatically the interactions of hot stars and molecular clouds and producing a three-dimensional rendering to the processes occurring within the dust pillars of M16

surrounding landscape. The flood of ultraviolet radiation from a nearby young star cluster designated NGC 6611 both illuminates and boils the surface of the columns, producing the fascinating three-dimensional pillar shapes we see at the center of M16 pictures.

The pillars show the effects of slow erosion by a process known as *photoevaporation*, in which less dense gas is slowly evaporated from the surface exposing denser material deep within the globule-like structures. The globules themselves are known as evaporating gaseous globules or EGGs.

Protostars have been forming for thousands of years within the EGGs of the Eagle Nebula. However, their growth has become stunted because the gaseous cocoons feeding their growth are being eroded away. This erosive process presents a rare opportunity for astronomers to observe the infant stars as they emerge prematurely from the evaporating pillars of M16.

In November 1995, almost 2 years after the first Space Shuttle servicing mission successfully corrected the HST's flawed optics, an HST image of M16 was released that immediately grabbed the world's attention. Titled the *Pillars of Creation*, Hubble's Wide Field and Planetary Camera 2, also known as WFPC-2, recorded the enigmatic process of star birth within the pillars the Eagle Nebula M16.

The image was recorded through narrowband filters using a process that selectively captures light emitted by specific elements. Each narrowband exposure is then assigned a visible hue that is electronically combined with other narrowband images to create a full color picture with novel and often spectacular coloration.

For the *Pillars of Creation*, red was assigned to the image capturing emissions from singly-ionized sulfur atoms, green was used for hydrogen emissions, and blue was used to tint the light emitted by doubly ionized oxygen atoms. When the color assigned filtered image were combined, the final result achieved extraordinary visual impact while simultaneously providing information about the chemical and physical processes occurring in the pillars. The dramatic three-dimensional rendering was achieved by Hubble's unparalleled resolution and the clever assignment of colors to each narrowband filter. This approach became popularly known as the *Hubble palett*e.

The Antennae: Snapshot of a Cosmic Collision

Arguably no single event in the universe is as imposing and as physically altering as the collision of two galaxies. Galactic interactions and mergers are now recognized as playing a critical role in galactic evolution.

Considering the immense vastness of space, collisions between these cosmic giants occurs more often than one might think. Due to their enormous size the average distance between galaxies is only 20 times greater than their diameter. Statistically, major collisions occur at least a few times during the life of an average galaxy.

Collisions or mergers can be characterized as *major* when two galaxies of about the same mass begin to physically intersect, or *minor* when a star system of low mass, such as a dwarf galaxy, is pulled into a larger galactic neighbor. Galactic mergers may take hundreds of millions or even billions of years to complete. Close encounters that do not involve collisions can create less catastrophic changes, such as distortion of spiral arms, stellar tidal tales, plumes of expelled gas or bursts of star formation. Like the forensic investigation of a crime scene, astronomers studying galactic interactions piece together subtle disturbances that may be the only clues to a previous encounter.

The merging galaxies NGC 4038 and 4039, popularly referred to as the *Antennae*, are the prototypical model of a major merger. Approximately one billion years ago NGC 4038 and 4039 existed as two separate spiral galaxies. The interaction between the two galaxies most likely began between 300 and 600 million in the past and will continue for several hundred million additional years likely ending in single, more massive galactic body.

The Hubble Space Telescope has imaged the Antennae three times in 1997, 2006 and 2013 with three generations of cameras. Each image iteration has provided deeper and more detailed views of the merging galactic pair.

In Hubble images merger effects can be observed on two separate fronts. First, the disturbed inner region, comprising the central mass of both galaxies, contains many young clusters of giant O- and B-type stars and super-clusters of massive stars arising from giant molecular clouds induced by the collision. The formation of stellar super-clusters is a phenomenon associated with galactic merger events. The rate of star formation is so prodigious in the Antennae that the galaxies are said to be in a constant starburst state.

Second, the outer regions display two sweeping tidal tails extending almost 500,000 light-years. Only seen in wide field images, the long antenna-like tidal tails contain gas and stars mutually stripped from both galaxies.

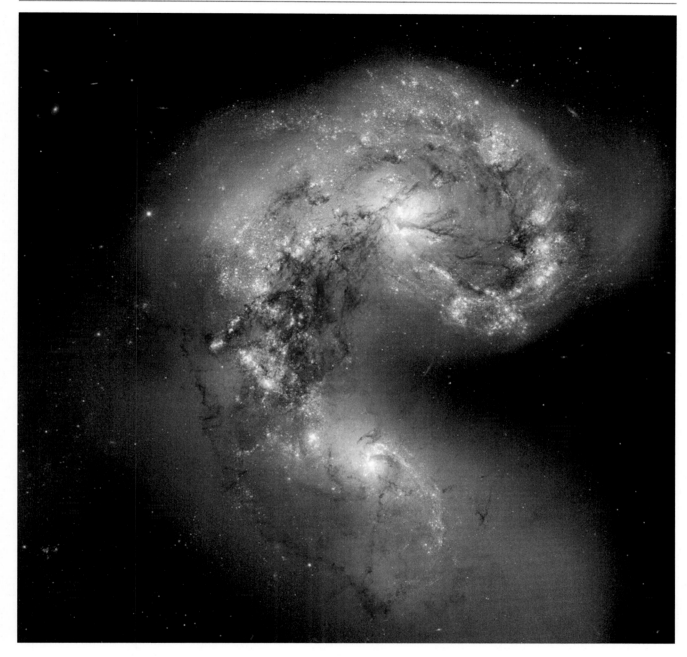

Fig. 5.6 The prototypical merging pair of galaxies, known as the Antennae, were imaged multiple times by the Hubble Space Telescope using its Wide Field and Planetary Camera 2 (WFPC2) in 1997, and again in 2006 from the Advanced Camera for Surveys (ACS). This latest image was released in 2013 using recent visible and near-infrared observations from Hubble's Wide Field Camera 3 (WFC3), along with some of the previously-released observations from the ACS. The chaos resulting from the merging of two immense galactic bodies is evident in the huge arcs of new blue stars and the myriad star-forming emission nebulae (pink)

The Crab Supernova Remnant

The Crab Nebula M1 is a supernova remnant displaying the remains of a shattered supergiant star that met its explosive end in the year 1054. Witnessed and documented by Chinese astronomers the star was observed to be four times brighter than Venus and visible in the daytime sky for 23 days after it was first noticed. The Crab is the most famous and most studied supernova remnant in the sky and one of only a few within our own galaxy observed by human beings when it exploded.

Scientific estimates predict a supernova occurs about once every three decades in our galaxy. But, dense interstellar material obscures much of our view making observations of supernovae within the Milky Way rare events even though they are regularly seen in other galaxies.

Supernovae enrich the surrounding interstellar medium with heavier elements such as carbon, nitrogen, oxygen, silicon, sulfur and iron that can only be created by the intense heat and pressure within the nuclear furnaces of massive stars.

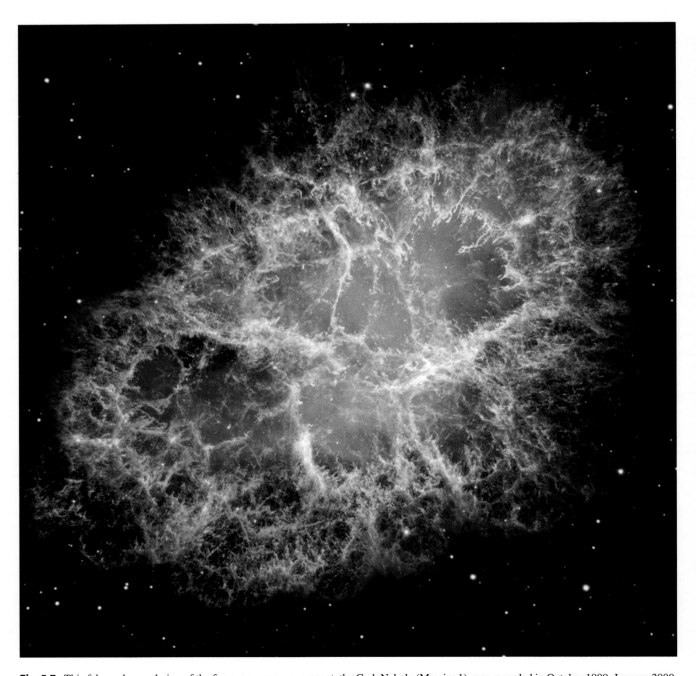

Fig. 5.7 This false-color rendering of the famous supernova remnant, the Crab Nebula (Messier 1), was recorded in October 1999, January 2000, and December 2000 by the WFPC2 through narrowband filters isolating the light from ionized oxygen, hydrogen, and sulfur. The remains of the once-massive star spans 6 light-years across, and its expansion can be seen in images taken years apart. The destructive end of the star was witnessed by ancient astronomers nearly 1,000 years ago in 1054 as a "guest star" in the sky for a period of several months

Supernovae also play a significant role in the birth of new stars because when a supernova explodes, expanding shock waves can trigger the collapse of nearby molecular clouds that subsequently become the nurseries for new generations of stars. Our Sun contains heavier elements that originated in an ancient supernova event around 5 billion years ago.

The matter ejected by the Crab supernova collided with the dust and gas of the nearby interstellar medium creating shock fronts of multi-million degree gas and high energy particles. The heated material continues to produce intense radio and X-ray emissions that will persist for thousands of years before the Crab gradually dissipates into space.

But, what forces power such an extreme event? In 1968 a pulsating radio source was identified at the heart of the Crab that is now known as the Crab *pulsar*, a neutron star rotating 30 revolutions every second. A neutron star is a remarkably dense stellar object with the mass of 1.4 Suns squeezed into a space about 10 km wide. Its incredible density approaches 50 trillion times that of lead and represents the final stage of a star that began with the mass of at least 15 Suns. The explosion tore the star apart and propelled its material into space, producing the nebula we call the Crab supernova remnant.

The Hubble image released in 2005 was recorded through narrowband filters isolating the emission of oxygen and sulfur. The picture reveals a complex network of filamentary structures made of gaseous material ejected when the star went super-nova in stunning detail. The nebula has steadily expanded since the time of the explosion at a rate of about 1,800 km per second. It now spans over 10 light-years.

Optically the nebula consists of two components. First, the web-like infrastructure of filamentary material glows from emissions from the shocked ambient gases in the interstellar medium. The second optical component is the diffuse feature-less glow that permeates the nebula. This emission, assigned the color blue, is the result of synchrotron radiation, a form of energy released when fast-moving electrons generated by the supernova's expanding shock front encountered the strong magnetic field produced by the Crab's pulsar.

The inner part of the Crab surrounding the rotating pulsar is an extraordinarily dynamic environment. High resolution images produced by HST and X-ray observations show a series of elliptical features, about 1 light-year from the pulsar, that change shape every few days. These features are faintly seen in the center of the accompanying image. These elliptical wisps represent the shock fronts of high-energy particles being outwardly accelerated at velocities up to 70 % the speed of light by the pulsar's magnetic field.

The Anomalous Arms of M106

M106 is a spiral galaxy located in the direction of the northern constellation Canes Venatici about 23.5 million light-years from Earth. It has the distinction of harboring the nearest extragalactic astrophysical jet. The proximity of M106 and its incline of about 72 degrees expose the central region of the galaxy's barred core to earthbound telescopes, giving astrono-mers the opportunity to learn about this unusual phenomenon in great detail.

Jets are highly collimated beams of matter and energy associated with the cores of active galaxies. They are best observed at radio wavelengths and usually come in pairs aimed in opposite directions. M106 is classified as a Seyfert galaxy by virtue of its active nucleus and characteristic emission spectra. Like other Seyfert galaxies it shows evidence of a 36 million solar mass super-massive black hole churning within its nucleus that's approximately ten times larger than the one at the Milky Way's center.

Surrounding the black hole is a disk of spiraling matter called an accretion disk. The physics of the accretion disk is such that material falling into the black hole releases copious amounts of energy sometimes in the form of powerful jets. The two-sided jet of M106 exits the nucleus traveling in opposite directions and extends through the galactic disk some 16,000 light-years before it deflects into the halo of the galaxy. The drop off in density within the galactic halo forces the jet to splinter into numerous filamentary components once outside the disk. This results in the galaxy's unique anomalous arms seen as arcing red structures in the Hubble image.

The peculiar arms protruding from the center of M106 are not like the spiral arms filled with stars, gas and dust typically seen in other galaxies. The extra arms are caused by the high energy jets emanating from the galaxy's supermassive black hole. Seen in the light emitted by hydrogen molecules when they become ionized, the arms display an artificial red hue to make them visible in the Hubble image.

Because the jets are tilted at a low inclination they pierce the disk and surrounding halo of this galaxy. So, as the jets pass through regions of gas, they create an expanding cocoon of shock waves that heats the surrounding material causing it to release radiation in optical wavelengths. The curvature and fraying seen at their extremities represents previous trajectories of the jet due to past precession. Precession is a change in the orientation of the rotation axis of a spinning object – the wobble of a spinning top is a good example.

Interestingly, water molecules in the accretion disk surrounding the supermassive black hole at the center of this galaxy have become so excited that they amplify microwave radio emissions in a manner similar to the way in which a laser ampli-fies light. These powerful naturally-occurring microwave amplifiers are called masers. The discovery and measurement of the masers in M106 have made distance estimates between Earth and other galaxies more precise.

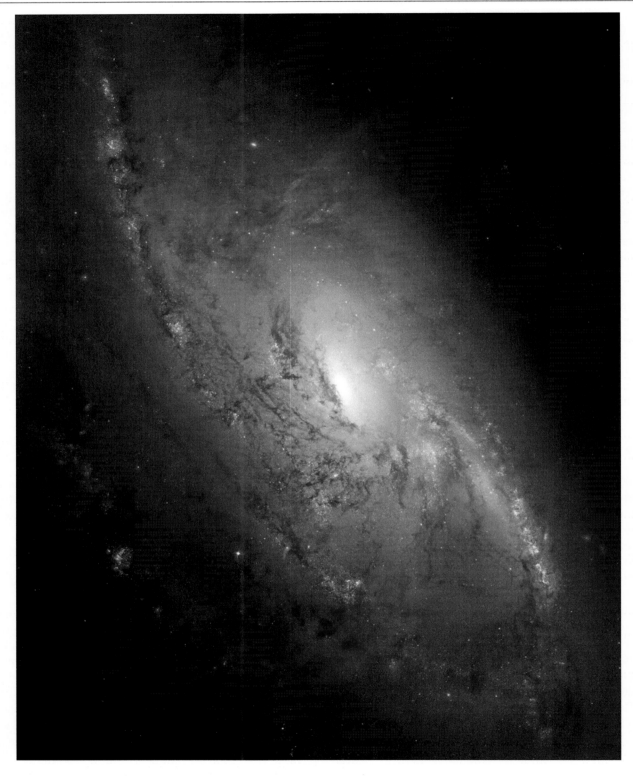

Fig. 5.8 This image represents collaboration among professional and amateur astronomers. The broadband and narrowband visible light data gathered by the Hubble Space Telescope was captured during multiple pointings of the HST over several years using its full complement of detectors (ACS, WFC3, and WFPC2). The composite image, which brought together all of the past Hubble datasets, was assembled by one of the authors (RJG) and released in February 2013. The image reveals the compact central detail of M106 and in particular the anomalous arms believed to be formed by jets of superheated gases released from the center of the galaxy, where a monstrous super-massive black hole exists

The Hubble release in 2012 was assembled and processed by the authors using some of their own photographic data to supplement Hubble Space Telescope data. The image represents a successful collaboration helping to bridge the amateur and professional astronomy communities.

Supernova 1987A

SN 1987A is a recent supernova that exploded in the outer region of the Tarantula Nebula. This nebula is embedded in the Large Magellanic Cloud, a satellite galaxy of the Milky Way. Located 168,000 light-years in the distance its light first reached Earth on February 23, 1987. Visible with the naked eye from the southern hemisphere it was the closest observable supernova to occur within the Milky Way since the supernova creating the Crab Nebula was observed in 1604. Because of its relative proximity to our planet SN 1987A is by far the best-studied supernova of all time.

Its visible brightness peaked in May 1987 before it declined over a period of several months. As it grew dimmer in visible light SN1987A grew brighter at X-ray and radio wavelengths; its shockwave crashed into surrounding ambient gases that had been released thousands of years earlier by its progenitor star. This interaction has created the peculiar present-day appearance of SN1987A in visible light. The progenitor star, identified as Sanduleak – 62 202, was a blue supergiant.

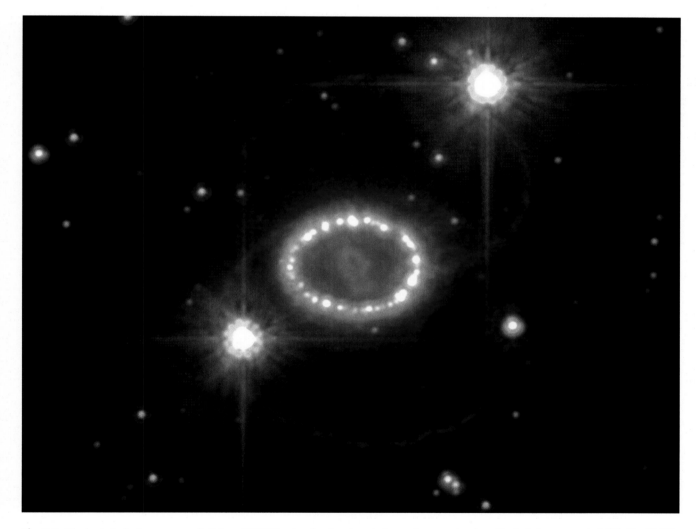

Fig. 5.9 The best-studied supernova of all time, SN1987a was also the closest observed supernova since Kepler's Supernova in 1604. The Hubble Space Telescope was not yet in operation when the supernova exploded in 1987 (HST was launched in April 1990), but as soon as 1993 it began taking images of this rare phenomenon. This image, taken in 2006, shows outer loops of glowing gas only hinted at in ground-based telescope images, along with a dumbbell-shaped central structure that is expanding outward from the supernova at 30 million kilometers per hour. The dynamic structure has continued to change in images taken years after the initial blast

The three bright rings of the supernova remnant are clearly visible in the first Hubble Telescope image from 1990. Each ring represents material previously ejected by the stellar winds of the progenitor star, possibly 20,000 years ago, that are now being energized by the ultraviolet flash from the supernova explosion. The ring structures became visible several months after the event. The inner ring is roughly a light-year in diameter.

Because the Earth's atmosphere absorbs ultraviolet light, Hubble was the first to image the remnant at that wavelength. Using its on-board STIS spectrograph the Hubble Space Telescope was able to detect the presence of glowing hydrogen expanding at a speed of 15,000 km per second coming from the inner ring. In addition to hydrogen emission STIS also detected emission from high-velocity ionized nitrogen.

The ring-like structures are formed as the ejected remains of the supernova slams into material released thousands of years earlier during the progenitor star's red giant phase. SN 1987A is thought to be a *core collapse* supernova that results in the creation of a neutron star. However its neutron star has not yet been identified. Explanations for its absence include the presence of obscuring dust and a possibility the neutron star continued its collapse into a black hole.

The release of visible light from a supernova is theoretically preceded by a burst of neutrinos. Predictably, approximately 2 or 3 hours before the supernova's visible light reached Earth, three separate observatories detected neutrino emissions. The detection of those neutrinos confirmed the theoretical predictions about the core collapse of a massive star. This represented the first time neutrinos emitted from a supernova had been directly observed and consequently marked the beginning of the field called neutrino astronomy.

In 2001, the expanding supernova ejecta, traveling over 7,000 km/second, reached the inner ring. The collision of blast debris with the inner ring caused considerable heat production and generated copious X-rays. Some of the X-rays were converted into visible light, causing a noticeable brightening of the ring complex that continued until 2009.

Although the Hubble Space Telescope has been following the progress of SN1987A since the early 1990s, the supernova remnant has also been photographed by other orbiting observatories, including the Chandra X-ray Observatory and the Herschel Space Observatory. Based on Herschel's infrared observations researchers calculated enough dusty material was expelled by the supernova to build 200,000 Earth-size planets. Included with the dust were other elements such as oxygen, nitrogen, sulfur, silicon, carbon, and iron. This was a reminder that supernovae create the building blocks of new suns, planets, moons and life itself.

NGC 604: Close Up of an Extragalactic Stellar Nursery

Spiral galaxy M33 is the located about 2.7 million light-years from Earth and it's the third largest star system in our Local Group; only the great Andromeda galaxy M31 and the Milky Way are larger. Nestled within M33's northeastern arm is one of the largest and most impressive star-forming regions among the over 54 galaxies in the local group. Designated NGC 604, it is known as a giant HII region. Typically located in the spiral arms of galaxies, H II regions are large clouds of partially ionized gas where star formation has recently taken place. The hot young blue stars forged within these regions emit copious amounts of ultraviolet light that ionize the surrounding hydrogen gas causing it to glow with characteristic pink and red hues. HII refers to the excited state of hydrogen when it is ionized by radiation from young stars.

NGC 604 is an unusually large HII cloud spanning some 1,600 light-years. It is over 40 times larger than the Orion Nebula and 6,300 times more luminous! Like all emission nebulae, its illumination comes from a cluster of young massive stars at its center. NGC 604 contains some 200 spectral O stars that are among the most massive and powerful known to astronomers. Some have over 120 times the mass of our Sun. Young by stellar standards; the blue giants are only about 2–3.5 million years old. The inner structure of NGC 604 contains a large number of shells, filaments and arches formed by the stellar winds of the energetic young stars and the supernovae they produce when their nuclear fuel is prematurely expended. Arranged somewhat loosely throughout the center of the NCG 604, these massive stars illuminate its cavernous structure like a lantern in a cave producing an extraordinary three-dimensional scene.

NGC 604 is often compared to 30 Doradus in the Large Magellanic Cloud, the only other giant HII region in its class. The central cluster of hot stars powering NGC 604 is comparable to the energetic cluster of O-type giants, designated R136, within the core of 30 Doradus. However the massive stars of NGC 604 are scattered over a considerably larger area spanning the entire nebula and are 100 times less concentrated than R136.

Different processes dominate the eastern and western sides of NGC 604. The western side appears to be powered predominantly by the winds of its 200 O-type giants, while the eastern side is much older and quiescent because it was formed by previous generations of young stars.

An endless number of tunnels and cavities allow the winds of giant stars to circulate through the caverns of NGC 604, causing huge bubbles that eventually expand, forming filaments and arches and eventually new bubbles of hot gas. Because of its cavernous structure, NGC 604 probably won't expand and disperse like other HII regions. Its tenuous nature and abundant stellar population will enable it to persist for a long time.

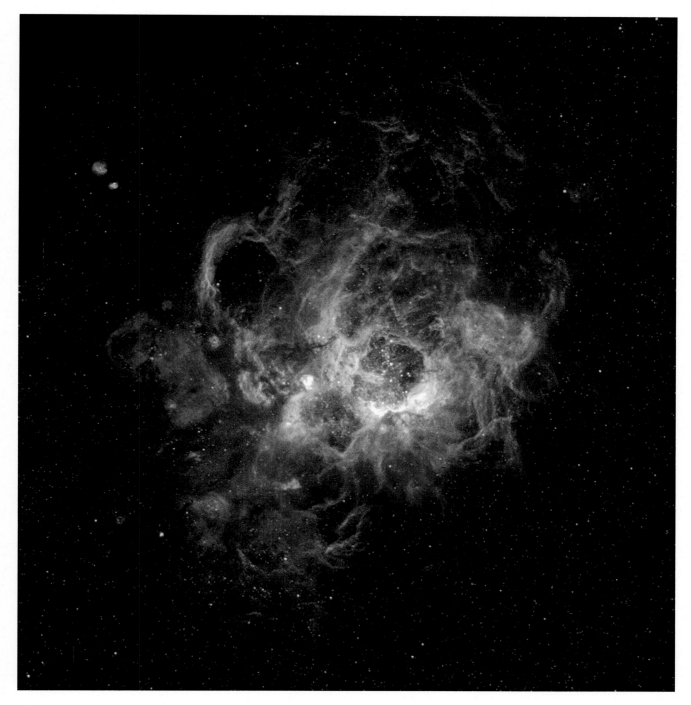

Fig. 5.10 This image was taken on January 17, 1995, using Hubble's Wide Field and Planetary Camera 2. Separate exposures were taken using filters that selectively transmit the light of specific elements such as oxygen, hydrogen, sulfur, and nitrogen. The narrowband filtered images were then combined using a false-color palette that maximally highlights the physical and chemical processes occurring in NGC 604

R136: The Core Cluster of 30 Doradus

The 30 Doradus region, also known as the Tarantula Nebula or by its new general catalog designation as NGC 2070, lies within the Large Magellanic Cloud, a small satellite galaxy orbiting the Milky Way. It's one of the largest and brightest HII regions among the more than 54 galaxies in our Local Group and it's the closest starburst region to Earth. Located only 170,000 light-years from our planet, its favorable inclination to our line of site and the absence of intervening dust makes 30 Doradus a virtual laboratory for studying massive star formation.

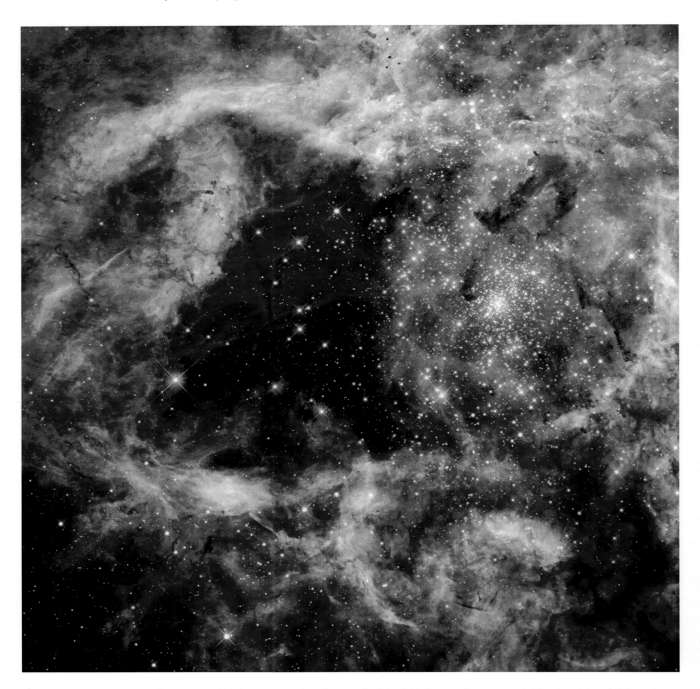

Fig. 5.11 This image, taken in October 2009 following the installation of Wide Field Camera 3, was recorded in ultraviolet, visible, and near infrared light. The field spans about 100 light-years. Hubble's remarkable resolving capacity is able to resolve individual stars within R136, giving astronomers important information about the stars' birth and evolution. Most of the stars are blue giants, which represent the hottest and most massive stars. Many of these hot stars end their lives quickly (in a few million years) as supernovae

Because the Tarantula Nebula is one of the few giant HII regions known by astronomers, it's worth noting a few of its impressive physical characteristics. For example, 30 Doradus has the mass of more than a million Suns and spans over 1,000 light-years making it large enough to swallow 100 Orion Nebulas. In fact, 30 Doradus is so bright it would cast a shadow at night if it was as close to Earth as the Orion Nebula.

The spectacular nebula is energized by an extraordinary cluster of young massive stars. Giant HII regions such as 30 Doradus typically exhibit extraordinary luminosity because they contain between 100 and 1,000 massive and energetic O-type stars that release an enormous ionization flux.

Some clusters, such as 30 Doradus, have such an exceptionally high concentration of massive stars they are referred to as super star clusters because they have a cumulative stellar mass ranging from 100,000 to 1 million suns. The central cluster of 30 Doradus, and source of almost half its illuminating energy, is the remarkable core cluster designated R136. Once thought to represent a single massive star, R136 is now known to represent a compact cluster of very massive stars. The ionizing radiation from R136 is so powerful, it distinguishes 30 Doradus as the most luminous HII region in our local galactic group.

R136 is an exceptional cluster by any standard. Although thousands of massive stars are scattered throughout 30 Doradus, R136 contains the main concentration of very massive O- and hot B-type giants including several extraordinarily powerful and rare stars known as Wolf-Rayet stars. Wolf-Rayet stars are some of the hottest and most luminous stars known. Some of the most impressive stellar specimens in R136 have an incredible mass of 120 suns! The brightest star in R136, a Wolf-Rayet designated Melnick 34, has a mass of 133 suns! R136 is also known for its compact nature because it packs 121 stars within a space of only 15 light-years. This extraordinary stellar density is several hundred times more concentrated than similar stellar associations in the Milky Way.

The striking honeycombed appearance of the Tarantula nebula is without a counterpart in our Milky Way. The unique form of the nebula suggests it has a series of giant interlocking shells with hollow cavities. The inner shells are tightly arranged and are expanding at about 35 km per second. The diameter of the outer shells is greater towards the outer periphery of the nebula. The shells are believed to have been sculpted from the collective stellar winds from successive generations of powerful stars and the supernovae they produce when their nuclear fuel is prematurely expended. It is estimated that the complex has experienced at least 40 supernovae within the last 10,000 years, including the most recent one, SN 1987a.

R136 does not contain all the massive stars of the Tarantula Nebula. Some massive young stars are oddly located just outside the Tarantula Nebula. Astronomers believe they formed within the Tarantula and were subsequently ejected at high speed by gravitational interactions with other massive stars in the nebula.

M51: Lord Rosse's Spiral Nebula

M51, also known as the Whirlpool Galaxy, was the first celestial object in which spiral structure was observed. In 1845 Lord Rosse, using his 72-inch (1.8 m) reflecting telescope at Birr Castle, Ireland, discovered the Whirlpool possessed a spiral form. Rosse's observation came at a time when the true nature of galaxies was unknown. This changed in the 1920s with Edwin Hubble's revelation that all *spiral nebulae* , such as M51, are separate island universes like our Milky Way.

M51, located approximately 23 million light-years from Earth, is universally regarded as a celestial showpiece and remains a favorite among both night sky observers and astrophotographers. This is possibly because the 51st entry in Messier's list is a dramatic interacting pair of galaxies. The larger spiral is designated in the new general catalog as NGC 5194 and the other component, designated NGC 5195, is an irregular-type dwarf galaxy that is being gradually consumed and incorporated by its more massive neighbor.

As truly immense structures, galaxies are relatively large compared to the average distance between them. Most galaxies are separated by a distance of only 20 times their diameter whereas stars are typically separated by 10 million times their diameter. As a result most galaxies are likely to encounter other galaxies at least a few times over their immense lifetimes. The encounters run the gamut from major mergers, involving the collision of two galaxies of comparable mass, to minor mergers that involve the consumption of a comparatively small satellite galaxy by its parent galaxy.

The accepted paradigm of galaxy formation is that galaxies grow and evolve through a hierarchical process that involves mergers and interactions with other galaxies over billions of years. These events occurred with great frequency in the early universe but continue into the present era because we can observe many galaxies in the local universe, such as M51, showing strong signatures of ongoing interactions. When encounters happen, the close proximity of the massive structures set up powerful gravitational forces known as tides. As the galaxies move closer the enormous tidal forces act to dramatically and often violently alter the structures of both participants.

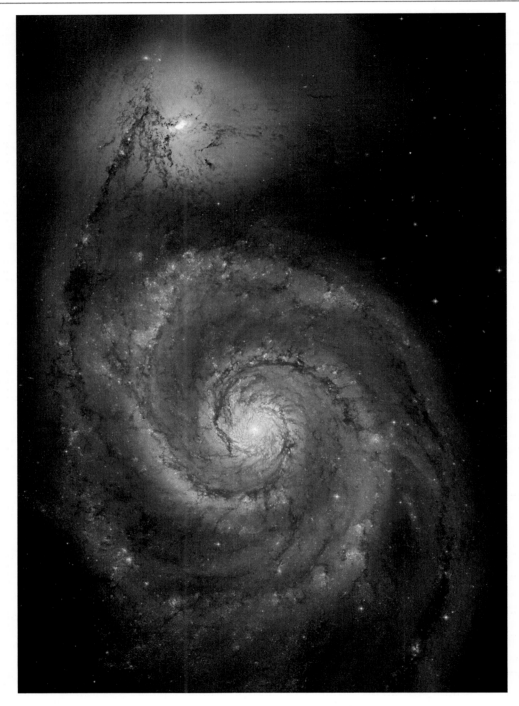

Fig. 5.12 This image of M51 was released in April 2005 to celebrate the 15th anniversary of the Hubble Space Telescope. Taken by Hubble's Advanced Camera for Surveys, the image reveals the complex interaction between the interacting galaxies NGC 5195 and 5194. Pink star-forming clouds known as HII regions are seen distributed throughout the blue spiral arms of NGC 5194

There have been many attempts to explain the morphology and evolution of the NGC 5194/5195 system, including its apparent tidal bridges and grand design spiral shape. The study of galaxy evolution is somewhat akin to forensic science because the investigators must piece together complex past scenarios based on subtle disturbances observed in the galaxy's existing structure.

Simulations suggest that NGC 5195 is located well behind NGC 5194 and that the two galaxies are now traveling away from each other. The two galaxies had their closest recent approach some 70 million years ago when the less massive NGC 5195 encountered the spiral disk of NGC 5194 during a highly inclined encounter. The effects of that interaction include several conspicuous disturbed features as well as a general brightening and strengthening of the NGC 5194 inner spiral arms. The disturbed features include the marked asymmetry of the near and far spiral arms in relation to the companion NGC 5195. The apparent spiral arm-bridge between the two galaxies is an illusion, as NGC 5195 is far behind the NGC 5194. The near spiral arm is superimposed over the disk of NGC 5195 along the same line of sight. A copious region of intense star formation is visible near the nucleus of NGC 5195 and was triggered by its recent approach.

Starburst Galaxy M82 and Its Superwind

Located 12 million light-years away in the direction of the northern constellation of the Bear, M82 forms a well-known pair with its neighbor M81. M82 also has the distinction of being the closest starburst galaxy to the Milky Way. Popularly known as the Cigar Galaxy, M82 is considered a prototypical starburst galaxy based on the intense star formation its experiencing. This activity may last up to 10 million years or longer. Typically, new stars can form 10 to 100 times faster than the rates observed in normal galaxies during a starburst period. The accumulated brightness of new massive stars also makes these galaxies some of the most luminous.

The triggering of starburst activity within galaxies is most often due to gravitational encounters with other galaxies. The resulting forces and shockwaves compress existing molecular clouds located in the central regions of the galaxy and induce the formation of new stars. The new stars, mostly hot massive blue giants, produce fierce stellar winds that combine with shock fronts from supernovae they produce to compress the interstellar medium and trigger a chain reaction of continuous star formation.

Waves of furious star formation can sweep through the central region of a galaxy and consume its enormous gas reservoirs. When the gas clouds are depleted star formation ceases. Astronomers believe most galaxies experience epochs of intense starburst activity at one time or another. This contributes to the galactic ecology by enriching the intergalactic medium with heavier elements that are the building blocks of new stars, planets and life.

The current starburst era has dramatically altered M82. A collective outgassing of stellar winds from thousands of new stars and shock fronts from supernovae explosions caused the ejection of several million degree ultra-hot hydrogen and nitrogen gases extending thousands of light-years from the galactic core. The combination of forces driving this process is known as a superwind.

From the Hubble image it becomes apparent the M82 superwind has a distinctly bipolar, cone-like configuration with the 1,300-light-year-thick apex of the cones tapering in the center of the galaxy's disk. The outflow direction is perpendicular to the stellar disc and shows a variety of knots, streamers, loops and arches. The superwind emits heavily in the red hues of the hydrogen alpha line but also glows strongly across the entire electromagnetic spectrum including ultraviolet, X-ray, and infrared. At its furthest extent, the superwind stretches about 15,000 light-years from the disk.

M82's starburst activity was triggered by a close encounter with M81 between 100 and 600 million years ago. Prior to the encounter, M82 may have been a more massive spiral galaxy. The last encounter with M81 seems to have left M82 stripped of stars and gas leaving its remaining bulge and nuclear disk considerably truncated, as it appears today.

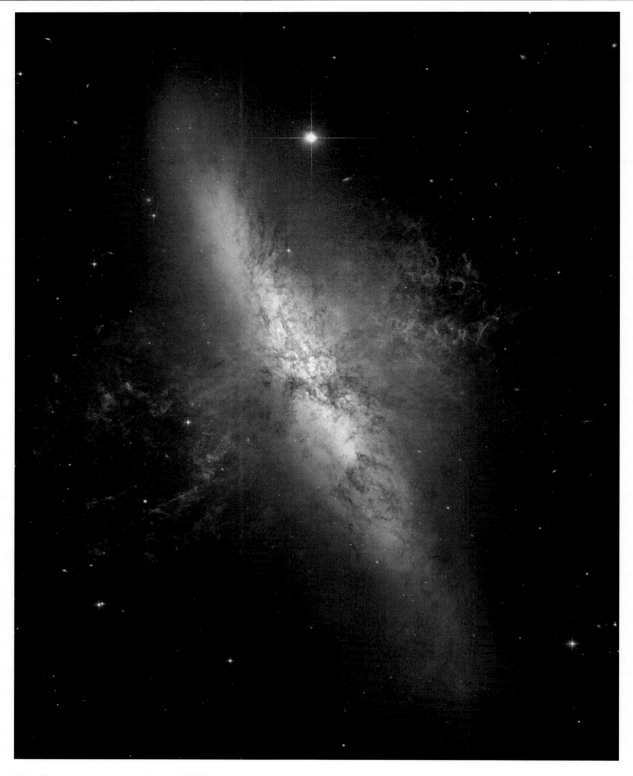

Fig. 5.13 This image was released in April 2006 to celebrate the 16th anniversary of the Hubble Space Telescope. The image was exposed through visible light and narrowband hydrogen alpha filters (which isolates the light of hydrogen) using the Advanced Camera for Surveys (ACS) detector. The deep image not only captured numerous clusters of young blue stars recently formed in the central region of the galaxy but also the extensive superwind of the galaxy, which emits heavily in the red hues of the hydrogen alpha line

The Trifid Nebula

Stars in the earliest formative stages are difficult to detect optically because they are shrouded from view by the molecular cloud in which they form. They reveal their presence by jets and outflows of gas that typify their unstable and turbulent beginnings. M20, a bright gem of the summer sky, is a virtual laboratory of the exhilarating science of star birth.

As an HII region, M20 is similar to the great Orion nebula M42 due to its complexity and relationship to its parent molecular cloud. But, M20 is comparatively much younger than M42. Although it is not visible in the HST image, a large blue reflection cloud forms the northern border of M20. In addition to Hubble Space Telescope observations, recent X-ray

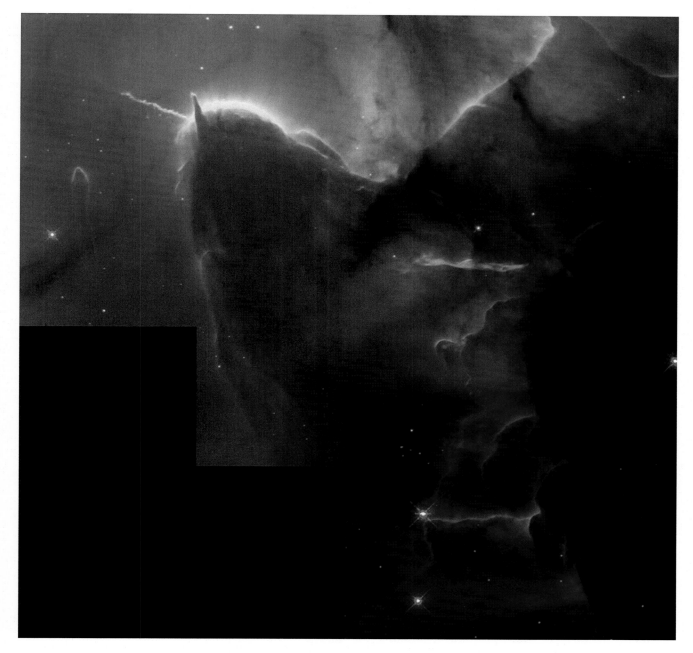

Fig. 5.14 This iconic image of star birth within the Trifid Nebula, taken on Sept. 8, 1997, was recorded using the Wide Field Planetary Camera 2 (WFPC-2) detector through four separate narrowband filters: F502N (O III), F547M (Strömgren y), F656N (H-alpha), and F673N (S II). The false-color narrowband images were composed to highlight the physical processes occurring in the area of the bright-rimmed globule TC2. Aside from the bipolar jet arising from TC2, a finger-like projection is seen in the far left, which is believed to be an evaporating gaseous globule, or "EGG," similarly observed in the Eagle Nebula

and infrared observations have discovered an amazing array of very early stars and protostars within M20, giving us a rare glimpse into the initial stages of star formation.

The 300,000 year old HII region is relatively young and represents a fertile hotbed of young stars displaying the turbulent phenomenon that defines their particular stage of stellar evolution. M20 is about 30 light-years across and is illuminated by a core of hot young massive stars situated at the center of its tri-lobed emission cloud. The star that ionizes the cloud is about 30 times the mass of our Sun. It is designated as the *A* component of a triple stellar system and its part of a small star cluster, designated *HD 164492 A* through *G,* that is packed within a half light-year of M20s center.

The protostar stage represents the earliest phase of star formation. It takes place when a molecular cloud contracts and the embryonic star remains shrouded in dust and gas. At this stage the nuclear furnace found within the core of mature stars has not yet ignited and the star emits radiation mostly in the microwave and infrared spectrum. Stars at this stage are not visible at optical wavelengths. But, as the star accretes more material from the cloud in which it is forming the protostar's temperature rises and it becomes unstable, resulting in outflows of mass and radiation. At this stage the outflows excite surrounding gases to glow in visible light thus indirectly revealing the presence of an evolving protostar.

A portion of the Trifid Nebula was imaged by Hubble on Sept. 8, 1997. It reveals in remarkable detail a snapshot of star birth occurring in a turbulent and unpredictable environment. The conditions at the center of the Trifid can be described as both nurturing and violently destructive. The HST image centers on a large bright-rimmed globule, designated *TC2*, located along the southern border of the Trifid about 8 light-years from the central illuminating star complex. This area has received much attention because of an enormous Herbig-Haro jet that rises from the globule.

Herbig-Haro objects and their jets represent energetic outflows that can be seen as the visible light signatures of low mass protostars hidden from view by thick clouds of dust. The bipolar TC2 jet extends about 0.75 light-years and is powered by an early few hundred thousand year old protostar buried deep within the globule. The globule is currently being evaporated by the strong ionizing field of the hot massive star illuminating M20. The fate of the embedded protostar is uncertain. It could meet a premature end if the intense radiation destroys the globule before the star has a chance to mature.

The Sombrero Galaxy

M104 is also known as the Sombrero Galaxy based on its resemblance to a broad-brimmed Mexican hat. Its luminous glowing bulge and symmetric ring-like disk has granted it iconic status and made it a very popular object for amateur astronomers in many respects. M104 has also attracted the attention of professional astronomers.

M104 lies near the southern edge of the Virgo cluster at a distance of about 28 million light-years from Earth. It's distinguished by its immense size and brightness. The Sombrero is a truly luminous and massive galaxy with an equivalent total mass of 800 billion suns. Once thought to be a spiral galaxy viewed on edge, recent data from the Spitzer telescope suggests that the Sombrero retains features observed in both elliptical and spiral galaxies. Measurements at infrared wavelengths reveal an enormous halo much more typical for a giant elliptical galaxy. In this regard M104 is similar to another famous galaxy with similar ambiguous features known as Centaurus A. The final classification of the Sombrero Galaxy awaits more information.

M104 is one of a growing list of galaxies known to possess a supermassive black hole within its nucleus. The Sombrero Galaxy's black hole contains a monstrous one billion solar masses. Supermassive black holes of that size tend to be found in very luminous galaxies, especially those possessing an active galactic nucleus. M104 is likely the brightest galaxy within a radius of 35 million light-years of the Milky Way. If the Sombrero Galaxy were located among the 2,000 galaxies of the Virgo cluster, it would be the third brightest member.

M104 has a rich population of globular clusters and several of the more impressive ones are easily visible in ground-based images. Some estimates purport it contains between 1,500 and 2,000 globular clusters, more than ten times the approximately 150 in the Milky Way. M104's globular cluster population exhibits a bimodal distribution of younger metal-rich clusters and older metal-poor clusters. The older metal-poor globular cluster population is presumed to have originated early in the formative years of the galaxy. The origin of the younger metal-rich population remains a mystery. The most popular explanation is the younger population came about through mergers and encounters with smaller galaxies.

M104 has been studied across the electromagnetic spectrum, particularly at infrared and X-ray wavelengths. Chandra X-ray observations revealed abundant X-ray emission extending as far as 60,000 light-years from the galaxy's center. The radiation is thought to be the result of supernova-driven winds from the galaxy's central bulge and disk.

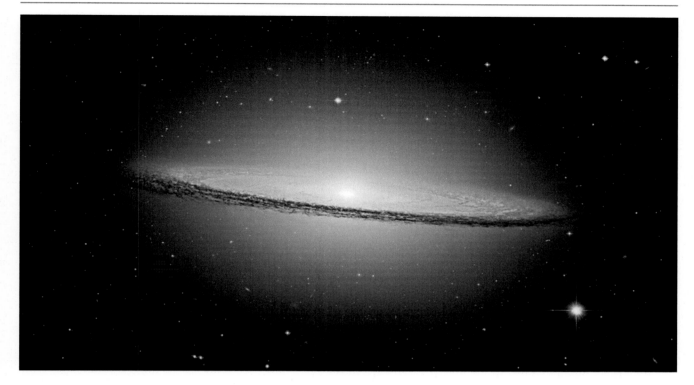

Fig. 5.15 This imposing image was taken during May and June 2003 with Hubble's Advanced Camera for Surveys. The image was recorded through broadband filters approximating red, green, and blue to yield a natural color image. Six pictures of the galaxy were taken and then stitched together to create the final mosaic image. It was one of the largest Hubble mosaics ever assembled up to that time

The Helix Nebula

The road to a planetary nebula begins with a main sequence star having 1–8 solar masses. A star of this mass spends most of its life on the main sequence fusing its hydrogen fuel into helium deep within its core. While the star remains on the main sequence equilibrium is maintained between energy production, which tends to expand the star, and gravity, which wants to contract it. The more mass a star possesses, the shorter its life. Stars with the mass of the Sun can last on the main sequence for 9 billion years, while very high mass stars may exhaust themselves in a million years or less.

Planetary nebulae are formed in the final stage of the life cycle of low- to intermediate-mass stars. In the period prior to the formation of the planetary nebula, the aging star is known as an asymptotic giant branch, or AGB star. The AGB star ultimately expels its outer envelope. This eventually becomes ionized by the hot remnant star called a white dwarf. Thus, the star enters its final planetary nebula phase.

Even though images of planetary nebulae are rendered in two dimensions, they are complex three-dimensional structures. The full picture requires astronomers to reconstruct their true forms from images and measurements taken across a variety of wavelengths.

The Helix Nebula is designated in the new general catalog as NGC 7293. It is located towards the constellation Aquarius at a distance of 700 light-years from our planet thus making it the closest planetary nebula. The nebula is the remnant of a dying star whose appearance is formed by a series of ring-like structures that extend outward and represent gases released during different phases of the star's demise. The main ring of the nebula, which is visible in optical images, is actually composed of inner and outer ellipsoidal-shaped rings inclined almost perpendicular to each other. The innermost ring has a diameter of 1.7 light-years. It was expelled about 6,500 years ago thus making it the youngest component. The inner ring is surrounded by a 2.5 light-year diameter toroid-shaped outer ring. The outer ring is approximately twice the age of the inner component at 12,100 years.

In the Hubble image we see plumes rising from the outer ring in its northwest and southeast aspects. Although the brightest part of the nebula spans approximately 2.5 light-years there is an extreme outer arc with a diameter of 5.7

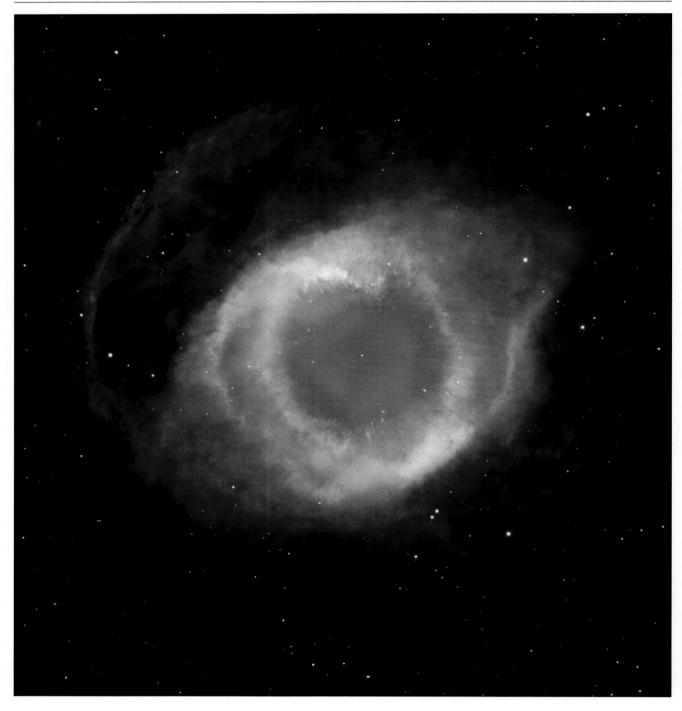

Fig. 5.16 This complex image is actually a composite of data taken by two separate telescope systems, the Advanced Camera for Surveys detector aboard the Hubble Space Telescope and the Mosaic II Camera on CTIO 4 m telescope at the Cerro Tololo Inter-American Observatory in Chile. The image is a false-color rendering of two narrowband exposures, one that records the light of hydrogen (hydrogen alpha) and the other that records the light of ionized oxygen (OIII). Hubble recorded the inner detail of the nebula, and the CTIO telescope recorded the fainter outer regions. The combined image spans 287 arcminutes (5.6 light-years). The Hubble images were taken on November 19, 2002, and the CTIO images on Sept. 17–18, 2003

light-years. Most likely, this arc represents recently ionized gas released much earlier during the stars red giant phase. Double and rotationally symmetric structures are common in planetary nebulae, but their origin remains a mystery. The different time scales of the inner and outer ring components suggest a rapid change of the nebula's axis during a short period of about 5,500 years.

The inner ring of the nebula shows a series of radially arranged cometary knots that exist in a circumferential ring several trillion miles from the hot central star. Each knot is about the size of our Solar System. Cometary knots are a phenomenon seen in other planetary nebula, too. The knots are several billion miles across and exhibit comet-shaped tails pointing to the central star and stretching some 100 billion miles in length. The cometary structures are thought result when two expanding gas fronts with different temperatures and densities collide. The collision causes the gaseous mixture to become unstable in a phenomenon known as Rayleigh-Taylor instability. This results in the fragmentation and condensation of the gas into large droplets that we see as the comet heads.

In pop culture the Helix Nebula has sometimes been referred to as the *Eye of God*, or the *Eye of Sauron*.

The Cat's Eye Nebula

The Cat's Eye Nebula, designated in the new general catalog as NGC 6543, is a planetary nebula located towards the constellation Draco at a distance of 3.3 light-years from Earth. As the gaseous remains of a dying star, the Cat's Eye has several distinctions. For example, its spectrum was the first to be investigated. This was accomplished by the English amateur astronomer William Huggins in 1864. His analysis demonstrated, for the first time, that planetary nebulae consist of rarefied hot gases unlike the stellar spectral characteristics of spiral nebulae. NGC 6543 is also considered one of the most complex nebulae known. Hubble Space Telescope images and more recent exposures across the electromagnetic spectrum have cast considerable light on its complex structure and evolution.

Planetary nebulae represent the late evolutionary stage of low to intermediate mass stars with 1–8 solar masses. A star of this mass spends most of its life on the main sequence fusing its hydrogen fuel to helium deep within its core. Towards the end of the star's life, the hydrogen fuel becomes depleted allowing gravity to precipitate the core's contraction. This results in a rise of the core temperature and a somewhat paradoxical expansion of the star's outer layers that cool the surface of the star. The star bloats 100 times its original size and its luminosity increases. At this stage the star is known as a red giant. Eventually its hydrogen fuel becomes completely depleted allowing the core to further contract. When this occurs, the core's temperature rises to about 300 million degrees and the extreme heat triggers the onset of helium fusion. At this stage, the star has found a new energy source; however, it won't last very long.

The onset of helium fusion raises the star's surface temperature and moves the star on a path of the Hertzsprung-Russell diagram that is almost aligned with its previous red giant track. Now it is classified as an Asymptotic Giant Branch star. When our Sun reaches the Asymptotic Giant Branch phase in about 5 billion years, its radius will extend past Earth's orbit potentially swallowing our planet if Earth has not already been pushed further out into the solar system by then.

Asymptotic Giant Branch stars become unstable and their instability induces them to pulsate erratically. These pulsations spur the star to lose half its mass. Much of the mass is converted into dust that eventually surrounds the dying star with a shell so opaque light becomes blocked and the star disappears from optical sight. This stage of the star's death is followed by a period of more profound mass loss called the *superwind phase*. During this chapter, dynamic interaction between fast and slow winds ultimately forms the complex shell structure observed in planetary nebulae.

Ultimately the Asymptotic Giant Branch star sheds so much mass the hot stellar core becomes exposed. The star's core is now reduced to about .6 solar masses but its temperature is incredibly intense. Gravity forces the star's hot stellar interior to collapse into an extremely compact object known as a white dwarf star. Within the white dwarf the electrons of every atom are pushed extremely close to their nucleus. Thus the white dwarf is an extraordinarily massive object with a density of one metric ton/cubic centimeter. White dwarf stars release copious amount of ultraviolet radiation that ionizes the surrounding shells of gas and dust thus causing them to glow. This marks the beginning of the star's planetary nebula phase. For most stars this is the final stage because forces known as electron degeneracy pressure prevents the core from collapsing further.

The Hubble Space Telescope initially pointed its mirror to the Cat's Eye Nebula in 1994. But, it returned for another look in 1997, 2000, and 2002. The last session was imaged with the telescope's third generation Advanced Camera for Surveys detector. The Hubble's unprecedented resolution revealed for the first time a bull's eye pattern of 11 or more concentric rings around the central white dwarf star. Each ring is thought to be a separate bubble of gas providing strong evidence that the initial ejection of gas from the late stages of the progenitor star occurred episodically about every 1,500 years.

Multi-wavelength imaging has contributed considerable information about the structure and dynamics of the Cat's Eye Nebula. Recent observations at infrared wavelengths confirmed an abundant concentration of stellar dust believed to have formed during the Asymptotic Giant Branch phase of the progenitor star's existence. X-ray observations revealed the presence of extremely hot 1.7 million degrees Kelvin gas produced by the violent interaction of the stellar remnant's fierce wind with its previously ejected material. Although not visible in the accompanying image, deep ground-based narrowband

imaging has confirmed an enormous but extremely faint halo of gas surrounding the Cat's Eye Nebula spanning almost 3 light-years. Recently, a number of planetary nebulae have been observed to possess similar very faint outer halos or shells that were likely formed from material ejected during earlier active episodes 100,000 years prior to their planetary nebula phase.

Establishing distances to planetary nebulae has always been challenging. The ability of HST to image the Cat's Eye Nebula on four separate occasions from 1994 to 2002 helped establish its distance within a small margin of error. Like all planetary nebulae, the Cat's Eye is expanding. Its rate of expansion is about 16.4 km/second. This information has enabled astronomers to establish that the planetary nebula is 3,300 light-years from Earth and about 1,000 years old.

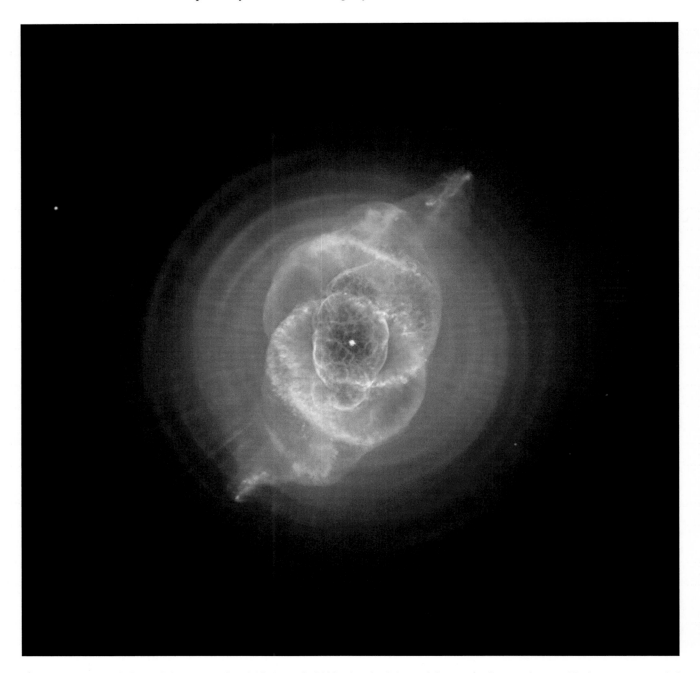

Fig. 5.17 The Hubble Space Telescope produced this image in 2002 using the Advanced Camera for Surveys detector. The image was recorded through narrowband filters and composed to produce a false-color image highlighting regions of high and low ionization. Three images were taken, in filters isolating the light emitted by singly ionized hydrogen at 656.3 nm, singly ionized nitrogen at 658.4 nm, and doubly ionized oxygen at 500.7 nm

Light Echoes from V838 Monocerotis

Stars are not static light sources. They are dynamic engines of light and radiation that change over time. That said, most stars, such as our Sun, are stable and do not vary their energy output over the eons. There is, however, a subset of stars that fluctuate the amount of radiation they release considerably over very short periods of time. The reasons for their light oscillations

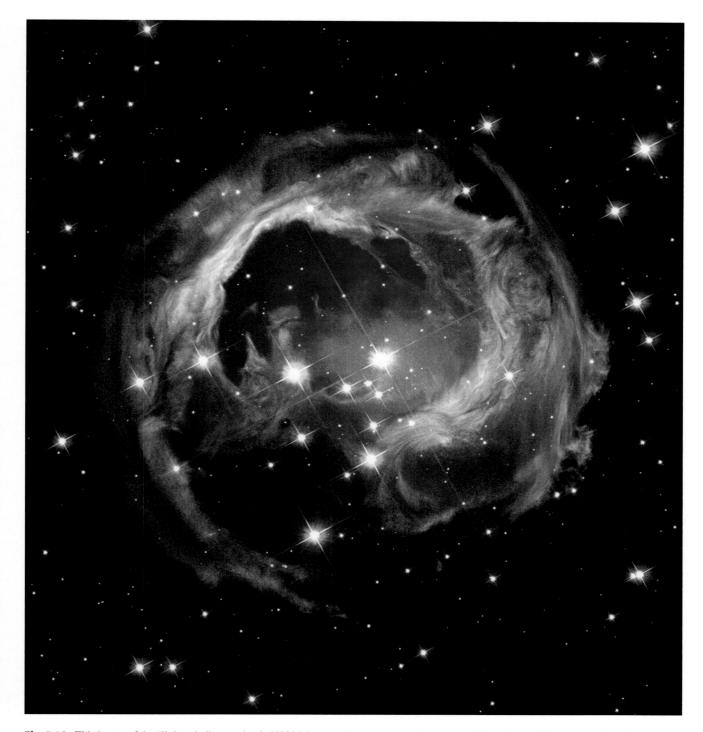

Fig. 5.18 This image of the "light echo" occurring in V838 Monocerotis exposed on February 8, 2004, with the ACS through visible light broad-band filters, is reminiscent of an impressionist painting, At the center of the expanding cloud of swirling dust (recently illuminated but released thousands of years earlier) is a peculiar young star from which a bright flash of light was emitted approximately 2 years before this image was taken. The light "echoes" from the expanding dust cloud transiently illuminate the swirling dust as it passes outward through the complex

include both internal and external causes. For example, the radiation released by a star can be eclipsed by a companion star if it is part of a binary system. This occurs when one star passes in front another along our line of site. One member of the stellar binary can also gravitationally accrete material from the other causing it to become temporarily unstable. The surfaces of some stars pulsate, often with predictable regularity, like a balloon inflating and deflating. This modifies their surface temperature and that increases or reduces the amount of radiation they release. Over 150,000 stars have been officially cataloged as *variable stars*. Most likely there are many more yet to be discovered in our galaxy.

A fascinating example of a variable star that has received great attention is V838 Monocerotis, a red supergiant variable star toward the constellation Monoceros and located at a distance of about 20,000 light-years from our planet. This star first came to the attention of astronomers in January 2002, when it underwent a tremendous and rapid brightening. During the outburst event, the normally faint star suddenly brightened, becoming 600,000 times more luminous than our Sun. For a short time it was one of the brightest stars in the entire Milky Way.

This phenomenon is known as a *light echo*. It was created when a massive pulse of light released by the star during January 2002 collided with a cloud of dust and gas released by the star during a much earlier period of instability, possibly as long as tens of thousands of years ago. The dust, previously invisible at optical wavelengths, became highly visible after contact with the light pulse. In a series of Hubble images the illuminated cloud around V838 Monocerotis shows fantastic eddies and turbulent swirling structures produced within the cloud as it expands from the supergiant star.

Hubble began imaging V838 Monocerotis in 2002, following the initial outburst, and continued to observe it on multiple occasions until 2006. Although the outburst lasted only three months, the changes occurring in the spectrum of the star and the structure of the cloud over an extended period of time gave interesting clues about the physical processes responsible for the observed phenomenon.

Initially, several different mechanisms were proposed to explain the outburst. Light echoes of this type initially raised the possibility of either a nova or supernova. Novae typically occur when the amount of material accumulated by a white dwarf from its binary companion triggers a thermonuclear explosion. Supernovae occur when a start detonates and completely destroys itself. The nova hypothesis lost favor because V838 Monocerotis was not observed expelling its outer layers. Instead, the star grew to an enormous size.

It seems that the V838 Monocerotis light echo is best explained by the *stellar binary merger model*, also known as a mergeburst. A mergeburst occurs when the orbits of two stars evolving toward or on the main sequence interact and merge into a single star.

Data supporting this theory include observations that the progenitor star was a young 8 solar mass B-type main sequence star. 3D computer simulations have predicted merging binary systems release energy and eject mass in a manner entirely consistent with observations of V838 Monocerotis. Although the mergeburst is currently the favored hypothesis, the jury is still out.

The Fate of Comet Shoemaker-Levy-9

Some 4.5 billion years ago, when our Solar System was coalescing from the disc-shaped cloud of gas and dust left over from the Sun's formation, celestial collisions were not only common but practically defined that period. Known as the heavy bombardment era, it lasted several million years and ended somewhat abruptly approximately 3.8 billion years ago at a time that coincides with the first evidence of life on Earth.

Despite the relative calm of the Solar System since that time celestial collisions still occur sometimes with devastating consequences such as the K-T extinction event. The K-T event took place around 65 million years ago when a massive 6-mile (9.6 km) wide comet or asteroid impacted Earth and caused a catastrophic cascade of damage to the global environment resulting in a major extinction of life on our planet that included the dinosaurs.

In modern times a major celestial collision has never been directly observed until July 16, 1994. Serendipitously discovered by a trio of comet lovers named Carolyn Shoemaker, her husband Eugene M. Shoemaker and amateur comet hunter David Levy, Comet Shoemaker-Levy 9 was first spotted on the night of March 24, 1993 in a photograph taken with a modest 15-inch (0.4 m) Schmidt telescope at the Palomar Observatory in California. This marked the comet hunting team's ninth discovery. But this comet was unlike any the team or anyone else had identified.

The comet's position in the sky was only 4 degrees from Jupiter. Initially, this was thought to be a line of site phenomenon but it was eventually determined the interloper was in fact orbiting the gas giant. The comet was believed to have been captured from its solar orbit by Jupiter's strong gravity and forced into orbit around the solar system's largest planet approximately 20 or 30 years earlier.

Significantly, the comet was fragmented into 21 individual nuclei, later designated *A* through *W*, traveling together in a loose, highly eccentric orbit around Jupiter. Calculations suggested Comet Shoemaker-Levy 9 was probably broken into

Fig. 5.19 This composite image was assembled from separate images of Jupiter and comet Shoemaker-Levy 9, taken by the NASA/ESA Hubble Space Telescope during May in 1994. The image of Jupiter was taken on May 18, 1994, while the image of the comet, showing all 21 fragments, was taken on May 17, 1994. The fragments collided with Jupiter from July 16 to 22, 1994, producing the largest, most energetic impact event on another planet ever observed

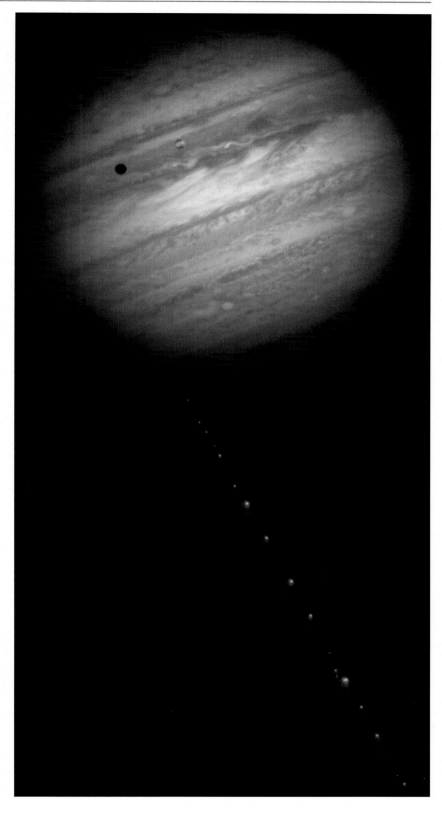

pieces during an extremely close encounter with Jupiter on July 7, 1992 when it came within 25,000 miles of the gas giant's surface. Team member Eugen Shoemaker lovingly referred to the trail of cometary fragments as a string of pearls he gifted to his wife and fellow comet hunter, Carolyn.

Global interest in Shoemaker-Levy 9 dramatically escalated when calculations of its orbit predicted all fragments would eventually crash into Jupiter's cloud tops over a 5 day period in July 1994. The intact original comet was estimated to be about 3.1 miles across. The sizes of the fragments ranged from a few hundred meters to two kilometers across with the largest fragments, G, K, and L, exceeding those size estimates. Therefore, the impact events were predicted to be significant.

The first impact occurred on July 16, 1994, when fragment A entered Jupiter's southern hemisphere at a speed of about 60 km/second. Over the next 6 days, a total of 21 impacts were observed, with the most dramatic coming on July 18, when fragment G struck Jupiter. Many ground-based telescopes and several space-based instruments were poised to record the event. The Hubble Space Telescope, the ROSAT X-ray observing satellite, the Galileo probe in route to Jupiter, the Ulysses spacecraft and even the distant *Voyager 2* all recorded the impacts at a variety of wavelengths from different perspectives.

Although the actual impacts occurred on the side of Jupiter opposite Earth, the planet's rapid rotation brought the sites quickly into view. 15 of the 21 fragments produced impact features on the planet visible to the Hubble Space Telescope. The Galileo spacecraft, then on its way to a scheduled 1995 rendezvous with Jupiter, was able to record the first impact's large fireball. Its plume quickly reached a height of over 3,000 km. All impacts left dark asymmetric spots of impact debris scattered across Jupiter's cloud tops.

The largest impact occurred on July 18 when fragment G struck the planet. It created a dark spot over 12,000 km across and released the energy equivalent of 6 million megatons of TNT or about 600 times the world's nuclear arsenal. For an interesting perspective, the K-T extinction event impact on Earth mentioned earlier produced an energy equivalent of 100 trillion tons of TNT.

The encounter of Comet Shoemaker-Levy 9 with Jupiter also left an impact back here on planet Earth. First scientists then the general public, by way of the event's mass media coverage, suddenly realized the vulnerability of our planet to random cosmic events. The destructive power seen on Jupiter unleashed by objects as small as two kilometers across were disturbing to many. If a relatively small piece of a comet could wreak such havoc on giant Jupiter, what would a similar impact reap here on Earth? Would humanity survive?

At that time, there was no coordinated effort to identify objects that might cross paths with Earth and strike our planet. In 1998, as result of the Comet Shoemaker-Levy 9's collision with Jupiter, the US Congress instructed NASA to discover 90 % of the near Earth objects larger than 1 km in diameter. Congress extended that goal in 2005 to include 90 % of the near Earth objects larger than 140 m.

There are thought to be about 1,000 near Earth objects larger than 1 km and roughly 15,000 larger than 140 m. Scientists and engineers are still debating how to prevent a comet or asteroid impact on Earth should the near Earth object survey identify an interplanetary interloper on an orbital path intersecting with our planet.

NGC 1999

Located about 2 degrees south of the Orion Nebula, NGC 1999 is a classic reflection nebula illuminated by the lone star V380 Orionis. The nebula lies within a vast stellar nursery known as the Orion A molecular cloud complex. NGC 1999 is a distinctive, fascinating and striking object that was brought out of obscurity into the public's awareness when the Hubble Space Telescope recorded its portrait in January 2000 .

NGC 1999 is notable for a dark T-shaped cavity located centrally in the nebula about 20 arcseconds southwest of V380 Orionis. The small dark cloud is designated *Parsamian 34* and its nature has been somewhat controversial. It was for a long time believed to be an example of a *Bok globule*, named after the late University of Arizona astronomer Bart Bok. More recent studies suggest it may in fact represent a peculiar-shaped hollow cavity within the reflection cloud.

The spectrum of the central star V380 Orionis and the nebula are identical. This indicates the nebula does not emit any light therefore the blue light from NGC 1999 is essentially reflected starlight. Reflection nebulae owe their appearance to blue starlight scattered by microscopic dust grains ranging in size from 0.2 to 0.5 microns. This is very small. For example, the particles in cigarette smoke are boulders compared to interstellar dust grains. Since blue light has a similar wavelength to the size of the nebula's dust particles it is reflected whereas the longer wavelengths, such as red light, pass between the dust grains. The true nature of reflection nebulae was discovered by American astronomer Vesto M. Slipher in 1912, when he found the spectra of the Pleiades reflection clouds and its stars were identical.

The geometry of NGC 1999 is that of a star centrally imbedded within a dense cloud of dust. V380 Orionis lies approximately a third of a light-year deep to the surface of the cloud as seen by the observer. V380 Orionis is a pre-main sequence B9 white star known as a Herbig Be star. It 3.5 times more massive than our Sun and its surface temperature of about 10,000 degrees Celsius is nearly twice that of our Sun. These 2–8 solar mass pre-main sequence stars are defined by their association

with dust clouds and specific spectral lines. There are many similarities between V380 and another Herbig Be star designated HD 200775. That star illuminates a well-known reflection nebula known as the Iris Nebula, or NGC 7023.

NGC 1999 was discovered by Sir William Herschel and his sister Caroline in the late 1700s. They added it to their *New General Catalogue* or NGC as object 1999. This region is also famous for two bright Herbig-Haro objects designated HH-1 and HH-2, which exist very close to this nebula but are just outside the Hubble image. They represent the first of these objects recognized by Mexican astronomer Guillermo Haro and American astronomer George Herbig in 1950. The nature of these objects was unknown to Herbig and Haro at the time they were catalogued, but astronomers now know they are the visible light signature of imbedded protostars.

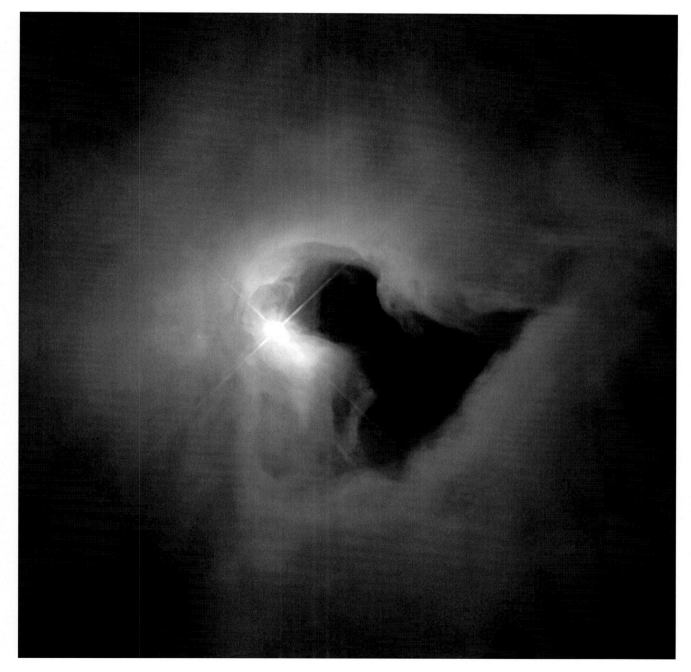

Fig. 5.20 This image was recorded in January 2000, soon after NASA astronauts repaired the Hubble Space Telescope in December 1999. The WFPC2 image of NGC 1999 was recorded through three broadband filters: F450W (blue), F555W (green), and F675W (red). The blue reflection nebula is illuminated by the bright star, V380 Orionis, visible in the image just to the left of center

The Hubble Deep Field

There exist only a few images that capture the imagination of people in a way that literally changes their perspective on the universe. The Hubble Deep Field is one such image. Although surpassed by more recent deep fields, the original Hubble Deep Field was a landmark achievement that shattered barriers of distance and time by taking astronomers back to an era when the universe was both young and quite different than it is today.

The Hubble Space Telescope was conceived for many reasons, but one of its primary purposes was to study distant galaxies in ways not possible from the ground. After its optics were restored in 1993 the instrument was ready to achieve its objectives and reach for greatness.

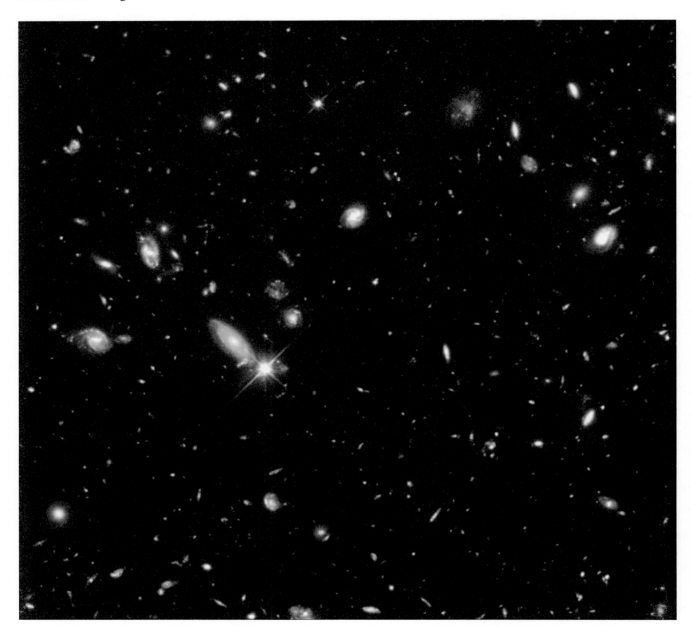

Fig. 5.21 The original Hubble Deep Field was released on January 15, 1996. Although the target was an unassuming and relatively tiny region of the sky, the unprecedented depth of the image reached further back in time than ever before. The modest field revealed almost 3,000 galaxies, some in the earliest stages of formation, less than a billion years after the Big Bang. A colossal undertaking, the visible light true-color image was exposed for ten consecutive days between December 18 and 28, 1995. It was truly a milestone image that contributed greatly to what we know about the early universe. The image here is a crop of the full field showing innumerable distant galaxies filling the field. Aside from a few foreground stars all objects and point sources in the image represent distant galaxies

In 1995 Robert Williams, the director of the Space Telescope Science boldly decided to donate his discretionary time allotment on the HST so it could be used to explore the deep universe in ways never previously imagined. He proposed an unprecedented deep field image created by an extremely long cumulative exposure. The patch of sky selected would need to have a high galactic latitude so dust in the plane of the galaxy that would prevent a clear deep view into the Universe could be avoided. It was also crucial to steer clear of bright visible stars or intense infrared, ultraviolet and X-ray sources because the plan included future investigations of the same field at a variety of wavelengths.

After reviewing a list of 20 potential target fields during a year of preparation, a small patch of sky only 5.3 arcminutes wide located in the constellation Ursa Major at RA 12 h 36 m 49.4 s and Dec +62° 12′ 58″ was deemed to fulfill the necessary criteria. The imaging strategy was to record exposures through four broadband filters covering the spectrum from near UV through the visible to near IR at 300 nm, 450 nm, 606 nm, and 814 nm. 342 images of the target area were exposed during 150 different orbits between December 18 and December 28, 1995. This produced 141 hours of total exposure during the 11.3 days of prime observing time.

Ultimately a tricolor image was prepared using separate exposures produced through 814 nm red, 606 nm green and 450 nm blue filters. After considerable image processing the final color image was released at a meeting of the American Astronomical Society in January 1996. An astounding 3,000 distinct galaxies could be identified in the single penetratingly deep image.

The Hubble Deep Field provided a bounty of cosmological information requiring years of analysis and ultimately spawned about 800 scientific papers as of 2008.

Significantly, the image revealed large numbers of galaxies with high redshift values. Redshift is a measurement of light displacement toward the red end of the spectrum. The amount of redshift tells astronomers how fast a galaxy is receding from the Milky Way and this can be translated into its distance. Prior to the Hubble Deep Field very few galaxies with redshifts greater than one were known. The deep field image revealed numerous galaxies with redshifts as high as six that corresponds to a distance of approximately 12 billion light-years.

The Hubble Deep Field's greatest legacy was its view of the early universe, less than one billion years after the Big Bang. The field evidenced a time in the early universe when it was teaming with disturbed and irregular galaxies. The image also revealed a disproportionate number of galactic collisions and mergers that are characteristic of an earlier, more turbulent epoch of galaxy formation.

The original Hubble Deep Field was a milestone and its cosmological legacy will be a lasting one. The Hubble Space Telescope probed even deeper with subsequent deep field projects such as the Hubble Deep Field South in 1998, the Hubble Ultra-Deep Field in 2003, the Hubble eXtreme Deep Field in 2012 and most recently the UV enhanced Hubble eXtreme Deep Field of 2014.

The Hubble eXtreme Deep Field was not a new set of observations. Instead, it combined previous deep explorations produced over a 10 year period, including infrared observations, into a single extraordinary image that reached exceedingly far back in time. Where the original Hubble Deep Field image contained the equivalent of 11 days' observations, the eXtreme Deep Field comprised 23 days of cumulative exposure time. Thus, it provided a remarkable glimpse of the universe as it appeared only 450 million years following the Big Bang.

IC 349: Barnard's Merope Nebula

IC 349 is a small but disproportionately bright extension of NGC 1435, the Merope Nebula, located in the Pleiades star cluster. It lies about 30 arcseconds southeast of the 4.2 magnitude star Merope. This separation corresponds to about 0.06 light-years. The small reflection cloud was discovered by American astronomer Edward Emerson Barnard in 1890 thus it is also known as called Barnard's Merope Nebula. Reflection nebulae are made visible when starlight is reflected from the surface of countless microscopic dust particles present in the clouds that often surround young stars. This relationship was confirmed for IC 349 by the similarity its spectra with the central illuminating star.

IC 349 is often lost in conventional photographs because of Merope's overwhelming brightness. When images are carefully exposed and enhanced, the nebula displays considerable structure and appears as a bright fan-like condensation of the more diffuse Pleiades nebulosity. Surprisingly, it is the brightest portion of the Pleiades nebulosity by a factor of 15.

A further discussion of IC 349 needs to begin with the Pleiades, also known as the Seven Sisters or M 45.

The Milky Way is filled with hundreds of open star clusters. But, the Pleiades' proximity enables close inspection of a young open cluster and the fascinating interplay of a moving star cluster with the interstellar medium.

The Pleiades is currently traveling through space at about 40 km per second. The cluster's compactness is indicative of its young age because its constituent stars were only formed about 100 million years ago and will probably travel together through space for another 250 million years before the Milky Way's gravity disperses its members into individual field stars. Although the core of the cluster contains some 100 bright stars, the total number of stars may approach 400. Historically, the Pleiades have had astronomical significance. For example, an explanation explaining why reflection nebulae shine was first revealed in 1912 by American astronomer Vesto Slipher when he discovered the Pleiades' cloud and its stars shared the same spectra.

Serendipity created a magnificent astronomical spectacle in the Pleiades because this cluster of young stars experienced a chance encounter with an isolated portion of the Taurus-Auriga molecular cloud. So, unlike most star clusters, the rich blue clouds and delicate tendrils of reflection nebulosity surrounding the brightest members of Pleiades originated in an unrelated molecular cloud and do not represent the ancestral nebula of cold molecular hydrogen and dust that originally gave rise to these stars.

So in essence the Pleiades is a galactic vagrant that has wandered into the interior of another molecular cloud. Recent data suggest that the collision may have been more complex than suspected, possibly involving separate molecular clouds having different paths, velocities and origins.

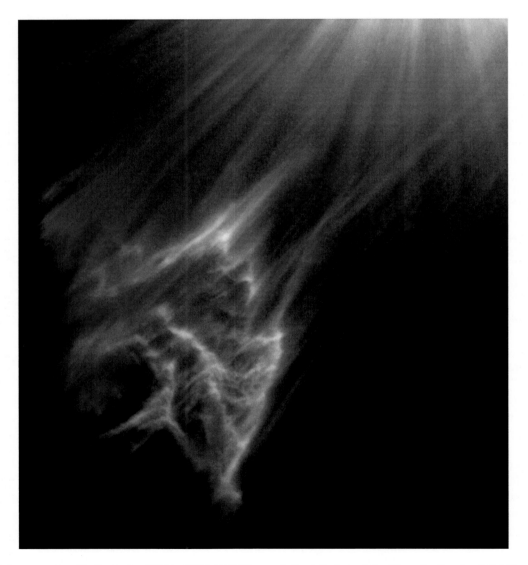

Fig. 5.22 This image, captured in September 1999 by HST's WFPC2, reveals the delicate tendrils of the reflection cloud IC 349, which is illuminated by the bright star Merope (off the *upper right* of the image). Small dust grains that make up IC 349 reflect the starlight from Merope, making the nebula visible. The parallel wisps of material extending from lower left to upper right are genuine features, seen for the first time in this remarkable image

What accounts for the delicate form and the tendrils of IC 349? The cloud is drifting through the Pleiades and is moving closer to Merope at about 11 km/second. It's believed the strong light from Merope shining on the dust in IC 349 is sufficient to decelerate its particles through a phenomenon known as radiation pressure. This is possible because interstellar dust particles are smaller than most bacteria. They range in size from 0.2 to 0.5 microns and have miniscule amounts of mass. In the presence of radiation pressure, smaller dust particles decelerate faster than the larger ones.

So, the parallel lines of nebulosity pointing toward Merope represent streams of larger particles, less impeded by radiation pressure, that continue to move toward the star. Thus, as the cloud approaches the star its dust particles are sifted by size thus creating the nebula's unique and delicate form.

Fomalhaut b

Fomalhaut is the brightest star in the southern constellation Piscis Austrinus, and at visual magnitude 1.16 one of the brightest stars in the sky. It is also known as Alpha Piscis Austrini or by its stellar designation of HD 216956. Fomalhaut holds a special significance in the field of extrasolar planet research because in 2008 it was the first stellar system declared to have an extrasolar planet candidate, named Fomalhaut b, photographed at visible wavelengths.

Fomalhaut is a 200-million-year-old star that resides 25 light-years from the Sun, and it is surrounded by several disks of debris. A debris disk is the orbiting remains of the planet formation process containing particles ranging in size from microscopic dust grains to planetesimals that failed to coalesce into planets. The thermal emission of dust heated by the star Vega was the first extrasolar debris disk discovered in 1983 by the Infrared Astronomical Satellite, also known as IRAS. Since 1983 circumstellar dust has been found to exist around several hundred main sequence stars. Most debris disks are observed in the far infrared because they are cold and dusty.

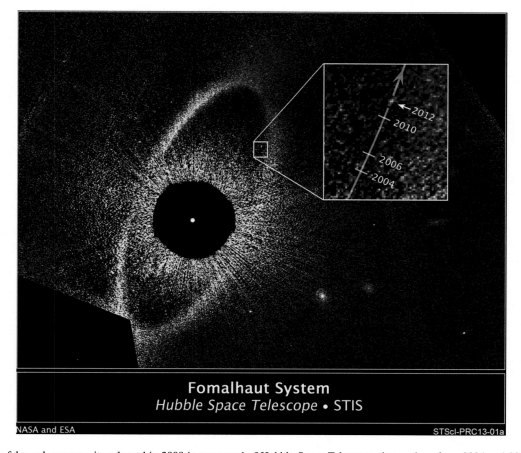

Fomalhaut System
Hubble Space Telescope • STIS

NASA and ESA STScI-PRC13-01a

Fig. 5.23 This false-color composite released in 2008 is composed of Hubble Space Telescope observations from 2004 and 2006 showing the change in position of the newly discovered planet, Fomalhaut b, during its 2,000-year orbital path around its parent star, Fomalhaut. With additional 2012 data the orbital period was revised up from 872 years (2008) to 2,000 years (2012). The composite images were obtained using the Advanced Camera for Surveys' coronagraph to block out the bright glare from nearby Fomalhaut, so that the dim planet could be detected

The debris disks are believed to form immediately following the protoplanetary disk phase of an intermediate-mass star during the first billion years after its thermonuclear furnace ignites and the star makes its appearance on the main sequence. Although planets are thought to form during the first 10 million years that mark the earlier and much more brief protoplanetary disk phase, planetesimals, asteroids, and small icy bodies comprising Kuiper Belt material are believed to form during the latter circumstellar disk phase.

2004 Hubble observations of Fomalhaut produced the sharpest visible light images ever produced of a circumstellar disk stretching some 21.5 billion miles across. Those HST observations also revealed an unexpected offset of the disk. They also detected a difference between the inner and outer edge structure. Together this predicted a gravitational body, presumed to be an unseen planet, lying between the star and the ring's inner edge.

On November 13, 2008, astronomers announced evidence of the elusive object predicted to exist in 2004. This became known as Fomalhaut b. Fomalhaut b was identified in HST images as an extrasolar planet orbiting 1.8 billion miles inside the ring's inner edge. This milestone observation constituted the first extrasolar object orbiting another star detected in visible light. The work is very significant because it offers a snapshot of similar conditions within our own Solar System some 4 billion years ago.

A series of observations obtained in 2004, 2006 and later in 2012 by Hubble's Advanced Camera for Surveys' coronagraph tracked Fomalhaut b and showed the object is traveling along a gravitationally bound path around its sun in a 2,000-year-long elliptical orbit. The highly elliptical orbit takes the planet from its innermost distance of 4.6 billion miles to its outermost point 27 billion miles away from the star.

The newborn 100-million-year-old star is burning hydrogen at a rate that predicts it will burnout in only 1 billion years or about 1/10th the predicted lifespan of our Sun. Therefore, there is little hope for advanced life to evolve on any planet orbiting Fomalhaut. Future observations with NASA's pending James Webb Space Telescope will hopefully shed more light on Fomalhaut b and tell us whether the planet possesses Earthlike characteristics such as an atmosphere containing water vapor.

M100 Cepheids: A New Cosmic Yardstick

Measuring distances to deep space objects has historically been one of the most supremely important and intensely pursued objectives in astronomy. Precise measurement of the universe and its constituents has implications for almost all fields of astronomy, especially the branch that studies the origin and evolution of the universe called cosmology. The tools of measurement have for the most part relied on a handful of methods having their own limits and flaws.

The early work of Henrietta Swan Leavitt and Edwin Hubble using Cepheid variable stars to measure the distance to other galaxies represented a monumental advance that, for the first time, provided a reliable yardstick to measure the universe. The refinement of that scale has remained one of the most important goals in cosmology ever since.

Distances to relatively nearby objects less than 150 light-years away can be calculated using parallax in which an object's movement in the sky over a specific period of time can be used to determine its exact distance from Earth. More remote objects require a standard candle that astronomers use to estimate the vast distances to objects outside our galaxy. Certain types of variable stars with fixed luminosity-brightness relationships, such as Cepheid variable stars, have been of paramount importance for estimating distances to galaxies within 100 million light-years.

Unfortunately, individual stars located further than 100 million light-years from our planet cannot be resolved, so other means of estimating distance to remote galaxies are employed. These include the use of bright supernovae or recessional velocities, because the recessional velocity of a galaxy will increase in proportion to its distance from us due to the expansion of the universe. One of the original goals of the Hubble Space Telescope was to determine the size and age of the universe through observations of Cepheid variables in distant galaxies.

Edwin Hubble's discovery that the universe is expanding is arguably the most important revelation ever made in cosmology. The rate of expansion remained a vexing question for the remainder of the twentieth century because it had broad implications for estimates about the size and age of the universe. Hubble's initial value for the expansion rate, now called the Hubble constant, was approximately 500 km/second/megaparsec in his landmark 1929 paper. The age of the universe based on this value was only 2 billion years. The value of the Hubble constant was reduced in 1956 to 180 km/second/megaparsec and again in 1958 to 75 km/second/megaparsec. By the 1970s the accepted value continued to be controversial and ranged from 55 to 100 km/second/megaparsec.

Mathematically the Hubble constant, or Ho, is expressed as the equation $Ho = v/d$ where v equals the galaxy's radial outward velocity; d equals the galaxy's distance from Earth and Ho equals the current value of the Hubble constant. The radial

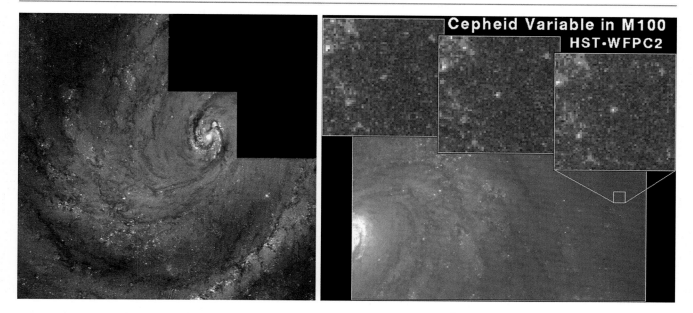

Fig. 5.24 The Hubble Space Telescope made twelve 1-hour exposures, during a 2-month observing window from April 23 to May 31, 1994, using the Wide Field Planetary Camera 2, to discover 20 Cepheid variable stars in the M100 galaxy. M100 is a member of the Virgo cluster, which consists of an estimated 2,500 galaxies. The light curves of the Cepheid variable stars were used to obtain the most precise distance measurement ever for M100. This and other Cepheid data was then used to calculate a new value for the Hubble constant. (**a**) Full field image of M100. (**b**) A sequence of images of a small field of M100, demonstrating the periodic pulsation of a Cepheid variable

outward velocity is derived from spectroscopic observations of the galaxy's redshift. However, the galaxy's precise distance from Earth is the most challenging variable.

An accurate determination of the universe's age hinged on a precise and reliable value for the Hubble constant. But, this could only be determined with precise distance measurements. So, it became an essential task of the Hubble Space Telescope to help achieve this goal.

After the first Space Shuttle servicing mission in December 1993 that corrected the telescope's primary mirror optical aberration, Hubble was finally able to produce images with a resolution that exceeded anything observed with ground-based instruments.

Prior to Hubble, the best ground-based observatories were able to detect Cepheids in nearby galaxies up to 12 million light-years in the distance. However, because the motions of galaxies at this distance are affected by the gravity of neighboring galaxies, it would be necessary to observe to Cepheid variable stars within galaxies at least 30 million light-years away to effectively study the overall expansion of the universe. A new era in detecting and measuring Cepheids was finally achieved using the refurbished optics of the Hubble Space Telescope. The project became known as *The Hubble Space Telescope Key Project on the Extragalactic Distance Scale*.

On December 31, 1993, using the freshly installed Wide Field Planetary Camera 2 or WFPC 2 and its corrected eyesight, the HST recorded multiple images of the face-on spiral M100 resolving at least 20 Cepheid variable stars in its spiral arms. From observations of their pulsation periods astronomers calculated how distant the stars must be to appear at the observed brightness magnitude. This produced a very precise value for the galaxy's distance at 56 million light-years, making it the farthest extragalactic object to have its distance precisely measured. Based on this information, the revised Hubble Constant value yielded a value of 80 km/second/megaparsec with an error of ±17 km/second. This value is still being refined today.

Sh2-106: A Celestial Snow Angel

Sharpless 2–106, also known by its common name of the Celestial Snow Angel, is a region of active star formation classified as an H II region or emission nebula. Sharpless 2–106 is located about 2,000 light-years from Earth within an isolated part of the Milky Way that lies towards the summer constellation Cygnus.

The nebula received its somewhat unusual designation from US astronomer Stewart Sharpless who worked at the U. S. Naval Observatory in Flagstaff, Arizona. In 1953, Sharpless published a catalogue of 142 H II emission nebula regions

designated Sh1. He updated this listing in 1959 with a final version featuring 312 nebula with the new additions noted as Sh2. Both catalogs were based on images from the Palomar Sky Survey.

The story of emission nebulae and star formation begins with a primordial cloud of dust and gas known as an interstellar molecular cloud. Formed from the interstellar medium molecular clouds are comprised of 1 % dust particles less than a micron in size and 99 % gas. 90 % of the gas is hydrogen and 10 % is helium. A small fraction of the molecular cloud consists of more complex molecules including water, hydrocarbons, ammonia and silicates.

Because of extremely cold temperatures, only a few degrees above absolute zero, elements in a molecular cloud exist in molecular form as opposed to individual atoms and ions which exist only at higher temperatures. As molecular clouds orbit a galaxy they come into contact and interact with other matter, including other molecular clouds, the galaxy's spiral arm structure, and supernovae shock fronts. These exert forces that can trigger the cloud to fragment and collapse.

Once the cloud begins to fragment, isolated concentrations known as *cores* begin to form. Under the influence of gravity the cores further contract and begin to generate heat. As the temperature and density of the cloud increases, infant stars known as protostars begin to form from the cores. During the process of star formation, the fledgling star eventually ignites its nuclear furnace and the star enters the mature phase of its existence known as the main sequence. The time from the start of core collapse to a mature star can span up to a million years. The most massive and hottest O- and B-type stars play a critical role because their intense UV radiation excites the remaining nearby gases.

Emission nebulae such as Sharpless 2–106 form when large amounts of ultraviolet radiation is released by hot massive young stars into the remaining molecular cloud where they formed. The ultraviolet light strips electrons from hydrogen

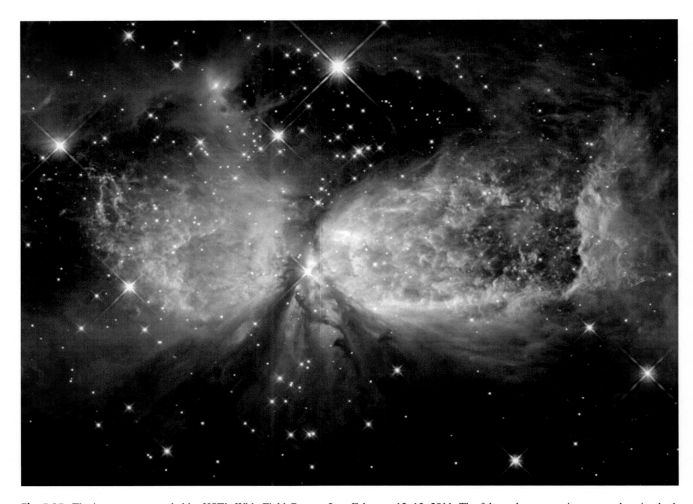

Fig. 5.25 The image was recorded by HST's Wide Field Camera 3 on February 12–13, 2011. The false-color composite was made using both broadband and narrowband filters in visible and infrared light. The palette of F160W (H) red, F110W (J) cyan, and F657N (H-alpha) blue was composed to highlight the different processes occurring in Sh2-106. Heated ionized hydrogen is seen as the central blue filamentary material, whereas the colder and more diffuse peripheral structure is visible in red hues. The central illuminating star is only inferred from its delicate glow in the center of the dusty complex

atoms within a radius of dozens or even hundreds of light-years in every direction by the process of *photoionization*. As the electrons randomly recombine with hydrogen nuclei, energy is emitted as light with some characteristic emission lines. For example, hydrogen glows in red light with a wavelength of 656 nm. The dominant emission line for hydrogen is termed HII, referring to the first ionization level of hydrogen. Hence the name of these clouds. Numerous H II regions exist in the spiral arms of the Milky Way and other spiral galaxies. They are regions of active star birth.

The story of Sharpless 2–106 follows the narrative of other emission nebulae or HII regions. The gases of Sharpless 2–106 are energized and illuminated by a single central hot star, designated S106 IR or Infrared Source 4. It's only visible at infrared wavelengths because it remains hidden from optical view by the dusty confines of Sharpless 2–106. Infrared Source 4 is a very young star that ignited its thermonuclear furnace and reached the main sequence only 100,000 years ago. It is approximately 15 times as massive as our Sun.

The bipolar structure of Sharpless 2–106 that resembles the outstretched wings of a snow angel is caused by twin opposing jets streaming from Infrared Source 4 that heat the surrounding nebulosity to a temperature of around 10,000 degrees Kelvin (9,700 C or 17,500 F). The heated gases emit light in a bi-lobed configuration. The hourglass shape stems from a ring of optically invisible gas and dust that cinches the center of the complex. Dust particles not ionized by the star's jets reflect its starlight.

With an estimated surface temperature of 37,000 K (66,000 C or 119,000 F), Infrared Source 4 is classified as one of the hottest type O8 stars . Its powerful and unstable nature results in the loss of considerable mass through its solar wind. It ejects material at 100 km/second losing 1/1,000,000 of a solar mass each year.

However, Infrared Source 4 is not the only young star within Sharpless 2–106. Astronomers have detected hundreds of low-mass brown dwarf stars and young protostars. Brown dwarf stars weigh less than a tenth of our Sun and do not produce energy though nuclear fusion. Thus they are regarded as failed stars.

The Hubble Frontier Field and Abell 2744

The original Hubble Deep Field and its successors emerged as some of the most successful endeavors of the Hubble Space Telescope. Early galaxy evolution remains one of the most compelling issues in astrophysics and the information gained by the deep field projects has shed critically important light on the early universe, particularly the first billion years of cosmic time when galaxies formed.

Spring boarding from the legacy of the Hubble Deep Field is a new project that promises to probe even farther into the era when the first primordial galaxies were assembling into the more complex and diverse galactic forms we observe today in the local universe.

The project involves a revolutionary use of naturally occurring gravitational telescopes, created by massive galaxy clusters, to magnify light from much more distant constituents of the early universe. The new initiative is known as *Hubble Frontier Fields* and it relies on gravitational lensing, a phenomenon predicted by Einstein's general relativity. According to *General Relativity*, massive concentrations of matter can bend the fabric of space-time in their vicinity thus magnifying light from far more distant sources located to their rear. The project entails the use of immense foreground galaxy clusters as lenses to magnify light coming from far more distant galaxies that existed when the universe was younger. Project researchers anticipate the magnification provided by a galaxy cluster will enable observations of far more distant galaxies 10–50 times fainter than would be otherwise possible without the lensing cluster. This novel technique should provide an unprecedented glimpse into the first billion years of the universe.

Modern cosmological theory presupposes the spiral and elliptical galaxies observed today were formed in the early universe by the hierarchical assembly of smaller units. Presumably, these were primitive dwarf galaxies created by matter coalescing from a near featureless even earlier universe. The portal to cosmology's greater understanding of this early galactic epoch requires the detection of galactic forms and their spectral information from that earlier time.

The most useful unit of measurement defining the earlier universe is the concept of redshift. Redshift is a measurement of distance that can be indirectly inferred by the frequency shift of distant light sources into redder lower energy frequencies. Measured spectroscopically, the amount of redshift is related to the speed the objects are moving away from us – the higher the redshift, the faster an object is receding. Since our universe is expanding in all directions, distant galaxies are receding from us at greater speeds than those located closer. Therefore, the light of distant galaxies is shifted further towards the red end of the spectrum.

The Hubble Deep Field project detected galaxies with a redshift greater than 8.0. This translates to a time only 500 million years after the creation of the universe in the Big Bang.

To provide some perspective it should be mentioned the most distant signal ever detected is the cosmic microwave background. This is the far redshifted light of the primordial universe before galaxies formed. It reaches back about 13.8 billion years into the past to a point only about 379,000 years after the initial moments of the Big Bang. The redshift of the cosmic microwave background observations is 1,089. For comparison, the redshift representing today is zero. Researchers anticipate

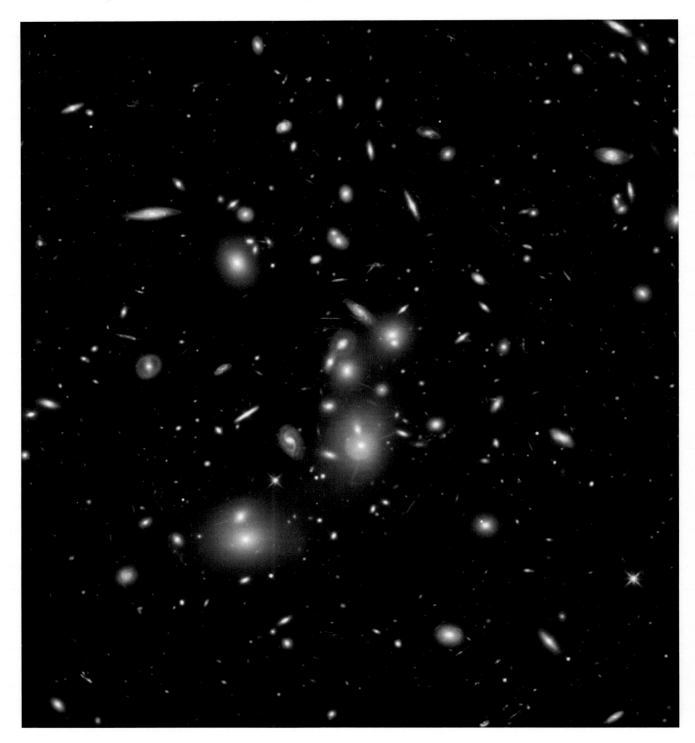

Fig. 5.26 The ground-breaking first image in the planned Hubble Frontier Field (HFF) project was exposed through both broadband and narrowband filters using Hubble's WFC3 and ACS detectors. The first completed set of images from this ambitious, collaborative, multiyear program, following on the heels of the Hubble Deep Field initiative, has exceeded expectations. Using the cluster as a lensing telescope has effectively increased the HST's aperture 10–50 times. Details within the image show numerous arcs, lines, and smudges representing distorted and enlarged images of distant galaxies behind the cluster, sometimes even replicating them. The data has been distributed widely to professional astronomers for detailed analysis

the Hubble Frontier Fields project will push the limits of our vision to the brink of cosmic dawn when the very first galaxies and stars were formed.

The Hubble Frontier Fields program is the highest priority of the Space Telescope Science. Therefore, it will be allotted considerable observing time and resources under the director's discretionary time. The current plan is to observe 4–6 strong lensing galaxy clusters in parallel with adjacent fields that do not have a natural lens with the goal of detecting and characterizing high redshift galaxies from the earliest epoch of galaxy formation yet observed.

Exploiting the lensing capabilities of massive galaxy clusters should enable researchers to identify remote objects with redshifts greater than 10 thus reaching galaxies 30 times fainter than those previously detected. The parallel blank fields will have comparable sensitivity and will expand the coverage area by a factor of three to include a much larger potential pool of high redshift galaxies. Multispectral information of these fields will be complemented by observations from the Spitzer Space Telescope and the Chandra X-ray Observatory.

With a look to the future, the same field will be observed by the James Webb Space Telescope, the successor to the Hubble Space Telescope, whose infrared observations will undoubtedly bring us even closer to understanding the most critical time in our universe's history when galaxies first formed.

The first phase in the Hubble Frontier Fields project was achieved between August and November 2013 when a 63-hour exposure of a portion of the sky containing the massive galaxy cluster Abell 2744, also known as Pandora's Cluster, was obtained. The results were staggering because the images captured several hundred galaxies belonging to Abell 2744. Knowledge of Abell 2744 will help astronomers measure the mysterious dark matter encompassing the cluster in a manner previously not possible. More importantly, the image captured an astounding 3,000 background galaxies, many 10–20 times brighter than they would normally appear without the foreground gravitational lens effect of Abell 2744. The picture constitutes the deepest-ever image of galaxies with some of the faintest and youngest star systems ever detected.

Mystic Mountain: HH 901 and HH 902

The Carina Nebula, also known as the Eta Carinae Nebula, or NGC 3372, is a bright HII region in the Carina-Sagittarius arm of the Milky Way. Bright enough to be visible with the naked eye it spans about 460 light-years across which is about four times the size of the Orion Nebula. As a vast star-forming region it is home to a number of spectacular objects, star clusters and two of the most luminous and powerful stellar specimens in the Milky Way, the massive unstable star named Eta Carinae and another star designated HD 93129A.

This region has witnessed two major epochs of star formation. The first, around 3 million years ago, sculpted much of what we see today in the form of a vast network of gas and dust clouds. The stellar winds from the first wave of stars caused a few of the surrounding cold molecular clouds to collapse. This triggered a second more recent wave of young stars to form.

Many of these nascent stars are invisible at optical wavelengths because they are hidden by the thick opaque clouds of gas and dust. However, the embryonic stars do release chemical and physical signatures of their presence making the region a virtual laboratory of the star-making process. For this reason Carina has captured the attention of astronomers who continue to observe its treasures using the Hubble Space Telescope.

The HST was upgraded for the last time in May 2009, during HST servicing mission 4, which included the installation of the telescope's highest resolution detector called the Wide Field Camera 3 or WFC3. WFC3 was put to the test soon after its installation, producing a series of spectacular images in time for the 20th Hubble Space Telescope anniversary event in April 2010. One of the most spectacular objects imaged was an area known as HH 901/HH902. This particular object is a peculiarly sculpted cloud with a number of imbedded embryonic stars.

The HH designation refers to objects first recognized by Mexican astronomer Guillermo Haro and American astronomer George Herbig beginning in 1950. The nature of these objects was unknown to Herbig and Haro at the time they first cataloged them. We now know that the small glowing clouds are the result of energetic outflows ejected from low-mass protostars hidden from view by thick clouds of dust. The outflows from these infant stars power shock fronts that collide with colder ambient dust and gases at speeds exceeding 100,000 miles per hour (160,000 km/hour). The heated ambient gases then release the newly acquired energy in the form of light and appear as a deep red glow in visible light images. Herbig-Haro objects are found most often in areas of active star formation and dozens of these objects have been detected within the Carina Nebula.

HH 901 and HH 902 were imaged by the Hubble Space Telescope on February 1 and February 2, 2010. The dynamic and sometimes destructive process of star formation can be observed in the image. Bipolar jets emanate from atop a 3-light-year-tall pillar of gas and dust carved out by the radiation and stellar winds of the nearby young star cluster Trumpler 14. While the pillar is eroded from the outside by fierce stellar winds, bipolar jets released by embryonic stars are destroying the pillar from within. The jets are formed as matter accretes onto the surface of embryonic stars from swirling disks of gas and dust that surround them.

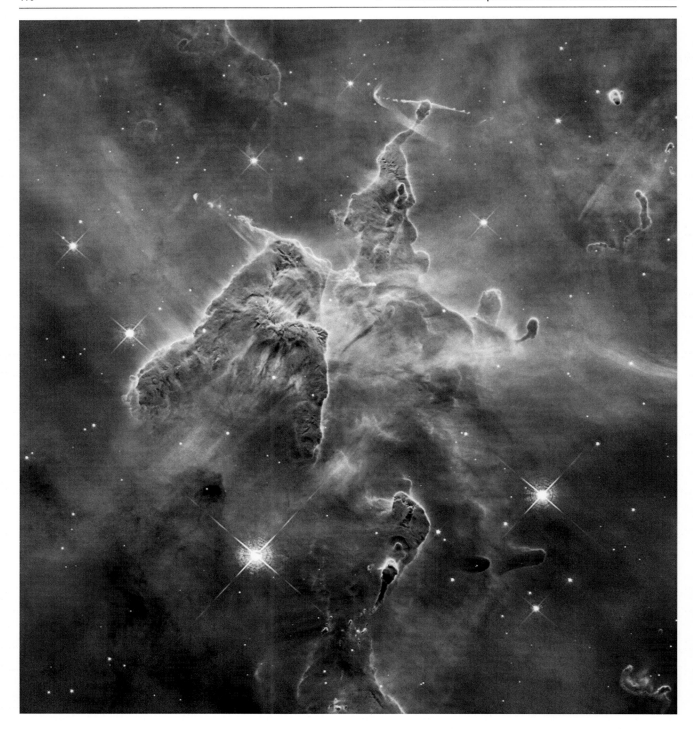

Fig. 5.27 HH 901/902 was observed by Hubble's Wide Field Camera 3 on February 1 and 2, 2010, using narrowband filters: F502N (O III)(blue), F657N (H-alpha)(green), and F673N (S II)(red). The image is a 2 × 2 panel mosaic. The Herbig-Haro objects 901 and 902 are seen as bipolar jets of material exiting perpendicular to the pillar in the top third of the image. The jets are produced by imbedded protostars invisible in the image

The Hourglass Nebula

Despite their namesake, planetary nebulae have nothing to do with planets. William Herschel applied this durable misnomer to these objects in the 1780s when, without knowing their nature, he described their appearance as resembling the rounded shapes of planets. The misleading moniker managed to stick even though we now understand much more about them.

The planetary nebula stage of an intermediate-mass star represents the final 10,000–30,000 years in the star's life cycle. This is a brief instant in astronomical time. The road to a planetary nebula begins with a main sequence star with about 1–8 solar masses. Stars with this mass, such as our Sun, spend most of their existence on the main sequence by fusing hydrogen fuel to helium deep within their core. About 90 % of the stars in the universe are on the main sequence.

While the star is on the main sequence, an equilibrium is achieved between the outward push of energy production that tends to expand the star and the inward pull of gravity that wants to contract it. The more massive a star, the shorter its life. Stars with a mass comparable to the Sun will remain on the main sequence for about 9 billion years while very high-mass stars may exhaust their nuclear fuel in a few million years or less.

Towards the end of the star's life, the hydrogen fuel becomes depleted allowing gravity to precipitate the core's contraction. This results in a rise of the core temperature and a somewhat paradoxical expansion of the star's outer layers that cool the surface of the star. The star bloats 100 times its original size and its luminosity increases. At this stage the star is known as a red giant. Eventually its hydrogen fuel becomes completely depleted allowing the core to further contract. When this occurs, the core's temperature rises to about 300 million degrees and the extreme heat triggers the onset of helium fusion. At this stage, the star has found a new energy source; however, it won't last very long.

The onset of helium fusion raises the star's surface temperature and moves the star on a path of the Hertzsprung-Russell diagram that is almost aligned with its previous red giant track. Now it is classified as an Asymptotic Giant Branch star. When our Sun reaches the Asymptotic Giant Branch phase in about 5 billion years, its radius will extend past Earth's orbit potentially swallowing our planet if Earth has not already been pushed further out from the Sun by then.

Asymptotic Giant Branch stars become unstable and their instability induces them to pulsate erratically. These pulsations spur the star to lose half its mass. Much of the mass is converted into dust that eventually surrounds the dying star with a shell so opaque light becomes blocked and the star disappears from optical sight. This stage of the star's death is followed by a period of more profound mass loss called the *superwind phase*. During this chapter, dynamic interaction between fast and slow winds ultimately forms the complex shell structure observed in planetary nebulae.

Ultimately the Asymptotic Giant Branch star sheds so much mass the hot stellar core becomes exposed. The star's core is now reduced to about .6 solar masses but its temperature is incredibly intense. Gravity forces the star's hot stellar interior to collapse into an extremely compact object known as a white dwarf star. Within the white dwarf the electrons of every atom are pushed extremely close to their nucleus. Thus the white dwarf is an extraordinarily massive object with a density of one metric ton/cubic centimeter. White dwarf stars release copious amount of ultraviolet radiation that ionizes the surrounding shells of gas and dust thus causing them to glow. This marks the beginning of the star's planetary nebula phase. For most stars this is the final stage because forces known as electron degeneracy pressure prevents the core from collapsing further.

A long-standing mystery in the science of stellar evolution is how planetary nebulae acquire their complex shapes and symmetries. Hubble's ability to resolve very fine structural details has helped elucidate some of the mechanisms behind the magnificent structures displayed by these stellar complexes.

On July 30, 1995, the Hubble Space Telescope photographed one of the most striking and peculiar planetary nebulae called the *Hourglass*. Many of the Hourglass Nebula structures revealed by the HST were completely new and unexpected including its striking central eye. Its non-symmetric bi-lobed configuration and intersecting elliptical rings were challenging to explain. The central white dwarf star also appeared to be located away from the geometric center of the complex.

How do we explain the lack of symmetry and other observations? A leading hypothesis that explains the displacement of the central star and misalignment of the main nebular structures proposes the accretion of a Jupiter-sized exoplanet by the dying star just prior to the planetary nebula phase resulted in the Hourglass Nebula's off-center internal alignment. A planet destruction event could have caused an asymmetric nova-type explosion producing deviations from the typical cylindrical symmetry of the nebula and the offset location of its central progenitor star.

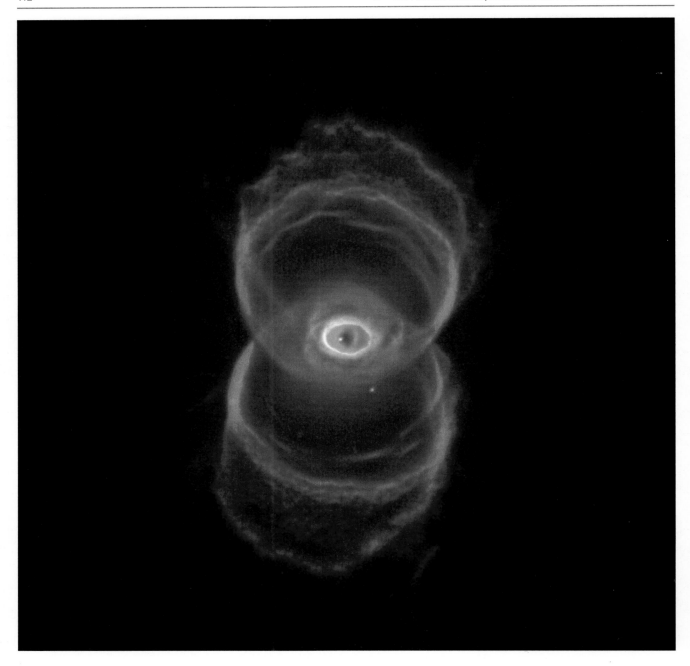

Fig. 5.28 Exposures of MyCn18 were made on July 30, 1995, using HST's WFPC2 camera through narrowband filters. Apparent is the bipolar "hourglass" configuration and fantastic network of elliptical rings and knots. Within the "central eye" structure the offset white dwarf can be seen

Saturn's Aurora

Aurorae are atmospheric phenomena well known to many people. When high energy particles escaping the Sun's gravity as a continuous stream, known as the solar wind, collide with high-altitude atmospheric atoms, an aurora display occurs. The particles are drawn into the atmosphere near the polar regions by Earth's magnetosphere. Excited by the solar wind particles, atoms of oxygen and nitrogen emit photons of light as they return to their ground state. Aurorae in northern latitudes are collectively known as the aurora borealis or northern lights and those in the southern latitudes are called aurora australis or southern lights.

Aurorae are not just Earthly phenomenon; they can occur on any planet with an atmosphere and a magnetic field. They are common on both Jupiter and Saturn which have magnetic fields much stronger than Earth's. Aurorae on Saturn were first observed in 1979 by *Pioneer 11* and then later by *Voyager 1* and *2*.

The arrival of the Cassini space probe at Saturn in 2004 set in motion simultaneous observations of Saturn by the Hubble Space Telescope to study Saturn's aurora activity. The HST observed Saturn's aurorae in ultraviolet and visible light while Cassini recorded radio emissions of the auroral regions while obtaining measurements of the solar wind. The research team, led by John Clarke of Boston University, discovered Saturn's faint aurora displays were very unlike those of Earth and Jupiter.

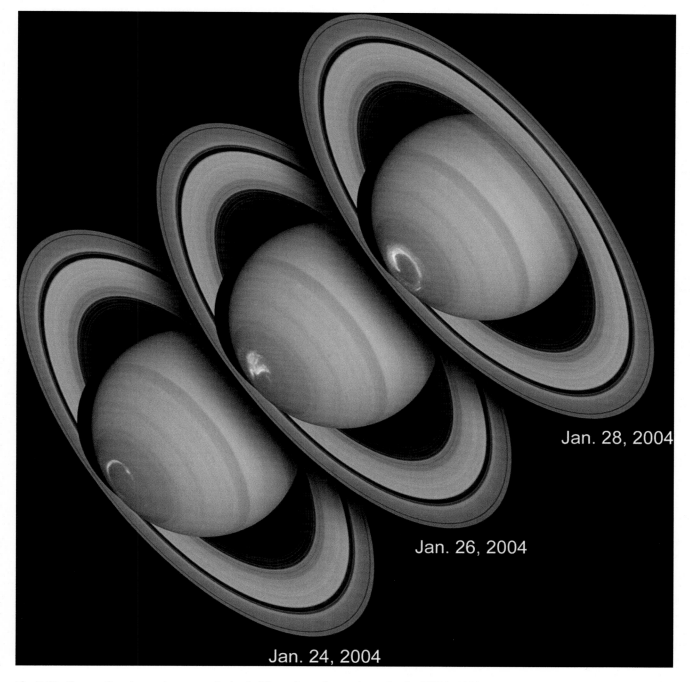

Fig. 5.29 Consecutive observations were obtained of Saturn's southern polar region by HST in 2004 on January 24, 26, and 28, using the ACS (visible) and STIS (UV) detectors. A composite set of images were made superimposing the UV data of the aurora over the visible light data. The STIS data taken in UV is beyond the visible spectrum and assigned the color blue, so the image is in reality a combination of natural and false-color. Saturn's changing aurora is seen dramatically as it evolves from its quiescent state on January 24 to its most active state on January 28

The dual observations revealed some similarities and some major differences in Saturn's aurora displays from Earth's. For example, Saturn's aurora storms are predominantly driven by the pressure of the solar wind as opposed to Earth's that are driven predominantly by the Sun's magnetic field. Saturn's aurora activity typically last for days whereas Earth's last only hours and Saturn's rotation plays a major role in auroral processes. Finally, Saturn's aurorae are very tall compared to Earth's. Saturnian aurora stretch hundreds of miles above its poles.

During the Hubble Space Telescope Saturn observations produced a remarkable sequence of both visible and ultraviolet light images from January 24 to 28, 2004. The HST images were the first to show the wide range of Saturn's auroral variability as it passed from quiescence to active state during the course of only 4 days. Saturn's aurora was noted to actually contract into a smaller ring as it reached its maximum on January 28. The maximum coincided with a large disturbance in the solar wind detected by Cassini.

M101: A Perfect Pinwheel

One of the final entries in Charles Messier's list of comet imposters is M101, the dominant member of a small group of nine galaxies located 25 million light-years from Earth. M101, also known as the Pinwheel Galaxy, is a gigantic galaxy. With a visible diameter of about 170,000 light-years, it is one of the largest disk galaxies known and contains approximately one trillion stars. As a face-on spiral galaxy M101 presents itself to the viewer in a way that maximally emphasizes its spiral structure. Spirals were not always the dominant type of galaxy in the universe. How they evolved is a story that is still being investigated.

A spiral galaxy has a flat shape similar to a compact disk with a central bulge. The spiral arms exist within the galaxy's disk and rotate around the bulge forming its central nucleus. Massive amounts of dust, gas and stars also populate the arms and comprise the star-forming regions of the galaxy. Within the disk's vast spiral arms new stars, star clusters and nebulae form. The dynamic processes of recycling matter also occur there.

Spirals can have dramatically different appearances based on their orientation in space and the inclination of their disk to our line of sight. When viewed edge-on a spiral galaxy will appear as an elongated structure split by its dark and thin equatorial disk. Viewed face on, like M101, the spiral pattern becomes immediately evident. Of course, there are many variations in between the two orientation extremes based on the angle of inclination to our line of sight.

The central ellipsoidal bulge consists of older star populations and is relatively devoid of interstellar gas and dust. Older yellow and red stars in the central bulge of spiral galaxies are referenced as stellar Population II stars. These are stars that formed long ago. Often, they are as ancient as the galaxy; sometimes approaching 10 billion years old. Younger massive, hot O- and B-type blue stars are located in the spiral arms and designated Population I stars. These are relatively short-lived stars, many of which will end their existence in a spectacular supernova explosion that can become brighter than the combined starlight released by all the stars within the galaxy.

Spirals also have a diffuse outer halo devoid of gas and dust where compact agglomerations of older stars, called globular clusters, are located. Globular clusters occur in all types of galaxies and contain anywhere from 100,000 to millions of stars. They are among the oldest components of a galaxy.

The elusive dark matter is also believed to exist in the halo. Although completely invisible, dark matter accounts for much of the mass in all galaxies.

What is the origin of spiral structure? The most popular theory to date, by the Chinese born American mathematician C. C. Lin and American astrophysicist Frank Shu in 1964, proposes the spiral shape of galaxies is generated by density waves propagating throughout the spiral disk.

Lin and Shu's theory explains stars rotate around the center of the galaxy at about twice the speed of the density wave. The stars tend to clump together as they encounter the density wave. As the stars concentrate in space, interstellar gas becomes compressed leading to bursts of new star formation.

So, we observe the density waves as the leading edges of spiral arms.

Although stars embedded within a galaxy's spiral arm have the appearance they rotate about the galaxy's center affixed to the spiral arm, stars within a galaxy orbit the galaxy's nucleus along separate individual paths. During their orbit, they pass into and out of spiral arms so their association with any arm is only temporary.

For example, the stars in the Milky Way rotate once every 200 million years.

Since the formation of the Milky Way, our Sun has made eight trips around the galactic center. We pass through a major spiral arm about every 100 million years, taking about 10 million years to go through. Interestingly, during our Sun's passage

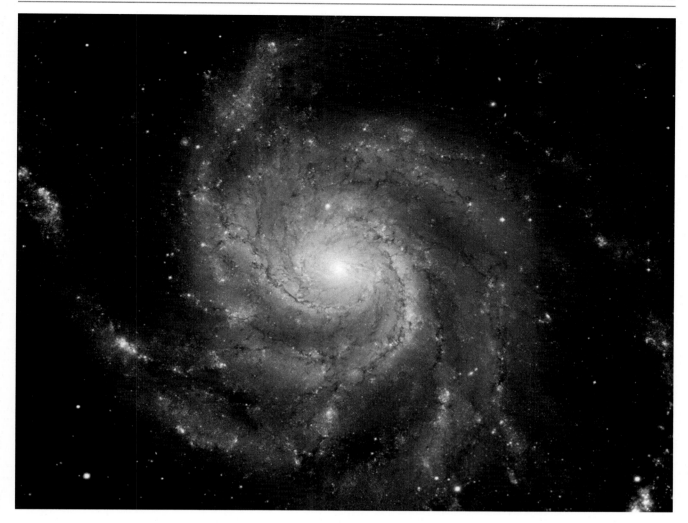

Fig. 5.30 This magnificent portrait of the face-on spiral galaxy M101, released on February 28, 2006, is composed of 51 individual Hubble exposures recorded between 1994 and 2003, plus some elements of ground-based images to complete the composition. The final composite image measures an extraordinary 16,000 by 12,000 pixels, the largest and most detailed photograph of a spiral galaxy produced by the Hubble Space Telescope at that time

through a spiral arm there might be a higher rate of nearby supernova and possibly other environmental stresses affecting our planet that are of intergalactic origin.

The process of star formation can also occur by self-propagation as newly formed stars further compress adjacent gas clouds triggering even more star birth. Star formation generally takes place almost exclusively within the spiral arms although it is unclear how much occurs by self-propagation and how much is due to the presence of density waves. More than likely both mechanisms contribute.

There are many questions about spiral galaxy dynamics and evolution that remain unanswered such the origin of the density waves. Possible explanations about what set these waves in motion include perturbations from interactions with other galaxies and non-symmetry about the disk axis of the primordial galaxy during its early formation.

Released on February 28, 2006, an extraordinary multi-panel mosaic image of M101 was assembled using exposures from multiple Hubble Space Telescope observations during March 1994, September 1994, June 1999, November 2002 and January 2003. Combining those images produced by the Advanced Camera for Surveys and *Wide-Field Planetary Camera 2* detectors and some ground-based exposures required to complete the composition yielded an image constituting the largest and most detailed photograph of a spiral galaxy by the Hubble Space Telescope. The galaxy's exquisite spiral form is showcased along with brilliant young clusters of hot, blue, newborn stars that populate its spiral arms.

NGC 3603: Starburst in the Carina Arm

NGC 3603 is known as a giant HII region located in the Carina arm of our galaxy where star formation has recently taken place. HII regions, also known as emission nebulae, are bright clouds of fluorescing hydrogen gas energized by very hot young stars. The dominant emission line for hydrogen is termed HII and refers to the elements' first ionization level. HII clouds glow with a red or pinkish hue in visible light images. NGC 3603 is likely the most massive visible HII region in our galaxy extending at least 1,000 light-years across and containing the overall mass of 400,000 suns.

A violent burst of new star formation is occurring deep within NGC 3603 where an extremely compact and bright cluster of several thousand young stars designated HD 97950 resides. HD 97950 contains at least 50 of the hottest and most massive O-type stars including a rare and exotic type of stellar giant known as a Wolf-Rayet star. The star cluster has an overall mass of 10,000 suns packed into a volume about 3 light-years across. The cluster recently formed 1–2 million years ago in a single burst of star formation.

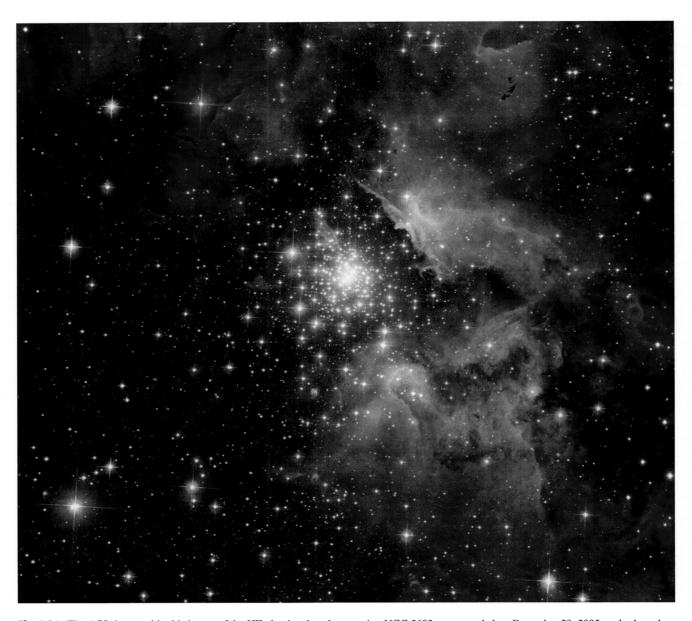

Fig. 5.31 The ACS data used in this image of the HII cloud and starburst region NGC 3603 was recorded on December 29, 2005, and released on October 2, 2007. The image was exposed through broadband visible light filters. Additional WFC3 narrowband data recorded at a later time (2010) was incorporated into this image, which is a remastered version assembled by one of the authors (RG). The explosion of young stars in the center is the young cluster HD 97950. The immense star-forming complex lies at a distance of 20,000 light-years, and the image covers a field about 17 light-years across

Wolf-Rayet stars were first described in 1867 by French astronomers Charles Wolf and Georges Rayet who detected their broad emission lines. Only later did it become clear these broad emission lines were indicative of a thick expanding atmosphere of matter being ejected from the star. The outflowing matter from the surface of these hot massive stars produces a fierce ejection of charged particles called a stellar wind that blow bubbles in the interstellar and circumstellar medium and result in copious mass loss from the star. An example of solar wind bubbles created by Wolf-Rayet stars is evident in the cavity at the center of NGC 3603.

The Wolf-Rayet stage is believed to represent the late evolutionary stage of ultra-luminous giant stars having an initial mass greater than 30 suns. Over 50 % of known Wolf-Rayet stars are associated with regions of nebular emission such as NGC 3603.

Studies of HD 97950 have revealed the presence of three immensely hot massive Wolf-Rayet stars designated *A1*, *B* and *C*. They are located only a tenth of a light-year apart in the center of the cluster. Each possesses over 100 solar masses and together they contribute an amazing 20 % of the ionizing energy plus 60 % of the kinetic energy driving the entire giant NGC 3603 HII region. The Wolf-Rayet phase occurs at the end of a very massive star's short existence. The energy of their stellar wind is far greater than the winds of typical O-type giants and dominates the energy output of starburst regions for several million years.

The three stars formed some 2 million years ago and this probably defines the age of the HD 97950 star cluster because Wolf-Rayet stars are potentially important age indicators for giant HII regions.

With its cache of extraordinarily luminous and massive stars HD 97950 produces an extraordinary ionizing flux of radiation around 100 times greater than the well-known Trapezium cluster in the Orion Nebula. Aside from the bright O- and B-type giants many low-mass stars have also been detected within HD 97950, proving that sub-solar mass stars do form alongside violent starbursts.

The Hubble Space Telescope has imaged NGC 3603 on many occasions beginning in the early 1990s with Wide Field Planetary Camera 2 and again in 2005 with the Advanced Camera for Surveys. The latter image in particular represents an extraordinary portrait of this powerful star-forming complex reminiscent of a celestial jewel box. The image showcases stars at almost every major stage of their evolution.

In the center lies the cluster HD 97950. Bok globules formed by cold clouds harboring low mass star formation at their center are present in the upper right of the image. The bright blue star to the upper left of center is the blue supergiant known as Sher 25, a massive star entering the last stages of its life cycle and likely close to becoming a supernova. Below the central cluster are several compact tadpole-shaped emission clouds. These are believed to harbor protoplanetary disks, the circumstellar material surrounding young stars, and the likely progenitors of future solar systems.

100 Million Stars in Andromeda

By virtue of being our closest spiral neighbor, the Great Andromeda Galaxy M31 has repeatedly been of pivotal importance throughout all eras of astrophotography including the current one. From its inception one of the primary goals of the Hubble Space Telescope has been the exploration of other galaxies and their stellar populations. Hubble's unprecedented vision has enabled astronomers to peer into the disks of other spirals and examine the individual stars within them. This is a feat not possible with ground-based instruments.

Enter the Panchromatic Hubble Andromeda Treasury. Conceived and directed by astronomers from the University of Washington, the Hubble Space Telescope performed an extraordinary survey of the star-forming disk of M31 from July 2010 to October 2013. The survey's images fully resolved over 100 million stars. Such a high definition study of another galaxy had never been achieved before. The immense task consisted of 7,398 exposures obtained by 411 individual Hubble observations. The images recorded by the Advanced Camera for Surveys and the Wide Field Camera 3 ranged from near ultraviolet through the visible spectrum to the near infrared and mapped a third of the galaxy's disk at stellar resolution.

The survey produced a vast archive of extragalactic stellar information that will require years of study by astronomers to determine where and how stars formed in M31 and to identify and characterize Andromeda's stellar clusters and obscuring dust. The culmination of the survey was the assembly of the more than 400 panels of contiguous images into a massive natural light mosaic picture of M31's disk at Hubble's resolution limit. This unique image was created by one of the authors using the visible light exposures from the Advanced Camera for Surveys.

The immense natural color panoramic mosaic is the largest Hubble image ever assembled. Its digital dimensions span 104,014 by 37,157 pixels. The enormous image extends across 61,000 light-years of M31, with a resolution of 0.62 light-years/pixel. The image was released at the 225 annual meeting of the American Astronomical Society on January 5, 2015, as part of the 25th anniversary year of the Hubble Space Telescope.

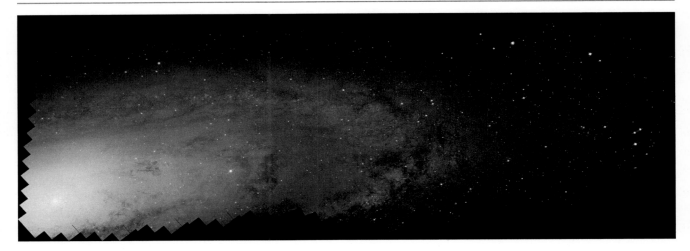

Fig. 5.32 This sweeping panoramic mosaic of M31, released on January 5, 2015, is the largest Hubble image ever created, and a new benchmark for precision studies of M31. The broad panoramic scene fully resolves an unprecedented 117 million stars across 61,000 light-years of Andromeda's star-forming disk. The image assembled by one of the authors (RG) for NASA/ESA/PHAT was the culmination of the Panchromatic Hubble Andromeda Treasury, a 3 year multi-cycle Hubble survey of M31 that recorded stellar populations using six filters from near IR to the visible to near UV

The Multiwavelength Universe

<div style="text-align:right">**6**</div>

The unaided human eye and brain are equipped to distinguish only a small fraction of the full spectrum of light produced by the universe. On a logarithmic scale of frequency, visible light represents only 2.3 % of the entire electromagnetic spectrum, and if the scale is linear it is reduced to a mere 0.0035 %. Each portion of the electromagnetic spectrum reveals a distinct and unique universe, shaped by different chemical and physical processes, and requiring unique technological strategies to unravel its secrets. Only by studying the universe at each portion of the spectrum can we begin to see with greater clarity its fundamental nature.

The contributions of multiwavelength astronomy are extraordinary. They span an impressive range from the physics of our Sun, the story of stellar evolution, the structure and dynamics of galaxies, and the earliest origins of the universe. Modern multiwavelength astronomy began in the twentieth century, and its role in astronomical research has expanded exponentially since, as astronomers look for answers to critical questions.

Advancements in multiwavelength astronomy have demanded engineering ingenuity of the highest order. The window to the multiwavelength universe was only made possible by extraordinary innovations not only in telescope and detector technology but also through the marvels of satellite observatories.

Missions such as COBE, WMAP, Planck, Spitzer, Chandra, Galex, SDO, CGRO, HST, and others have proved nothing short of revolutionary in advancing astronomy to the next level and have confirmed that space-based astronomy will no doubt be the vehicle that brings us to a more complete understanding of the cosmos.

Two Micron All Sky Survey (2MASS)

By the early 1900s there was a gradual realization of the benefit of infrared observations of the universe. Cosmic dust particles render large parts of the universe impervious to visible light. Fortuitously, however, dust is transparent at IR wavelengths, and therefore IR observations have become critical to the study of interstellar dust clouds where young stars are forming. Much of the dust-shrouded center of our galaxy can only be studied using IR imaging. In addition asteroids, comets, and planetary satellites radiate much of their energy at IR wavelengths that makes them ideal for IR observations. Finally because radiation emitted by galaxies during the earliest stages of the formation of the universe is now shifted into the IR range, studies of the most distant objects in the universe at IR wavelengths are vital.

IR imaging has specific demands. Earth's atmosphere poses a significant barrier to IR light, as water vapor absorbs a significant amount of infrared radiation. The atmosphere also emits its own radiation at infrared wavelengths. For this reason, most ground-based infrared observatories are constructed in very dry places at high altitude, located above most of the water vapor in the atmosphere. Ultimately space has become the ideal setting for infrared telescopes.

Because they emit their own IR radiation, dedicated infrared telescopes and detectors need to be cooled to extremely low temperatures. Also, dedicated IR detectors are by necessity composed of unique substrates, such as cadmium mercury telluride, as opposed to optical detectors, which are predominantly made of silicon.

Infrared light was discovered in 1800 by Sir William Herschel. Early inroads were made in studying the Moon and planets in IR during the late 1800s and early 1900s. With the success of radio astronomy during the 1950s and 1960s there was a new appreciation for multiwavelength astronomy. This became a driving force that pushed the evolution of infrared astronomy

© Springer International Publishing Switzerland 2015
R. Gendler, R.J. GaBany, *Breakthrough!: 100 Astronomical Images That Changed the World*,
DOI 10.1007/978-3-319-20973-9_6

and saw the advent of more sophisticated IR detectors and the use of balloons and rocket probes to extend the reach of IR observations beyond the Solar System. By the 1970s it became clear that observations at infrared wavelengths would be critical to advancing astronomy on many different levels. With this realization the modern era of infrared astronomy was about to be born.

The 1970s and 1980s began to see more dedicated use of large ground-based instruments in exploring the infrared sky and the development of more efficient IR detectors. In 1983 the first dedicated satellite IR observatory known as IRAS (Infrared Astronomical Satellite) was launched, which ushered in the era of satellite "all-sky" surveys. IRAS made some highly significant contributions by scanning 96 % of the sky at wavelengths of 12, 25, 60, and 100 microns. IRAS essentially doubled the number of cataloged Infrared astronomical sources by detecting approximately 500,000 infrared sources. In the late 1980s and early 1990s several other ground-based and satellite IR observatories (COBE, SPIREX, IRTS, ISO) continued to advance infrared and multiwavelength astronomy.

A major advance in infrared astronomy came with the "Two Micron All-Sky Survey" (2MASS). This ambitious ground-based all-sky survey was conducted from 1997 to 2001. It employed two highly automated 1.3 m telescopes, one at a northern facility, Mt. Hopkins, AZ, and the other at a southern facility, CTIO, in Chile. The survey recorded the entire sky at three near IR bands, 1.25, 1.65, and 2.17 microns, at unprecedented arcsecond resolution.

The 2MASS survey advanced infrared astronomy by providing an unprecedented view of the Milky Way free of the obscuring effects of interstellar dust, revealing with high accuracy the distribution of luminous matter throughout our galaxy. The 25 terabytes of imaging data gathered by 2-MASS produced the first all-sky photometric census of over one million galaxies out to a redshift of $z = 0.2$, including galaxies in the 60°-wide "zone of avoidance," where dust within the Milky Way highly limits optical galaxy surveys. It also helped catalog extremely low-luminosity stars and brown dwarfs as well as observing dust-obscured active galactic nuclei. In all, 2-MASS cataloged an astounding 500 million point sources and 1 million extended sources.

The Two Micron All-Sky Survey was a joint project of the University of Massachusetts and the Infrared Processing and Analysis Center/California Institute of Technology (IPAC).

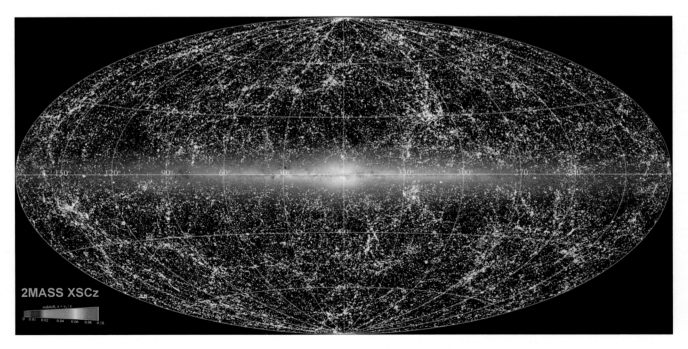

Fig. 6.1 This image, created by T. Jarrett (IPAC/Caltech), was derived from the all-sky 2MASS Extended Source Catalog (XSC). The map charts the positions of one million galaxies in the near universe, at 5 arcminute resolution, with colors assigned according to calculated redshifts. The image is a projection of the local universe as viewed in the galactic coordinated system with the Milky Way at the center. The image also reveals the complete disk and central bar as traced by a half-billion stars measured in infrared light by 2MASS

COBE: The Earliest Light

The historical background of the Cosmic Background Explorer, also known as COBE, has its rightful beginning in the discovery and first simple measurements of the cosmic microwave background made by Arno Pensiaz and Robert Wilson. On May 20, 1964, the two American radio astronomers made a most serendipitous observation while using the giant radio antenna built by Bell Labs in Holmdel, New Jersey. The giant Holmdel antenna was originally built by Bell Labs for the purpose of radio astronomy and satellite communication experiments.

While using the 6 m Holmdel antenna, the two discovered a pervasive background "noise" of radiation that hovered with amazing uniformity at a wavelength of 7.35 cm. The mysterious signal persisted over the entire sky, and at all times of the day and night. Through their investigation they determined that the signal could not possibly be explained by any ground or terrestrial interference or even galactic phenomenon. Their conclusion was that the persistent microwave radiation must have its origin from outside the galaxy.

They enlisted the help of the Princeton-based theoretical physicist Robert Dicke (1916–1997), who was known at the time for his work regarding the origin of the universe. Through their collaboration they concluded that the microwave energy picked up by the Holmdel antenna must be low-level background radiation left over from the Big Bang. Termed the cosmic background radiation, this phenomenon, combined with Edwin Hubble's revelation of an expanding universe, made the strongest case yet for the Big Bang, which since has become the standard model of the origin of the universe. Penzias and Wilson were awarded the Nobel Prize in Physics for their work in 1978.

Today we know that the universe is roughly 13.7 billion years old. The current model proposes that the universe arose from a theoretical singularity at the time of the Big Bang; it has been expanding and cooling ever since. At around 380,000 years it became cool enough for the simplest atoms to form. This was an important milestone, as the fledgling universe became transparent to light for the first time. The light, or "afterglow," from this transition has been traveling across space and time ever since. Essentially this "earliest light" permeates our world and can be detected all around us, both on Earth and in space. However because of the expansion of the universe the original signal has been stretched about 1,000 times its original wavelength, we detect it now at just 3 degrees above absolute zero. This is referred to as the 3 K radiation.

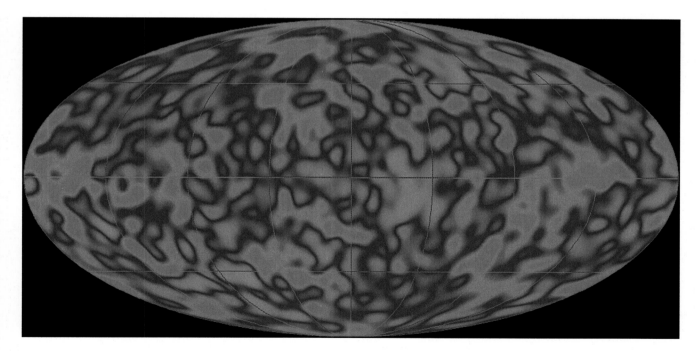

Fig. 6.2 The cosmic microwave radiation mapped by COBE between 1989 and 1993 provided the first high-precision measurement of the "universe's first light." This led to a monumental leap in our understanding of the origins of the universe. It is now believed that the tiny fluctuations in the radiation seen throughout the map gave rise to the first condensations of matter in the early universe, ultimately leading to the formation of stars and galaxies

Precise measurements of the CMB would be critical to the Big Bang or any theory about the origin of the universe, as it would need to account for this radiation. To help answer this question the Cosmic Background Explorer (COBE) satellite was initially conceived in a 1974 proposal from the NASA Goddard group.

COBE was launched by NASA on November 18, 1989. Its mission was to make high-precision measurements of the CMB radiation between 1 μm and 1 cm over the entire celestial sphere. Its instrument operations were terminated on December 23, 1993, but during its work life it produced an extraordinary map of the CMB, the oldest light in the universe, unprecedented in resolution for that time.

The CMB was found to be extraordinarily uniform, although it did exhibit tiny fluctuations, or ripples, in the 3-K temperature, at about one part in 100,000. The implications of the minuscule non-uniformity found by COBE became of paramount importance, as it forms the foundation of the current model of galaxy formation. Essentially from the slight density fluctuations of the primordial universe became the gravitational impetus that brought matter together to form the earliest stars and galaxies.

COBE's legacy was that it measured the CMB for the first time with a remarkable precision of 0.005 %, essentially eliminating competing theories on the origin of the universe and confirming the Big Bang theory. COBE paved the way for deeper and higher precision exploration of the microwave background that would later be made by the WMAP mission and the current European Space Agency's Planck mission.

WMAP: Cosmology Becomes a Precision Science

The CMB, or cosmic microwave background, discovery work of Penzias and Wilson and the landmark observations of COBE answered highly important cosmological questions but also created the need for more refined observational evidence to support the evolving standard model of modern cosmology. COBE succeeded greatly in providing an all-sky map of CMB fluctuations, also known as anisotropies; however, its resolution was limited to only large-scale fluctuations. A more highly resolved and more sensitive map would be necessary to truly answer questions concerning the universe's geometry, its content and evolution, and to confirm the prevailing Big Bang model and cosmic inflation paradigm.

The next phase of observing the CMB was proposed by NASA in 1995. Originally known as the MAP (Microwave Anisotropy Probe) mission, it would explore the CMB in 5 frequency bands and would be 45 times more sensitive and provide 33 times the resolution of COBE. WMAP would resolve the CMB down to a resolution of 13 arcminutes. The orbiting observatory was launched aboard a Delta II rocket from Kennedy Space Center in Florida on June 30, 2001. The mission was renamed WMAP, for the Wilkinson Microwave Anisotropy Probe, in 2003 to honor the cosmologist David Todd Wilkinson (1935–2002), who was a member of the mission's original science team.

WMAP operated from 2001 to September 2010. Initially planned for only 2 years of operation, the mission was granted four extensions, leading to 9 years of data collection. There were five major data releases, the last being in 2012. By the end of its stunningly successful mission WMAP's contributions to fundamental cosmology were astonishing. The 2011 winner of the Nobel Prize in physics, Adam Riess said about WMAP: "The last word from WMAP marks the end of the beginning in our quest to understand the Universe. WMAP has brought precision to cosmology and the Universe will never be the same."

WMAP's contributions to cosmology are many. WMAP essentially transformed the field of cosmology from a theoretical science to a precision science. The oval-shaped maps generated by its data describe the temperature fluctuations of the primordial universe as far back as 375,000 years after the Big Bang or about 13.8 billion years ago.

Some of its more profound accomplishments include the precision dating of the universe as 13.77 billion years old to within a half percent. WMAP's data confirmed the curvature of space to be within 0.4 % of "flat" Euclidean geometry. WMAP revealed the universe to be composed of over 95 % dark matter and dark energy (24 % dark matter, 71.4 % dark energy), leaving only 4.6 % of the universe composed of ordinary atoms. WMAP's measurements of density variations in the early universe confirmed the paradigm of "cosmic inflation," which predicted that soon after the Big Bang, the universe underwent a period of exponential expansion, growing by more than a trillion, trillion fold in less than a trillionth of a trillionth of a second. The data also pinpoints the age in which the universe emerged from the cosmic dark ages, as stars began to shine about 400 million years after the Big Bang.

The milestones achieved by COBE and WMAP are now being even further refined by the European Space Agency's Planck cosmology probe, launched on May 14, 2009, which promises to further refine our knowledge of the CMB and its characteristics. See more about Plank below.

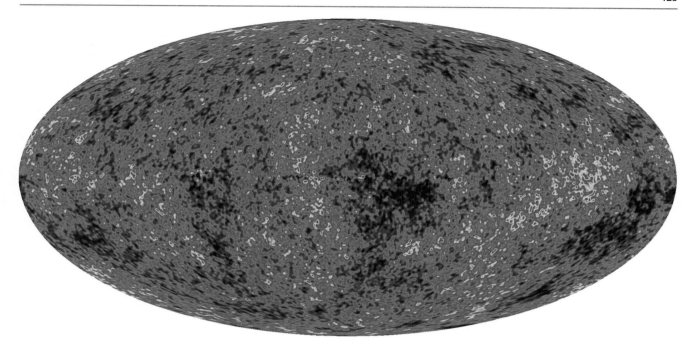

Fig. 6.3 On December 20, 2012, the 9-year WMAP data was released. The 13.8 billion-year-old temperature fluctuations are charted in the image, which covers the entire sky. This microwave afterglow shows the state of the universe around 375,000 years after the Big Bang and represents the first cosmic light. Analyses of WMAP's data confirmed several cosmological predictions – that 95 % of the early universe was composed of dark matter and energy, the curvature of space is less than 0.4 % of "flat," and that the universe underwent a period of exponential inflation early in its formation, which produced miniscule variations in the density of matter that ultimately led to the formation of galaxies and the universe as we know it today

Planck: Further Refining the Primordial Universe

The European Space Agency's Planck mission follows on the heels of its ground-breaking predecessors, COBE and WMAP. The discovery and refinement of the cosmic microwave background by COBE and WMAP has successfully transformed cosmology. The CMB, a snapshot of the universe at 13.8 billion years ago when it was only 380,000 years old, represents the observational proof of the Big Bang model of the universe.

To understand the concept of the cosmic microwave background, we need to first understand the earliest epochs of the universe and the events that defined those periods. The CMB, also termed the "relic radiation," left over from the Big Bang, is the furthest back in time we can explore the early universe using light. The CMB can be detected in all directions of the sky and peaks in the microwave spectrum as an almost uniform background.

The origin of the CMB begins in the early universe a few hundred thousand years after the Big Bang. During this period the universe was filled with hot plasma consisting of particles, that were mostly protons, neutrons,, electrons, and photons of light. The photons of light were constantly being absorbed by free electrons, rendering it non-transparent to light similar to a thick fog, essentially an opaque universe from which light could not escape. When the universe cooled enough, protons and electrons combined to form neutral atoms. These neutral atoms no longer absorbed all the thermal radiation, and so at around 380,000 years the universe became transparent to light. Cosmologists refer to this time period when neutral atoms first formed as the recombination epoch.

Following the recombination epoch light began to travel freely through space, and this milestone is known as the photon decoupling era. These primordial photons have been propagating ever since. At the time of their origin they existed at a temperature of 3,000 Kelvin (approximately 2,700 °C). As these photons moved unhindered through a transparent and expanding universe their wavelengths have been stretched, or redshifted, to roughly 1 mm, and thus their effective temperature has decreased to just 2.7 Kelvin, or around −270 °C, just above absolute zero. These very first photons, released from the newly transparent primordial universe, represent the cosmic microwave background.

The CMB, initially predicted theoretically, was discovered accidentally by Arno Penzias and Robert Wilson, and later measured with increasing precision by COBE and WMAP. A peculiarity of the CMB is that although extremely uniform it

does possess irregularities, known as anisotropies. It turns out that in a most astonishing finding, the non-uniformity, or clumpiness, of the CMB, represents the seeds of the modern universe, where clumps of matter have condensed to form all the large-scale structure we see today in the current universe. The anisotropies of the CMB, in turn, have their origin in minuscule quantum fluctuations embedded during the period of cosmic inflation, when the universe suddenly and exponentially expanded almost immediately after the Big Bang.

COBE, launched in 1989, produced the first large scale map of the CMB. This was followed by WMAP, launched in 2001, which further refined the CMB while making critical discoveries about the nature and fate of the modern universe. The Planck mission, launched in 2009, promises to further refine the temperature fluctuations of the CMB. Planck's instrument detectors have a range, resolution, and sensitivity far superior to WMAP and COBE and promise to detect temperature variations of a few millionths of a degree, providing even greater insight into the density fluctuations within the CMB that gave rise to all present-day structure in the universe.

Launched on May 14, 2009, the Planck mission, named in 1996 in honor of the German physicist Max Planck (1858–1947), is imaging 95 % of the sky across the microwave range from 27 GHz to 1 Thz. Planck is measuring the CMB down to an unprecedented spatial resolution better than 10 arcminutes, compared to WMAPs 13 arcminutes, and a temperature resolution of 1 microKelvin. Planck's instruments have ten times better sensitivity to subtle temperature variations of the CMB and greater than 50 times the angular resolution COBE.

Precise measurements of the CMB are critical to cosmology, and Planck's goals are to further refine the monumental contributions of COBE and WMAP. Planck will simultaneously map the sky at a wide range of frequencies that will enable the separation of the galactic and extragalactic foreground radiation from the primordial cosmological background signal. Ultimately Plank's data will help to provide more accurate values of fundamental cosmological parameters such as the Hubble constant with the greatest precision yet. Planck will also further characterize the inflationary period of the early universe, and define with high precision the amount and nature of dark matter and dark energy in the universe.

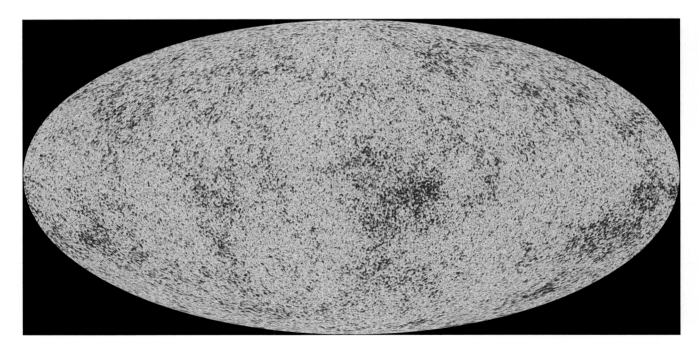

Fig. 6.4 Planck's 1-year data produced the most highly resolved "all-sky" map of the cosmic microwave background, the first light of the primordial universe. The map of the CMB surpasses in resolution and sensitivity all previous maps of the CMB made by its satellite forerunners, COBE and WMAP. The image shows extremely small temperature fluctuations representing the seeds of all future large-scale structure in the modern universe

The Helix in Infrared Light (Spitzer)

The era of infrared satellite observatories began with IRAS, the InfraRed Astronomical Satellite, launched in 1983, which explored the infrared sky for 10 months before its liquid helium was exhausted. IRAS, a collaboration of NASA, the UK, and the Netherlands, scanned 96 % of the sky at four IR bands and essentially doubled the number of cataloged IR astronomical sources by detecting about 500,000 infrared sources.

IRAS essentially opened the door to the remarkable potential of orbiting infrared sky surveys with some of its ground-breaking discoveries such as circumstellar disks, the infrared cirrus throughout the Milky Way Galaxy, and the discovery of a class of starburst galaxies. Later missions, such as the Infrared Space Observatory (ISO) in 1995, and other space-based

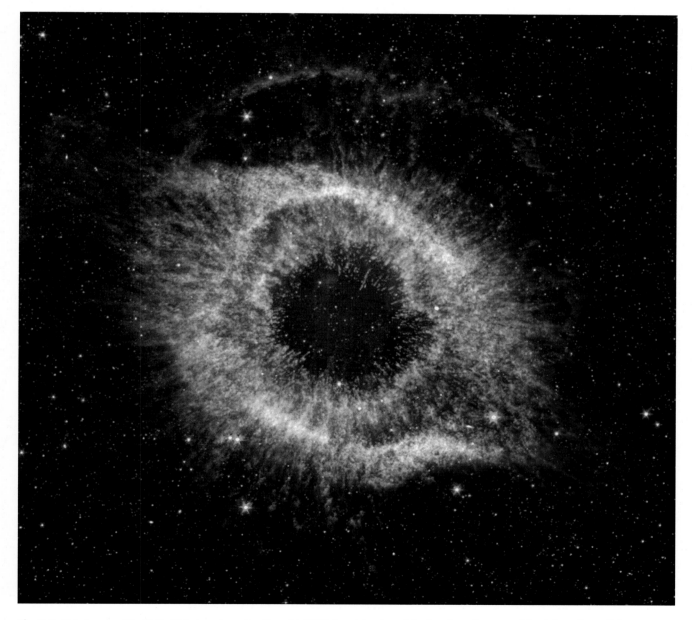

Fig. 6.5 This image of the Helix Nebula, released on June 24, 2007, in celebration of the fourth anniversary of the Spitzer Space Telescope, was made from three bands of near and mid-IR data. The image is a false-color composite with the following color assignments: blue (3.6 microns), green (4.5 microns), and red (8.0 microns). The image features detailed mapping of the expansive outer structures of the 6 light-year-wide planetary nebula. The well-known "cometary knot" features of the Helix show blue-green "heads" representing a higher energy level due to excitation of their molecular material from radiation emitted by the hot stellar remnant. The tails of the cometary knots appear redder (less energetic) as a result of being shielded from the central star's intense radiation by the heads of the knots

observations, such as COBE/FIRAS, IRTS and MSX, have made substantial contributions to the field of infrared astronomy research.

The planning for the next generation of infrared satellite observatories began in the early 1990s. In 1991 the National Research Council released what is now known as the Bahcall report. This report characterized the 1990s as "the Decade of the Infrared" and declared that infrared observatories, both satellite and ground-based, would be critical to making major advances in our understanding of fundamental astronomical problems, from Solar System studies to cosmology. One of its major recommendations was a space-based cryogenically cooled infrared telescope with unprecedented infrared sensitivity that could observe across the infrared spectrum.

After years of design changes, driven by budgetary constraints, the mission originally referred to as the Space Infrared Telescope Facility, or SIRTF, was launched on August 25, 2003. After 4 months in orbit it received its new name, the Spitzer Space Telescope, in honor of the renowned astrophysicist Lyman Spitzer, Jr., one of the first astronomers to propose the idea of research astronomy from space-based observatories.

The infrared spectrum ranges from 1 micron in the near IR to 200 microns in the far IR. The Spitzer Space Telescope is equipped with three cameras that together are capable of recording the full IR spectrum. To avoid contamination from its own IR emissions, Spitzer's cryogenic telescope system is cooled to only a few degrees above absolute zero, about −459 °F or −273 °C. This is achieved with an onboard tank of cryogen, specifically liquid helium.

Spitzer's lifetime with cryogenic cooling was designed for a minimum of 2.5 years but lasted more than five years, with its cryogen being depleted on May 15, 2009. Unfortunately this ended its ability to image in the far IR. Spitzer then entered a new phase, known as its "warm" mission. It's near and mid IR cameras still operating, Spitzer will continue to study comets and asteroids in our Solar System, planets orbiting other stars, and distant galaxies in the universe well into the end of this decade, providing a science mission lasting up to 15 years. Spitzer is considered one of NASA's family of Great Observatories, along with the Hubble Space Telescope, the Chandra X-Ray Observatory, and the Compton Gamma-Ray Observatory.

Spitzer's image data, among its many contributions, has cast considerable light on the final stages of stellar evolution. Intermediate-mass stars such as our Sun end their lives as objects known as planetary nebulae. Spitzer's image of one such object, the Helix Nebula, located 650 light-years away in the constellation Aquarius received considerable worldwide attention for both its informational content and its stunning beauty.

Chandra's Crab: A Cosmic Generator

NASA's Chandra X-ray Observatory, launched into space aboard the space shuttle *Columbia* (STS-93) on July 23, 1999, is part of NASA's family of Great Observatories, along with the Hubble Space Telescope, the Spitzer Space Telescope, and the Compton Gamma-Ray Observatory. Named for the late Indian-American Nobel laureate Subrahmanyan Chandrasekhar (1910–1995), Chandra mission's data is processed by the Chandra X-ray Center (CXC) located in Cambridge, Massachusetts, at the Smithsonian Astrophysical Observatory.

X-ray radiation is absorbed by Earth's atmosphere; therefore, historically, X-ray astronomy was initially achieved using rockets and balloons. Rockets with X-ray detectors were used as early as 1949 to study the Sun, but were limited by their very short duration. Balloon-based observations began in 1964. In fact the first balloon mission discovered the X-ray emissions from the Crab Nebula. The satellite era of X-ray observatories began with the launching of NASA's Einstein Observatory, in 1978, and was followed by a series of increasingly sophisticated X-ray observatories such as the Roentgen satellite, or ROSAT (1990), the Advanced Satellite for Cosmology and Astrophysics (ASCA) (1993), the Rossi X-ray Timing Explorer (RXTE) (1995), BeppoSAX (1996), and the High-Throughput X-ray Spectroscopy Mission (XMM) (1999).

NASA's Chandra X-ray Observatory, launched in 1999, is the premier X-ray observatory to date. Its four sets of mirrors and advanced detectors can pick up X-ray sources more than twice the distance and at least five times the resolution of any previous X-ray observatory.

Why image celestial objects at X-ray wavelengths? X-ray telescopes are the only way we can observe extremely hot matter at temperatures of millions of degrees Celsius. The conditions that produce these extreme temperatures are found in the corona of the Sun and other similar stars, neutron stars, black holes, supernova remnants, and the rarified hot gases found between the member galaxies of large galaxy clusters.

In order to avoid having its image data contaminated by charged X-ray emitting particles that surround Earth, Chandra's high Earth elliptical orbit takes it from its furthest distance, almost a third of the way to the Moon, to as close to Earth as 16,000 km. There are many peculiarities of X-ray observatories and telescopes that make them different from

other telescopic systems. For instance, the almost parallel nature of the mirrors on X-ray telescopes is necessary to avoid X-ray photons from penetrating the mirror surface.

The Chandra mission has been a huge success and led to the discovery and better understanding of a number of supermassive black holes at the center of galaxies and helped us understand more about dark matter, supernova remnants (SNR) and galaxy clusters. Chandra has also investigated the nature of neutron stars and in particular has generated unique high-resolution images of the pulsar wind of the famous and prototypical SNR, known as the Crab Nebula.

One of Chandra's very first observations was the pulsar region of the Crab Nebula M1. The Crab supernova remnant represents the remains of a shattered supergiant star that destroyed itself in the year 1054. Witnessed and documented by Chinese astronomers, who described it as a "guest star," it was observed to be four times brighter than Venus and amazingly visible in the daytime sky for 23 days after the initial event. It is the most famous and most studied supernova remnant and one of only a few observed within our own galaxy by humans.

In 1968 a pulsating radio source was identified at the heart of M1, which we now know to be the Crab pulsar, a neutron star rotating at 30 revolutions per second. A neutron star is a remarkably dense object of about 1.4 solar masses crushed into a space about 10 km wide. The incredible density approaches 50 trillion times that of lead and represents the endpoint of collapse of a massive star that began its life on the main sequence with at least 15–30 solar masses. Stars beginning their lives

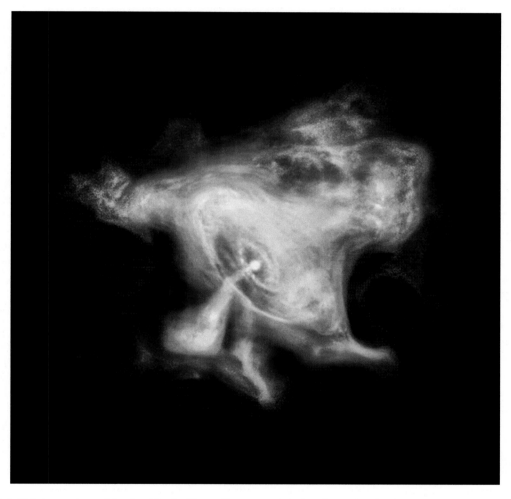

Fig. 6.6 The Crab Nebula was imaged by the Chandra X-ray Observatory less than 2 months after its launch in 1999. This milestone image revealed for the first time a series of rings around the pulsar region as well as high-energy jets that can be traced in the image all the way to the Pulsar. The Crab pulsar generates X-rays by accelerating particles up to the speed of light and flinging them out into interstellar space. The spinning pulsar acts like a gigantic cosmic generator, producing 10 quadrillion volts of electricity plus high-energy particles, including X-rays. Other high-energy particles are created further out from the pulsar when matter ejected by the supernova collides with the interstellar medium, creating shock fronts of multimillion degree gas and high-energy particles

with greater than 30 solar masses collapse into black holes, while those under 15 masses, like our Sun, produce a white dwarf and its transient planetary nebula phase.

Chandra observed the inner part of the Crab surrounding the rotating pulsar, which by all standards is an exotic and extraordinary environment. High-resolution images taken by Chandra show a series of elliptical features at a distance of about 1 light-year from the pulsar, which changes shape every few days. The elliptical wisps represent the shock fronts of high-energy particles being accelerated outward by the pulsar's magnetic field at velocities up to 70 % the speed of light. Although previous studies at the X-ray wavelength hinted at these features, Chandra's high resolution and high sensitivity have clearly resolved the ring-like structures surrounding the pulsar. This was an extraordinary milestone for astronomical researchers.

The Radio Lobes and Galactic Jets of Centaurus A

NGC 5128 is the nearest large elliptical galaxy to our Sun. It is also the nearest of the giant radio galaxies, possessing an active galactic nucleus and optically one of the most luminous galaxies in the sky. Among many other things NGC 5128 is also the prototypical post-merger elliptical galaxy. Structural peculiarities, including the prominent rotating disk of stars and gas and the complex shell structure of its halo, suggest a large-scale merger within the last billion years.

In 1949, NGC 5128 was found to be a loud source of radio energy, in fact the loudest radio source in its region of the sky second overall to Cygnus A , earning it the designation Centaurus A. As a radio galaxy it releases 1,000 times the radio energy of the Milky Way in the form of large bi-directional radio lobes that extend some 800,000 light-years into intergalactic space. The source of the radio emission is very compact, about 10 light-days across, and is believed to be a super-massive black hole in the galaxy's center with an estimated total mass of 200 million to possibly 1 billion suns.

As a radio galaxy, NGC 5128 belongs to the subgroup of galaxies called active galaxies, which include quasars, Seyfert galaxies, blazars and radio galaxies. Active galaxies are distinguished by their prodigious energy output, which cannot be explained by their stellar populations and must have another source. Active galaxies have in common an active galactic nucleus (AGN), which is believed responsible for their prodigious energy output.

Super-massive black holes are almost certainly the central engines of active galactic nuclei, powering the enormous outflows of energy that characterize this subgroup of bright galaxies. Like most active galaxies, NGC 5128 shows high-velocity bi-directional jet phenomena arising from its nucleus. The jets represent streams of multimillion-degree plasma, leaving the nucleus at extremely high velocities. The streams of hot gas are thought to be released when matter is accreted by the super-massive black hole at the galaxy's center.

In one of its first observations in September 1999, the Chandra X-ray Observatory began imaging Centaurus A. Chandra identified several strong X-ray emitting sources that included a bright central source corresponding to the galaxy's active galactic nucleus. Chandra also detected an enormous bi-directional jet of multimillion-degree gas arising from the galaxy's super-massive black hole. The jet containing particles traveling at half the speed of light extends in one direction, toward the northeast, some 13,000 light-years into the outer reaches of the galaxy. From the opposite side of the black hole the shorter "counter-jet" is seen extending southwest.

Although the jets were previously detected at radio wavelengths at much lower resolution, Chandra's data has resolved for the first time several of the distinct components of the X-ray emission. The more collimated inner part of the X-ray jet closer to the black hole contains distinct knots of X-ray emission caused by powerful shockwaves. The outer reaches of the jet shows a more diffuse and broader X-ray emission. Bi-directional jets such as the one in Centaurus-A are not an uncommon phenomenon. They exist in most galaxies harboring an AGN. Due to its proximity at 11 million light-years, and its favorable inclination, Centaurus A has been a perfect subject for Chandra's X-ray telescopes, producing an unprecedented detailed view of galactic jet phenomena.

Older radio data showed that the inner portion of the jet is moving away from the center of the galaxy at about half the speed of light. However Chandra's data revealed an abundance of X-ray emission produced farther out, where the jet interacts with gas reservoirs within the galaxy. The jet's high-energy particles collide with the galactic gas, generating powerful shockwaves producing the X-rays we see in Chandra's images. Chandra's observations offer one of the most detailed looks yet at the interaction of a jet with galactic gas.

Several hundred point sources of X-ray emission are also present in Chandra's X-ray images of Centaurus-A. Some are believed to be X-ray binaries, a complex containing a stellar-mass black hole and a companion star in orbit around each another.

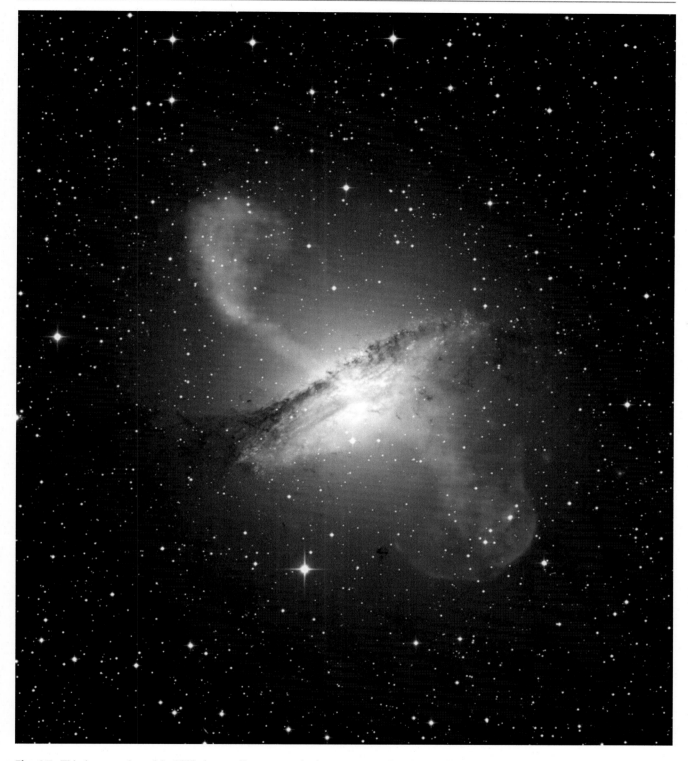

Fig. 6.7 This image, released in 2009, is actually a composite image representing three different portions of the electromagnetic spectrum. Chandra X-ray data (blue, acquired in 1999 and 2000) and sub-millimeter data (orange, MPIfR/ESO/APEX/) are superimposed over optical data (ESO/WFI). Chandra's X-ray data traces the path of the bi-directional jets, leaving the central super-massive black hole in the opposite direction from the central X-ray source produced by the galaxy's AGN

The Bullet Cluster and the Detection of Dark Matter

The concept of invisible mass in the universe was proposed as early as 1933 by the Swiss astronomer Fritz Zwicky, in order to explain the unaccounted-for mass in the orbital velocities of galaxies in clusters. The first good evidence for dark matter came from the work of the American astronomer Vera Rubin, who studied galaxy rotation curves during the late 1960s and 1970s, determining that galaxies must contain from 6 to 10 times as much invisible mass compared to its visible matter in order for them to maintain their integrity as cohesive units and not disintegrate.

Newtonian mechanics predicts that, similar to planets within our Solar System, stars within a rotating galaxy would have different velocities, depending on their distance from the center in an inverse square root relationship. The stars located near the edge would have rotational speeds much slower than stars near to the center. Rubin's work measuring the velocity curves of edge-on galaxies came to the startling conclusion that the velocity rotation curve was unexpectedly flat, meaning that all stars within a spiral galaxy tend to travel at the same speed regardless of their distance from the center. The only explanation for this phenomenon would be the presence of a substantial amount of invisible matter permeating the galaxy. This matter would neither emit nor absorb light and would be distributed not within the central bulge but throughout the galactic halo.

Since Rubin's landmark 1980 paper presenting her work, direct observational evidence has proven the existence of dark matter, but its true nature has remained elusive. Gravitational lensing observations of galaxy clusters has allowed for direct measurements of total mass, both visible and non-visible, of the cluster based on the lensing of its mass on the light of back-

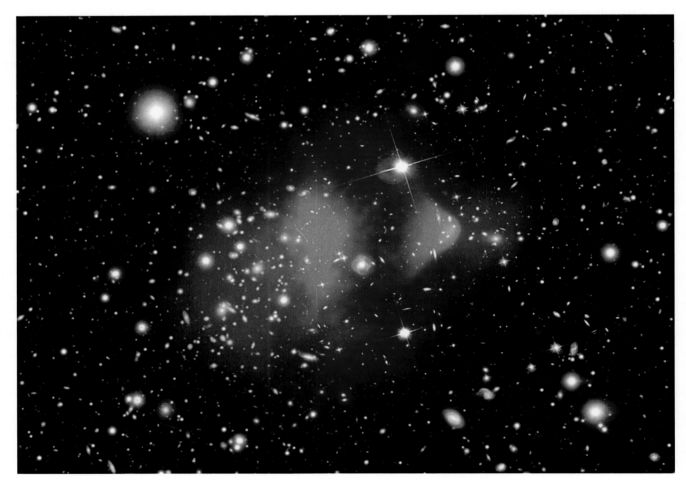

Fig. 6.8 This composite image was assembled from visible light data (Magellan and Hubble Space Telescope) and X-ray emission (Chandra X-ray Observatory, recorded in 2004). The X-ray emission is assigned the color red. A map, based on the strength of the gravitational lensing power of each cluster, is depicted in blue. When the clusters passed through each other (some 150 million years ago) the X-ray emitting gas (which accounts for most of the baryonic matter in the clusters) lagged behind the visible clusters. However the strongest areas of gravitational lensing remained with the visible cluster, indicating the presence of a much larger aggregate of invisible mass presumed to be dark matter

ground galaxies. Measurements confirm the presence of considerably more mass than is accounted for by the clusters' visible mass alone.

The observations of the Wilkinson Microwave Anisotropy Probe, also known as WMAP, recorded from 2001 to 2010 showed with a high degree of accuracy the percentage of dark matter in the universe. WMAP's results revealed a universe composed of 4.6 % visible matter, 24 % dark matter, and 71.4 % dark energy.

Perhaps the most compelling evidence for the existence of dark matter came from the gravitational lensing studies of the Bullet Cluster, designated 1E 0657–558. The Bullet Cluster is made up of a pair of colliding galaxy clusters. The bullet-shaped sub-cluster passed through the main cluster center 150 million years ago, forming a shockwave that can be seen along the right side of the image.

The major components of the cluster pair, which includes stars, gas, and dark matter, all behave differently as a result of the collision. The stars observed in visible light are the least gravitationally affected, passing through the main cluster relatively undisturbed. The cumulative hot gas of the two clusters revealed by their X-ray emission represents most of the ordinary matter, also known as baryonic matter, of the cluster pair. The gases interact electromagnetically and lag behind the stars of the galaxies in the clusters. The third component, the presumed dark matter, is measured indirectly by gravitational lensing of background galaxies by the cluster pair. Without the presence of dark matter the lensing would be expected to follow only the baryonic matter with X-ray emitting hot gas. Instead the lensing is strongest in two separate regions close to the visible galaxies and away from the area of greatest gas concentration. The conclusion is that the overwhelming mass of the cluster exists as dark matter that permeates the visible galaxies and is unaffected by the collision.

The problem of the nature of dark matter is still unresolved. By definition dark matter cannot be observed with a telescope and does not interact with electromagnetic radiation. The prevailing consensus among cosmologists is that dark matter is composed of a yet to be characterized sub-atomic particle. The elucidation of its nature is an extremely vigorous area of particle physics research today.

The Ultraviolet Sun from the Solar Dynamics Observatory

Due to its brightness, proximity, size, and its overwhelming influence on Earth, the Sun is probably the most studied celestial body. The fact that the Sun's surface changes constantly while emitting energy across the electromagnetic spectrum makes it a most dynamic and intriguing subject for space-based telescopic observation. Lastly the presence of an intermediate mass G2-type star in our own backyard has taught us an enormous amount about stellar astronomy.

The Sun emits much of its energy beyond the visible spectrum including infrared, ultraviolet and X-ray radiation. Those wavelengths, being subject to atmospheric absorption, make space-based observation a requirement for high-level solar research. Space-based studies of the Sun began as early 1962 with the first of the Orbiting Solar Observatories, also known as OSO, a series of dedicated unmanned solar satellites launched by NASA. Since that time there have been over 80 space-based missions launched primarily to study the Sun. This list includes the first major manned solar mission from space known as *Skylab*, which operated for 6 years from 1973 to 1979 and made many outstanding contributions to solar science with its diverse collection of onboard solar instruments.

Some of the more notable solar missions that followed the OSO series include P78-1 (1979), NASA's Solar Maximum Mission (SMM) (1980), Hinotori (Japan) (1981), the joint ESA-NASA Ulysses mission (1990), NASA's Compton Gamma Ray Observatory (CGRO) (1991), and Russia's "CORONAS" program (1994).

Current space-based solar missions include the Geosynchronous Operational Environmental Satellite (GOES) Series, the Solar and Heliospheric Observatory (SOHO), the Transition Region And Coronal Explorer (TRACE), the Reuven Ramaty High-Energy Solar Spectroscopic Imager (RHESSI), the Solar Radiation and Climate Experiment (SORCE), Hinode (a joint Japan/US/UK mission), the Solar Terrestrial Relations Observatory (STEREO), and the Solar Dynamics Observatory (SDO).

The Solar Dynamics Observatory, also known as SDO, was launched on February 11, 2010, and is the first mission in NASA's Living With a Star Program, also known as LWS. The LWS program was initiated to elucidate the causes of solar variability and its impact on Earth and human technology by studying the solar atmosphere in many different wavelengths simultaneously. The SDO's advanced array of telescopes and detectors are capable of continuous observations of the Sun and exceptionally rapid download of its data.

One of the prime objectives of the SDO is to study the Sun across the ultraviolet spectrum. Lower energy ultraviolet light is a known carcinogen to human skin, while extreme ultraviolet radiation released by solar flares and storms can disrupt communication and navigation systems. Therefore knowledge about the Sun's ultraviolet energy emission is critical to safeguarding both humanity and technology from its adverse effects.

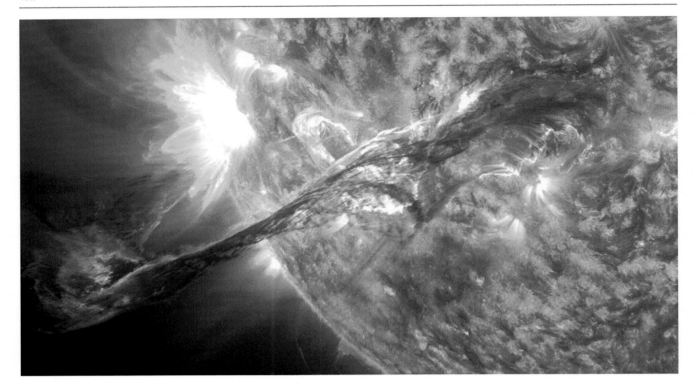

Fig. 6.9 On August 31, 2012, SDO's continuous imaging of the Sun across the UV spectrum produced a single remarkable image made from two bands of extreme ultraviolet light (30.4 and 17.1 nm). The image conveys both the power and dynamic nature of our star. The Sun's surface is a constantly changing environment influenced by its ever-shifting magnetic field. In the image an arc of multimillion-degree plasma hovers over the Sun's surface. The arc known as a "filament" stretches nearly 200,000 miles across. The filament suddenly erupted into space, producing an enormous outflow of matter and energy traveling outward at 900 miles per second in what is known as a coronal mass ejection (CME). Captured by the detectors of the SDO in a single dramatic image, the CME ejected an abundance of charged particles into space, which 3 days later collided with Earth's magnetosphere, producing visible auroral displays at northern and southern latitudes

The Solar Dynamics Observatory's suite of instruments, which includes its AIA (Atmospheric Imaging Assembly), EVE (Extreme Ultraviolet Variability Experiment) and HMI (Helioseismic and Magnetic Imager), represents a significant advance over previous solar observatories. SDO's AIA instrument has twice the image resolution than STEREO and four times greater imaging resolution than SOHO. Specific SDO mission goals include measurements of the interior of the Sun, the Sun's magnetic field, the hot plasma of the solar corona, and the irradiance that creates the ionospheres of the planets.

M31 in Infrared: Clues to the Story of Andromeda

By virtue of being our galactic neighbor the Andromeda Galaxy enjoys many distinctions, which include its location as the closest spiral galaxy to the Milky Way, located only 2.5 million light-years in the distance, and one of only a few naked-eye galaxies seen from Earth. M31 has also been a pivotal object in the shaping of modern cosmology. It is only fitting that M31 became a subject of intense investigation at infrared wavelengths by one of NASA's premier infrared satellite observatories.

The Spitzer Space Telescope began pointing its infrared sensors at M31 exactly 1 year after its launch on August 25, 2004. Additional Spitzer observations were made in 2005 and 2006, each at a resolution and sensitivity never before achieved in the infrared spectrum. Using its Multiband Imaging Photometer for Spitzer detector, also known as MIPS, with its three arrays in the far infrared at 24, 70, and 160 μm, Spitzer revealed a very different morphology to the galaxy than what was previously apparent in visible light images. Spitzer's data also shed light on M31's interactions with one of its satellite galaxies, the dwarf elliptical galaxy M32.

What researchers found in Spitzer's IR data is a considerably disturbed galaxy possessing two main spiral arms that end at M31's barred nucleus. In addition they were surprised to find an offset ring of recent star formation believed to be separate from M31's spiral arm structure. The ring is split near the location of M32, a satellite dwarf elliptical galaxy gravitationally bound to M31. Detailed computer simulations of M31 and the satellite galaxy M32 show that M32 has likely passed through

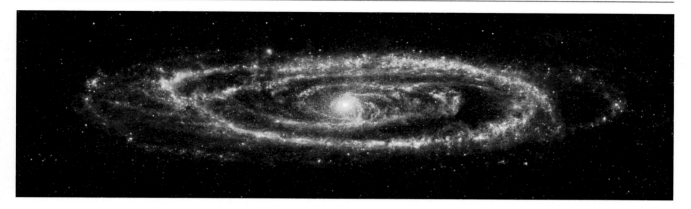

Fig. 6.10 This 1-year anniversary image recorded by the Spitzer Space Telescope on August 25, 2004, was recorded in infrared at 24 microns. The data, which required 11,000 separate exposures over 18 hours, produced this detailed map of the dust population of our galactic neighbor in unprecedented resolution and depth. Curious features noted in the image include a ring of dust, representing recent star formation, plus a split in the offset ring (upper left) in the location of M32 (Andromeda's gravitationally bound dwarf elliptical galaxy), where it is believed to have passed through the Andromeda Galaxy's disk some 200 million years ago. The dust map also reveals with unprecedented clarity inner spiral structure converging on Andromeda's barred nucleus

the disk of M31 along its polar axis roughly 200 million years ago, creating the split in the ring as well as pulling the ring off center. The same data also reveals tracings of spiral arms within the star-forming ring that reach into the very center of the galaxy and were likely at least partially formed from the passage of M32 through its disk.

Computer simulations made with this data also surmise that M31's brilliant OB association, NGC 206, within its southwest arm, may have arisen as the outcome of triggered star formation from the passage of M32.

Additional Spitzer data released in 2006 was recorded using its Infrared Array Camera, named IRAC, at four wavelengths (3.6, 4.5, 5.8 and 8 μm). Infrared light at 3.6 and 4.5 microns is sensitive predominantly to starlight, and 8 μm data is limited to the presence of warm dust throughout the galaxy. Using this data, astronomers were able to calculate the infrared "brightness" of M31, and from that value they estimated its overall stellar population at one trillion stars. Compared to our Milky Way's 400 billion stars, M31's stellar census is an astounding figure. The new Spitzer data also put a size on Andromeda at 260,000 light-years across, dwarfing its Milky Way neighbor, which spans only 100,000 light-years. The new measurements of M31 derived from the IR data, proves that our neighbor is indeed a giant spiral galaxy in every respect.

The Galactic Center Across the Spectrum

The center of our galaxy, a typical spiral in many respects, may provide insight to the forces which drive billions of similar spiral galaxies in our universe. Our solar system, located 26,000 light-years from the center of our galaxy, potentially offers a bird's-eye view of this tantalizing region; however, the view at optical wavelengths is blocked because of massive amounts of intervening dust in the plane of the galaxy. Fortunately astronomers have learned to peer through this dust, utilizing instruments capable of observations at radio, infrared, and X-ray wavelengths.

Cosmic dust grains have a fairly consistent diameter of about 0.1 micron. Being similar in size to wavelengths of visible light, dust grains tend to block the passage of visible light. On the other hand, radio and infrared waves being much larger, and X-rays being much smaller than dust grains, allows the energy of these wavelengths to pass through the dust clouds without being deflected or absorbed.

Our galaxy's central galactic bulge can be seen in the summer sky just a few degrees west of the large Sagittarius Star cloud. The true galactic center harbors a powerful and enigmatic object known as Sagittarius A. Sagittarius A has long been known as one of the most powerful radio sources in the sky, second only to the Sun. Radio and X-ray observations revealed that within the central-most 30 light-years surrounding Sagittarius A, things really start to get strange.

The central region is extremely compact, containing many millions of stars. Getting closer to the true center we find a number of young blue supergiant stars among older red giants and scattered supernova remnants. Astronomers postulate that multiple epochs of star formation have occurred in the galactic center spawned by collisions of closely compacted molecular clouds.

High resolution imaging of the true galactic center across the electromagnetic spectrum reveals a 7 light-year-wide rotating mini-spiral and a surrounding circumnuclear disk that delivers matter to a central object of extraordinary mass known as

Sagittarius A* or Sgr A*. Several stars within a few light-years of Sagittarius A* show orbital velocities so rapid that the center of the mini-spiral must be an extremely compact object, between 4.1 and 4.3 million solar masses. The incredibly massive object occupies a space of only 0.1 astronomical units, or about 1 light-minute. An object this compact and massive can only be explained by a super-massive black hole at the extreme center of our galaxy.

Astronomers owe a great deal of their knowledge about the Milky Way's center to NASA's suite of great multiwavelength satellite observatories. In 2009, to celebrate the International Year of Astronomy 2009, these observatories pooled together their amazing resources to create a composite image of the galactic center like none before. The image is comprised of observations made by the Hubble Space Telescope, the Spitzer Space Telescope, and the Chandra X-ray Observatory to create an image that spans the electromagnetic spectrum from infrared through visible to X-ray wavelengths.

The X-ray component of the composite image, contributed by Chandra, was recorded over a 2-week observation, and remarkably the X-ray intensity was not static. X-ray intensities flared up at least a half-dozen times during that period. The X-ray flares are believed to occur near the event horizon of the galaxy's central black hole, likely due to matter falling into it from its accretion disk. In addition huge lobes of 20 million-degree Centigrade gas extend out over dozens of light-years on either side of the black hole, believed to be the fossil remains of previous outbursts over the last 10,000 years.

The Hubble Space Telescope near-IR and optical light contribution shows the massive stars and star clusters of that region at very high resolution. The Spitzer infrared contribution, recorded from 2004 to 2005, reveals populations of previously hidden massive stars and supernova remnants invisible at optical wavelengths.

The core of our galaxy harbors hundreds of thousands of stars that cannot be seen in visible light. These stars heat the surrounding gas and dust, which then glow in infrared light, revealing their varied structure. Together the three observatories collaborated to create the most detailed image ever of the central 300 light-years of our galaxy. The different wavelengths work together to tell the story of the turbulent nature and enormous energy output of our galactic center. The information gained from the study of our own galactic center offers insight into the nature of the nuclear regions of other similar galaxies.

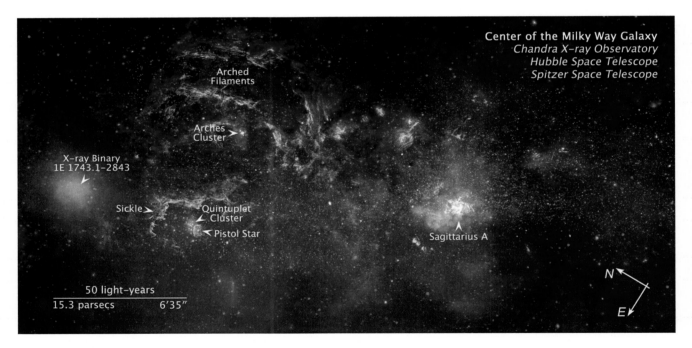

Fig. 6.11 The turmoil of the central 300 light-years of our galaxy's center is revealed in this unique composite image assembled with data from the Hubble Space Telescope, the Spitzer Space Telescope, and the Chandra X-ray Observatory. This composite image, released in 2009, was created from infrared, optical, and X-ray light and represents the most revealing image of the galactic center ever made. The colors assigned to the components of the image are as follows: optical and near-IR data from the Hubble Space Telescope (yellow), infrared data from the Spitzer Space Telescope (red), and X-ray data from the Chandra X-ray observatory (blue). A super-massive black hole at the center of our galaxy, some four million times more massive than our Sun, resides within the bright region in the lower right known as Sagittarius A*. The diffuse X-ray light seen in blue is produced by outflows of hot gas from the super-massive black hole, in addition to winds from massive stars and supernova explosions. The diffuse red filaments and clouds captured in infrared light represent enormous dust clouds glowing from the light of embedded young massive stars. Also present in the image is the exotic Pistol Star, a blue hyper-giant and one of the most luminous stars known, plus an assortment of young star clusters and supernova remnants

The Tycho Supernova Remnant (SN1572)

In early November 1572 a "guest" star appeared unexpectedly in the constellation Cassiopeia. The new star rivaled Venus in brightness and remained visible to the naked eye well into 1574. Although not the first to discover the star, the Danish astronomer Tycho Brahe made perhaps the most extensive study of the new star. In 1573 he published his and others' observations of the new star in a small book titled *De Nova Stella,* coining the term "nova" for the appearance of a "new" star in the sky.

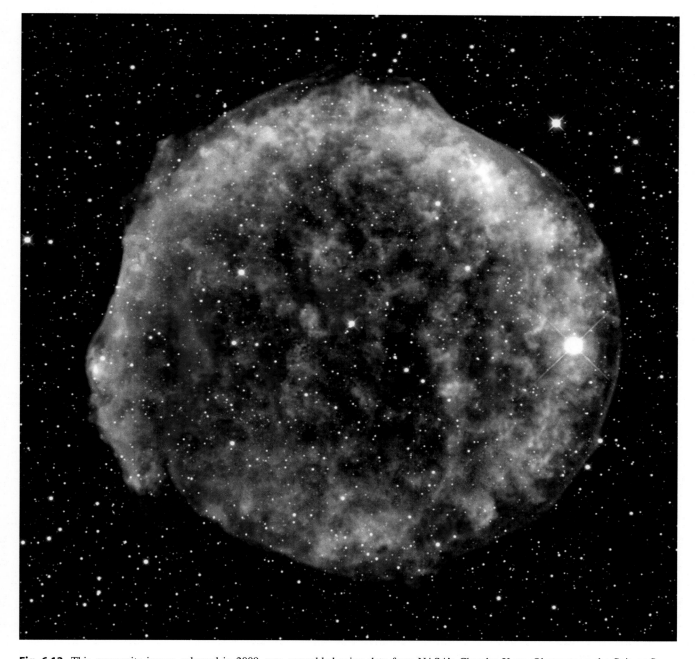

Fig. 6.12 This composite image, released in 2009, was assembled using data from NASA's Chandra X-ray Observatory, the Spitzer Space Telescope, and the Calar Alto observatory in Spain. Tycho's supernova ejected the contents of its star into space in 1572 at speeds of more than 5,000 km/second. As this material collided into surrounding gas clouds, shock fronts were created, releasing energy at a variety of wavelengths. Multimillion-degree X-ray emitting gases (seen as yellow and green) make up much of the complex. The hottest and highest energy X-rays (blue) are seen in the outer shell known as the shock front, where the expanding SNR collides with the interstellar medium. Much cooler dust, either recently formed or previously ejected by the progenitor star (seen as red), is scattered throughout the complex

Brahe, who went on to become one of the greatest observational astronomers in history, made the astute observation that the new star lacked any detectable parallax and therefore must be located beyond the planets and likely at a similar distance to the known fixed stars in the sky. This challenged the dogma of his time, which believed that the stars were fixed and unchangeable.

We know today that Tycho's nova was in fact a supernova, or the explosive death of a super-massive star. A supergiant star shines for only a few million years, a short life compared to lower mass stars. Although lower mass stars end their lives passively as compact white dwarfs, massive stars end their lives violently, destroying themselves in cataclysmic explosions, expelling their contents out into space.

For a star to end its life as a supernova it must meet specific mass requirements. Generally stars that begin their lives with greater than 10–15 solar masses tend to proceed to supernova. More important, however, is the mass remaining in its core during its final stages. Those with final core masses greater than 1.4 solar masses reach a critical value known as the "Chandrasekhar limit," named for the Indian-American astrophysicist Subrahmanyan Chandrasekhar, who made pioneering contributions to stellar science. The road to the Chandrasekhar limit, however, has many pivotal steps.

Close to the end of its life the most massive stars will shed prodigious amounts of mass and gradually deplete their hydrogen fuel. Without hydrogen the nuclear furnace fuses progressively heavier elements within its core. The sequence of elemental fusion is hydrogen (H), helium (He), carbon (C), neon/magnesium (Ne), oxygen (O), silicon (Si), and iron (Fe). The resulting fusion by-products rain down upon the next lower layer, building up the shell below. As a result of silicon fusion, an inert core of iron (Fe) is formed. The endpoint of nuclear fusion is iron (Fe). Iron cannot be fused further, as thermodynamics will not allow it. When the total core accumulation reaches 1.4 solar masses, the Chandrasekhar limit is achieved, and the core collapses in on itself.

At this stage things happen quickly, as the extreme conditions leading to the supernova event are reached. In an instant the core collapses, producing a titanic blast that rips through the surrounding nuclear fusion shells and the remaining stellar envelope. The explosion tears apart the star and expels its envelope into space, producing a nebula we call a supernova remnant. The explosive force and energy release is so intense that for a short time the visible light of the supernova can match the light output of an entire galaxy. This explains why supernova events can be detected in very remote galaxies even billions of light-years away. A supernova of this type is known as a Type II supernova.

Tycho's nova was in fact a Type 1a supernova. This type of supernova occurs within binary star systems, when matter from a companion star is gravitationally transferred to the surface of a white dwarf. If the additional mass causes the white dwarf to reach the Chandrasekhar limit of 1.4 solar masses, then a supernova event occurs. Type 1 supernovae are distinguished from Type II by their mechanism of core collapse and by the lack of hydrogen in their outer envelopes. Type 1 supernovae are sometimes referred to as stripped core-collapse supernovae because their hydrogen envelopes have been stripped away long before. Types 1b and 1c are distinguished from Type 1a by their lack of silicon spectral lines.

With both Type II and Type 1 supernovae the layers of elements forged within the doomed star are violently ejected into space and for many years continue to expand in a shell called a supernova remnant. The matter ejected by the supernova collides with the surrounding stationary dust and gas of the interstellar medium, creating shock fronts of multimillion-degree gas and high-energy particles. The heated matter produces intense radio and X-ray emission as well as visible light for thousands of years before gradually dissipating into the interstellar medium.

Cassiopeia A: A Cosmic Wreckage

Cassiopeia A (Cas A) is a supernova remnant in the constellation Cassiopeia. It has several special distinctions, which include being the strongest extrasolar radio source in the sky and one of the first discrete radio sources identified when it was first discovered in 1947. Cas A is also the youngest known supernova remnant in the Milky Way Galaxy. Interestingly, in contrast to its radio brightness it is extremely faint at optical wavelengths, making it a most challenging object to image in visible light.

Located 11,000 light-years from Earth, Cas A's light is thought to have reached Earth roughly 340 years ago, sometime around 1667. No definite documentation of its presence in the sky exists from that time, although there are a number of theories as to why it went undetected. One theory is that the supernova was obscured in visible light by dense matter previously released by the massive progenitor star. No supernova in the Milky Way has been visible to the naked eye from Earth since.

The progenitor star, a supergiant 15–20 times more massive than our Sun, ended its life cycle in a cataclysmic supernova explosion. As a supernova remnant (SNR), Cas A's youth and proximity make it ideal for observation across the electromagnetic spectrum. Cas A has been investigated extensively at radio, infrared, optical, and X-ray wavelengths, revealing a com-

plex system of knots, filaments, shells, and bubbles, with each feature corresponding to a different component of the progenitor star, allowing researchers to tease apart the details of the explosion, layer by layer.

The supergiant's original layers were ejected outward in successive order, but at different average velocities, so the SNR's components are all expanding independently at a non-uniform rate. Cumulative X-ray, infrared, and optical data from Chandra, Spitzer, Hubble, and ground-based observatories were combined to create the first ever multiwavelength three-dimensional reconstruction of a supernova remnant.

The combined data reveals two main components to Cas A – a spherical component in the outer parts of the remnant, and a flat disk-like component within the inner region. The outer sphere represents the shock front and corresponds to the outer layers of the progenitor star, mostly composed of helium and carbon. The inner flat component consists of heavier elements from the inner layers of the star, such as oxygen, neon, silicon, sulfur, argon, and iron. High-velocity bi-directional jets, rich in silicon, appear to arise from the inner disk-like component and likely formed soon after the explosion.

About 95 % of all stars fade away passively as white dwarfs. Therefore less than 5 % of stars, the most massive ones, end as supernovae. Although they represent a small fraction of all stars, supernovae serve a critical function in the overall ecology of the universe by enriching the interstellar medium with heavier elements such as carbon, nitrogen, oxygen, calcium, silicon, sulfur, and iron, which can only be produced by the intense heat and pressure deep within the nuclear furnace of stars.

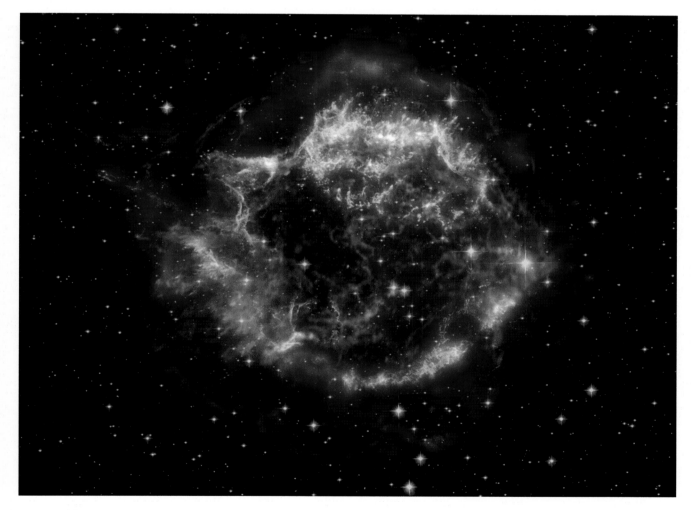

Fig. 6.13 This false-color composite image of Cas A released in 2005 was assembled using data taken by three of NASA's Great Observatories: infrared data from the Spitzer Space Telescope (red); visible data from the Hubble Space Telescope (yellow); and X-ray data from the Chandra X-ray Observatory (green and blue). The features captured by each spectral band correspond to wide differences in temperature of the different components of the SNR. Hubble (optical) detects the delicate filaments of hot gases about 10,000 Kelvin. Chandra reveals superheated gases, up to ten million Kelvin. These extremely hot gases represent the shock front of the expanding SNR, where ejected material from Cassiopeia A collides with ambient gas and dust of the interstellar medium. Chandra can also see Cassiopeia A's neutron star (turquoise dot at center of shell). Spitzer's infrared detectors reveal warm dust in the outer shell of only a few hundred Kelvin

Supernovae carry out their role by both forming and dispersing the heavier elements created deep within them. Supernovae also play a significant role in the birth of new stars, as their expanding shock fronts often trigger the collapse of nearby molecular clouds, leading to new generations of stars. Our own Sun contains a small fraction of heavier elements that allude to its origin from an ancient supernova some 5 billion years ago.

Supernovae have contributed in a critical way to the story of life on Earth. Heavier elements found in abundance in living organisms, such as carbon, nitrogen, oxygen, sulfur, and calcium, among others, are formed by ordinary stars but are only released into the interstellar medium by supernova events. For instance the iron that contributes to the hemoglobin in our blood can only be created deep within the cores of massive stars that produce supernovae. Therefore we are not only the "stuff of stars" but the stuff of supergiant stars.

Hercules A in Radio Light

The unaided human eye and brain is capable of seeing only a minuscule fraction of the full spectrum of energy produced by the universe. On a logarithmic scale of frequency, visible light represents only 2.3 % of the entire electromagnetic spectrum, and if you make that scale linear it is reduced to a mere 0.0035 %. Each part of the electromagnetic spectrum reveals a distinct and unique universe shaped by different chemical and physical processes and structures. Only by studying the universe at each portion of the spectrum do we begin to piece together its fundamental nature and evolution.

Radio astronomy was born in 1932, when the radio engineer Karl Jansky, while studying sources of radio frequency interference for Bell Laboratories, concluded that the diffuse background noise detected by his receivers was extraterrestrial in origin. This was the first time that radio waves were detected from outer space.

Some of the most important astronomical information has come by way of studying the weakest and coolest part of the electromagnetic spectrum, as radio waves represent the largest contribution of electromagnetic radiation emitted by objects in the universe. A sample of objects and phenomenon that emit at radio frequencies include our Sun, the galactic center, supernova remnants, pulsars, star-forming regions, radio galaxies, the cosmic microwave background, and black holes. One controversial area receiving considerable attention currently is the possibility of detecting radio sources of extraterrestrial communications (SETI).

Earth's atmosphere serves as a barrier to much of the non-visible spectrum, including X-rays, ultraviolet, infrared, and microwave; however, fortuitously, the atmosphere is transparent to radio waves. In fact radio telescopes can observe even on cloudy days. Radio telescopes need to be extremely large for two reasons. Radio signals have a characteristic low signal/noise ratio. Also, angular resolution is a function of the diameter of a telescope, and radio waves being on the order of meters in length require radio telescopes to be much larger in comparison to their optical counterparts.

Ground-based radio telescopes record wavelengths of radio signals ranging from fractions of a millimeter to tens of meters long. A special technique used in radio astronomy used to boost resolution is known as interferometry, which combines data from two or more telescopes, creating images that have the same resolution, as if they were imaged with a single telescope of an aperture as large as the distance between those telescopes. Examples of radio interferometers include the Very Large Array (VLA) in New Mexico, consisting of 27 individual telescopes; the Very Large Baseline Array (VLBA), comprising ten radio telescopes spread across 5,351 miles; and the Atacama Large Millimeter/Sub-millimeter Array (ALMA) in Chile, which combines 66 high-precision dish antennas.

Radio astronomy has made key contributions to the study of galaxies, which are very luminous at radio wavelengths. These are known as radio galaxies. They are exclusively highly luminous active galaxies. Active galaxies contain an active galactic nucleus that releases copious amounts of energy. The energy release is believed to be powered by super-massive black holes. The host galaxies are almost exclusively large elliptical galaxies.

The radio emission from these galaxies has its origin in synchrotron radiation, a form of radiation created by accelerating charged particles through a magnetic field. The synchrotron radiation emitted by radio galaxies arises as a result of the accretion of mass by a supermassive black hole at the center of its host galaxy. As the mass spirals inward across the event horizon of the black hole, the energy released produces bidirectional, highly collimated jets that emerge in opposite directions from close to the galactic disc. Although the jets emit broadly they are loudest at radio frequencies and produce enormous large-scale structures known as radio lobes, which are characteristically paired, symmetrical, and roughly ellipsoidal structures positioned on either side of the active nucleus.

The largest radio galaxies produce radio lobes extending to millions of light-years from the host galaxy. Perhaps one of the most interesting radio galaxies is Hercules A, also known as 3C 348, an active elliptical galaxy in the constellation Hercules, located some 2 billion light-years away. The galaxy, an ordinary appearing elliptical at visible wavelengths, is

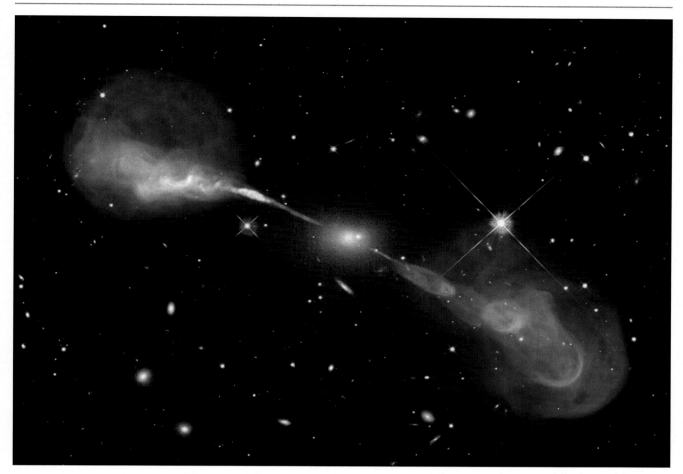

Fig. 6.14 This optical-radio composite image released in 2012 was made from visible light data recorded by the Hubble Space Telescope and radio wave data recorded by the Very Large Array (VLA). Although the visible light data is displayed in natural color, the radio data is assigned the color red. Dramatically displayed in the image are the enormous optically invisible bidirectional radio lobes that each stretch one-and-a-half million light-years in length. The lobes are formed by jets of subatomic particles ejected at nearly the speed of light from the vicinity of the black hole. The outer portions of both jets show ring-like structures, suggesting multiple previous outbursts from the supermassive black hole

known to harbor a 2.5-billion-solar-mass central black hole, 1,000 times more massive than the black hole at the center of our Milky Way. Long known as a very bright radio-emitting object, recent VLA observations at radio frequencies revealed 3C 348 to be one of the brightest extragalactic radio sources in the entire sky.

The Gamma Ray Universe

Gamma rays have the most energy of any wave in the electromagnetic spectrum and are therefore produced by the hottest and most energetic objects in the universe. The phenomena that produce such high energy emissions include neutron stars and pulsars, supernova explosions, and regions around black holes.

Similar to other high-energy waves, gamma rays are absorbed by Earth's atmosphere. Therefore gamma ray research is performed by satellite observatories. Because of their very high energy, gamma rays cannot be reflected by mirrors, so they cannot be recorded by ordinary telescopes. Gamma ray detectors contain densely packed crystal blocks that rely on the deflection of gamma rays as they collide with electrons in the crystal in a process known as Compton scattering.

The first of the great gamma ray observatories was the Compton Gamma Ray Observatory (CGRO), launched by NASA on April 5, 1991, aboard the space shuttle Atlantis. The CGRO gathered data until 2000. Its contributions included the discovery of more than 2,600 gamma ray bursts, plus hundreds of previously unknown sources of gamma rays, including 30 exotic objects, while also studying active galaxies and the mechanism of how black holes eject gamma rays at nearly the speed of light.

A successor to the highly successful CGRO, the Fermi Gamma-ray Space Telescope was launched by NASA into low-Earth orbit in June 2008 and is expected to be in operation for 10 years. Originally called the Gamma-ray Large Area Space Telescope, or GLAST, NASA renamed the satellite in honor of Enrico Fermi, after its first-light image. Fermi utilizes two instruments to observe the gamma-ray universe: the Large Area Telescope, or LAT, and the Gamma-ray Burst Monitor, or GBM. The LAT can image 20 % of the sky at any time and can cover the sky every 3 hours during two orbits. The GBM is designed to observe gamma ray bursts, or GRBs. These are sudden, brief flashes of gamma rays that occur about once a day at random positions in the sky.

Discovered in the late 1960s by U. S. military satellites, a gamma ray burst is an intense flash of gamma rays in the sky, lasting anywhere from a fraction of a second to up to a few minutes. GRBs are beamed, meaning they are focused into a narrow jet or more likely bi-directional jets. GRBs are followed by a fainter and much longer-lived signal in visible light known as the GRB "afterglow." The afterglow, discovered in the 1990s, allows localization of the origin of the GRB, something not possible from the short-lived gamma-ray signal alone.

Initially believed to arise from our own galaxy, we now know they have their origins mostly in extremely distant galaxies, often from the most distant galaxies in the known universe, literally billions of light-years away. Visible light observations following a GRB often reveal extremely faint, poorly resolved, immensely distant galaxies at the GRB position.

The prevailing theory about GRBs is that they arise from extreme types of supernovae or from the mergers of compact objects like neutron stars and black holes. The immense energy of a GRB is mind boggling and still an enigma to astronomers. GRBs are hundreds of times brighter than a typical supernova, and during their eruption they outshine briefly any other source of light in the observable universe. Gamma-ray bursts are the most energetic and luminous events since the Big Bang and can release more energy in 10 seconds than our Sun emits in its entire 10-billion-year lifetime.

Two types of GRBs exist, short duration and long duration. Short-duration bursts last anywhere from a few milliseconds to 2 seconds. Long-duration bursts last anywhere from 2 seconds to a few minutes. Long-duration GRBs are believed to be associated with supernovae, while short-duration GRBs are possibly related to exotic events, such as the merger of two neutron stars into a black hole or a neutron star falling into a black hole to form a larger black hole.

One of Fermi's goals is to advance the science of GRBs by using its detectors large field of view to see bursts from over two-thirds of the sky at one time, and then provide locations for follow-up observations by other ground-based and satellite observatories. Localizing the GRBs was something that its predecessor, the CGRO, could not do.

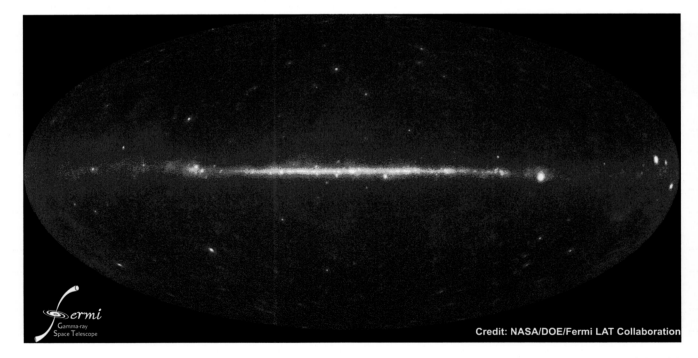

Credit: NASA/DOE/Fermi LAT Collaboration

Fig. 6.15 This gamma ray all-sky view released in 2009 shows a wide range of gamma ray sources. The galactic plane is seen as a bright, thick band, a result of gamma rays produced by cosmic ray interactions with the interstellar medium. Many discrete gamma ray sources are also visible as bright spots scattered around the sky. Large gamma ray lobes extend above and below the galactic center and are believed to represent huge reservoirs of energetic particles, possibly produced during previous eras of activity in the core region of the Milky Way. The largest classes of relatively nearby gamma ray sources, however, are pulsars (rapidly rotating neutron stars) and supernova remnants. Most extra-galactic gamma ray sources are associated with active galactic nuclei (AGN), in particular a subclass of AGNs known as blazars

Mira's Tail in Ultraviolet Light

Ultraviolet light, referring to light from 10 and 320 nm, represents an astronomically relevant part of the electromagnetic spectrum. Phenomena that produce ultraviolet light include stars at the extremes of their evolution, either early on, when they are relatively unstable, or at the end of their lives. UV light is generally the signature of hotter objects, and aside from stars UV observations can also provide essential information about the evolution of galaxies and the interstellar medium.

Realizing the value of ultraviolet astronomy, NASA has launched several dedicated UV observatories. Aside from UV instruments attached to rockets and those aboard the space shuttle, the first UV satellite observatory was the Far Ultraviolet Spectroscopic Explorer (FUSE). FUSE was launched in 1999 and operated until 2007.

By far the most sophisticated UV satellite observatory built by NASA is the Galaxy Evolution Explorer (GALEX). GALEX was launched on April 28, 2003, and operated until early 2012. GALEX made significant contributions to galactic astronomy by measuring and cataloging UV emission from hundreds of thousands of galaxies across 10 billion years of cosmic time. GALEX also made significant contributions to stellar astronomy by observing UV emission from both very young and very old stars.

In November 2006 GALEX made an extraordinary discovery about one particular star. Mira is a red giant star located between 220 light-years in the constellation Cetus. Mira has the distinction of being the brightest periodic variable in the sky. Not visible to the naked eye for most of its cycle, its variability was recorded for the first time by the David Fabricius, a German pastor who made significant contributions to astronomy during the era of visual observations, on August 3, 1596.

Mira is known as a pulsating variable star. It dims and brightens by a factor of 1,500 every 332 days. Its variability is caused by its existence within a binary star system comprised of the red giant Mira A and its white dwarf companion Mira B. The relationship is a symbiotic system, where Mira B is accreting mass from the red giant Mira A. X-ray observations by Chandra shows a direct mass exchange along a bridge of matter from Mira A to its white dwarf companion, which is separated from it by a mere 70 astronomical units.

During a routine survey of the sky in November 2006 GALEX discovered for the very first time an enormous tail of ultraviolet emission extending from the star some 13 light-years long. The tail is composed of matter shed from the red giant star over the course of 30,000 years. Like other red giants, Mira loses considerable mass in the form of gas and dust, roughly the equivalent of Earth's mass every 10 years and the equivalent of 3,000 Earth-sized planets during the last 30,000 years.

The other peculiarity of Mira is that it is a rapidly moving star, traveling at 130 km per second relative to its surroundings. Mira's movement, coupled with its mass loss, creates what is known as a "bow shock" at the leading edge of the star similar to water at the front of a speeding boat. As the hot gases in the bow shock collide with the cooler gases previously shed by the star, energy in the form of UV light is emitted in the wake of the star's path. This process has created the extraordinary 13 light-year long tail of Mira.

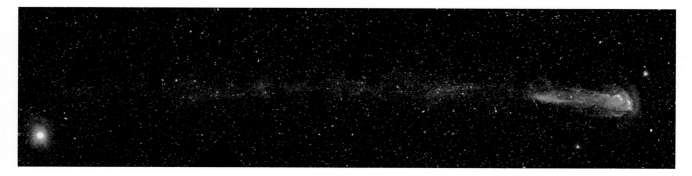

Fig. 6.16 GALEX observations from November 18 and December 15, 2006, show a bow shock of intense UV emitting gas at the leading edge of the red giant Mira (right). The UV emission captured by GALEX extends along the entire 13 light-year long tail of heated gas and dust stripped from the bow shock over the last 30,000 years as the star continues to move forward relative to its surroundings

Photographing Worlds Explored by Manned and Robotic Spacecraft

Our connection to the night sky runs very deep. Until the last century, people venturing outside at night would see a black sky punctuated by the glow of over 5,000 visible stars, planets, and the Milky Way arcing overhead. It filled our forebears' minds with wonder, reminded them of creation's vastness and found its way into their most profound beliefs.

Humankind has always looked to the stars for answers about our lives on the ground. The constant, seemingly unchanging, movement of the greater and lesser lights became a metaphor to help interpret the unpredictability of our existence. It provided a framework to explain life's greatest mysteries by prophets, priests, philosophers, and poets down through the ages.

Today, the shaman and their chants have been supplanted by scientists and the roar of rockets. And even though science attempts to remove subjectivity and the bias of long-held beliefs, the exploration of space still touches upon the deepest unanswered questions that stubbornly persist: Why are we here? Where did we come from? Are we alone?

Since the middle of the last century, humanity has taken its first few steps to find answers by sending humans as far as the Moon and launching robotic explorers to other planets and beyond. Along the way, the eyes of our explorers became our eyes through pictures that transformed abstract thought into images of other landscapes, skies of other worlds, vistas more grand than those conjured by the most unbridled imaginations of any poet or artist.

Most pictures asked more questions than they answered. Some looked back at our world and revealed a new perspective about our place in the universe. Like postcards returned from a traveling family member or friend, each image is a memento of a point in history when humankind replaced speculation with fact and exchanged myth for reality as we set out on our first voyages into the great beyond.

The Hellish Surface of the Planet Venus

Gleaming in the western sky shortly after sunset or visible in the east during the early morning hours, the light of planet Venus shines so bright it is often mistaken for approaching aircraft by airport flight controllers and given permission to land. Only the Sun and the Moon appear more brilliant in the sky.

Named for the Roman goddess of love, the glow of Venus has provided ample inspiration for painters, writers, and poets alike. However, views through early telescopes revealed a featureless sphere obscured by clouds, punctuated by changing phases that mimicked the Moon through its monthly cycle.

Virtually a twin of Earth in size, the planet lays 26 million miles closer to the Sun and receives twice the amount of solar radiation. Because of the planet's proximity to the Sun and its perpetually cloudy face, until the mid-twentieth century Venus was assumed to be a hot, tropical planet possibly with vast rain forests and creatures similar to Earth's dinosaurs. Thus, it was proposed, Venus provided a verdant second abode for life in our solar system.

However, nothing could be farther from the truth.

Earthbound investigations during the early 1960s, including those by astronomer Carl Sagan, revealed the copious presence of carbon dioxide and heat signatures suggesting searing surface temperatures fueled by a runaway global greenhouse effect. These conclusions were finally confirmed when *Venera 9* and *10* made the first successful landing on another planet October 22, 1975, and 3 days later on October 25, 1975, respectively.

© Springer International Publishing Switzerland 2015
R. Gendler, R.J. GaBany, *Breakthrough!: 100 Astronomical Images That Changed the World*,
DOI 10.1007/978-3-319-20973-9_7

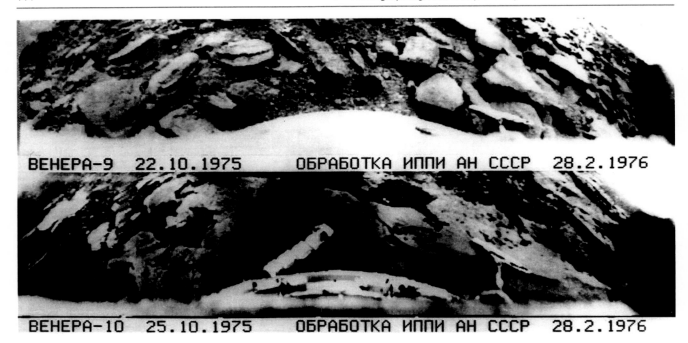

Fig. 7.1 The surface of Venus was shown to be barren and rock-strewn when the first images were captured by the Soviet Union's *Venera 9, top,* and *Venera 10* during October 1975

The canister-shaped spacecraft were designed to withstand enormous atmospheric pressures and temperatures hot enough to melt lead. Onboard cameras were able to take the first snapshots from the surface of another world and return them back to waiting scientists on Earth before the instruments were crushed. These historic images first revealed Venus to possess a barren, lifeless landscape extending into the distance.

The Heavily Cratered Face of Mars

Until the mid-1960s, Mars was considered the most likely place, other than Earth, that could harbor life. This perception was rooted in the 1877 Martian observations of Italian astronomer Giovanni Schiaparelli, who described seeing a network of linear structures that he called *canneli,* or "channels." Unfortunately, *canneli* was mistranslated into the word "canals." Canals suggested an artificial construction, whereas canneli were meant to connote the features were natural in origin.

The mistake led to waves of speculation that found its way into folklore, then widespread popularization, claiming evidence of intelligent life had been discovered on Mars by scientists. One of the most enthusiastic proponents for the artificial nature of canals on the planet was Percival Lowell, a wealthy American businessman, mathematician, and amateur astronomer who spent much of his adult life trying to prove the existence of the canals.

Edgar Rice Burroughs, who later penned *Tarzan of the Apes,* wrote a series of popular science fiction and fantasy stories involving the exploits of Earthly adventurers who were transported to Mars and lived among the inhabitants of that planet. English author H. G. Wells was also inspired by the notion of Martian beings by fictionalizing their attempt to conquer Earth in his novel *War of the Worlds.* In the 1930s, Wells' novel was updated and adapted into a radio play that is said to have spawned hysteria when it aired, even though listeners were warned of its fictional origins during the presentation.

Countless other works of popular fiction – in books, on the radio, and on the silver screen – further expounded on the dark consequences of Earth's first contact with beings from this nearby planet. Starting in the late 1940s, flying saucer sightings caught the world's imagination because these other-worldly vehicles were widely regarded to be piloted by Little Green Men from Mars.

When observing Mars from the ground, the light from the planet must first pass through the atmosphere. Because the air above the observer is constantly in motion, its turbulence can bend the light and throw it out of focus when viewing through a telescope. This phenomenon can also be seen with the naked eye when stars appear to twinkle.

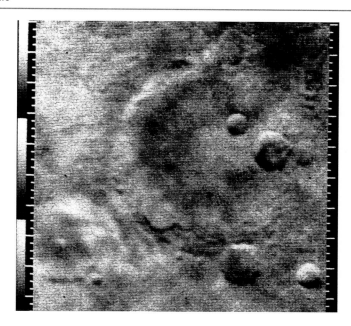

Fig. 7.2 On July 14, 1965, NASA's *Mariner 4* spacecraft ended centuries of debate about the habitability of Mars when it returned surprising images of the Red Planet's heavily cratered surface

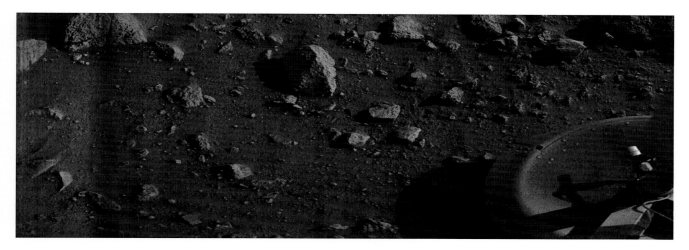

Fig. 7.3 The first image from the surface of Mars centered on one of the *Viking I* lander's foot pads out of the precaution that the lander would sink because the surface could not support its weight

Thus, when Schiaparelli, Lowell, and other astronomers who followed them viewed Mars under high magnification, the planet only snapped into sharp focus for brief instances of time. This forced the observers to remember what they saw, so it could be transferred onto a sketch pad. Couple these naturally poor observing conditions with the fact our brains tend to connect separate fine features at the threshold of perception into longer shapes, and what astronomers perceived as channels or canals were actually optical illusions caused by something entirely else.

Then, on July 14, 1965, NASA's *Mariner 4* spacecraft returned the first real images, showing a heavily bombarded Martian surface and therefore proving that the linear canal-like features reported by astronomers were most likely fleeting glimpses of individual closely spaced craters.

Designed to conduct scientific observations of Mars, then transmit its observations back to Earth, *Mariner 4* was the fourth in a series of spacecraft designed to conduct fly-by planetary reconnaissance and the first to return images of another planet from deep space. Its view of a desolate, pock-marked Martian surface, similar in appearance to the Moon, forever changed scientists' views about the possibility of life on Mars.

Perhaps if Mars is too inhospitable to shelter large organisms, it may yet prove to be the abode of microorganisms below its surface. Thus, NASA set out to place landers on the surface of Mars within 10 years of the Mariner mission. Called *Viking 1* and *2*, two identical spacecraft were launched during the summer of 1975. Each included an orbiter to map the planet's surface and a lander capable of scooping soil samples, loading them into an onboard laboratory and detecting the chemical signatures produced by life.

Viking 1 touched down on the Martian surface on July 20, 1975. Its first order of business was to return a photograph of one landing pad back to Earth in case the soil could not support the lander's weight and swallow it like quicksand. The first image from Mars quickly allayed these fears. It showed a firm sandy surface covered with a scattering of rocks.

At no point during the Viking program did the landers or the orbiters detect, with absolute confidence, that life was present on Mars – today or in the past.

Vega 1 at Comet Halley

For millennia, humankind has noticed the sudden, unexpected presence of comets in the night sky. For example, the ancient Chinese Shang dynasty oracle bones were inscribed with records of eclipses, sunspots, and comets. Comets struck fear and foreboding into the hearts of our ancestors as omens of imminent catastrophes, political unrest, the death of kings, or the attack of heavenly mythical creatures.

Aristotle believed comets existed within the atmosphere, but Tycho Brahe, the sixteenth century Danish observational astronomer, basing his ideas on the apparent positions of comets against the starry background as seen by widely spaced observers, concluded that comets resided far beyond Earth. Edmond Halley was the first to recognize comets had a solar orbit, when he correctly predicted the return of the 1682 comet in 1758–1759.

Newton and scientists that followed believed the center of comets, called the nucleus, were solid bodies covered with volatile substances that gave off vapors as they approached the Sun, thus forming their characteristic long tails. In 1950, astronomer Fred Whipple proposed cometary nuclei were icy objects containing a mix of dust and rocks. Also known as the dirty snowball model, his theory is still accepted today.

Fig. 7.4 The nucleus of Halley's Comet imaged by *Vega 1*, the Soviet Union's reconnaissance spacecraft that was re-purposed to fly by the comet prior to the arrival of the European Space Agency's Giotto probe

However, until the mid-1980s, no close observation had ever been made of a cometary nucleus because they are small – only a few miles in diameter – and millions of miles from our planet, even when they are at their closest approach. As such, the nucleus of a comet has a stellar appearance, even when seen through the largest telescopes on Earth.

This changed when, on March 6, 1986, *Vega 1,* a Soviet Union robotic fly-by reconnaissance spacecraft equipped with the first CCD cameras placed on an interplanetary spacecraft, rendezvoused with the nucleus of Halley's Comet a week prior to the close encounter by the European Space Agency's Giotto mission.

Launched in December 1983, *Vega 1* and its twin, *Vega 2,* were first directed to swing by the planet Venus. There they released a descent module containing a surface lander. Then they used a gravity assist from the planet and continued on to their encounter with the comet.

The image above appears somewhat fuzzy due to imperfections in the early CCD chip. However, it is possible to make out the shape of the nucleus and several jets that formed the comet's tail.

Earthrise Above the Moon's Shoulder

Apollo 8 was the second manned mission in the U. S. Apollo space program. Launched on December 21, 1968, it was to be the first time a manned spacecraft left Earth orbit, travel to the Moon and orbit it, then return to Earth safely. Commander Frank Borman, Command Module Pilot James Lovell, and Lunar Module Pilot William Anders became the first humans to

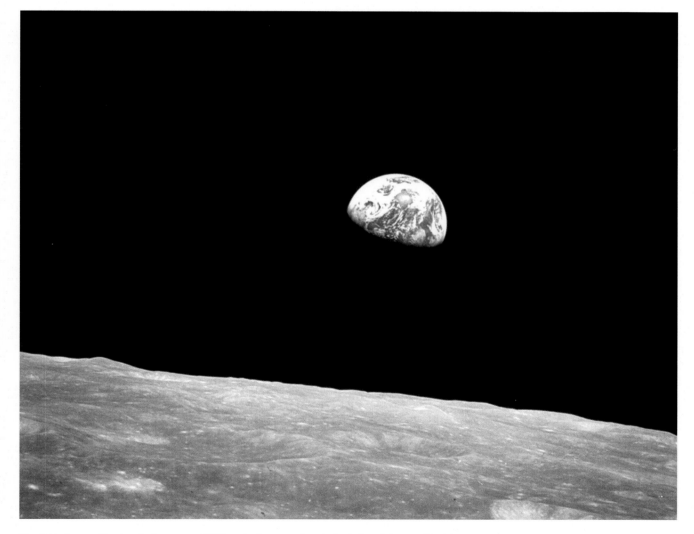

Fig. 7.5 Snapped by *Apollo 8* astronaut William Andrews on the mission's fourth lunar orbit, this is one of the most iconic images produced by the *Apollo* Moon missions of the 1960s. It captures the gibbous planet Earth as the crew witnessed it rising for the first time above the Moon's surface

launch into space from the (then new) Kennedy Space Center at Cape Canaveral, Florida, the first to visually observe the back side of the Moon, which never faces Earth, and the first human beings to view the entirety of our planet against the backdrop of deep space.

Apollo 8 required 3 days to reach the Moon after it departed Earth orbit. Arriving on Christmas Eve 1968, the crew televised live images of the Moon's surface from lunar orbit while sending well wishes and reading quotes from the Bible.

On their fourth orbit, the crew witnessed their first Earth-rise while returning from behind the Moon. Thoughtfully, astronaut William Andrews snapped an image of the event showing the entire Earth hanging above the limb of the Moon passing by below.

For the first time, humankind was able to grasp both the beauty and fragility of our planet as it floated in the capricious vastness of space. This was the first picture of the whole Earth taken by a person holding a camera, and it was credited with inspiring the Earth Day celebrations that have followed each year since 1970. The editors of *Life Magazine* later included the image in its list of 100 images that changed the world.

The First Walk in Space

Beginning in the late 1950s, the Cold War raged between the countries aligned with the United States and those under control of the Soviet Union. Each used the exploration of outer space as a new competitive stage for demonstrating their supremacy of technology and military might over each other.

The Space Race, as it was known, started in 1957 when the Soviet Union launched the first artificial satellite, called *Sputnik,* into orbit atop an R-7 intercontinental ballistic missile. Its success came as a surprise to most Americans, who considered outer space to be the next great frontier and therefore the next stage in their tradition of exploration. It also indicated that the Soviets had the technology to hang a nuclear weapon above the continental United States and threaten any of its large population centers with devastation from the heavens.

Within a year, the United States had successfully launched its first satellite, called *Explorer 1.* In 1959, the Soviets sent a probe that hit the Moon. This was followed, in April 1961, with the launch of the first person, Yuri Gagarin, into Earth orbit, traveling in a capsule-like spacecraft called *Vostok 1.* Three weeks later, on May 5, the United States sent its first person above Earth. Later in May, President John F. Kennedy announced plans to place a person on the Moon and return him safely to Earth by the end of the decade. His primary goal was based on the desire to create a military deterrence against aggressive Communist nations because the Moon represented the ultimate high ground from which nuclear-tipped missiles could be launched toward any nation that threatened the United States. Although the Soviet Union did not comment on Kennedy's proclamation, they secretly engaged in their own program to place a person on the Moon before the United States.

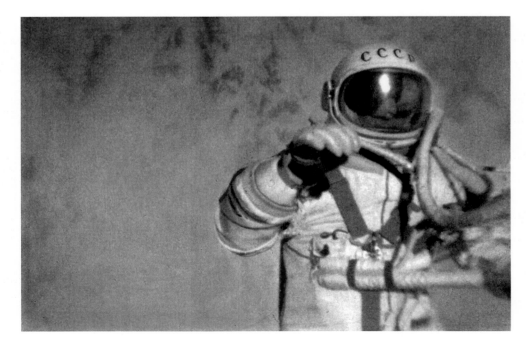

Fig. 7.6 A rare full-color image of Alexey Leonov hanging above the world below, taking the first excursion outside a spacecraft

Through the rest of the decade, both countries developed programs to build and test ever more complex launch systems and increasingly daring manned space missions to perfect the systems and procedures that would be needed for a manned journey to the Moon and the return voyage home.

The U. S. manned space program took a more conservative approach that placed crew safety ahead of attention-grabbing headlines. Even so, many of the U. S. achievements during this time were filled with risk that could have derailed their efforts and cost the lives of their astronauts. Conversely, the Soviets proceeded with an eye for the spectacular that placed a high value on the propaganda opportunities each manned launch represented. They experienced a number of setbacks, but many of these were kept secret.

A week before the United States sent its first two-person crew into orbit, the Soviet Union scored another first by launching its first two-person mission, named *Voskhod 2,* with Pavel Belyayev and Alexey Leonov. Their spacecraft included a special modification that acted as an airlock through which Leonov, early in the flight, exited the capsule and performed the first extra vehicular activity (EVA), or spacewalk.

During the excursion, a disaster was narrowly avoided when Leonov's spacesuit over-inflated. To squeeze back into the airlock, he had to partially reduce its internal air pressure to a life threatening level.

This again demonstrated that venturing into the unforgiving environment of outer space was never to be mistaken as a walk in the park.

Boots on the Lunar Soil

The journey to place a person on the Moon and return that person safely to Earth began on May 25, 1961, when U. S. President John F. Kennedy challenged the country in a speech to both houses of Congress. In it he stated,

> I believe that this nation should commit itself to achieving the goal, before this decade is out, of landing a man on the moon and returning him safely to the Earth. No single space project in this period will be more impressive to mankind or more important for the long-range exploration of space; and none will be so difficult or expensive to accomplish.

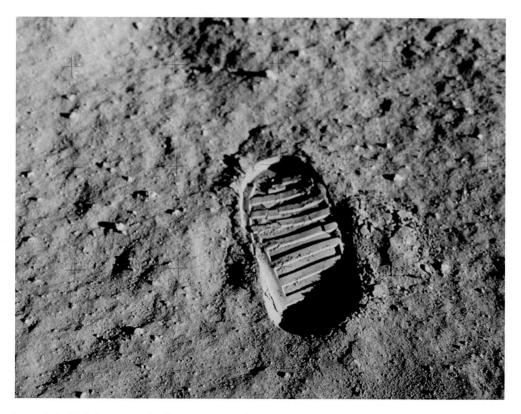

Fig. 7.7 A footprint made by Neil Armstrong, the first person to set foot on the Moon, during humankind's historic first visit to the lunar surface on July 20, 1969

Slightly more than 8 years later, on July 20, 1969, the United States successfully landed *Apollo 11* with its two occupants, Neil Armstrong and Edwin (Buzz) Aldrin, Jr., on the lunar surface. A few hours after landing, Neil Armstrong stepped out of the spidery spacecraft and placed his left foot on the Moon's powdery surface – a live event watched by billions back on Earth via television cameras the crew had brought with them.

Armstrong's first footprint, along with the numerous others left behind by both of the crew during their excursions on the lunar surface, will likely remain essentially untouched for millions of years into the future, evidencing humankind's first baby steps off its home planet. It's not far-fetched to speculate the landing sites of the Apollo missions will become a tourist attraction for people living on or visiting the Moon in the far future. Hopefully, someone will have the vision to cordon the area and prevent mankind's first boot prints from being comingled with the steps of eager early space history buffs.

It is also quite plausible that as the twentieth century fades into antiquity, historians a thousand years in the future will overlook the social turmoil, wars, and conflicts occurring during that time and consider this human boot print on the Moon as the most significant event of the era.

A Precise Moon Landing

Although *Apollo 11* was successful in landing the first people on the Moon, the lander's onboard computers, with less processing power than most modern smart phones, became overwhelmed by the stream of information it was receiving during the spacecraft's decent from lunar orbit. A series of heart-stopping alarms occurred minutes prior to touch-down that neither of the astronauts on board the lunar lander nor flight controllers back on Earth in Mission Control clearly understood.

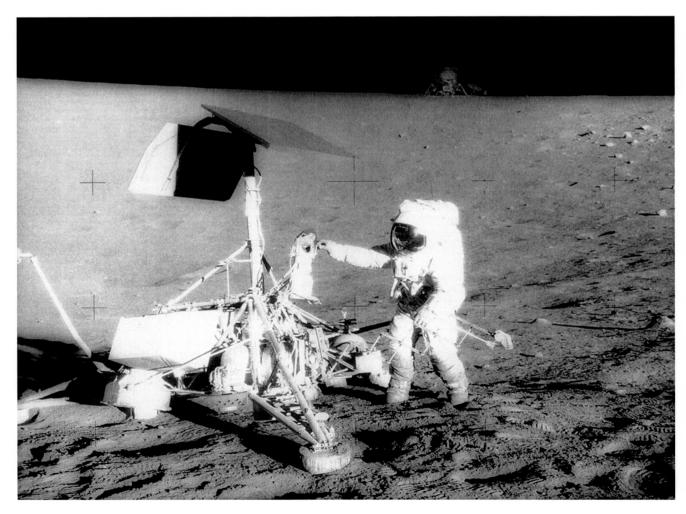

Fig. 7.8 *Apollo 12* lunar module Pilot Alan Bean, on November 20, 1969, standing next to *Surveyor 3,* a robotic spacecraft sent to explore the lunar surface environment 2 years earlier. The lunar lander carrying Bean and mission commander Pete Conrad to the Moon can be seen about 600 feet in the background

Commander Neil Armstrong eventually took manual control and guided the lander to the surface with only seconds of fuel remaining. As a result, Eagle, as the Moon lander was named, touched down on the lunar surface miles from its intended destination. Thus, the first Moon landing was accomplished by a combination of Armstrong's skills and a measure of good fortune.

So, performing a precise landing became one of the top priorities for *Apollo 12,* the second mission to land people on the Moon, else no further lunar landings could be considered in good conscious.

Between June 1966 and December 1968, NASA launched seven robotic spacecraft, called Surveyors, to develop the procedures necessary to soft land people on the Moon. The main body of each Surveyor spacecraft sat on three hinged legs fitted with shock absorbers and large landing pads. Attached to this structure was a solar panel to supply power; electronics, and antennae for communicating with controllers on Earth; propulsion and navigational engines and other payload systems changed with each flight. The lander stood about 10 feet tall and weighed slightly more than a ton at launch. By the time each Surveyor touched down on the Moon, it weighed only about 650 pounds because its retrorockets burned through their fuel, slowing the craft to make a soft landing.

Two of the Surveyor missions were lost, but five, including the first one, successfully soft landed on the Moon. The third Surveyor mission included several design changes. For example, the spacecraft was fitted with a television camera to take pictures of the surface, an articulating arm with a small scoop to measure the mechanics of the lunar soil, and instruments to analyze thermal conditions.

Within an hour of touchdown, the camera produced its first surface image. Two days later, the scoop dug its first trench into the lunar soil. The spacecraft performed all its assigned tasks over the full 2-week length of a day on the Moon. Following that, it fell into silence.

However, that was not the end of its mission because on November 19, 1969, *Apollo 12* landed within 600 feet of *Surveyor 3*, performing an amazing feat of precision landing. Commander Pete Conrad and lunar module Pilot Al Bean walked over to the Surveyor on their second journey outside their lunar lander. They took pictures, examined its condition and surroundings, removed over 20 pounds of equipment, and returned it to Earth.

Each of the Surveyors that reached the Moon are still there. They were not designed to return back to Earth. Only parts from *Surveyor 3* gathered by *Apollo 12* astronauts came home. Today, the camera of *Surveyor 3* is on display at the Smithsonian Air and Space Museum in Washington, D. C.

The Fateful Voyage of *Apollo 13*

By the time *Apollo 13,* the third mission to land people on the Moon, took place, most of the world's attention had shifted from space exploration to the events shaping their world. So, when *Apollo 13* left, missions to the Moon were already considered routine and commonplace. However, nothing could have been further from the truth.

The Apollo spacecraft consisted of three units. The first was a cone-shaped, pressurized command module (named Odyssey on *Apollo 13*) that housed and protected the three-person crew, and the second was a four-legged lunar insertion module, or LIM (named Odyssey) that was attached to the front of the command module by a short tunnel and shuttled two astronauts between lunar orbit and the Moon's surface. The third unit was a cylindrical service module that was attached to the rear of the command module. It contained the crew's oxygen and water plus fuel required to power the module's primary rocket engine and several smaller navigational thrusters.

When *Apollo 13* was closing on the Moon, the three astronauts on board, Commander James Lovell, Command Module Pilot "Jack" Swigert, and Lunar Module Pilot Fred W. Haise, felt the spacecraft violently shudder immediately after commencing a routine procedure involving the contents of one of the oxygen tanks in the service module. This was followed by numerous alarms indicating something catastrophic had just occurred.

Immediately, both the astronauts on board *Apollo 13* and flight controllers at Mission Control on Earth noticed a rapid drop in the level of oxygen. Because the Apollo spacecraft was powered by fuel cells that required oxygen, electricity within the spacecraft was also diminished. The astronauts could also observe oxygen being vented into space from somewhere in the service module. This venting caused the spacecraft to rotate uncontrollably. Unfortunately, several thrusters were also damaged, so they produced little stabilizing effect.

The astronauts quickly realized that the lunar lander, which normally wasn't opened until they reached the Moon, would have to serve as a lifeboat until they swung around the Moon and re-approached Earth. Then they could return to the command module, which had a heat shield necessary to protect them from the fiery re-entry though Earth's atmosphere. But first, they needed to power the lunar module and shut down the command module's electrical systems to conserve enough power for their re-entry. Lovell and Haise powered the LIM faster than it was designed for while Swigert shut down the electrical components in Odyssey. When completed, he joined the other two in the lunar module.

Fig. 7.9 Damage to the *Apollo 13* service module was not visible until the command module, carrying the three astronauts, separated from it shortly before their re-entry into Earth's atmosphere

Over the next few days, the cabin temperature dropped to near freezing, and the crew balanced their need to conserve power in the lunar lander with the challenge of staying alive. Back on Earth, as news of the disaster spread, the world's attention became riveted on events taking place near the Moon.

The crew lost weight, and Swigert developed a kidney infection during their ordeal. But, before re-entering Earth's atmosphere, they separated from the service module and took a picture showing the damage wreaked by the explosion. It was later determined that a bare wire within one of the service module's oxygen tanks sparked its contents, resulting in a fire that ripped the tank open, also damaging another oxygen tank in the process. On April 17, 1970, the crew of *Apollo 13* safely splashed down in the Pacific Ocean. The next Apollo mission included an extra oxygen tank and reconfigured wiring to prevent future reoccurrences from happening.

Apollo 13 demonstrated that there is nothing routine or commonplace about space travel.

Illuminating the Dark Side of the Moon

Around 4.5 billion years in the past, the planets in our Solar System were still forming. During this early period, the planets were still accreting material from the leftover cloud of dust and gas that formed the Sun. This was a violent process that included storms of meteoroids and comets raining down on the early proto-planetary surfaces punctuated by occasional planetary collisions.

Scientists now believe the early Earth was struck by another proto-planet about half its size during this era. The smaller planet was absorbed, but the encounter resurfaced Earth and sprayed billions of cubic miles of material into orbit. Over time, the orbiting debris gravitationally coalesced and formed our Moon.

The early Moon rotated on its axis much faster than today, so it would have been possible to observe its entire surface over time if one could have stood on the primitive Earth. However, over millions of years, the gravitational pull of Earth produced a tidal bulge in the early Moon, similar to the bulge in Earth's oceans that creates our tides. This bulge created friction that

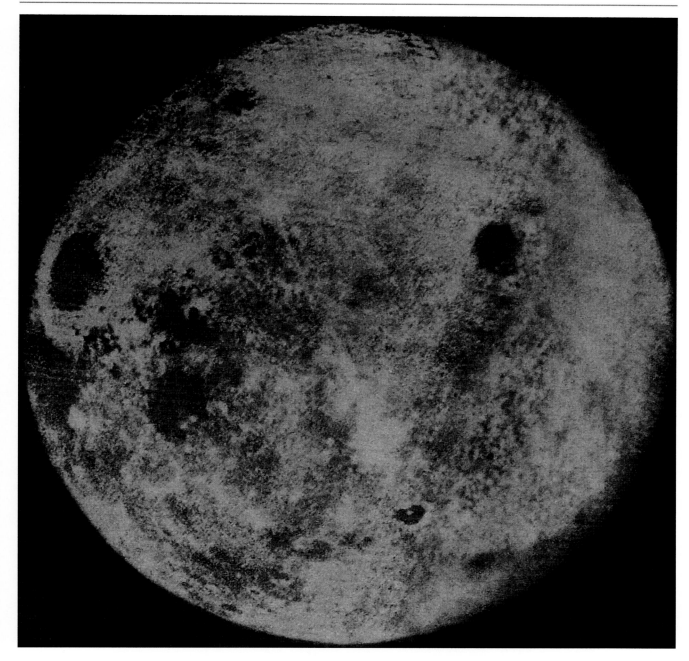

Fig. 7.10 Humanity's first fuzzy glimpse of the side of the Moon forever turned away from Earth, as seen by the Soviet Union's *Luna 3* spacecraft in early October 1959

acted like a brake, gradually slowing the Moon's rotation. The Moon's gravity had a similar, although much smaller, effect on Earth, and, over time it caused our planet's days to grow longer, too.

Eventually, the Moon's rotation slowed to such a degree that it practically equaled the time it took to complete one orbit around Earth. As a result, the Moon appeared to show only one face to us, making it impossible to see the other side.

This was the situation for billions of years until October 7, 1959, when the Soviet Union's *Luna 3* spacecraft, a small canister-shaped probe slightly over 4 feet long and 3 feet wide, made its way to the other side of the Moon and started taking photographs. *Luna 3* carried two cameras and emulsion-based rolls of film with on-board facilities to develop and scan the final images then transmit the pictures back to an anxious Earth.

The blurry images banded by electronic noise revealed the other side of the Moon was mountainous and heavily cratered, but, surprisingly, it hardly resembled the side facing our planet. The presence of large dark areas, or maria, that visually merges to form the familiar Man in the Moon pattern was conspicuously absent on the back side, other than two small dark patches.

Since *Luna 3,* the entire surface of the Moon has been mapped with high precision by numerous robotic missions that have followed. Today, lunar space craft photographs show features as small as a coffee table with clarity.

The Great Red Spot of Jupiter and the Rings of Saturn

During the mid-1960s, NASA planners began to envision a spacecraft reconnaissance of all planets within our Solar System. They recognized a rare upcoming alignment of the outer planets, Jupiter, Saturn, Uranus, Neptune, and Pluto, that would enable a Grand Tour by using the gravity of each planet to slingshot a spacecraft toward the next planetary target, gaining speed in the process. This chance alignment occurred during the early 1970s and would not happen again for another 175 years.

Unfortunately, NASA budget cuts following the Apollo missions to the Moon prevented the development of the probes originally envisioned and delayed the launch of a scaled-down mission, called the Mini-Grand Tour, until 1977 with the lift-offs of *Voyager 1* and *2.* Both spacecraft were targeted to visit Jupiter and Saturn, but *Voyager 2's* itinerary also included Uranus and Neptune – a voyage that would take the second Voyager 12 years to complete.

Although Jupiter had been previously visited by NASA's *Pioneer 10* and *11* in the early 1970s, the higher development budget for the Voyager missions combined with the technology leaps occurring during the intervening years enabled the Voyager spacecraft to produce evocative imagery of significantly higher quality.

Voyager 1 made its closest approach to Jupiter on March 5, 1979, nearing the same the distance separating Earth and the Moon. Although the close approach enabled its cameras to capture the Solar System's largest planet in greater detail, it also

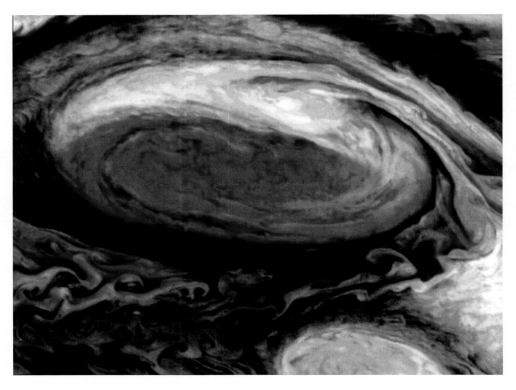

Fig. 7.11 A color-enhanced view of Jupiter's Great Red Spot, a gigantic 150+ year-old hurricane capable of swallowing two or three Earths, seen close up by *Voyager 1* as it passed the giant gas planet on its journey to Saturn and interstellar space

required the probe to conduct most of its observations during the 48-hour period before and after its closest encounter because the mission was a flyby.

The Voyager missions significantly expanded our knowledge about the four large Galilean moons, discovered the existence of rings surrounding Jupiter and three small moons, revealed that the Great Red Spot was a complex counterclockwise storm extending deep into the planet's atmosphere, and observed the dynamics of smaller storms and eddies throughout the cloud bands.

On November 12, 1980, *Voyager 1* made its closest approach to the planet Saturn. Just as during its time at Jupiter, the data returned by the spacecraft, including dramatic high-resolution imagery, painted a new picture of the planet, with its complex system of rings and orbiting moons.

Saturn is surrounded by the most extensive set of planetary rings in the Solar System. The rings are not solid but consist of countless individual fragments ranging from boulders the size of houses to grains of dust smaller than particles in cigarette smoke. Each fragment is in a unique orbit around the planet.

The rings are comprised mainly of water-ice along with a small percentage of rocky material. They most likely formed early in Saturn's history and may be the remnants of a long lost moon that became disrupted by the gravitational field of Saturn when its orbit decayed and it ventured too close to the planet.

Gaps within the rings were first discovered in 1675 by Italian astronomer Giovanni Domenico Cassini. The largest gap now bears his name. The Pioneer spacecraft that preceded Voyager to Saturn discovered hundreds of grooves within the rings. Voyager images confirmed this, and provided unprecedented detail. These structures in the rings are most likely caused by the gravitational effect of Saturn's moons that pull material into areas of greater density, thereby creating regions with less debris.

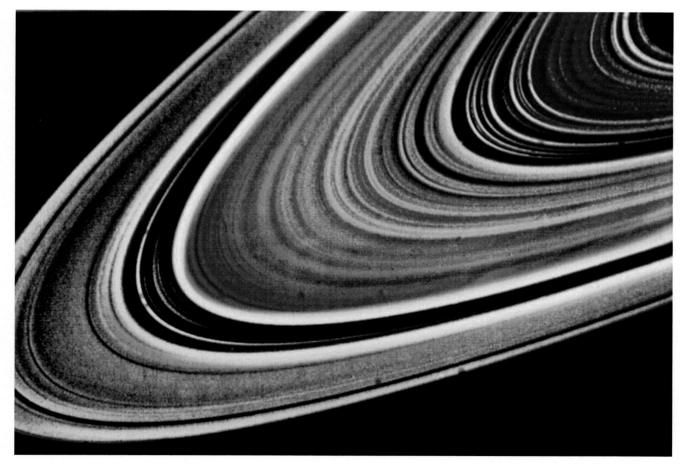

Fig. 7.12 Before probes visited Saturn, Earth-based telescopes had identified seven rings surrounding the planet. However, spacecraft found the rings to have hundreds of subdivisions and other unsuspected structures, as seen in this picture returned by *Voyager 2*

The Methane Lakes of Saturn's Moon Titan

When *Voyager 1* and *2* flew by the planet Saturn, both spacecraft also made observations of its system of natural satellites. The largest moon, Titan, is also the largest moon in the Solar System and the only moon known to have an atmosphere. Scientists speculated that the density of Titan's atmosphere, its chemical composition, and its optical opacity could be an indication that the surface was covered with oceans of liquid methane or other organic material.

In 1997, NASA and Europe's space agency, ESA, launched a bus-sized robotic probe named *Cassini-Huygens,* whose mission was to orbit Saturn and conduct multi-year observations of the planet, its ring system, and surrounding satellites. Also included was a small robotic probe, named Huygens, whose mission was to enter Titan's atmosphere and safely land on its surface.

Arriving at Saturn on July 1, 2004, after an 8-year voyage that included flybys of Venus, Earth, and Jupiter, *Cassini* entered orbit around the planet after plunging through its ring system. One day later, *Cassini* had its first close encounter with Titan.

Using special optical filters that could penetrate the haze surrounding the moon, Cassini's images showed that the south polar cap was covered by features of widely varying brightness. Later that year in October, *Cassini* made another even closer pass by Titan. During this encounter, the spacecraft collected and transmitted over 4 gigabits of data back to Earth.

The October 2004 flyby included the first radar images of Titan's surface. Combined, the radar and optical images displayed dark north polar regions larger than Lake Michigan on Earth. Subsequent flybys revealed more evidence that the darker areas on Titan's northern and southern polar areas were lakes of liquid methane.

In December 2004, Huygens separated from *Cassini,* and on January 15, 2005, the probe drifted through Titan's atmosphere, collecting data and snapping pictures once its parachute opened to slow its decent. Huygens was targeted to land near Titan's equator but did not find direct evidence of liquid lakes. However, its images showing drainage gullies and features resembling shorelines strongly suggested the presence of liquid in the recent past.

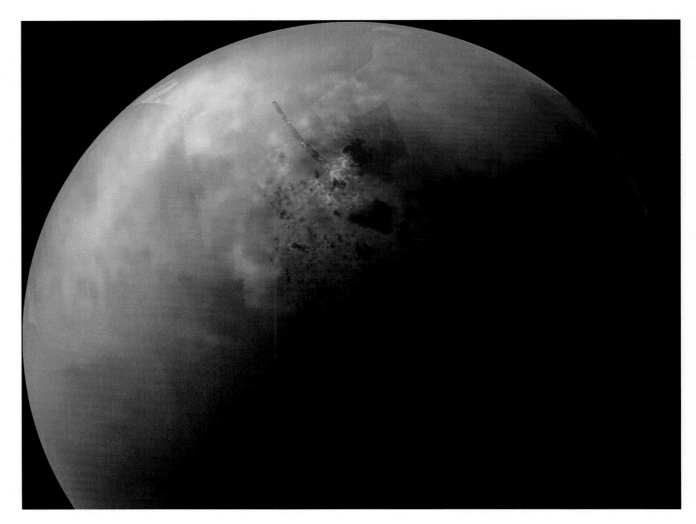

Fig. 7.13 A false-color near infrared image of Titan showing its dark-colored liquid methane lakes and seas

The Fountains of Enceladus

Could there be life elsewhere in the Solar System in addition to the verdant oasis in space we know as our home planet, Earth?

Certainly not Mercury; the innermost planet is constantly flooded by intensive, deadly solar radiation. Not Venus, the second planet from our star. Robotic probes have already confirmed the surface of Venus is inhospitable, with temperatures capable of melting lead. So far, Mars has proven to be a barren, windswept landscape that, perhaps, once harbored living organisms. But any Martian life that may have existed has either passed into history or sought refuge by burrowing far beneath its surface. The giant outer gas planets – Jupiter, Saturn, Uranus, and Neptune – are too removed from the Sun's heat and thus locked in perpetual cold that could never give life the chance it needs to take a foothold. So, it was quite surprising when the NASA/ESA jointly funded probe named *Cassini-Huygens* discovered evidence of a vast subterranean sea beneath Saturn's sixth largest moon, Enceladus.

Not much was known about Enceladus before *Cassini's* initial encounters in 2005. First observed in the late eighteenth century by astronomer William Herschel, for almost 200 years Enceladus remained a far off mystery of little consequence – a barely discernible telescopic blip circling Saturn. Then, in mid-1981, *Voyager 2* passed within 87,000 km of its surface, capturing high-resolution images showing a highly reflective, young surface with a heavily cratered northern half. Astronomers speculated that the satellite may be geologically active and a source of material for Saturn's tenuous E-ring, in which Enceladus orbited.

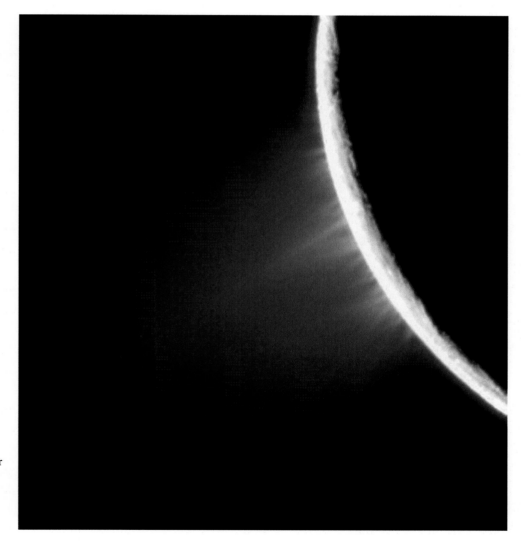

Fig. 7.14 Plumes of liquid water erupt from the vast subsurface seas of Enceladus, as seen in this enhanced color image by the NASA/ESA spacecraft *Cassini-Huygens*

Within its first year at Saturn, *Cassini-Huygens* discovered that Enceladus had a substantial water vapor atmosphere, giant geysers spewing water jets hundreds of miles above its surface, and the presence of cryo-volcanoes that erupted water and ice instead of molten rock. This confirmed that the E-ring was most likely created by Enceladus and explained how the moon was constantly being resurfaced with fresh, bright material.

The spacecraft also detected that the moon was producing its own internal heat, most likely due to the pull of nearby Saturn's gravity. This gravitational tug produces friction inside Enceladus by constantly stretching and squeezing the moon, changing its shape. Most scientists have now concluded that the source of water surrounding Enceladus, gushing from its gigantic geysers and oozing from its volcanoes, must be a vast underground ocean many miles deep.

Based on the chemical signatures detected in the water vapor and the discovery of the moon's internal heat, it has also been proposed that the underground oceans of Enceladus could be an excellent place to search for life.

Capturing Solar Prominences Without an Eclipse

In the 1960s, Wernher von Braun, the famous rocket engineer, proposed that NASA build a human outpost in space, but the space agency was too focused on getting people to the Moon at that time. So, funds for other projects were not available, and the idea languished.

But, as budget cuts hit the Apollo program in the early 1970s, NASA was forced to cancel the last three planned Apollo missions. Around the same time, they announced the creation of the Apollo Applications Program to repurpose unused Apollo

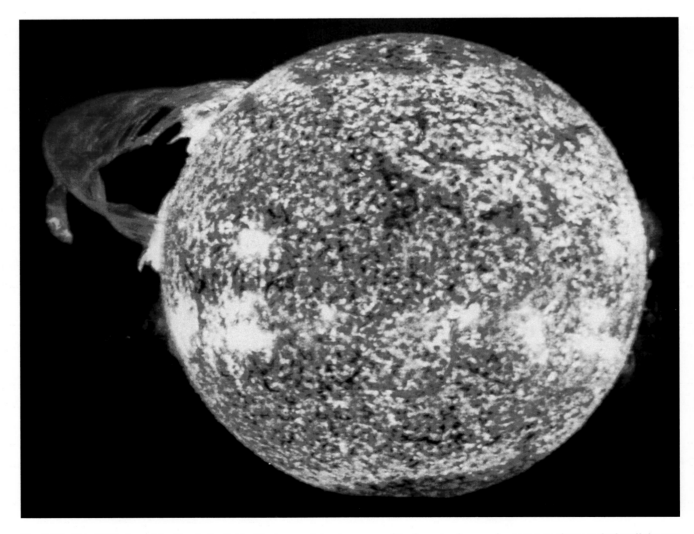

Fig. 7.15 This 1973 view of the Sun in the light of hydrogen-alpha shows one of the largest solar prominences ever photographed until the turn of the last century. It was one of over 160,000 solar observations completed over the course of three Skylab missions

hardware. For example, on January 4, 1970, NASA announced that the Saturn V rocket, originally intended for *Apollo 20*, would be used for the Skylab space station, based, in part, on the idea suggested by von Braun during the previous decade.

At the time of its launch in May 1973, the boxcar-sized *Skylab* was the largest and most complex space vehicle ever sent into space by the United States. Built from the third stage of a Saturn V rocket, the three-person orbiting laboratory was designed to conduct scientific experiments in near-zero gravity and study the effects of weightlessness on people. However, *Skylab* wasn't only an experiment to prove that humans could spend an extended time in space. It was also a powerful solar observatory.

The technological centerpiece of *Skylab* was the Apollo Telescope Mount (ATM). It bristled with eight instruments dedicated to scrutinize the Sun. Combined, they could observe the Sun at several wavelengths and in particular X-ray and ultraviolet. The ATM could also create an artificial solar eclipse by blocking the Sun's disc with a mask. Thus it could view the Sun's extended atmosphere, called the solar corona, for long periods of time – something only visible from the ground for fleeting moments during a real eclipse.

Earth's ozone layer prevents most ultraviolet light from reaching the ground. This is an obstacle for Earth-based telescopes to study solar flares, because they are most easily viewable in that wavelength. The study of solar flares was important because these eruptions on the Sun's surface had the ability to knock out communications, damage electronics, short-circuit the power grid, and pose a grave risk to people in space. But, orbiting above Earth's atmosphere, *Skylab* had an unimpeded view of the Sun in ultraviolet light.

Over the 8 months of *Skylab's* operation, three sets of crews produced over 160,000 solar exposures using almost 30 canisters of photographic film. The chronograph, alone, logged almost 9 months of continuous operation. This accomplishment can be contrasted with the only 80 hours of coronal observations from all the natural solar eclipses collected from the ground since the invention of photography in the nineteenth century.

The ATM provided data that exceeded the scientific expectations of quality, quantity, and the range of observed solar activity. Significant new scientific findings were revealed, and the mission provided a wealth of valuable information that resulted in advancement of our understanding of Earth's nearest star.

The Face on Mars

Pareidolia is a phenomenon that occurs when an indistinct sound or image is perceived as something more significant, such as hearing hidden messages on records when played in reverse, seeing images of animals or faces in clouds, spotting the man in the Moon, or studying relatively low resolution pictures of planetary features taken under unusual lighting conditions by orbiting spacecraft.

Carl Sagan, the famous astronomer, speculated that evolution favored our ability to recognize human faces. This enabled us to see faces from large distances even in conditions of poor visibility. The evolutionary advantages of this ability are many such as, for example, it gives us the ability to discern friend from foe. But, it can also lead to the sincere misidentification of otherwise random light and dark patterns as looking like a face, too.

Such may be the case of the face many thought they saw on Mars.

When the Mars *Viking 1* and *2* were developed, each spacecraft was comprised of a lander and an orbiter capable of mapping the planet at, what was then considered, high resolution. The orbiter would also serve as a relay station to facilitate communications between Earth and the lander on the ground.

Cydonia is a northern region on Mars that lies between a heavily cratered area and relatively smooth plains. Scientists believe that the heavily cratered area was once covered by water, whereas the plains may have been an ancient coastal shore.

This region was imaged by the *Viking I* orbiter on July 25, 1976, at a resolution of about 825 feet (250 m) per pixel. One of the images it captured included a ground feature that had the appearance of a face. Thirty-five orbits around Mars later, a second image of the same feature was also taken under different lighting conditions. It, too, captured the facial feature.

Speculation about the existence of sentient life on Mars, either past or present, has been a hallmark of books and movies about the planet since the presence of canals was accidently misinterpreted from the observations of astronomer Giovanni Schiaparelli in 1877. So, the identification of a facial feature on Mars sparked widespread speculation by individuals, groups, and popular media that an artifact from an ancient Martian civilization had finally been discovered. When NASA scientists dismissed these claims as examples of pareidolia, accusations of a government cover-up quickly ensued.

Although the instruments aboard the Viking spacecraft were state-of-the-art, like all space missions, both Mars probes were designed and built several years earlier using technology available in the early 1970s. The advancements in spacecraft design, the sensitivity of their detectors, and resolution of their optical cameras were huge between the years that intervened from Viking to the Mars Reconnaissance Orbiter (MRO) mission, launched in 2006. The camera on MRO continues to

Fig. 7.16 The face on Mars as imaged by the HiRISE camera onboard the Mars Reconnaissance Orbiter in 2007. The insert shows the same feature captured by the *Viking 1* orbiter in 1976

transmit images with its HiRISE camera operating at a resolution as high as 36 inches (90 cm) per pixel. Compared to Viking, MRO has vastly improved optical acuity.

So, the controversy was finally put to rest when the face on Mars in the Cydonia region was re-captured by MRO in 2007, revealing a barren, eroded, and cratered mesa without any hint of a face.

Martian Blueberries

Is there, or has there ever been, life on Mars?

This is a question that has puzzled scientists and the public alike for well over a hundred years. To answer the question, a fleet of spacecraft has been sent to the Red Planet since the 1960s. Many missions ended in failure. Several, however, have yielded surprising results.

During the early 1990s, NASA adopted a philosophy to follow the water for its future exploration of Mars. This approach insisted that life would not be possible without the presence of water. Water, it was reasoned, is the essential ingredient for life because, on Earth, where we find water we almost always find life. Therefore, if the Red Planet has ever harbored living organisms, evidence of liquid water would help reveal it.

So, on April 7, 2001, NASA launched the Mars Odyssey robotic mission to search for evidence of past or present water or ice on the surface of Mars. The craft also served as a communication relay station for signals between Earth and robotic rovers on the planet's surface. Onboard were remote sensors that could identify the distribution of minerals on the Red Planet by detecting the thermal infrared energy they emitted at nine different spectral wavelengths. The spacecraft could also

produce high-quality optical images of features on the ground at a resolution of approximately 59 feet (18 m) per pixel, which is about the size of a semi-tractor trailer.

On January 25, 2004, the Mars Exploration Rover named Opportunity soft-landed near the Martian equator at Meridiani Planum a few weeks after its twin, named Spirit, reached the other side of the planet. Opportunity's landing location was selected because Mars Odyssey had identified hematite covering hundreds of miles. On Earth, hematite is often formed inside hot springs or in pools of water.

The arid western landscapes of southern Utah resemble the Red Planet because of the area's similarity to Mars in both climate and geography. Since it's not possible for geologists to personally examine the sediments, outcroppings, and rocks on Mars, they study areas with similar weather and wind patterns here on Earth to help understand the patterns seen in orbital pictures or images returned by rovers. For example, before Opportunity landed, some scientists predicted there might be hematite balls similar to those found in rock shops near Utah's Zion and Capitol Reef national parks.

Sure enough, within 5 days after Opportunity touched down, it identified countless gray pebbles composed of hematite about the size of marbles, littering the landing site and embedded in rock outcroppings. The Opportunity science team called the hematite balls "blueberries" because the generous quantity of the mineral marbles in the rocks surrounding the landing site was similar in appearance to the popular breakfast muffin and partially due to their blue hue in false-color images released by NASA. The hematite spherules were also loosely scattered across the surrounding plains.

In 2004, scientists concluded that the Martian blueberries were formed when groundwater percolated through rock, causing the dissolved minerals to precipitate and form layered, spherical balls. Over time, the rock layers that encased them weathered and exposed the hematite balls. Therefore, many scientists believed the hematite at Opportunity's landing site provided strong evidence of ancient bodies of water.

Fig. 7.17 Hematite spherules, dubbed blueberries by the mission controllers, are abundant on the Martian surface where the Mars Exploration rover Opportunity soft-landed near the Martian equator at Meridiani Planum on January 25, 2004

Over the next decade, ongoing research into the origin of the Martian blueberries raised new questions about the role water may have played. For example, scientists found that similar spheres analyzed on Earth were formed by microorganisms. Thus, this evidence suggests both the presence of water and microbial life on Mars sometime in the distant past.

Other scientists, however, have cast doubts about the need for water for life. They can explain the presence of blueberries by the breakup of incoming meteorites in the Martian atmosphere. Their research points to similar spherical objects found in lunar soil samples returned by the *Apollo 12* astronauts.

So, like many discoveries involving the Red Planet, the question about life continues to swing back and forth between "possibly" and "no."

The Icy Subsurface of Mars

There are events in space exploration when fantasy and speculation become fact. Such was the case when NASA's Phoenix lander discovered water-ice just below the Martian surface.

Touchdown for the Phoenix occurred on May 25, 2008. Within days of landing, the probe began to collect and transmit data and images from its −58 °F temperatures (−50 °C) location near the planet's north pole.

Phoenix was the first probe to land in a Martian polar region. The principal goal of its mission was to investigate the polar area's habitability. Until Phoenix, previous missions landed in the arid equatorial areas of the planet. The Phoenix mission landing location was selected because subsurface ice was likely present.

Giovanni Cassini was the first to discover the Martian polar caps during the mid-seventeenth century. About 100 years later, English astronomer William Herschel first suggested the caps might be made of ice or snow. Herschel also made many comparisons between Earth and Mars and is credited with first speculating that the Red Planet could be an abode for life. However, during the late 1800s, scientists began to question that ice was present in the Martian polar caps due to the planet's extremely low average temperature and the absence of water anywhere else on its surface.

Water vapor was not unequivocally detected on Mars until 1963. Today we know that during the northern Martian winter, carbon dioxide freezes out of the atmosphere and forms a thin dry ice layer about 39 inches (1 m) thick that rests on top of a permanent ice layer. The planet's southern cap is also permanently covered by water-ice with an overlapping dry ice layer about 26 feet (8 m) thick. Even more ice is probably locked away below ground.

Mars' water estimate is based on spacecraft imagery, remote sensing instruments, and surface analysis from landers and rovers. Most scientists now believe if it were possible to melt all the water-ice frozen in the Martian polar caps, it could cover the entire planet to a depth of about 115 feet (35 m).

Water is also suspected to have been abundant in the ancient history of the Red Planet. Evidence for this is based on the observation of enormous channels carved by floods, ancient river valley networks, deltas, dry lakebeds, and the discovery of rocks and minerals on the Martian surface that could only have formed in liquid water.

Although we now believe the surface of Mars may have been wet enough to support microbial life billions of years ago, the current Martian environment makes the likelihood of present-day life extremely low due to the planet's frigid and dry conditions.

The absence of liquid water on the planet's surface can be attributed to the confluence of several unfortunate events on Mars. For example, Mars is only half the size of our planet; therefore its core, which remains molten and dynamic inside Earth, cooled much more quickly, leading to a cessation of widespread volcanism and the severe diminution of its protective magnetic field. The magnetic field shields Earth from the damaging effects of the solar wind that would slowly strip it of its atmosphere. On Mars, the atmosphere, along with the water vapor it contained, was blown into space by the particle winds blowing from the Sun. In addition, some of the Martian water was ejected off the planet by huge numbers of asteroid and cometary impacts that occurred 4 billion years ago, as evidenced by countless craters covering the Red Planet's surface. It is also suspected that some of the water on Mars sank into the ground, where it remains frozen to the present day.

The cold temperatures, the thin atmosphere, and the damaging effects of solar radiation that was allowed to reach the surface of Mars were limiting factors on the survival of surface life. Therefore, the best potential locations for discovering life on Mars are now assumed to be below the ground, hiding in the trapped water.

So, detecting subsurface water-ice was one of main mission goals for the Mar Phoenix lander. Soon after the probe soft-landed, it set to work. Less than a month after arriving at Mars, a soil sampling device onboard the lander carved a short trench in the Martian soil. Photographs revealed several dice-sized clumps of bright material at the bottom. Over the next 4 days, these clumps sublimated (went from a solid to a gaseous state) and disappeared. Chemical analysis from other onboard instruments confirmed that the clumps were water-ice.

Fig. 7.18 The Mars Phoenix lander discovered water-ice beneath the Martian surface less than a month after it landed on the Red Planet on May 25, 2008

Three months after it landed, the Phoenix lander lost contact with its handlers on Earth, its mission completed and completely successful. Over the years that have past, the Mars Opportunity rover has also detected water-ice beneath the surface of the soil at its equatorial location. Scientists now are confident that a vast amount of water exists beneath Mars, and it may represent the last bastion of life that once was abundant on the planet's surface.

Portrait of Planet Earth

For several months of each year, the planet Saturn can be spotted as a pale yellow point of light noiselessly floating in the evening sky. It's not the brightest light, nor is it the most dim. Like the other visible planets, Saturn can be distinguished because it seldom twinkles.

However, its stellar appearance is deceptive because compared to our world Saturn is a giant. At over nine times larger than Earth, Saturn could swallow over 750 copies of our planet if it were hollow. Although they appear solid, Saturn's dazzling set of rings are actually composed of countless fragments ranging from boulders the size of houses to dust finer than particles of smoke that would stretch three-quarters the distance between Earth and our Moon.

Yet, despite its magnificence, from here on the ground, Saturn is just a "star" in an ocean of stars.

On July 19, 2010, at a distance of almost 750 million miles (1.2 billion kilometers) from Earth, the *Cassini* spacecraft, in orbit around the Ringed Planet since 2004, looked back to snap a photo of its point of origin. Months prior to this date, NASA, the space agency in charge of the mission, recognized conditions would be optimal – the spacecraft's position would have a clear view of Planet Earth poised between two of Saturn's outer most rings.

The last time Earth was photographed from deep space was in 1990. Back then, the *Voyager 1* spacecraft returned a portrait of our planet as a "Pale Blue Dot" when it passed Neptune on its outward voyage to interstellar space. The timing of that picture was only known by scientists close to the mission. This time, NASA issued press releases encouraging people to look up, smile, and wave at the cosmic camera when the appointed moment arrived.

To avoid blinding *Cassini's* sensors and losing our world in the Sun's glare, the spacecraft waited until it had cruised deep into Saturn's shadow. It then methodically captured 140 images over a 4-hour period. These were later stitched into a large, seamless mosaic picture featuring Venus, Mars, Earth, many of Saturn's moons, and a large number of far more distant stars.

What it observed was a tiny glint easily mistaken for random static, confused with one of Saturn's many small moons, or overlooked entirely by an unsuspecting eye. To make our world more apparent in the final photograph, NASA editors artificially brightened it about eight times relative to Saturn.

Even with this enhancement, from Saturn, the Solar System's most important planet, the only world in the universe where we know life is possible and the place humanity calls home appears miniscule, unrecognizable and entirely unremarkable. Signs of civilization are far below the limit of perception – no web work of highways, no city centers, and none of our grandest monuments are visible. The eye strains to detect the separation between continents and oceans or the presence of vast weather systems without success and, of course, none of the estimated millions of people waving enthusiastically can be seen.

From this vantage point, Planet Earth is but a handful of pixels hanging like an ornament below the brim of Saturn's rings, surrounded by the inky blackness of space that stretches forever in every direction. It reminds us about the true nature of our existence – huddled on a tiny world of rock, water, and ice afloat in a vast cosmic ocean that surrounds and engulfs us.

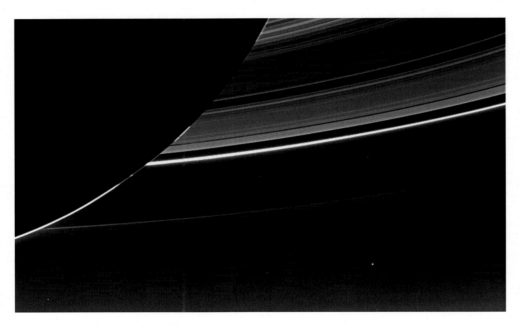

Fig. 7.19 Like an ornament hanging from the brim of some gigantic hat, Earth can be seen below the rings of Saturn in this section of a large 140-panel mosaic image that also captured Venus, Mars, and several of Saturn's moons

Image Sources

Chapter 2

Fig. 2.1 Courtesy of the Harvard College

Figs. 2.1–2.7 Catchers of the Light, Stefan Hughes

Fig. 2.8 (*Top*) Spectroscopy Reproduction of Fraunhofer's original 1817 drawing of the solar spectrum (Courtesy: Denkschriften der K. Acad. der Wissenschaften zu München 1814–15, pp. 193–226). (*Bottom*) The Hugginses, the Drapers, and the rise of astrophysics, Griffith Observer, October 1986

Fig. 2.9 *Project Gutenberg's A Text-Book of Astronomy*, by George C. Comstock New York D. Appleton and Company 1903 Copyright, 1901, By D. Appleton and Company

Fig. 2.10 Harvard-Smithsonian Center for Astrophysics, Smithsonian Astrophysical Obervatory 60 Garden Street | Cambridge, MA 02138

Fig. 2.11 *The Hertzsprung-Russell Diagram by Raymond Kneip*, Chandra-Harvard. EDU

Chapter 3

Figs. 3.1, 3.4, 3.5 and 3.11 Catchers of the Light, Stefan Hughes

Fig. 3.2 Powerhouse Museum, Sydney Australia, Remastered by David Malin, with permission from David Malin

Fig. 3.3 Isaac Roberts (d. 1904) – *A Selection of Photographs of Stars, Star-clusters and Nebulae*, Volume II, The Universal Press, London, 1899

Figs. 3.6 and 3.7 A Photographic Atlas of Selected Regions of the Milky Way

Fig. 3.8 The Modern Photographic Telescope and the New Astronomical Photography-Part VI. Authors: Ritchey, G. W. Journal: *Journal of the Royal Astronomical Society of Canada*, Vol. 23, p. 167 Bibliographic Code: 1929JRASC..23..167R

Fig. 3.9 Courtesy of the Hale Observatory, or Carnegie Observatories, via Center for History of Physics, a Division of the American Institute of Physics

Fig. 3.10 *"Realm of the Nebulae" Edwin Hubble, 1936*. Or *A Relation Between Distance and Radial Velocity Among Extra-Galactic Nebulae* by Edwin Hubble, Volume 15: March 15, 1929: Number 3

Chapter 4

Fig. 4.1 William C. Miller, Cal Tech, Remastered by and courtesy of David Malin

Fig. 4.2 William C. Miller, life Magazine article: The Hues of Heaven, April 27th, 1959

Figs. 4.3 and 4.4 Courtesy David Malin

© Springer International Publishing Switzerland 2015
R. Gendler, R.J. GaBany, *Breakthrough!: 100 Astronomical Images That Changed the World*,
DOI 10.1007/978-3-319-20973-9

Fig. 4.5 Courtesy Tony Hallas
Fig. 4.6 Courtesy Fairchild Imaging
Fig. 4.7 Courtesy Robert Gendler
Fig. 4.8 Gemini Observatory
Fig. 4.9 Courtesy Nick Risinger
Fig. 4.10 Courtesy R. Jay GaBany
Fig. 4.11 Credit: J. Rhoads, S. Malhotra, I. Dell'Antonio (NOAO)/WIYN/NOAO/NSF

Chapter 5

All images courtesy NASA/ESA
Fig. 5.8 NASA/ESA/R. Gendler/R. Jay GaBany
Fig. 5.16 NASA/ESA/ Cerro Tololo Inter-American Observatory
Fig. 5.31 NASA/ESA/R. Gendler
Fig. 5.32 *NASA, ESA, J. Dalcanton (University of Washington), the PHAT team, R. Gendler*

Chapter 6

Fig. 6.1 University of Massachusetts and the Infrared Processing and Analysis Center/California Institute of Technology (IPAC)
Fig. 6.2 NASA
Fig. 6.3 NASA
Fig. 6.4 ESA
Fig. 6.5 NASA, Caltech, JPL
Fig. 6.6 NASA, Harvard-Smithsonian Center for Astrophysics
Fig. 6.7 Radio data: (MPIfR/ESO/APEX/), optical data (ESO/WFI), X-Ray: Chandra X-Ray Observatory, NASA, Harvard-Smithsonian Center for Astrophysics
Fig. 6.8 Optical data: Magellan and Hubble Space Telescope and X-ray: Chandra X-ray observatory, NASA, Harvard-Smithsonian Center for Astrophysics
Fig. 6.9 NASA, Solar Dynamics Observatory (SDO)
Fig. 6.10 NASA, Caltech, JPL
Fig. 6.11 Hubble/NASA/ESA, Spitzer, Chandra
Fig. 6.12 NASA/ESA/Chandra X-ray Observatory/Spitzer Space Telescope/Calar Alto Observatory
Fig. 6.13 Hubble NASA/ESA, Spitzer/Chandra
Fig. 6.14 Hubble Space Telescope, NASA/ESA/ radio wave data recorded by the Very Large Array (VLA)
Fig. 6.15 NASA/DOE/Fermi LAT Collaboration
Fig. 6.16 GALEX/NASA

Chapter 7

Fig. 7.1 Vernera 9 and Vernera 10 surface landers, Soviet Space Program (USSR)
Fig. 7.2 Mariner 4, National Aeronautics and Space Administration (NASA)
Fig. 7.3 Viking 1 surface lander, National Aeronautics and Space Administration (NASA)
Fig. 7.4 Vega 1, Soviet Space Program (USSR)

Fig. 7.5 Apollo 8 Astronaut William Andrews, NASA
Fig. 7.6 Voskhod 2 cosmonaut Pavel Belyayev, Soviet Space Program (USSR)
Fig. 7.7 NASA
Fig. 7.8 Apollo 12 astronaut Jim Bean with Surveyor 7, Apollo 12 astronaut Pete Conrad (NASA)
Fig. 7.9 Apollo 13 astronauts James A. Lovell, John L. Swigert, Jr. and Fred W. Haise, Jr., NASA
Fig. 7.10 Luna 3, Soviet Space Program (USSR)
Fig. 7.11 Voyager 1, NASA
Fig. 7.12 155 Voyager 2, NASA
Fig. 7.13 NASA/ESA
Fig. 7.14 Cassini-Huygens, NASA/ESA
Fig. 7.15 Skylab mission astronauts, NASA
Fig. 7.16 Mars Reconnaissance Orbiter and Viking 1 orbiter (inset), NASA
Fig. 7.17 Mars Exploration Rover Opportunity, NASA
Fig. 7.18 NASA
Fig. 7.19 Cassini-Huygens, NASA/ESA

Index

A
Accretion disk, 69, 79, 134
Active galaxy, 64, 79, 128, 138, 139
Adaptive optics, 9
Afterglow, 121, 123, 140
AGB star, 91
Amateur astrophotographers, 10, 20, 55, 58, 59, 61, 62
Andrews, William, 147, 148
Apollo 8, 147, 148
Apollo 11, 150
Apollo 13, 151–152
Apollo Telescope Mount (ATM), 159
Arecibo, 11
Armstrong, Neil, 149–151
Astrometry, 22–24
Atacama Large Millimeter/Sub-millimeter Array (ALMA), 138
Aurora, 112–114, 132

B
Bell Laboratories, 7, 138
Bell Labs, 8, 11, 57, 121
Big Bang, 4, 43, 47, 100, 101, 107, 108, 121–124, 140
Black hole, 10, 64, 68, 69, 79, 80, 82, 90, 126–129, 134, 138–140
Bok globule, 98, 117
Bolometer, 11, 12
Bow shock, 141
Broadband, 68, 80, 91, 95, 99, 101, 106, 108, 116

C
Cassini-Huygens, 156–158
Cassini spacecraft, 163
Cassini space probe, 113
CCD. *See* Charged-couple device (CCD)
Cepheid, 4, 29, 43–44, 104, 105
Chandra, 61, 69, 82, 90, 109, 119, 126–129, 134, 137, 141
Chandrasekhar limit, 136
Charged-couple device (CCD), 7–9, 12, 49, 51, 57–59, 62, 147
 camera, 7–9, 12, 49, 58, 59, 62, 147
COBE. *See* Cosmic Background Explorer (COBE)
Comet, 2, 18–20, 31, 39, 40, 55–57, 93, 96–98, 114, 146–147
Core cluster, 84–85
Corona, 20, 21, 26, 126, 132, 159
Cosmic Background Explorer (COBE), 119–124, 126
Cosmic dust, 119, 133
Cosmic microwave background, 108, 121–124, 138
Cosmic yardstick, 104–105
Cosmology, 22, 26–29, 41, 43–47, 104, 107, 122–124, 126, 132

D
Daguerre, Louis, 2, 15, 17
Daguerreotype, 2, 15–31, 57, 58
Dark energy, 8, 122, 124, 131
Dark matter, 39, 64, 109, 114, 122–124, 127, 130–131
Dark nebula, 38, 40, 73
Debris disk, 103, 104
Density wave, 114, 115

E
Einstein, Albert, 47
Einstein ring, 64
Emission nebula, 55, 77, 82, 105–107, 116
Enceladus, 157–158
European Extremely Large Telescope, 9
Evaporating gaseous globules, 75, 89

F
False-color palette, 83
Fermi, 140

G
Galactic center, 114, 133–134, 138, 140
Galactic merger, 76
GALEX, 13, 119, 141
Gamma ray, 11, 13, 139–140
 burst, 139, 140
Gelatin dry plate, 2
Glass plate, 2
Globular cluster, 36, 44, 67, 90, 114
Gravitational lens, 8, 64, 107, 109, 130, 131
Great Red Spot, 154–155

H
200-inch Hale Telescope, 5, 7, 8, 51, 52
Herbig-Haro object, 54, 90, 99, 110
Hertzsprung-Russell, 29–30, 93, 111
HII region, 69, 71, 82–86, 89, 90, 107, 109, 116, 117
Homunculus, 71–73
Hooker Telescope, 4, 43, 44, 47
Hubble, Edwin, 4, 26, 29, 43–44, 67, 85, 104, 121, 150
Hubble constant, 47, 104, 105, 124
Hubble Deep Field, 100–101, 107, 108
Hubble Space Telescope (HST), 8–10, 43, 67–118, 126, 130, 134, 137, 139
Hypersensitization, 6

© Springer International Publishing Switzerland 2015
R. Gendler, R.J. GaBany, *Breakthrough!: 100 Astronomical Images That Changed the World*,
DOI 10.1007/978-3-319-20973-9